KT-104-383

29-95 ✓

emotional_digital

SWANSEA COLLEGE LEARNING CENTRE
TYCOCH ROAD, SKETTY
SWANSEA SA2 9EB

Tel: 01792 284133

This book is YOUR RESPONSIBILITY and is due for return/
renewal on or before the last date shown. You can renew by
telephone.

-2 FEB 2006

14 JAN 2008

23 APR 2015

8 FEB 2006

April

10. OCT 2001

15 FEB 2006

11 OCT 2006

27 FEB 2015

RETURN OR RENEW - DON'T PAY FINES!

SWANSEA COLLEGE
LEARNING CENTRE
LLWYN BRWYN
77
SA2 9RW

ACCESSION No: G 44916

SWANSEA COLLEGE
LEARNING CENTRE

CLASS No: 741 . 6 BRA

emotional_digital

A Sourcebook of Contemporary Typographics

Edited by
Alexander Branczyk
Jutta Nachtwey
Heike Nehl
Sibylle Schlaich
Jürgen Siebert

Thames & Hudson

Any copy of this book issued by the publisher
as a paperback is sold subject to the condition
that it shall not by way of trade or otherwise
be lent, resold, hired out or otherwise circu-
lated without the publisher's prior consent in
any form of binding or cover other than that
in which it is published and without a similar
condition including these words being imposed
on a subsequent purchaser.

First published in the United Kingdom in 1999
by Thames & Hudson Ltd,
181 A High Holborn, London WC1V 7QX

First published in the United States of America
in 1999 by Thames & Hudson Inc.,
500 Fifth Avenue, New York, New York 10110

© 1999 Verlag Hermann Schmidt Mainz

All Rights Reserved. No part of this publication
may be reproduced or transmitted in any form
or by any means, electronic or mechanical,
including photocopy, recording or any other
information storage and retrieval system,
without prior permission in writing from the
publisher.

British Library Cataloguing-in-Publication Data
A catalogue record for this book is available
from the British Library

ISBN 0-500-01925-8

Printed and bound in Germany

_Contents

__More is more

Jürgen Siebert

People who work with fonts are often
confronted with the old design principle
' less is more'. Many a time, we've heard
old-school typographers claim,
' I have never used more than the same
three type families in my work'.

This is a commendable limitation that can make life easier. But look at the vast selection of type available internationally and you'll see that the less-is-more approach no longer holds true. Every day new fonts and foundries spring up from the soil like mushrooms.

Today it is easier than ever before to produce and distribute fonts independently. All you need is a computer and the proper software, and you're in business. The Internet promotes this trend: our Web browser, for example, contains over five hundred bookmarks detailing original typeface manufacturers. We have to condense them into alphabetically sorted submenus just to keep sight of them all.

When asked by a journalist why so many typefaces exist, Adrian Frutiger, whose international reputation was made with the creation of Univers typeface (1957), responded with a question of his own, 'Why are there so many wines?'. There is no justification for complaining about the constantly expanding selection. You can never have too much choice.

'Why are there so many wines?'

The font market has been in turmoil for over ten years. A font-designing application called Altsys (now Macromedia) Fontographer first enabled type users, i.e., graphic designers and layout artists, to digitally produce fonts themselves. Things that previously could only be done with punchcutter and hot-metal compositors, or that required filmsetting equipment costing millions, suddenly became possible for everyone to do – it was a revolution.

This revolution spread like a Marxist uprising, with mottoes such as 'Wipe out the ruling class!', 'Take back the means of production!', 'Destroy what is destroying you!'. Many took these mottoes literally. 'Holy' type, protected for centuries under the quasi-religious cloak of an élite circle, is

now bent and distorted and sometimes even ruined by the power of the mouse attached to a computer. Anything goes. The rules of typography are melting away like snow in the spring.

Every revolution causes heads to roll. Traditionalists, in particular, soon end up in history's junkyard. Leading typesetter companies and large type manufacturers, such as Compugraphic, Scangraphic or Letraset, slowly disappeared from the screen, or monitor.
The names of big font libraries, such as Berthold or Monotype, may live on, but they are now pawns in the hands of the young group of experimental typographers who have provided new models for many graphic designers: Neville Brody, David Carson, Erik van Blokland, Just van Rossum, Max Kisman, Rian Hughes, Jonathan Hoefler and Zuzana Licko.

The clouds of revolution have cleared. Now it's time to take stock. Meanwhile, the enduring leaders among the type foundries have parted ways with the passing fads. We've invited fifty companies that most strongly influence the international type industry to submit their best printed matter and visual materials for reproduction in this book. These companies include independent newcomers, such as Type-Ø-Tones, [T-26], Garagefonts, Thirstype and House Industries, as well as 'old-timers' like Linotype, (URW)++, Monotype or ITC. Included are examples from brochures, flyers, picture postcards, type specimen books and much more. We selected the material according to the originality of the artwork and to the important status that some of the fonts have achieved in a short time.

www.emodigi.de

emotional_digital

Special thanks

Ingo Krepinsky

André Ringel

Diana Simon

Annette Wüsthoff

Thomas Nagel

Uwe Otto

Heidi Specker

Bertram Schmidt-Friderichs

Brigitte Raab

Louise Wood

Catherine Hall

These advertising media not only reflect market trends as authentically as possible, they reveal a variety of cultural groups and provide communication designers with a broad spectrum of ideas for their everyday work. They are not just any old application examples; in many cases, the type designers themselves made them to show each font's unique perspective – that of the designer.

emotional_digital is a snapshot of the current state of typography: it provides an overview of the international type scene; it gives information about the designers and foundries; and serves as a history book and future-oriented reference work in one. Many of the fonts shown here will be with us for many years in advertising, books, magazines and on the Internet. The producers of fonts are ahead of their times. They have an instinct for predicting the coming trends in visual communication.

Font advertising

Erik Spiekermann

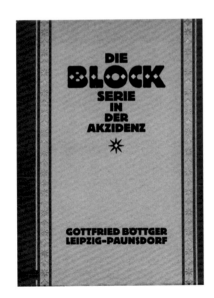

Berthold specimen no. 206, 1926
Designed for the Block family, with the
imprint by Gottfried Böttger, Leipzig.

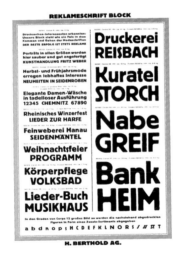

Reklameschrift (display typeface)
Block was first published by the
Berlin foundry H. Berthold in 1908.
It was extended into a series of
ten weights until 1929.

Typefaces have always been commercial
products, designed and produced for a specific
market. There's no point in a type designer
spending hundreds of hours drawing a new
alphabet, which then sits on his desk with
nowhere to go. Today, designing a trendy face
may not require as much work as it used to and
the result may consist of data, not drawings,
but the public still needs to be told about
the new typeface: what it looks like and how
to use it.

Typographic advertising, therefore, is not a new
invention, but is as old as the craft of type foun-
ding. The earliest known example is a specimen
by Konrad Berner, a type founder from Frank-
furt, published in 1592. The text (in very
quaint Old German) says something like 'Spe-
cimen and print of the most noble and very
best typefaces ever seen, produced with great
care and at large expense…' Praise of this
kind makes today's advertising slogans sound
modest in comparison.

Well into the eighteenth century type foun-
dries used broadsheets like Berner's to an-
nounce new faces. When they had to show large
type families, they were folded into brochures
with several pages. The most famous specimen
book, in my opinion, must be Giambattista
Bodoni's Manuale Tipografico, published by
his widow in Parma in 1818. I am the lucky
owner of a complete reprint.

Now and again I come across original letterpress type specimens, mainly dating to the beginning of this century. They are very popular among typomaniacs – where else would they find an alphabet displayed in all sizes, with an almost complete showing of characters? Essentially, these are nothing more than technical data sheets, but can any other industry claim to have such exquisitely designed and good-looking material? The most beautiful examples don't just show complete character sets in all the available sizes, but actually display each type in use. The type foundries' in-house print shops pulled out all the stops when it came to colour printing and graphic design.

The 1970s saw more typefaces appear for various photosetting systems than ever before. Again, competition between type manufacturers provided users with professionally designed specimens, which today serve as perfect reminders of design styles and fashions. At MetaDesign, we developed a concept for Berthold's Exklusiv Probes, as they were called, each of which was dedicated to a family and designed by a different designer.

At that time fonts cost ten times as much as they do today and only worked on one manufacturer's system. As these systems also cost ten times as much as they do today, expensive specimens were worth the investment. In 1989 Agfa paid for journalists and opinion-makers to fly to Paris for the introduction of their latest typeface, Rotis! No type house can afford that sort of lavish performance any more.

The tradition of type specimens, however, still exists, albeit on a more modest scale. The democratization of font manufacturing has actually created many more varied and interesting methods of introducing new typefaces. In the age of multimedia, there are hardly any objects that can't be covered in type: T-shirts, postcards, beer mats and packaging, not to mention multimedia shows on CD-ROM and the Web. And there are still posters and brochures for freshly published typefaces.

This project, emotional_digital, by Alexander Branczyk, Jutta Nachtwey, Jürgen Siebert and the moniteurs has gathered new type specimens from around the world. For me, browsing through this collection sometimes feels like meeting almost forgotten friends, discovering many new ones and affirming my suspicion that only time will tell what may become a classic.

In 1979 Berthold published LoType, Erik Spiekermann's redesign of Louis Oppenheim's typeface dating to 1911. He also designed a sixteen-page specimen for the new face, which appeared as the first brochure in the Berthold Exklusiv series.

I had never seen many of these examples before and I had totally forgotten about others – as happens with a lot of advertising. Even some of the specimens I had been involved in myself, as a member of FSI FontShop International's typeboard, suddenly looked completely new and different in this context. Thanks to emotional_digital, examples of typographic advertising, which are too often short-lived, are kept alive. They are a good mirror of the times, past and present.

SWANSEA COLLEGE
LEARNING CENTRE
LLWYN-Y-BRYN
77 WALTER RD., SWANSEA SA1 4RW

2Rebels

Location_Montreal, Canada

Established_1995

Founders_Denis Dulude, Fabrizio Gilardino

Type designers_Annie Bastien, Robert Beck, Marc Borgers
Christine Côté, Denis Dulude, Patrick Giasson
Fabrizio Gilardino, Marie-Frédérique Laberge-Milot
Anna Morelli, Clotilde Olyff, Martijn Oostra
Serge Pichii, Jean-François Rey, Marc Tassell
Michel Valois and others

Distributors_2Rebels, FontShop International (FSI), FontHaus
Faces, MindCandy, [T-26]

Dirty, blurry, scratched up and cut through,
2Rebels' designs are edgy

Fabrizio Gilardino left Milan in 1990 and emigrated to
Montreal. He had completed a traditional design training
programme, but did not know how to work a computer. Conse-
quently, he chose to explore the experimental music scene,
write articles and work in radio, during which time, however,
he became computer literate and took up design again.

It was in Montreal that he met and collaborated with Denis
Dulude, who had worked in various ballet ensembles before
starting a second career as a designer. Under the name 2Rebels,
they published their first font catalogue in 1995: a brochure,
stapled together by hand, showing twenty fonts that they had
designed using everyday items as starting points. The collec-
tion has now grown to contain more than one hundred fonts by
twenty-two type designers. Caught between the classical and the
chaotic – and just on the cusp of legibility – their irreverent
fonts fly in the face of tradition. Denis Dulude and Fabrizio
Gilardino have also worked together for certain customers as
graphic designers under the name 2Rebels. Each also has his
own studio for graphic design: Gilardino Design and K.O.
Creation.

Stupid game 1 and 2, 1997
13 x 7.5 cm
Both games were included in a font kit
with four fonts and four posters.

Design: 2Rebels
Type design: Marie-F. Laberge-Milot _Fred

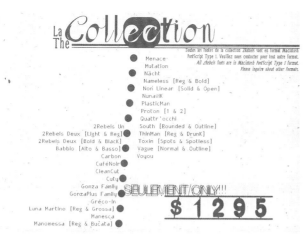

La The **Collection**

Toutes les fontes de la collection 2Rebels sont en format Macintosh PostScript Type 1. Veuillez nous contacter pour tout autre format.
All 2Rebels fonts are in Macintosh PostScript Type 1 format. Please inquire about other formats.

- Menace
- Mutation
- Nächt
- Nameless [Reg & Bold]
- Nori Linear [Solid & Open]
- Nunavik
- PlasticMan
- Proton [1 & 2]
- Quattr'occhi
- 2Rebels Un — South [Rounded & Outline]
- 2Rebels Deux [Light & Reg] — ThinMan [Reg & Drunk]
- 2Rebels Deux [Bold & Black] — Toxin [Spots & Spotless]
- Babblo [Alto & Basso] — Vague [Normal & Outline]
- Carbon — Voyou
- CaféNoir
- CleanCut
- Cuty
- Gonza Family
- GonzaPlus Family
- Gréco-In
- Luna Martino [Reg & Grossa]
- Manesca
- Manomessa [Reg & Bucata]

SEULEMENT/ONLY!!!

$1295

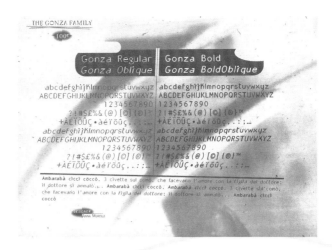

THE GONZA FAMILY
100$

| Gonza Regular | Gonza Bold |
| Gonza Oblique | Gonza BoldOblique |

abcdefghijklmnopqrstuvwxyz
ABCDEFGHIJKLMNOPQRSTUVWXYZ
1234567890
?!#$£%&(@)[©][®]™
+ÀÈÍÕÛÇ·àéíõûç..:;...

abcdefghijklmnopqrstuvwxyz
ABCDEFGHIJKLMNOPQRSTUVWXYZ
1234567890
?!#$£%&(@)[©][®]™
+ÀÈÍÕÛÇ·àéíõûç..:;...

abcdefghijklmnopqrstuvwxyz
ABCDEFGHIJKLMNOPQRSTUVWXYZ
1234567890
?!#$£%&(@)[©][®]™
+ÀÈÍÕÛÇ·àéíõûç..:;...

abcdefghijklmnopqrstuvwxyz
ABCDEFGHIJKLMNOPQRSTUVWXYZ
1234567890
?!#$£%&(@)[©][®]™
+ÀÈÍÕÛÇ·àéíõûç..:;...

Ambarabà ciccì coccò, 3 civette sul comò, che facevano l'amore con la figlia del dottore; il dottore si ammalò... Ambarabà ciccì coccò. Ambarabà ciccì coccò, 3 civette sul comò, che facevano l'amore con la figlia del dottore; il dottore si ammalò... Ambarabà ciccì coccò

DESIGNER
ANNA MORELLI

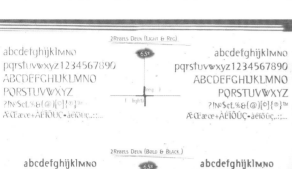

2Rebels Deux (Light & Reg.) 65$

abcdefghijklmno
pqrstuvwxyz1234567890
ABCDEFGHIJKLMNO
PQRSTUVWXYZ
?!№$¢£%&(@)[©]{®}™
ÆŒæœ+ÀÉÍÕÛÇ·àéíõûç,.:;...

[reg.]
[light]

abcdefghijklmno
pqrstuvwxyz1234567890
ABCDEFGHIJKLMNO
PQRSTUVWXYZ
?!№$¢£%&(@)[©]{®}™
ÆŒæœ+ÀÉÍÕÛÇ·àéíõûç,.:;...

2Rebels Deux (Bold & Black) 65$

abcdefghijklmno
pqrstuvwxyz1234567890
ABCDEFGHIJKLMNO
PQRSTUVWXYZ
?!№$¢£%&(@)[©]{®}™
ÆŒæœ+ÀÉÍÕÛÇ·àéíõûç,.:;...

[black]
[bold]

abcdefghijklmno
pqrstuvwxyz1234567890
ABCDEFGHIJKLMNO
PQRSTUVWXYZ
?!№$¢£%&(@)[©]{®}™
ÆŒæœ+ÀÉÍÕÛÇ·àéíõûç,.:;...

DESIGNER
Denis Dulude

2rebels en toutes lettres

Parce que dans notre civilisation moderne la lettre tend, de plus en plus, à redevenir image, 2Rebels est là pour rappeler qu'en typographie, comme en musique, il n'y a pas que le classique. Notre époque est génératrice de styles nouveaux et dans l'univers toujours en mouvement de la typographie, 2Rebels a une approche subversive : elle crée des fontes qui sortent des sentiers battus, parlent au monde et livrent le message. Des fontes qui flattent, qui griffent, qui marquent et qui impressionnent. Des fontes qui chantent, sifflent, crient, aboient et hurlent. Des fontes qui séduisent, ensorcèlent, subjuguent, envoûtent et vampirisent. Les lettres-images investissent et envahissent notre monde moderne; 2Rebels est là pour rappeler que **la révolution typographique** continue.

[menace & cuty
nori linear Open & gonza Bold Oblique]

2REBELS TO THE LETTER

As letters once again become more and more like images, 2Rebels is a reminder that in typography, as in music, classical isn't everything. Our epoch is one that generates new styles and, in the continuously evolving universe of typography, 2Rebels' approach is subversive: it creates fonts that stray from the beaten track, that talk to the world and deliver a message. Fonts that flatter, lash out, mark, and impress. Fonts that sing, whistle, bark and holler. Fonts that seduce, bewitch, and amaze. The letter-image pervades and invades our modern world; 2Rebels is proof that **the typographical revolution continues.**

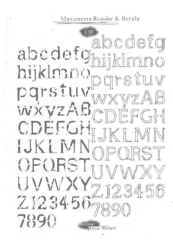

Manomessa Regular & Bucata 65$

abcdefg
hijklmno
pqrstuv
wxyzAB
CDEFGH
IJKLMN
OPQRST
UVWXY
Z123456
7890

abcdefg
hijklmno
pqrstuv
wxyzAB
CDEFGH
IJKLMN
OPQRST
UVWXY
Z123456
7890

DESIGNER
Anna Morelli

CUTY 50$

abcdefghijklmn
opqrstuvwxyz
ABCDEFGHIJKLMN
OPQRSTUVWXYZ
1234567890
?!#$¢£%&(@)[©]{®}™
ÆŒæœ+ÀÉÍÕÛÇ·
,.:;àéíõûç;...

DESIGNER
Denis Dulude

Font catalogue, 1996
18 x 12.5 cm

Design: 2Rebels
Type design: Denis Dulude _2Rebels Un
_2Rebels Deux
_Cuty
_PlasticMan
_ThinMan
_Menace
Anna Morelli _Gonza Family
_Manomessa
Fabrizio Gilardino _Non Linear

Diskette Sleeve, 1997
9 x 9.5 cm
The background fonts are derived from a street sign in Montreal.

Design: 2Rebels
Type design: Fabrizio Gilardino _Scritto

Promotional card for
2Rebels' Fonts at [T-26]
12 x 12 cm

Design: 2Rebels
Type design: Denis Dulude _2Rebels Un
_Nameless

Patrick Giasson _Proton

Font catalogue, 1997
14 x 29.5 cm

Design: 2Rebels
Type design: Clotilde Olyff _Perles

Denis Dulude _K.O. dirty

Marie-F. Laberge-Milot _Fred

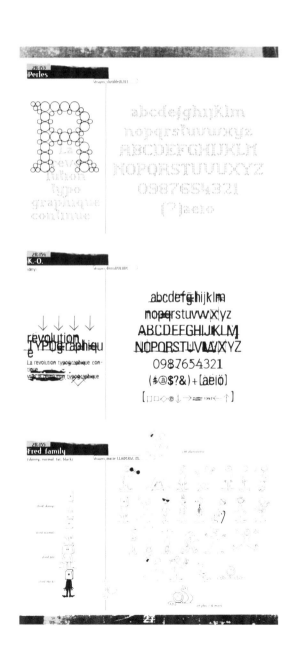

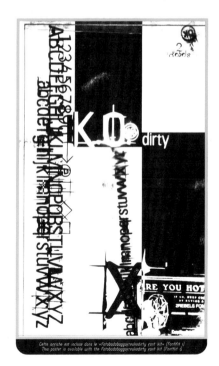

Font catalogue, 1997
14 x 29.5 cm

Design: **Marie-F.** Laberge-Milot
Annie Bastien
Type design: **Marie-F.** Laberge-Milot _Fred

Annie Bastien _Sofa

_ScratchNsniff

_SemiSans

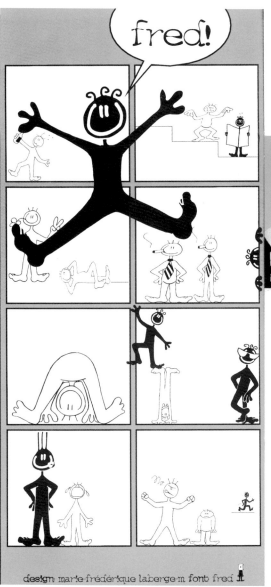

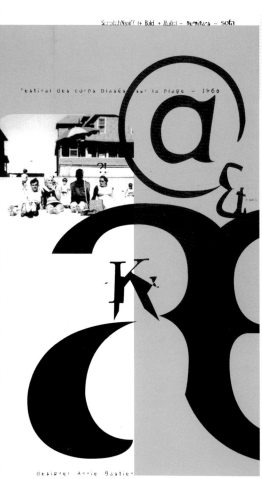

ABCdefg

ABCDEFGHIJKLMNOPQRSTUVWXYZ

ABCDEFGHIJKLMNOPQRSTUVWXYZ

abcdefghijklmnopqrstuvwxyz

abcdefghijklmn

Type design: Richard Lipton, 1997 _Bickham Script
Joachim Müller-Lancé, 1997 _Flood
Julian Waters, 1997 _Waters Titling
Tim Donaldson, 1998 _Postino
Robert Slimbach, 1996 _Kepler

Adobe

Location _San Jose, California, USA

Established _1982

Founders _John Warnock, Chuck Geschke

Type designers _Richard Lipton, Robert Slimbach
Mark Jamra, Tim Donaldson, Julian Waters
Joachim Müller-Lancé, David Siegel, Jim Wasco
Jovica Veljović, Carol Twombly and many more

Distributors _Adobe, FontShop International (FSI)
Elsner+Flake and others

Adobe's goal is to help people effectively use
computers to create, assemble and deliver information

Adobe started the desktop publishing revolution in the mid-
1980s with the PostScript page-description language, a mathe-
matical computer description that determines the appearance
of a page, including such elements as text, graphics and
scanned images to a printer or other output device. All Adobe
fonts are available in Type 1, the outline font format invented
by Adobe that is a key component of the PostScript language.
By bringing high-quality, scaleable type to desktop-computer
users, Adobe Type 1 fonts have made it less expensive and more
efficient to create professional-looking documents.

The most prestigious type foundries in the world produce
fonts in the Type 1 format and license their typeface designs
to Adobe. Now, with more than 2400 typefaces from interna-
tionally renowned foundries such as Agfa, Berthold, ITC,
Linotype Library and Monotype, as well as sixty-seven Adobe
original designs, the Adobe Type Library offers one of the
largest collections of superlative type in the world.

Minion

stuvwxyz

Brochures for Adobe Jenson,
Tekton, Ex Ponto, Myriad, 1991–96
10 pages
14.5 x 22.8 cm

Design: Fred Brady
Robert Slimbach, Min Wang
James Young, Laurie Szujewska
Type design: Robert Slimbach _Adobe Jenson

Jovica Veljović _Ex Ponto

Carol Twombly, Robert Slimbach _Myriad

David Siegel, Jim Wasco _Tekton

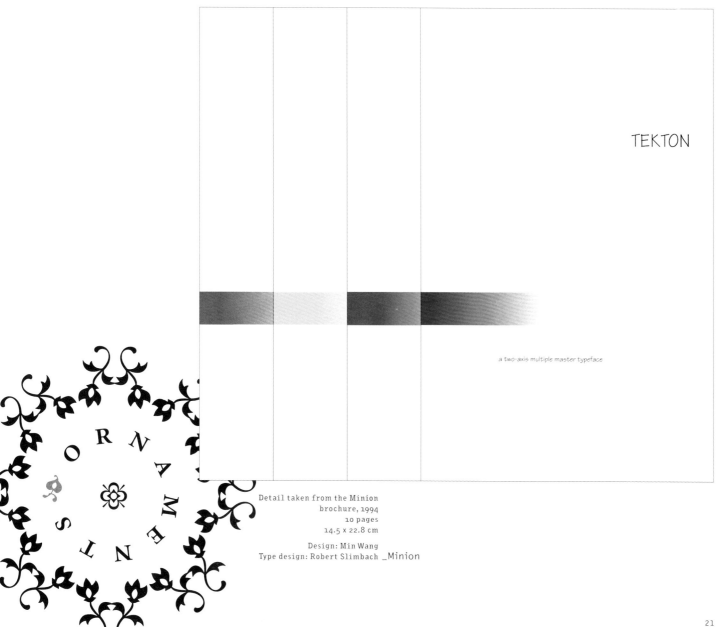

TEKTON

a two-axis multiple master typeface

Detail taken from the Minion
brochure, 1994
10 pages
14.5 x 22.8 cm

Design: Min Wang
Type design: Robert Slimbach _Minion

ORNAMENTS

Throughout the process, the Adobe Originals team assisted with aesthetic commentary and technical advice, and provided inspiration during the difficult moments.

Ex Ponto represents the process of combining my calligraphic and typographic experience. I found the transcription of handwriting into a digital typeface to be very challenging. My focus was to preserve the spontaneity and individuality of handwriting while creating a graphically balanced and captivating design.

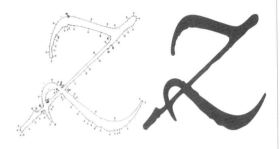

Top to bottom: *Legende, designed by Ernst Schneidler in 1937; Reiner Script, designed by Imre Reiner in 1951; Codex-Kursiv, designed by Oldřich Menhart in 1930. Says Veljović: "Some of the script typefaces I admire were done by the 20th century designers Imre Reiner, Ernst Schneidler and Oldřich Menhart. They practiced other graphic disciplines alongside type design, such as calligraphy, illustration, painting, wood engraving and etching. Each art influences the other, and this is reflected in their type designs."*

Veljović's writing studies for the typeface, including his notes. From many handwritten pages, he chose letterforms for further development into type characters.

Ex Ponto has an alternating rough and smooth outer contour, reflecting what actually happens to pen strokes on rough paper. To produce this rough edge on the computer, Veljović placed hundreds of Bézier points strategically on each character of the typeface. The Z, for example, has 95 Bézier elements defining its contour, including both curves and straight lines.

Pages from the Ex Ponto
brochure, 1995
14.5 x 22.8 cm

Design: James Young
Type design: Jovica Veljović _Ex Ponto

A set of primary fonts is supplied with each multiple master typeface, and comprises a complete, ready-to-use typeface family. In addition to the custom fonts that can be generated along the weight and width axes, Myriad and Myriad Italic each include the fifteen pre-built *primary fonts* highlighted below. Primary fonts are named according to their position along each axis in the typeface. Myriad's weight and width axes have been assigned a specific numerical range within an overall range of 1 to 999; other multiple master typefaces will have different numerical ranges depending on their relative weight and width. See the *Adobe Multiple Master User Guide* for detailed information on multiple master font names.

tangible	tangible	tangible	tangible	tangible	tangible	tangible	tangible	tangible
tangible	tangible	tangible	tangible	tangible	tangible	tangible	tangible	tangible
tangible	tangible	tangible	tangible	tangible	tangible	tangible	tangible	tangible
tangible	tangible	tangible	tangible	tangible	tangible	tangible	tangible	tangible
tangible	tangible	tangible	tangible	tangible	tangible	tangible	tangible	tangible
tangible	tangible	tangible	tangible	tangible	tangible	tangible	tangible	tangible
tangible	tangible	tangible	tangible	tangible	tangible	tangible	tangible	tangible
tangible	tangible	tangible	tangible	tangible	tangible	tangible	tangible	tangible
tangible	tangible	tangible	tangible	tangible	tangible	tangible	tangible	tangible
tangible	tangible	tangible	tangible	tangible	tangible	tangible	tangible	tangible
tangible	tangible	tangible	tangible	tangible	tangible	tangible	tangible	tangible
tangible	tangible	tangible	tangible	tangible	tangible	tangible	tangible	tangible
tangible	tangible	tangible	tangible	tangible	tangible	tangible	tangible	tangible

Metro-North Commuter Railroad
CASH FARE RECEIPT

FORM C-9

Axis abbreviations
weight axis	width axis
LT *light*	CN *condensed*
RG *regular*	NO *normal*
SB *semibold*	SE *semi-extended*
BD *bold*	
BL *black*	

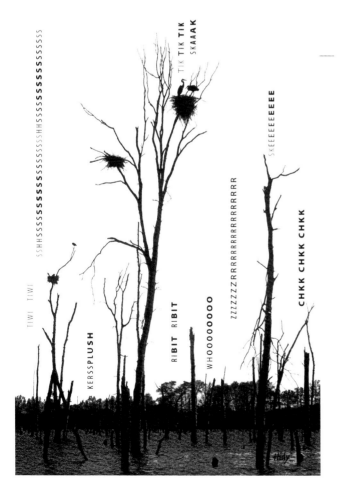

Pages from the Myriad
brochure, 1991
14.5 x 22.8 cm

Design: Laurie Szujewska
Type design: Carol Twombly
Robert Slimbach _Myriad

23

→
Leaflets, 1996
23 x 38 cm (unfolded)

Design: Jean-François Porchez
Type design: Olivier Nineuil _Comedia

Franck Jalleau _Virgile

Albert Boton _Scherzo

Thierry Puyfoulhoux _Cicéro

Agfa Typographic Systems

Location_ Wilmington, Massachusetts, USA

Established_ 1982

Founder_ The Compugraphic Type Group

Type designers_ Otl Aicher, Dave Farey, Carolyn Gibbs
Cynthia Hollandsworth, John Hudson
Franck Jalleau, Richard Lipton
Christian Schwartz, Pierre di Sciullo
and many more

Distributors_ Agfa, Monotype Typography, FontShop
International (FSI), FontWorks, FontHaus
and many more

Agfa aims to become the most important supplier of design
tools for professional graphic designers.

Booklet cover, 1995
18 x 18 cm

Design: Robin Farren
Type design: Lennart Hansson _Runa Serif, Medium,
Light, Italic

The type group at Agfa, now called Typographic Systems, was
originally the type-drawing office and font production group
at Compugraphic Corporation. Bill Garth, a former Photon
employee, founded Compugraphic in 1968. Agfa purchased
Compugraphic in the early 1980s and the group became Agfa
Typographic Systems.

Agfa Typographic Systems is made up of two groups: the retail
font group and the OEM (original equipment manufacturer)
group. The retail group is in charge of the development,
marketing and sales of fonts licensed to users worldwide.
Agfa Direct, the Agfa Direct Commercial Website and the
Creative Alliance (see p. 44) also fall within the distribution
range of the retail font group. The OEM group is responsible
for developing and marketing its products to companies
such as Hewlett Packard, Microsoft, Xerox and Lexmark and
comprises engineers and software developers, marketing
personnel and sales representatives. Agfa is a leading supplier
of OpenType technology components, designed to be an indus-
try-standard portable document solution.

Différentes apparitions du Comedia

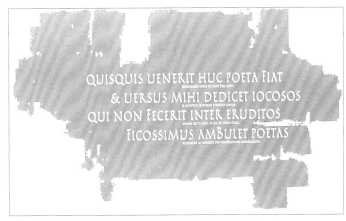

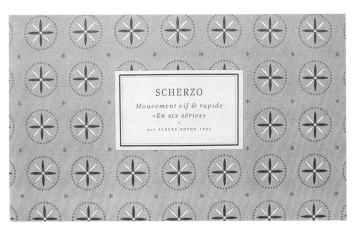

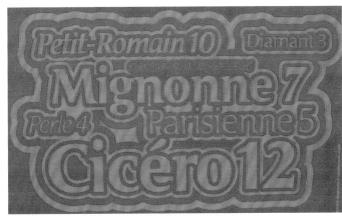

Booklet, 1995
22 pages
18 x 18 cm

Design: Robin Farren
Type design: Franck Jalleau _Oxalis

Pierre di Sciullo _Le Gararond

→
Promotional poster for the Agfa,
Icon and Type Series, 1997
28 x 64.5 cm
The poster can be divided into twelve postcards.

Design: Robin Farren

Franck Jalleau

Parisian Franck Jalleau has studied typography and lettering design in France under Bernard Arin, José Mendoza & Stanislas Mandel. Today, he designs type and creates fonts for the French Imprimerie Nationale and teaches typography at the Ecole Estienne. Jalleau's Oxalis family is an exciting new creation which is available exclusively through Agfa.

Oxalis has the grace and the flow of form that can only come from the calligrapher's hand, but it never sacrifices versatility and functionality for artistic expression. The result is a typeface that looks good & wears well. Oxalis is a lively design which will add sparkle to a block of text copy or a display headline. Its alternate capitals also create a spontaneous, pen drawn quality not found in most sans serif faces.

OXALIS

An Agfa Exclusive

This page is set in Oxalis Regular & Medium—both new Agfa Exclusives from Franck Jalleau.

Pierre di Sciullo

Iconoclast Pierre di Sciullo has been creating uncommon designs since 1984, both graphic and typographic. With a taste for institutional editing and very unusual projects, he pushes the envelope in experiments with graphic techniques. Thirty-three year old di Sciullo has developed several highly interpretive typefaces, and he has published a series of nine manuals which combine text and image. di Sciullo's latest endeavor, le Gararond, is an Agfa Exclusive.

Le Gararond is an irreverent homage to the historic typeface Garamond. di Sciullo has used the same proportions & structure as the classic face, but has designed le Gararond with all curves and no serifs.

Le Gararond

An Agfa Exclusive

This page is set in Asphalt Black, Condensed, Oxalis Regular, and le Gararond—all Agfa Exclusives.

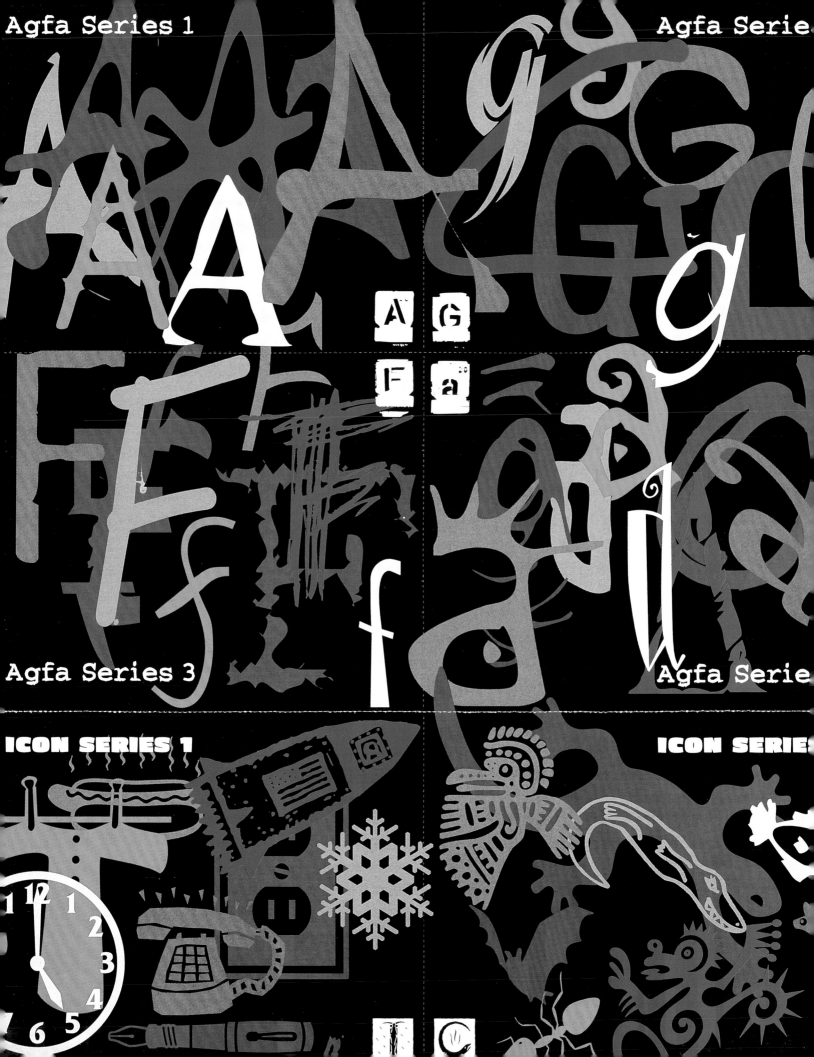

Agfa Series 1

Agfa Serie

Agfa Series 3

Agfa Serie

ICON SERIES 1

ICON SERIE

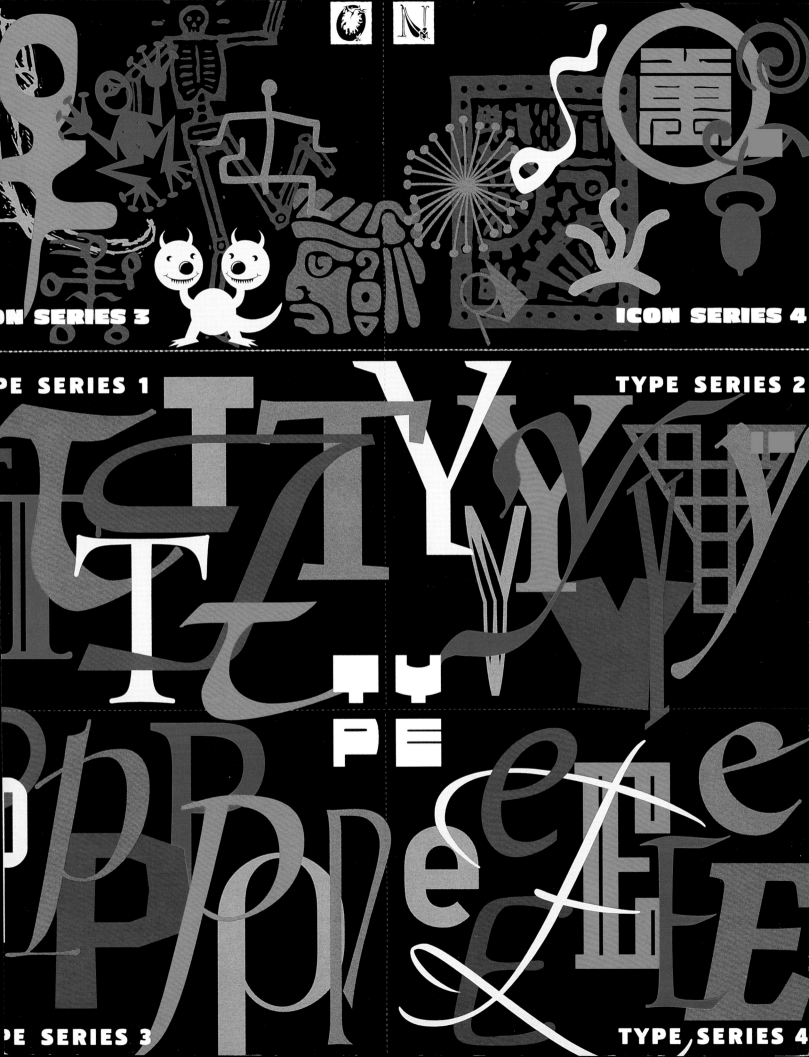

ON SERIES 3

ICON SERIES 4

PE SERIES 1

TYPE SERIES 2

TYPE

PE SERIES 3

TYPE SERIES 4

Type design: Yanek Iontef, 1997 _CaseSeraSera

Don Synstelien, 1998 _Nurse Ratchet

Harald Oehlerking, 1996 _Aspera

Apply Design Group

Location_Hanover, Germany

Established_1989

Founder_Thomas Sokolowski

Type designers_Steven Boss, Jens Gehlhaar, Yanek Iontef
Catinka Keul, Manfred Klein, Alexander Koch
Carlo Krüger, Harald Oehlerking, Alfred Smeets
Thomas Sokolowski, Don Synstelien
Christian Terbeck, Antje Wolf and others

Distributors_FontHaus, EF fontinform [Germany]

Form follows fun

In the early 1990s Apply Design Group became
known as an independent font label producing
cutting-edge typefaces. Twenty type designers
have so far published more than one hundred
fonts through Apply. In Germany the design
group became well known through it's maga-
zine Apply, even though many subscribers have
been irritated by the magazine's irregular
publications. The award-winning design maga-
zine features Apply's latest font creations and
other articles about design and the aesthetics
of everyday life. Since most innovative type-
faces have become mainstream and even typo-
saurs like Linotype and Letraset have discov-
ered 'grunge' fonts, Apply designers have
shifted their activities to the illustration and
photo CD market.

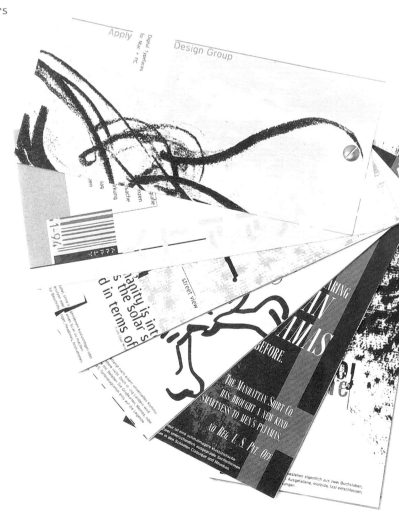

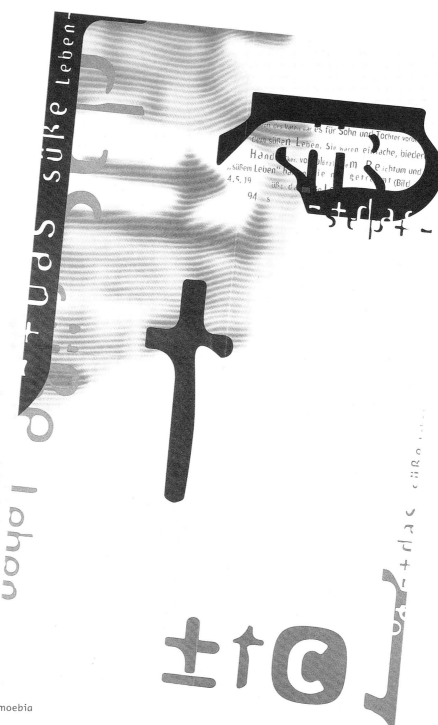

Front of the type poster, 1995
40 x 64 cm
Fauna natural paper

Design: Pepa Reimann
Type design: Jens Gehlhaar _Amoebia

←
Specimen fan, 1994
9.9 x 21 cm
Fauna natural paper
The array includes sample cards
for a total of thirty-six fonts. The front
of each card presents a design example
and the back shows a complete
character set.

Design: Carsten-Andres Werner

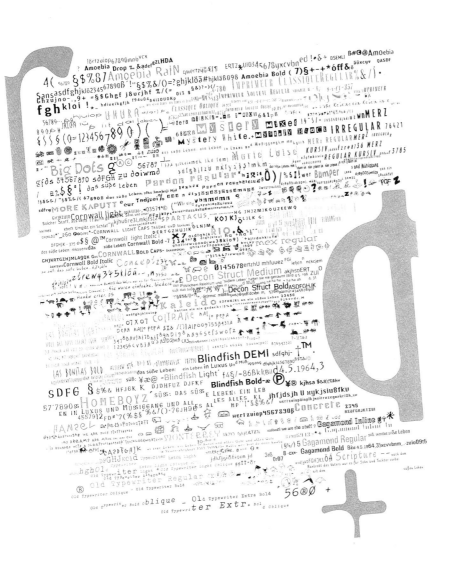

Back of the type poster, 1995
40 x 64 cm
Fauna natural paper
Overview of the thirty-six fonts.

Design: Pepa Reimann

Type design: Steven Boss, 1997 _DNA

APPLY Digital Typefaces

Gesamtübersicht

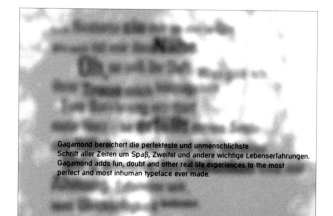

Digital font catalogue, 1995
The typographic information
has been transformed into a
digital application. Users select a
font from the main menu (above),
in this case Gagamond, and then
call up the character set and design
example. Another level contains
information about the font.
When activated, the application
example is displayed blurred in
the background.

Design: Carsten-Andres Werner
Thomas Sokolowski
Type design: Manfred Klein _DeconStruct

Jens Gehlhaar _Gagamond

The font Galaxy is based on
the text of the <u>StarTrek</u> film,
adapted for digital use.

Type design: George Ryan
Dave Robbins _Semaphore

Mike Leary _Galaxy

Frank Pendrell _Space

Bitstream

Location_Cambridge, Massachusetts, USA

Established_1981

Founders_Mike Parker, Matthew Carter
Cheri Cone, Rob Freedman

Type designers_Matthew Carter, Denis Pasternak
Richard Lipton, Jackie Sakwa
Jim Lyles, George Ryan and many more

Distributors_Bitstream, FontShop International (FSI)
International FontBolaget, FontWorks
Elsner+Flake, Fontinform and many more

TypeShop Pro catalogue and CD-ROM, 1995
The CD-ROM contains the additions to
the Bitstream library, developed since the
release of the original TypeShop in 1994.
It includes nine new symbol/Pi fonts,
thirty-eight typographer sets, and thirty-
nine other faces that are either new and
original designs or additions to type
families already in the library.

Design: Andrew Joslin

Publish. Once and for all.

Bitstream was one of the world's first digital
type foundries. Over the years the company's
focus has expanded to include type rasteriza-
tion and portability technology (TrueDoc™).
Following the acquisition of Archetype in
1987, the company has developed an interest in
page-composition technology (NuDoc™) and
on-demand publishing servers (PageFlex™).
Bitstream's philosophy blends creativity and
innovation with high-quality production and
service standards, within a company culture
that promotes integrity and personal growth
to meet the evolving needs of their customers
in the graphics communication industry.

Alphabet Soup Tilt

1255
regular

ABCDEFGHIJKLMNOPQRSTUVWXYZ
ABCDEFGHIJKLMNOPQRSTUVWXYZ
1234567890 &$?! çœÄéñòûß

A new display typeface designed by the Bitstream type design staff. Note that using the shift key tilts the characters the other way.

Bitstream Chianti™1

1210
roman

abcdefghijklmnopqrstuvwxyz
ABCDEFGHIJKLMNOPQRSTUVWXYZ
1234567890 |&$?! ÇŒäéñòûß

1211
bold

abcdefghijklmnopqrstuvwxyz
ABCDEFGHIJKLMNOPQRSTUVWXYZ
1234567890 &$?! ÇŒäéñòûß

1212
italic

abcdefghijklmnopqrstuvwxyz
ABCDEFGHIJKLMNOPQRSTUVWXYZ
1234567890 &$?! ÇŒäéñòûß

1213
bold it

abcdefghijklmnopqrstuvwxyz
ABCDEFGHIJKLMNOPQRSTUVWXYZ
1234567890 &$?! ÇŒäéñòûß

1214
extra bold

abcdefghijklmnopqrstuvwxyz
ABCDEFGHIJKLMNOPQRSTUVWXYZ
1234567890 &$?! ÇŒäéñòûß

1215
extra bold it

abcdefghijklmnopqrstuvwxyz
ABCDEFGHIJKLMNOPQRSTUVWXYZ
1234567890 &$?! ÇŒäéñòûß

Chianti is a new sanserif design by Dennis Pasternak drawn in 1991. The inspiration behind the face was to provide a sanserif of high readability at a wide range of sizes. See the "Typographer Sets" section for more information.

Galaxy

1240
regular

abcdefghijklnmopqrstuvwxyz
ABCDEFGHIJKLMNOPQRSTUVWXYZ
1234567890 &$?! ÇŒäéñòûß

Galaxy is a new display face by the Bitstream design staff.

Horizon

1238
regular

abcdefghijklmnopqrstuvwxyz
ABCDEFGHIJKLMNOPQRSTUVWXYZ
1234567890 &$?! ÇŒäéñòûß

Horizon is a new display face by the Bitstream design staff.

Incised 901

1189
nord
outline

abcdefghijklmnopqrstuvwxyz
ABCDEFGHIJKLMNOPQRSTUVWXYZ
1234567890 &$?! ÇŒäéñòûß

This weight of Incised 901 (Bitstream's version of Antique Olive™15) rounds out the selection already in the Library.

Kuenstler 165

1194
roman

abcdefghijklmnopqrstuvwxyz
ABCDEFGHIJKLMNOPQRSTUVWXYZ
1234567890 &$?! ÇŒäéñòûß

1196
bold

abcdefghijklmnopqrstuvwxyz
ABCDEFGHIJKLMNOPQRSTUVWXYZ
1234567890 &$?! ÇŒäéñòûß

1197
heavy

abcdefghijklnmopqrstuvwxyz
ABCDEFGHIJKLMNOPQRSTUVWXYZ
1234567890 &$?! ÇŒäéñòûß

During the first half of the 20th century, a group of german artists reworked the oldstyle model with touches from the traditions of the German blackletter. The result is a mannered and easily recognizable style that we call Kuenstler. Kuenstler 165 is Bitstream's version of Koch's 1922 Koch Antique.

Revival 555 Cont'd

1134
semi bd.

abcdefghijklnmopqrstuvwxyz
ABCDEFGHIJKLMNOPQRSTUVWXYZ
1234567890 &$?! ÇŒäéñòûß

1135
semi bd.it

abcdefghijklnmopqrstuvwxyz
ABCDEFGHIJKLMNOPQRSTUVWXYZ
1234567890 &$?! ÇŒäéñòûß

Revival 555 is Bitstream's version of Horley Old Style.™2 A 1920s oldstyle revival with shades of Jenson, Caslon and Goudy.

SnowCap™1

1237
regular

abcdefghijklmnopqrstuvwxyz
ABCDEFGHIJKLMNOPQRSTUVWXYZ
1234567890 &$?! ÇŒäéñòûß

SnowCap is a wintry display face with snow effects dropped onto Mister Earl.™1

Sonic

1248
extra bold.

abcdefghijklmnopqrstuvwxyz
abcdefghijklmnopqrstuvwxyz
1234567890 &$?! ÇŒäéñòûSS

Sonic Cut Through

1247
heavy

ABCDEFGHIJKLMNOPQRSTUVWXYZ
ABCDEFGHIJKLMNOPQRSTUVWXYZ
1234567890 &$?! ÇŒäéñòûSS

Sonic is a new display face by the Bitstream design staff.

Space

1254
bold

ABCDEFGHIJKLMNOPQRSTUVWXYZ
ABCDEFGHIJKLMNOPQRSTUVWXYZ
1234567890 &$?! ÇŒäéñòûß

Space is a new display face by the Bitstream design staff.

Maritime Pi

9795
regular

Maritime Reversed

9785
regular

Semaphore

6566
regular

Zodiac

8732
regular

brass_fonts

Location_Cologne, Germany

Established_1996

Founders_Hartmut Schaarschmidt, Guido Schneider
René Tillmann, Rolf Zaremba

Type designers_Martin Bauermeister, Hartmut Schaarschmidt
Guido Schneider, René Tillmann, Rolf Zaremba
Astrid Groborsch

Distributor_brass_fonts

brass_fonts plans the hostile takeover of all large type foundries.

brass_fonts was established in 1996 by designers Hartmut Schaarschmidt, Guido Schneider, René Tillmann and Rolf Zaremba. Since mid-1997 the 'brass band' has been strengthened by the addition of Martin Bauermeister and Andrea Markewitz to the team. The company experienced great success in its founding year with many trash and decon-structed fonts and then set itself the goal of offering sophisti-cated and contemporary alternatives to conventional and fre-quently used fonts. brass_fonts took a particular interest in the area of flowing text, in which typefaces like Meta, Rotis and, for decades, Helvetica have been employed in an almost inflationary way.

With the appearance of the new catalogue in autumn-winter 1998, an additional five typefaces and a dingbat series were made available. In total brass_fonts now offers twenty-six typefaces. Since early 1999 brass_fonts has created an on-line shopping facility for fonts and devotional items. It allows users to download layout fonts from the entire products (www.brassfonts.de). In addition, all brass_fonts contain a symbol for the euro that is consistent with the typeface.

→
Additional set of cards for the basic
brass_fonts catalogue, summer 1998
11.7 x 13.5 cm

Design: Hartmut Schaarschmidt
René Tillmann, Rolf Zaremba
Guido Schneider, Martin Bauermeister
Andrea Markewitz
Type design: Guido Schneider _Jaruselsky
_Corpa Gothic

Cover of the basic
brass_fonts catalogue, spring 1997
11.7 x 13.5 cm

Design: Hartmut Schaarschmidt
Type design: Guido Schneider _SoloSans

Battery card from the basic
brass_fonts catalogue, spring 1997
11.7 x 13.5 cm

Design | Type design: Guido Schneider _Battery

Nobody card/Anorexia card
from the basic
brass_fonts catalogue, spring 1997
11.7 x 13.5 cm
Design | Type design: Guido Schneider _Nobody
_Anorexia

Amnesia card from the basic
brass_fonts catalogue, spring 1997
11.7 x 13.5 cm
Design: Rolf Zaremba
Type design: René Tillmann _Amnesia

Command (Z)

Location_London, UK

Established_1995

Founder | Type designer | Distributor_Ian Swift (Swifty)

In 1995 Swifty asked himself a fundamental question: why do fonts cost so much when they sell for so little? His search for an answer led him to look for possibilities to both publish and sell fonts cheaply. The concept of FUSE, the experimental type journal established by Jon Wozencraft and Neville Brody, served as a model: the user not only receives fonts, but also application examples and a pamphlet covering a specific topic. Swifty's goal was to create a more accessible project that would appeal to a broader public.

The first and only edition so far of Command (Z) consists of two fonts, Dolce Vita and Miles Ahead, as well as an A6 fan magazine with eighty-two pages. The fanzine shows the fonts in various applications, introduces material from Swifty's scrapbook and presents the work of, among others, the illustrator Ian Wright. It appeared in a limited edition of one thousand copies and was intended as a collector's item for enthusiasts. In the future, new editions of Command (Z) are expected to appear, but in 1998 Swifty started another typographic project, Typomatic (see p. 280).

Slipcase and fanzine 1995
10.5 x 14.9 cm
Included is a disk containing the fonts Dolce Vita and Miles Ahead and a fanzine. The signs for the logo were scanned from the computer keyboard.

Design | Type design: Swifty _Dolce Vita
_Miles Ahead

ABCDE
FGHIJKLMNOPQRSTU
VWXYZ

Type design: Swifty _Dolce Vita

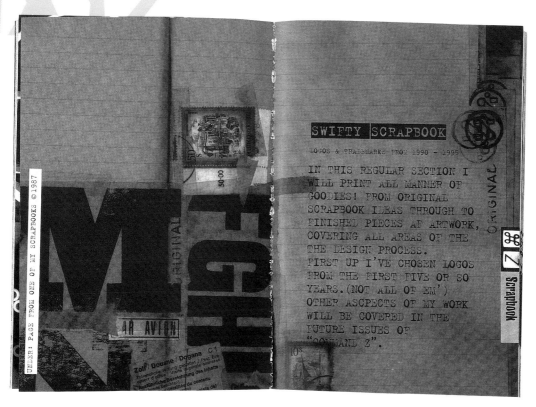

Pages from Command (Z)
fanzine, 1995
10.5 x 14.9 cm
Collage from Swifty's
student scrapbook.

Design: Swifty

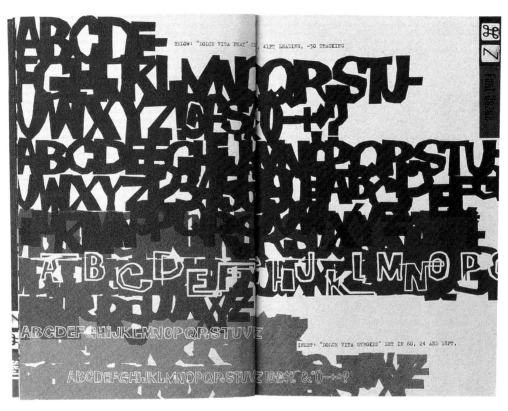

BELOW: "DOLCE VITA PHAT" SET, 41PT LEADING, -30 TRACKING

INSET: "DOLCE VITA STROKES" SET IN 60, 24 AND 18PT,

Pages from <u>Command (Z)</u>
fanzine, 1995
10.5 x 14.9 cm

Design | Type design: Swifty _Dolce Vita

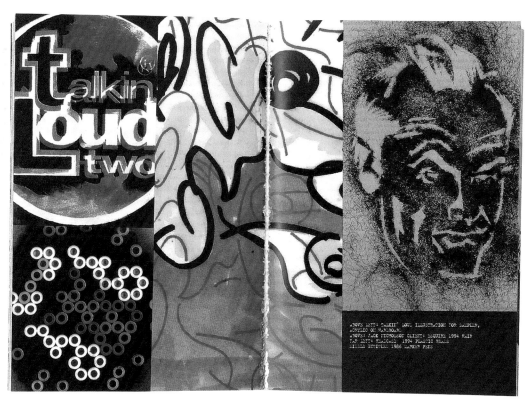

ABOVE LEFT: TALKIN' LOUD ILLUSTRATION FOR SAMPLER,
ACRYLIC ON HARDBOARD
ABOVE: JACK NICHOLSON CLIENT: ESQUIRE 1994 HAIR
FAR LEFT: HEADCASE 1994 PLASTIC BEADS
MIDDLE UNTITLED 1986 LACKER PENS

Pages from <u>Command (Z)</u>
fanzine, 1995
10.5 x 14.9 cm
A feature on the painter and
illustrator Ian Wright.

Illustration: Ian Wright
Design: Swifty

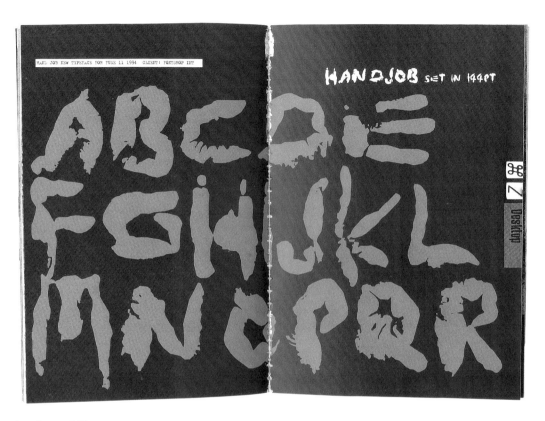

Pages from <u>Command (Z)</u>
fanzine, 1995
10.5 x 14.9 cm
The typeface Hand Job created by
Ian Wright was commissioned for
<u>FUSE</u> 11, 1994, which was devoted to the
issue of pornography.

Design: Swifty
Type design: Ian Wright _Hand Job

→
Promotional Poster , 1995
42 x 59.4 cm
Produced on recycled paper.

Design | Type design: Swifty _Dolce Vita

_Miles Ahead

DOLCE ViTA

FOUR WEIGHTS -
REGULAR, THIN,
PHAT AND STROKES

A BRAND NEW FONT PACKAGE DESIGNED AND PRODUCED BY SWIFTY.

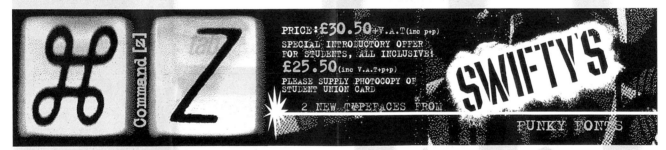

⌘ Command [z] Z

PRICE:£30.50+V.A.T(inc p+p)
SPECIAL INTRODUCTORY OFFER
FOR STUDENTS, ALL INCLUSIVE!
£25.50(inc V.A.T+p+p)
PLEASE SUPPLY PHOTOCOPY OF
STUDENT UNION CARD
2 NEW TYPEFACES FROM

SWIFTY'S
FUNKY FONTS

INCLUDES SWIFTY FANZINE PLUS TWO
POSTSCRIPT™, TYPE 1™ MACINTOSH TYPEFACES

"miles ahead"

SEND NAME AND ADDRESS
CARD TO:-
"SWIFTY'S FUNKY FONTS",
41 CORONET ST, LONDON N1
6HD. TEL: 071 613 2061,
FAX: 071 739 5411 * DON'T
FORGET TO INCLUDE CHEQUE
OR POSTAL ORDER, MADE
PAYABLE TO IAN SWIFT. FOR
OVERSEAS ORDERS FAX FOR
DETAILS

TWO WEIGHTS - REGULAR AND OUTLINE

Creative Alliance

Catalogue, 1997
364 pages
15 x 22.8 cm

Design: Robin Farren
Type design (cover):
Ted Szumilas _Ovidius Demi
Tom Rickner _Amanda Bold

Location_Wilmington, Massachusetts, USA
Redhill, Surrey, UK
Established_1994
Founder_Agfa
Type designers_David Berlow, Bo Berndal, Albert Boton
Philip Bouwsma, Lennart Hansson
Franck Jalleau, Oliver Nineuil, Aldo Novarsese
Jean-François Porchez, Poul Søgren
and many more
Distributors_Agfa, Monotype Typography, FontShop International (FSI), FontWorks, FontHaus and
many more

The goal is to become the most important font resource for professional graphic designers.

Agfa was a major provider of fonts sold mainly to high-end imagesetter customers. As desktop-publishing technology advanced, it changed the way graphic designers worked. At first Agfa continued to concentrate on providing tools and equipment to those who serviced designers. This proved to be a good decision in 1985, but times and market needs changed. In 1994 Agfa saw the need for fresh, new typeface designs and created the AgfaType Creative Alliance. Three years later, in 1997, Monotype Typography joined Agfa to develop the Creative Alliance typeface library, a growing resource of new and exclusive typefaces specifically for the graphic design community.

Every quarter Agfa and Monotype release between fifty and one hundred new typefaces as part of the Creative Alliance programme. Today, there are over 6800 typefaces in the Creative Alliance, and over eight hundred of these are exclusive to Agfa.

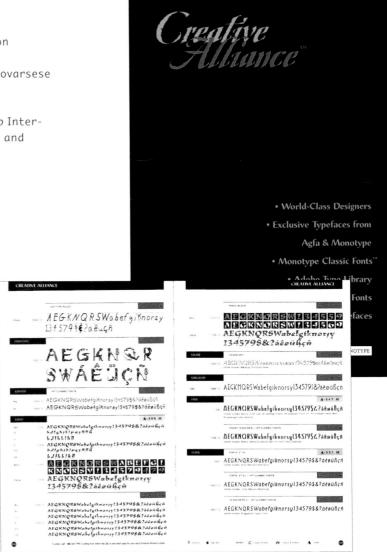

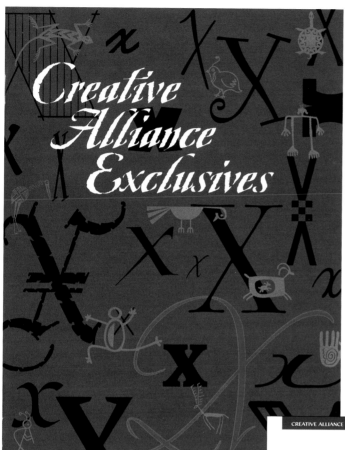

Exclusive catalogue, 1997
44 pages
15 x 22.8 cm

Design: Robin Farren
Type design (cover):
Lennart Hansson _Runa
Richard Lipton _Avalon
Steve Matteson _Curlz
Tobias Frere-Jones _Asphalt Black

CREATIVE ALLIANCE EXCLUSIVES

Pierre di Sciullo

Gararond Light
Gararond Light Italic
Gararond Medium
Gararond Medium Italic
Gararond Bold
Gararond Bold Italic

The Font Bureau Inc

Tobias Frere-Jones

Asphalt Black
Asphalt Black Condensed
Citadel Solid
Citadel Inline
Pilsner Light
Pilsner Regular
Pilsner Bold
Pilsner Black

Carolyn Gibbs

Artifact One
Artifact Two
Artifact Three
Artifact Four

Val Fullard

Science Regular

Lennart Hansson

Crane Light
Crane Light Italic
Crane Medium
Runa Serif Light
Runa Serif Italic
Runa Serif Medium

To order: call 1-800-424-TYPE if calling from within the US, or see back page for your local Creative Alliance contact.

43

Letters are actors

Alessio Leonardi

In Italian we call letters <u>caratteri</u>, that is, characters – and this is not mere coincidence. In fact, every letter has its own character and qualities that distinguish it clearly and unmistakably from all others. Despite these differences, all letters belonging to a specific font look amazingly similar. They are all related: brothers and sisters, sons and daughters, from the same hand, the same epoch, the same idea. Letters are actors who always bring new theatrical pieces to the stage. A kind of roaming <u>compagnia teatrale</u>, that – in accordance with the audience's cultural level and taste – constantly sets new plays in scene and attempts to present them as well as possible. There are ensembles that specialize in classical pieces; others that make their best appearance in light comedies; or still others that have experimental ambitions. As an audience, we are free to applaud or boo these performances.

Context of the text: a political responsibility

Good and bad fonts are often discussed without considering the context. Some people might say, 'There are fonts that are good and that we should use.' These are readable, proper and familiar fonts that preserve the values of our culture and can save us from decline. In contrast, other type styles are perceived to be the product of a sick society, a subculture that will eventually infect our great culture. I do not find this argument very funny. If we transfer it to the human level, it becomes even less funny: the good people are serious, like classical theatre, they earn a proper living and make neither dirt nor noise.

Throughout the course of history, from the Romans to Charlemagne to Mussolini, numerous attempts have been made to express principles of order, absolutist thoughts, or the immortality of an empire through a uniform typography. Such megalomania was communicated by a totalitarian typography. It is a welcome fact that they did not succeed: how boring it would be if every message were set in the same type! Always the same actor: on one occasion, he tries to appear tragic, the next, dramatic; now he is dressed as a woman, now he is trying to be funny. But, without exception, he is proper, serious, well-spaced. Terrible! How beneficial it is to go unshaven occasionally, to wear ripped trousers and to sleep a bit longer!

Resistance: on the necessity of typo-terrorism

As typographers or designers we not only have the right to defend ourselves, we also have the political duty to offer resistance. We must, if necessary, commit typo-terrorist acts in order to show clearly that we will not conform under any circumstances, that we will not accept a clinical typographic death. The computer can help us, and has already supported us considerably. When the barons were able to control hot-metal type, it was very difficult for the individual to develop something personal because the production process was too complicated and expensive. Today, we can all draw letters ourselves for our own needs. It does not matter if the results are not always brilliant: if we see more beautiful letters designed by someone else, we can always buy them.

My life as a passionate typo-terrorist

I have developed an allergy to all rules that are based on dogma. Type has a long and lively history, so it is not only interesting to see how a font was created, but also to see how it works. A font is a code that people use to understand each other in writing. Still, it always communicates more than we think.

When considering my fonts, I have tried to analyze some of the mechanisms of typography to see to what extent they are used in communication, consciously or unconsciously, and how much we can change fonts without destroying their functionality. These were small experiments that gave different results, and often contradicted each other.

One of the aspects that fascinates me most is the meeting of digital and analogue, the coldness of the binary code and the warmth of imperfect handwork. I have tried to turn these elements around by creating fonts that, while digital, appear home-made. Conversely, I have given handmade fonts impersonal characteristics, as if they were computer-generated.

Furthermore, I have tried to transform alphabetic characters into pictures – precisely the opposite of the development of the alphabet, which was created from ideograms. The signs and drawings that resulted tell the story contained in the text, but at the same time transport it to a further narrative level: it is its own story, completely accidental, not explicit, but open to interpretation.

I have wondered if it is possible to change the traditional forms of letters and replace them with new ones, and, if so, where the limits of this transformation could lie. I have also drawn more practical fonts to understand how an alphabet takes on personality and how it loses its individual characteristics. Finally, I have treated letters as people: we do not always agree, but we respect each other.

→
Foonky poster, 1997
42 × 59.4 cm
Foonky and its more decorative variant
Foonky Starred are full-on disco
fonts that should have existed in the
1970s, only someone omitted
to design them.

Design | Type design: Rian Hughes _Foonky Heavy, Starred

Device

Location_ London, UK

Established_ 1997

Founder | Type designer_ Rian Hughes

Distributors_ FontWorks, FontShop International (FSI), [T-26]

How can there be too many typefaces
in the world? Are there too many songs,
too many films, too many books?

Rian Hughes studied graphic design at the
London College of Printing, and later gained
further experience at I.D. magazine (UK) and at
the Studio da Gama operated at that time by
John Warwicker. Eight years ago Hughes
became a freelancer and since then has been
working primarily in the music and fashion
industries, as well as in the field of comics and
magazines.

In 1997 Rian Hughes established the type label
Device to market the special fonts he had
created for a large number of jobs. The collection so far comprises more than 120 fonts,
drawn for the most part in Illustrator then
imported to Fontographer. As far as Hughes is
concerned, there is no difference between
letters and illustrations. The computer has
lifted all restrictions and has given designers
the freedom they need: for Hughes, designing
fonts is also about making pictures.

Unpublished postcard, 1996

Design | Type design: Rian Hughes _Cyberdelic
_Mastertext Symbols One, Two
_Pic Format

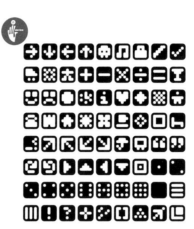

CYBERDELIC!

a DEVICE font. ©1995 Rian Hughes, 6 Salem Road, W2 4BU England.
Device: +44 [0] 171 221 9580 Fax: +44 [0] 171 221 9589.

MASTERTEXT SYMBOLS ONE

a DEVICE font. ©1995 Rian Hughes, 6 Salem Road, W2 4BU England.
Device: +44 [0] 171 221 9580 Fax: +44 [0] 171 221 9589.

MASTERTEXT SYMBOLS TWO

Pic Format

→
Mastertext poster, 1997
42 x 59.4 cm
Mastertext is a digital font that plainly
shows its digital history.
It refuses to take advantage of today's
transparent technology and is generated
from a simple grid.

Design | Type design: Rian Hughes _Mastertext Light, Plain, Heavy, Boxed

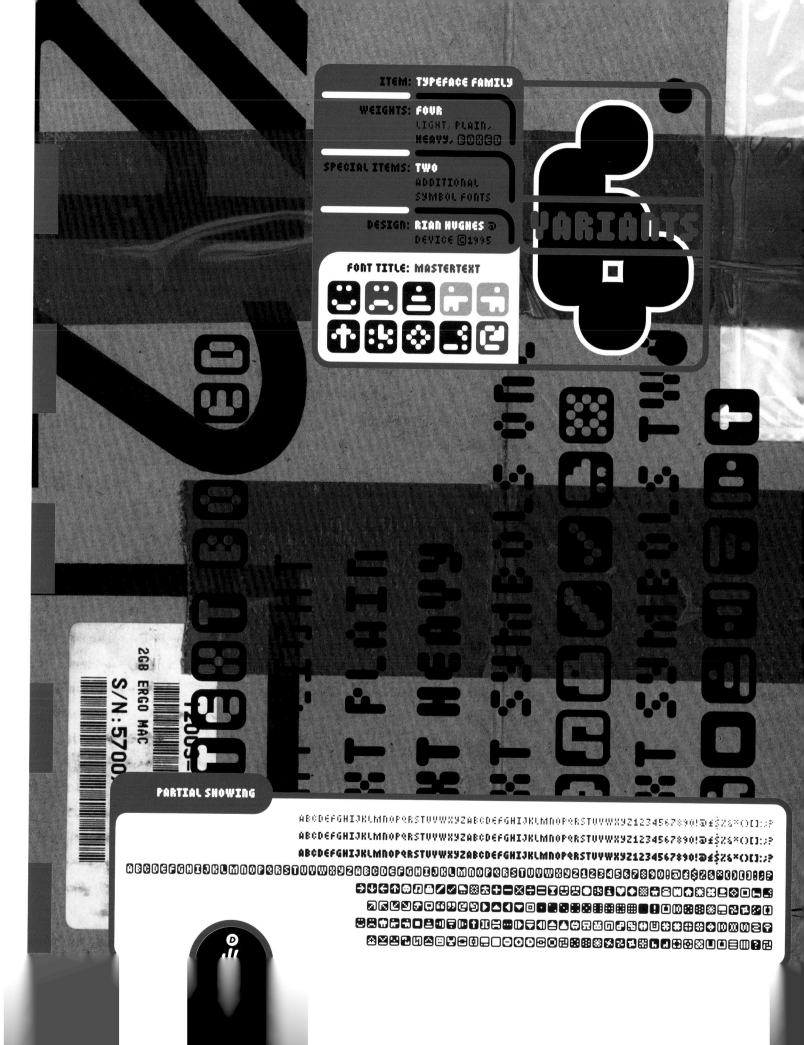

ITEM: **TYPEFACE FAMILY**

WEIGHTS: **FOUR**
LIGHT, PLAIN,
HEAVY, BOXED

SPECIAL ITEMS: **TWO**
ADDITIONAL
SYMBOL FONTS

DESIGN: **RIAN HUGHES** @
DEVICE ©1995

FONT TITLE: MASTERTEXT

PARTIAL SHOWING

2GB
ERGO MAC
S/N:5700

ABCDEFGHIJKLMNOPQRSTUVWXYZABCDEFGHIJKLMNOPQRSTUVWXYZ1234567890!@£$Z&*()[]:;?
ABCDEFGHIJKLMNOPQRSTUVWXYZABCDEFGHIJKLMNOPQRSTUVWXYZ1234567890!@£$Z&*()[]:;?
ABCDEFGHIJKLMNOPQRSTUVWXYZABCDEFGHIJKLMNOPQRSTUVWXYZ1234567890!@£$Z&*()[]:;?

Elektron: a typeface family in four variants designed by Rian Hughes @ Device. ©1995.

ABCDEFGHIJKLMNOPQRSTUUWXYZabcdefghijklmnopqrstuuwxyz1234567890!?@£$%&[{}]:;.∫
ABCDEFGHIJKLMNOPQRSTUUWXYZabcdefghijklmnopqrstuuwxyz1234567890!?@£$%&[{}]:;.∫
ABCDEFGHIJKLMNOPQRSTUUWXYZabcdefghijklmnopqrstuuwxyz1234567890!?@£$%&[{}]:;.∫
ABCDEFGHIJKLMNOPQRSTUUWXYZabcdefghijklmnopqrstuuwxyz1234567890!?@£$%&[{}]:;.∫

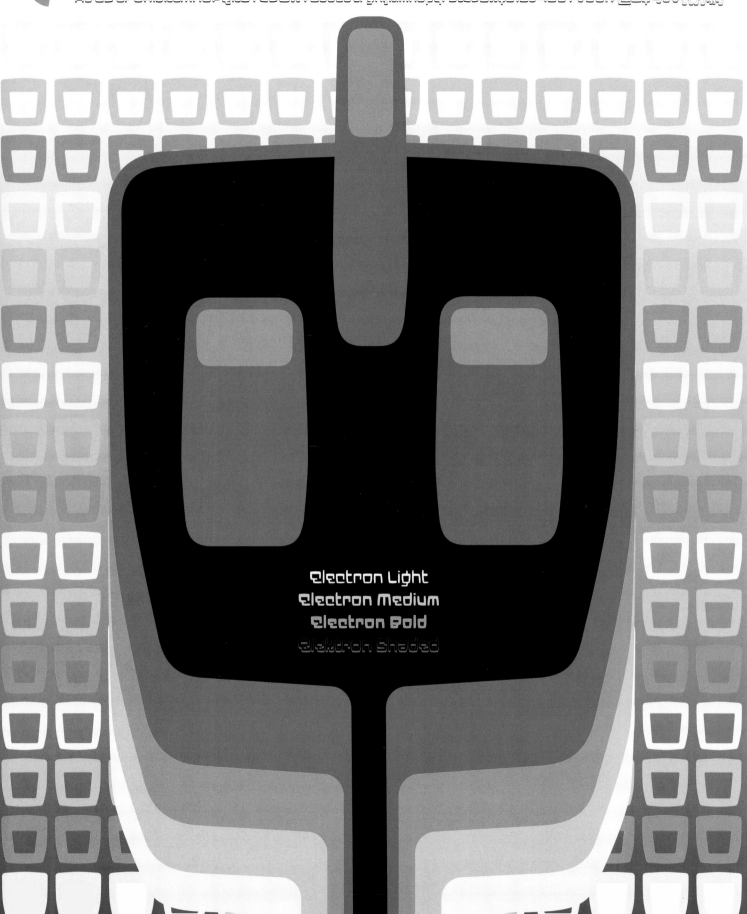

Electron Light
Electron Medium
Electron Bold
Elektron Shaded

Unpublished postcard, 1996

Design | Type design: Rian Hughes _Lusta One Sixty Sans, One Twenty Sans,
Two Hundred Sans
_Mac Dings

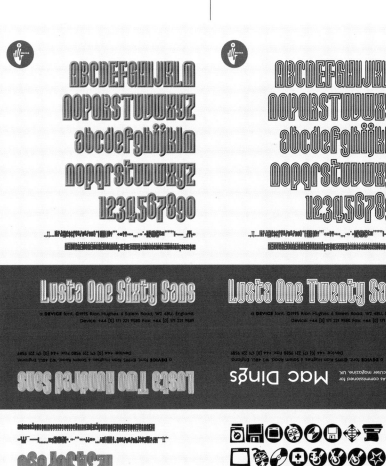

←
Electron poster, 1997
42 x 59.4 cm
Electron is the TV-as-icon-
of-the-future typeface that has its faith
in the plastic
future of an artificial world.

Design | Type design: Rian Hughes _Electron Light, Medium, Bold, Shaded

160

ABCDEFGHIJKLMNOPQRSTUVWXYZabcdefghijklmnopqrstuvwxyz1234567890!@£$%^&*()!?
ABCDEFGHIJKLMNOPQRSTUVWXYZabcdefghijklmnopqrstuvwxyz1234567890!@£$%^&*()!?
ABCDEFGHIJKLMNOPQRSTUVWXYZabcdefghijklmnopqrstuvwxyz1234567890!@£$%^&*()!?
ABCDEFGHIJKLMNOPQRSTUVWXYZabcdefghijklmnopqrstuvwxyz1234567890!@£$%^&*()!?
ABCDEFGHIJKLMNOPQRSTUVWXYZabcdefghijklmnopqrstuvwxyz1234567890!@£$%^&*()!?
ABCDEFGHIJKLMNOPQRSTUVWXYZabcdefghijklmnopqrstuvwxyz1234567890!@£$%^&*()!?
ABCDEFGHIJKLMNOPQRSTUVWXYZabcdefghijklmnopqrstuvwxyz1234567890!@£$%^&*()!?

80

40

200

120

Lusta a typeface in 7 variants
designed by Rian Hughes
@ Device. © 1995.
40 Lusta Forty Sans
40 Lusta Forty Serif
80 Lusta Eighty Sans
80 Lusta Eighty Serif
120 Lusta One Twenty Sans
160 Lusta One Sixty Sans
200 Lusta Two Hundred Sans

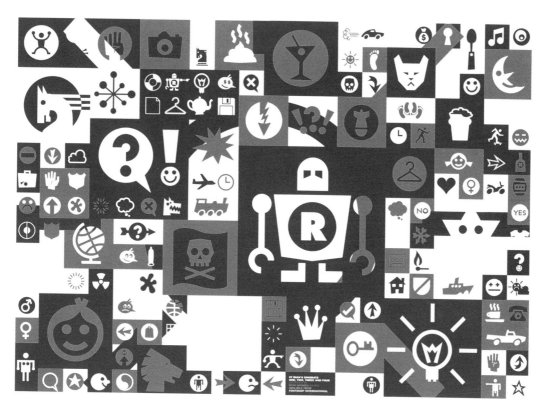

Rian's Dingbats poster, 1993
42 × 59.4 cm
Rian's Dingbats is a pictorial
font with some unusual but
useful icons, for example, a pile of
shit, a range of expressive
heads, a pint of beer
and a condom.

Design | Type design: Rian Hughes _Rian's Dingbats

←
Lusta poster, 1997
42 × 59.4 cm
Lusta is a strict geometric type family
that grew from the 'inline in
the outline' idea for the letter S and
developed into two styles (serif and
sans) over two weights. Further strictly
mechanical processes were applied to
create the decorative variants.

Design | Type design: Rian Hughes _Lusta Forty Sans, Forty Serif,
Eight Sans, Eighty Serif, One Twenty Sans,
One Sixty Sans, Two Hundred Sans

YOU'RE THE ONE THAT I WANT

YOU'RE ELECTRIFYIN

HOPELESSLY DEVOTED TO YOU

BLACKCURRANT BY RIAN HUGHES
PART OF THE DEVICE COLLECTION FROM [T-26]

[T-26] Digital Type Foundry. 1110 North Milwaukee Avenue, Chicago, Illinois 60622.4017 USA, Planet Earth.
Two weights for $84. Includes *Blackcurrant Cameo*, free with every **Device** order or visit to the **Device** web site.
To order, call 773. 862. 1201, fax 773. 862.1214, or e-mail us at t26font^Taol.com.
Visit our website at www.t26font.com and view the full **Device** collection.
This text set in *Regulator*©. Two sets of five and six fonts for $162 and $180.
Illustrations by Rian Hughes©. You can contact the designer at: rianhughes^Taol.com

REASONIST M

REASO

Stadia is built from a limited number
of basic elements and their mirrored
and reflected variations, totalling
thirty-two shapes, and adheres to a
strict square grid – or at least that was
the intention. After much fiddling,
Rian gave in and let elements of the T,
the Y and the accents break the grid and
sit between squares. The name derives
from the O, which resembles a stadium
from above.

Design | Type design: Rian Hughes _Stadia

←
Blackcurrant poster, 1997
42 x 59.4 cm
Blackcurrant was created for a series
of posters designed for Tokyo fashion
house Yellow Boots, a retail clothing
chain aimed at sixteen to twenty-five
year olds. In its original form it
was quite wide (Black), so a more
condensed version was developed
to enhance useability (Squash). This
poster was designed to advertise the
Blackcurrant family.

Design | Type design: Rian Hughes _Blackcurrant

Reasonist poster, 1997
42 x 59.4 cm
Reasonist has its roots in a kind of
brushstroke-meets-Cooper Black, but
tries to have even more fun.

Design | Type design: Rian Hughes _Reasonist

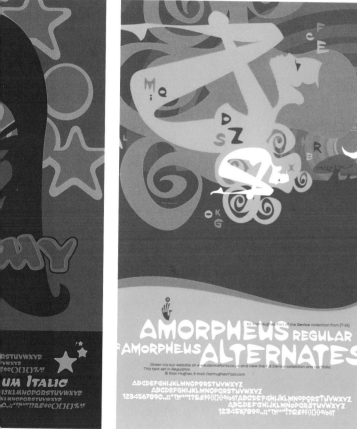

Amorpheus poster, 1997
42 x 59.4 cm
Amorpheus has been adopted by the
hardcore trance record label Transient
as a corporate font, and also by 'Blankety
Blank', a light-hearted TV quiz show.

Design | Type design: Rian Hughes _Amorpheus

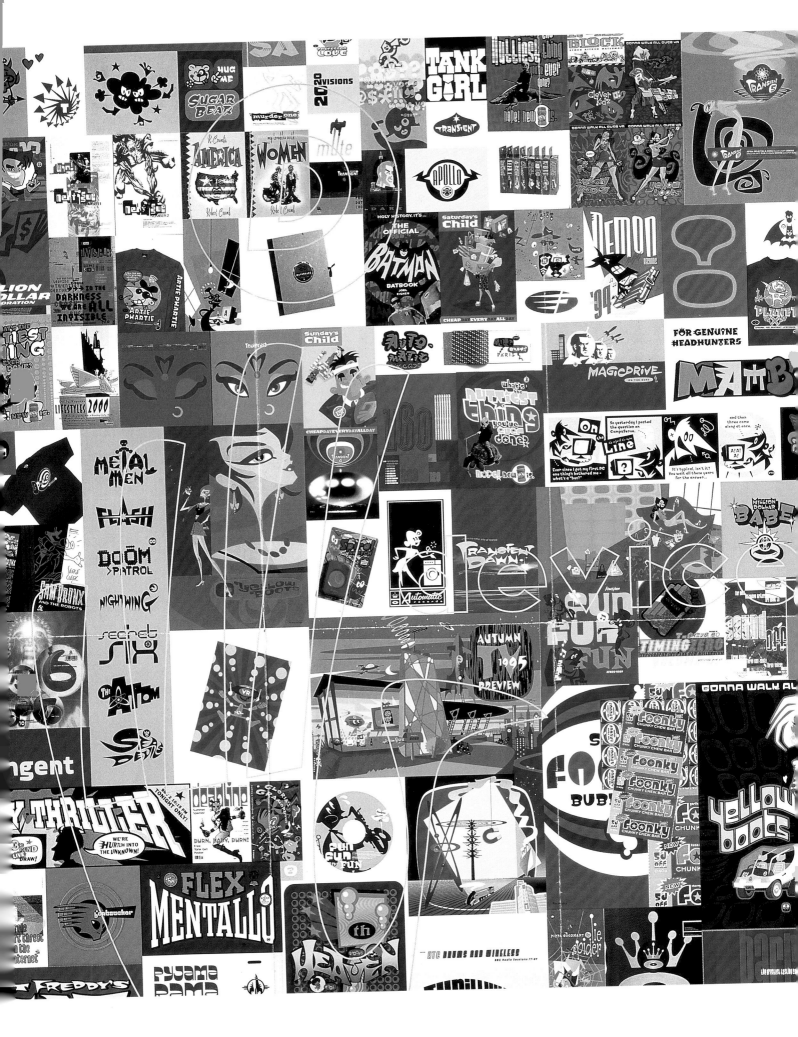

A scrolling list at the bottom of the
page allows the user to select any font
or variant (bold, inline) and when
clicked upon, brings a sample up in
the main window. A free font
is available on every visit.

Design | Type design: Rian Hughes _Customised
Foonky Starred
_Regulator

Website, 1998
www.devicefonts.co.uk
Promotional material

Design | Type design: Rian Hughes _Customised
Foonky Starred
_Regulator

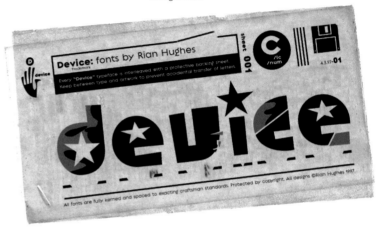

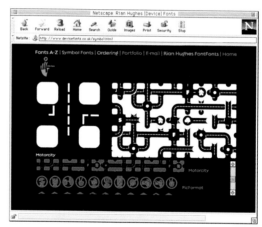

Autofont was developed for a car
magazine called Autocar.
It provides an exhaustive
range of cars, a few bikes, some cones
and whizz lines.

Design | Type design: Rian Hughes _Autofont
_Regulator

Motorcity is a range of intersections,
bends and other road sections that,
when set without leading, combine to
form a complex maze of streets,
resembling a city map from above.

Design | Type design: Rian Hughes _Motorcity
_Regulator

←
Device fonts poster, 1997
42 x 59.4 cm
The front shows the illustrations from
which the fonts were derived. The back
of the poster (not shown) lists
alphabetically the first hundred fonts.

FontShop mailing card, 1995
Pool considers DIN-Mittelschrift – the
German motorway typeface – to be
'probably the most non-designed typeface
ever made'. Taking this opinion as a
starting point, it seemed logical to
enhance the typographic quality of the
design while maintaining its overall
appearance.

Design: Jürgen Siebert
Type design: Albert-Jan Pool _FF DIN light, regular, medium, bold, black

Dutch Design

Location_Hamburg, Germany

Established_1994

Founder | Type designer_Albert-Jan Pool

Distributors_FontShop International (FSI), (URW)++

The Dutchman Albert-Jan Pool studied graphic
design and typography at the Koninklijke Aka-
demie van Beeldende Kunsten in The Hague,
before working as a graphic designer. In 1985
he helped to found Letters, a group of young
Dutch font designers that also staged exhibi-
tions. Pool worked as a type director at Scan-
graphic at the end of the 1980s before becoming
manager for type design and production at URW
Software & Type GmbH in Hamburg in 1991. At
that time he designed various fonts for URW,
such as Linear, Imperial and Mauritius. He set
up Dutch Design in 1994 and now works as a one-
man font and graphics studio. Pool is also an
author and has taught type design and typo-
graphy at the Muthesius University in Kiel and
the Hanseatic Academy for Marketing and Media
in Hamburg. Dutch Design has been a member of
the studio group FarbTon Design und Medien-
büro in Hamburg since 1997.

Diesel **Benzin** bleifrei **Super** bleifrei **Super+** bleifrei

91 95 98

3 4

Diesel
Benzin
Super
Super+

Gas pump lettering for the corporate
identity manual of Jet petrol stations
(Conoco Mineral Oil Company).
At the request of the Hamburg agency,
Syndicate, Pool designed an exclusive font
for the company by adapting the arched
wing, angles and bold characters of the
corporate logo and simplifying some
letter forms to achieve a visual unity.

Design: Syndicate
Type design: Albert-Jan Pool _Jet Bold Italic

Illustrations from FontShop
mailing card, 1995
When Pool was asked to rework the type-
face OCR-B for FSI, his first thought was:
how could he improve this typeface,
which is considered to be derived from
Adrian Frutiger's Univers? Then he remem-
bered the words of his teacher Gerrit
Noordzij, 'Turning things upside-down
does not always lead to improvement, but
it certainly makes them funnier.'
So why not redesign OCR-B and supply
designers with a useful typographic toy
named FF OCR-F?

Design: Jürgen Siebert
Type design: Albert-Jan Pool _FF OCR-F, light, regular, bold

F 1234

→
Page from the loose-leaf type specimen
showing Nobel Bold
21 x 29.7 cm
The first edition of this type specimen,
which is constantly updated, was
published in 1994. There are now about
two hundred pages. Nobel was originally
designed by Sjoerd H. de Roos for Letter-
gieterij Amsterdam (now Tetterode) in
1929. The revival was released in 1993;
the digitization was carried out by
Fred Smeijers and Andrea Fuchs.

Design: Frank E. Blokland
Type design: Sjoerd de Roos
Andrea Fuchs & Fred Smeijers _Nobel Bold

Dutch Type Library

Location_'s-Hertogenbosch, The Netherlands

Established_1990

Founder_Frank E. Blokland

Type designers_Gerard Unger, Jan van Krimpen, Chris Brand
Erhard Kaiser, Fred Smeijers, Gerard Daniëls
Elmo van Slingerland, Frank E. Blokland
and others

Distributors_Dutch Type Library, (URW)++

When it was established in 1990, the Dutch Type
Library (dtl) was the first digital type foundry
in The Netherlands. Its intention was to make
exclusive and original Dutch type designs to a
high technical level. dtl has always tried to find
the right balance between new designs and
revivals of historical typefaces, and as a result
supports talented young type designers. So far
this has resulted in two premieres:
Caspari by Gerard Daniëls and Dorian by Elmo
van Slingerland. Among dtl users are museums,
publishers of art books and university presses,
but also schools, a public transport company,
a pharmaceutical magazine and even a hospital.
The Dutch Type Library believes that custom-
made fonts are the future. Examples are the
Sans for Haarlemmer, commissioned by Museum
Boijmans van Beuningen in Rotterdam and the
adaptation of Albertina for the European Union
in Luxembourg. Besides the constant extension
of existing families, the Dutch Type Library is
now working on many new designs such as Unico
by Michael Harvey, Rosart (based on an eight-
eenth-century typeface) by Antoon de Vylder
and Sheldon and Romulus by Jan van Krimpen.

Cover of Jan van Krimpen's
Memorandum, 1996
20 pages
24.1 x 16.2 cm
This annotated publication was
meant to introduce Haarlemmer,
a typeface originally designed by
Jan van Krimpen in 1938 and commis-
sioned by de Vereeniging voor
Druken Boekkunst. The production
was carried out at Monotype, but
technical problems and the Second
World War meant that Haarlemmer was
never finished. In 1995 Frank E.
Blokland created the digital revival.

Design: Frank E. Blokland
Type design: Jan van Krimpen
Frank E. Blokland _Haarlemmer, Haarlemmer Italic

ABCDEFGHIJK
LMNOPQRSTUV
WXYZ&ŒÆÇ
1234567890
abcdefghijklmno
pqrstuvwxyzœæ
fiflçøñáàâäãå
éèêëóòôöŭùûü
ß?!;:$£¥¢§⬚
†©®%#

48/56

10

10/12 Nederland heeft in de ontwikkeling van drukletters altijd een grote rol gespeeld. Het zetten en drukken met losse loden letters was een Nederlandse uitvinding. Misschien dat Laurens Janszoon Coster (1405–1468) de uitvinder was ofwel een andere, onbekend gebleven, drukker. In de zeventiende eeuw was Nederland het typografisch centrum van de wereld. De bekendste Nederlandse stempelsnijder uit de gouden eeuw is Christoffel van Dijck, wiens ontwerpen door de beroemde uitgeverij Elzevir in Leiden

11/14 Nederland heeft in de ontwikkeling van drukletters altijd een grote rol gespeeld. Het zetten en drukken met losse loden letters was een Nederlandse uitvinding. Misschien dat Laurens Janszoon Coster (1405–1468) de uitvinder was ofwel een andere, onbekend gebleven, drukker. In de zeventiende eeuw was Nederland het typografisch centrum van de wereld. De bekend-

DTL ALBERTINA MEDIUM T/ST· ITALIC
ABCDEFGHIJKLM
NOPQRSTUVWXYZ
&ŒÆÇ
1234567890
abcdefghijklmnopqr
stuvwxyzœæfiflßço
áàâäãåéèêëñóòôöúùûü
!?.,:;-$£¥¢§¶†©®%#
1234567890

24/29

Nederland heeft in de ontwikkeling van drukletters altijd een grote rol gespeeld. Het zetten en drukken met losse loden letters was een Nederlandse uitvinding. Misschien dat Laurens Janszoon Coster (1405–1468) de uitvinder was ofwel een andere, onbekend gebleven, drukker. In de zeventiende eeuw was Nederland het typografisch centrum van de wereld. De bekendste Nederlandse stempelsnijder is Christoffel van Dijck, wiens ontwerpen door de beroemde uitgeverij Elzevir in Leiden met succes werden

8/10

Nederland heeft in de ontwikkeling van drukletters altijd een grote rol gespeeld. Het zetten en drukken met losse loden letters was een Nederlandse uitvinding. Misschien dat Laurens Janszoon Coster (1405–1468) de uitvinder was ofwel een andere, onbekend gebleven, drukker. In de zeventiende eeuw was Nederland het typografisch centrum van de wereld. De bekendste Nederlandse

9/12

OHamburgefonstiv

14/18 Nederland heeft in de ontwikkeling van drukletters altijd een grote rol gespeeld. Het zetten en drukken met losse loden letters was een Nederlandse uitvinding. Misschien dat Laurens Janszoon Coster (1405–1468) de uitvinder was ofwel een andere, onbekend gebleven, drukker. In de zeventiende eeuw was Nederland het

18/00 Nederland heeft in de ontwikkeling van drukletters altijd een grote rol gespeeld. Het zetten en drukken met losse loden letters was een Nederlandse uitvinding. Misschien dat Laurens Janszoon Coster (1405–1468) de uitvin-

15

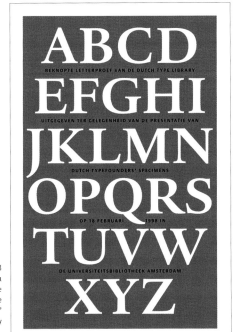

Page from the loose-leaf
type specimen presenting
Albertina Medium Italic.
21 x 29.7 cm
Albertina was originally designed by
Chris Brand in 1961 and was used only
once: for an exhibition in the Royal
Library of Brussels, named Albert I.
The digital version was produced at
the Dutch Type Library in 1996, with the
full backing of Brand and Monotype.
The European Union recently
selected Albertina as its corporate
typeface.

Design: Frank E. Blokland
Type design: Chris Brand, dtlStudio _Albertina

Cover of a type specimen leaflet, 1998
24 x 16 cm
The leaflet gives an overview of the
complete library, and was made for the
presentation of Dutch Type founders'
specimens in the University Library
of Amsterdam.
Design: Frank E. Blokland
Type design: Jan van Krimpen
Frank E. Blokland _Haarlemmer
Gerard Unger _Argo

ThrowingAPPLES

APOLLOprogramFonts

Grooves

CRT

MasterCylinder

Icons from the enhanced CD-ROM
'Throwing Apples at the Sun', 1995
Design: Elliott Peter Earls

Elliott Peter Earls

Location_Greenwich, Connecticut, USA

Established_1993

Distributors_Emigre, The Apollo Program

Remember to do accounting on Friday

Elliott Peter Earls received his MFA from Cranbrook
Academy of Art. Upon graduation, his 'holistic' experimen-
tation with nonlinear digital video, spoken-word poetry, the
composition of music and design, led him to form the studio
The Apollo Program. The form the work takes is very simple:
high-resolution nonlinear digital video compositions are
delivered via video projection in theatres and on CD-ROM.
Clients include Elektra Entertainment, Nonesuch Records,
Scribner Publishing, Elemond Casabella, The Cartoon Net-
work, Polygram Classics and Jazz, The Voyager Company and
Janus Films.

Earls has spent time as a visiting artist at Maine College of
Art, Cranbrook Academy of Art, Eastern Michigan University
and the University of North Carolina and, most recently, at
Benetton's research centre in Fabrica. In addition, he has
run workshops on design, culture and new media in Europe
and America.

→
Poster, 1994
63.5 x 94 cm
The poster 'Idle|Idol King Suffered'
was produced to announce the release
of the enhanced CD.

Design | Type design: Elliott Peter Earls _Penal Code
_Toohey and Wynand
_Dysphasia

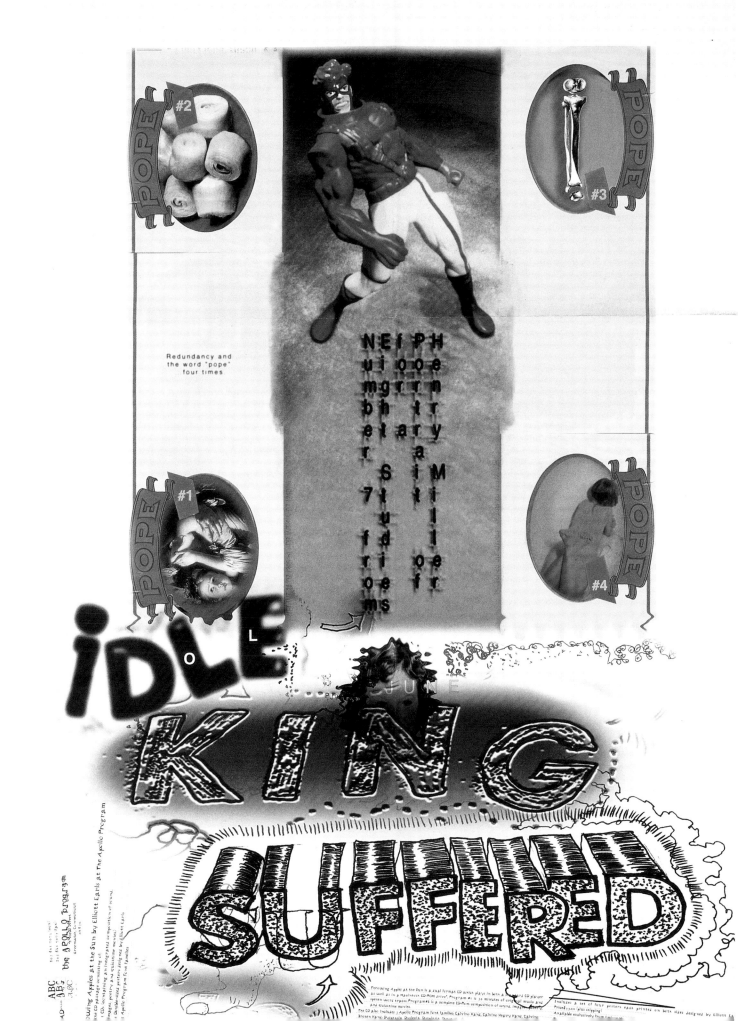

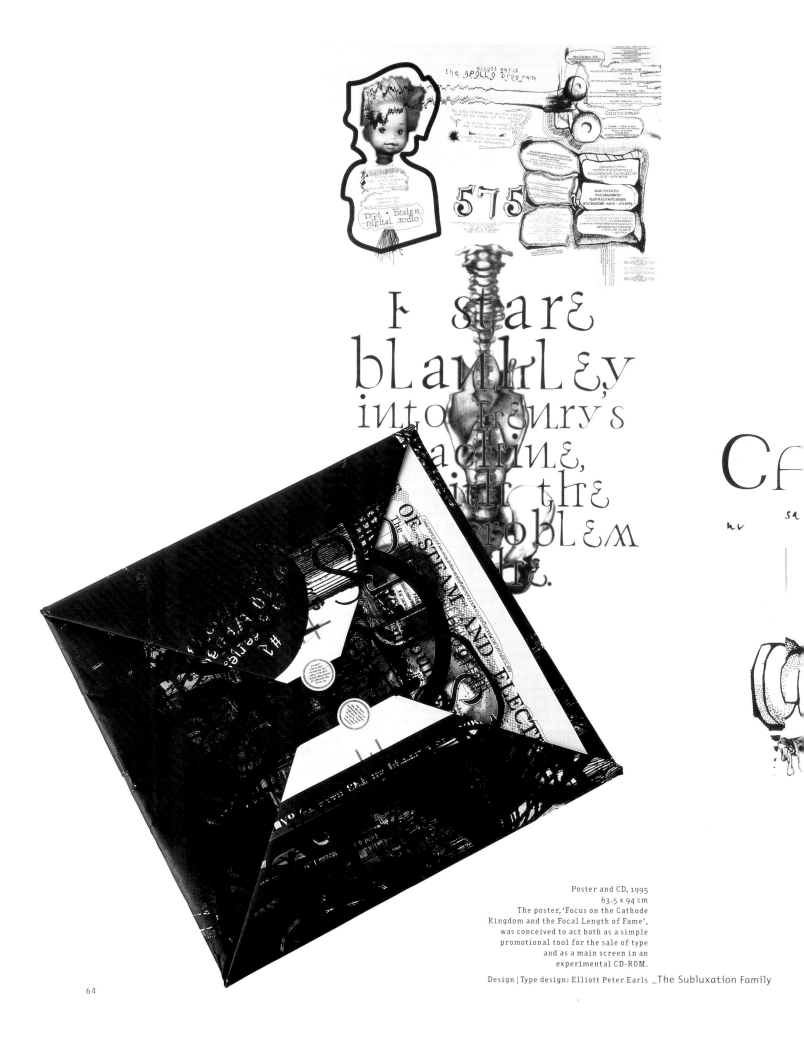

I stare blankley into Freury's machine, with the problem of...

Poster and CD, 1995
63.5 x 94 cm
The poster, 'Focus on the Cathode
Kingdom and the Focal Length of Fame',
was conceived to act both as a simple
promotional tool for the sale of type
and as a main screen in an
experimental CD-ROM.

Design | Type design: Elliott Peter Earls _The Subluxation Family

←
Poster, 1995
63.5 x 94 cm
The poster was created to promote
the design of the font Subluxation.

Design | Type design: Elliott Peter Earls _The Subluxation Family

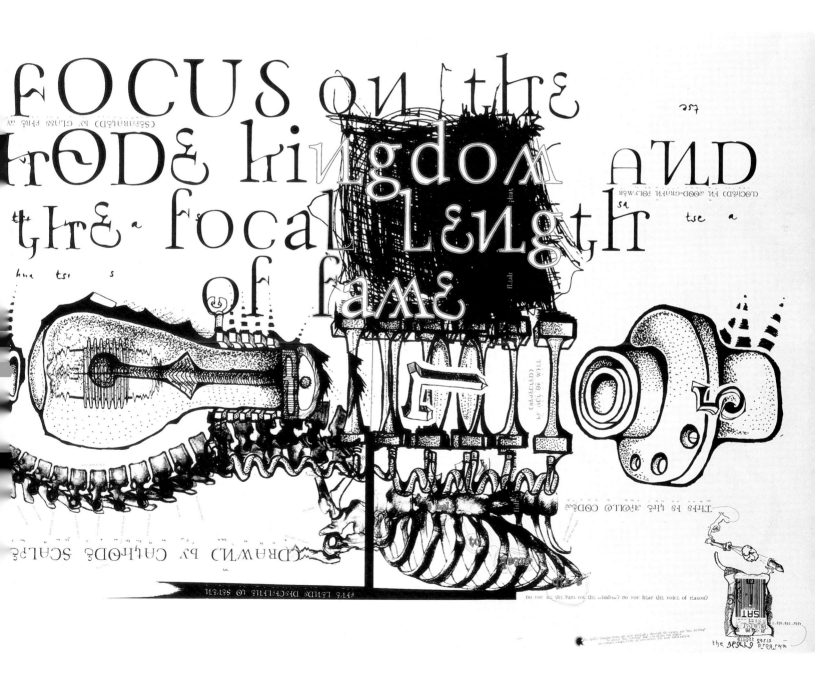

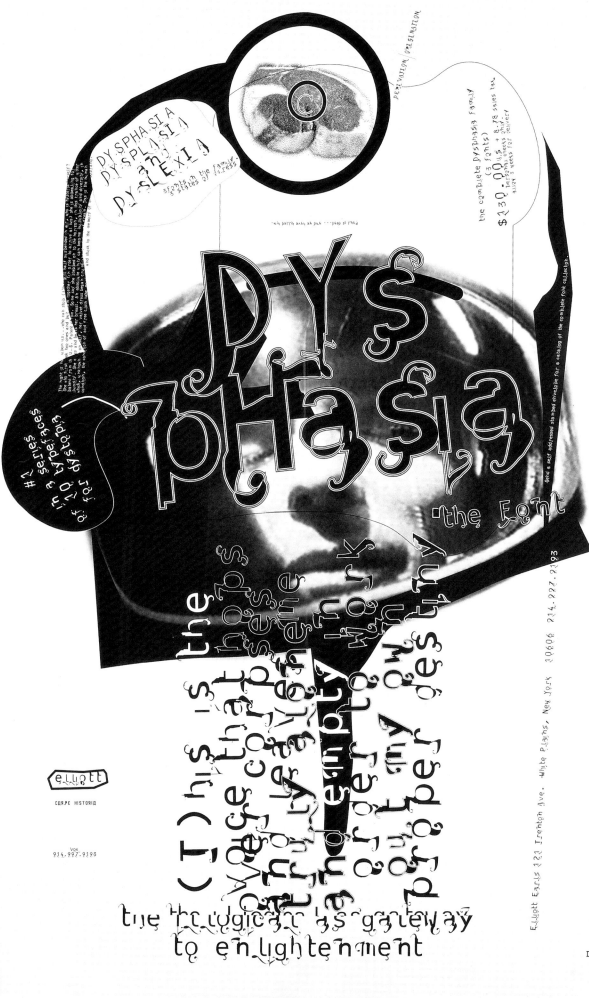

DYSPHASIA
DYSPLASIA
and
DYSLEXIA

3 fonts in the family.
3 states of distress

DERIVATION/ORIGINATION

the complete Dysphasia family
(3 fonts)
$130.00 us + 8.78 sales tax.
personal checks okay.
allow 3 weeks for delivery.

DYS
phasia
the Font

#1 series
in a series
of 10 typefaces
for dystopia

Send a self addressed stamped envelope for a catalog of the complete font collection.

(T)his is the
voice that hopes
that you can
truly contemplate
the empty
order to empty
murder my own
proper destiny

the theological is gateway
to enlightenment

elliott
CARPE HISTORIA

vox
914.997.9193

Elliott Earls 121 Trenton Ave. White Plains, New York 10606 914.997.9193

The Dysphasia
poster and CD, 1995
63.5 x 94 cm

Design | Type design:
Elliott Peter Earls _The Dysphasia Family

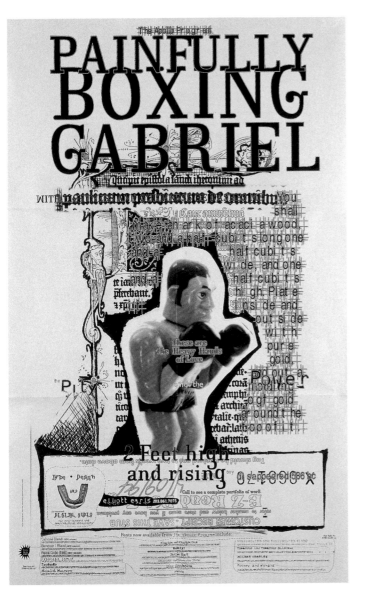

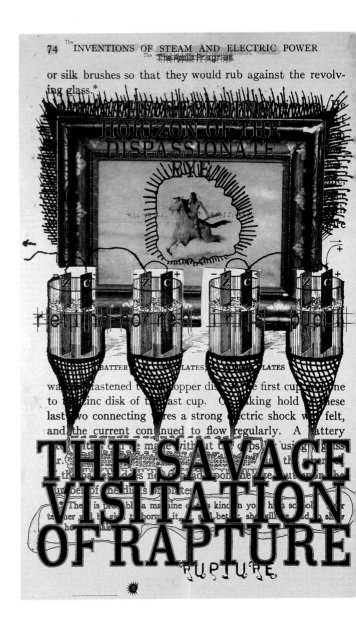

Poster, 1995
63.5 x 94 cm
Front and back of
the poster 'Painfully Boxing
Gabriel'.

Design | Type design:
Elliott Peter Earls _Penal Code
_Bland Serif Bland
_Calvino Hand

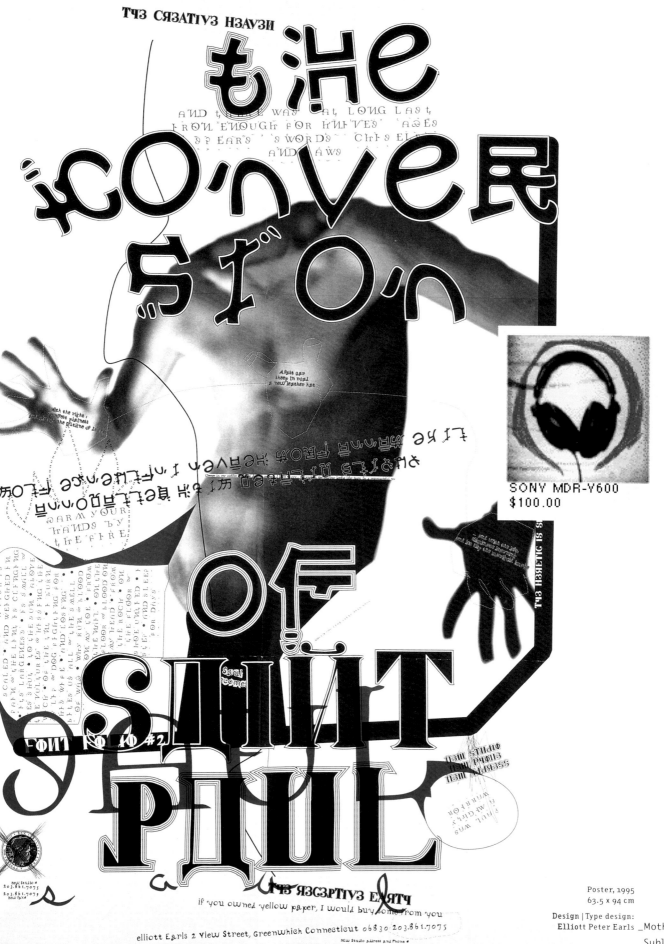

Poster, 1995
63.5 x 94 cm

Design | Type design:
Elliott Peter Earls _Mothra Paralax
_Subluxation Bland

©1995. The APOLLO Program. All rights reserved.

The Apollo Program

MFA – May 1993
Cranbrook Academy of Art
Bloomfield Hills, Michigan
Design

BFA – May 1988
The Rochester Institute of Technology
Rochester New York

APPLE CD-ROM –$250
APS DAT – $1100
APS 2 GIG HD – $1150
Syquest 44 meg – $250

Microtek
Scanmaker 2XE
$1100

SONY DAT TCD-D7
$599.00

Screenshots from the
enhanced CD-ROM 'Throwing
Apples at the Sun', 1995
It contains thirty minutes of
music, poetry, Quicktime movies,
typography and an integrated
multimedia composition.

Design | Type design:
Elliott Peter Earls _The Distillation Family
_The Subluxation Family

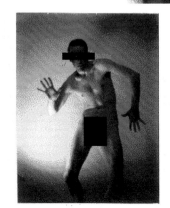

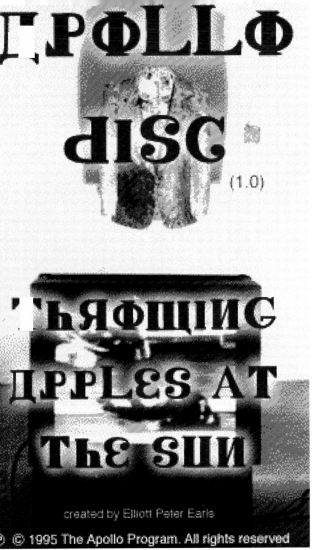

abcdefghijklmnopqrstuvwxy
[äöüßåøœç] A B C D E F G H I J K
L M N O P Q RSTUVWXYZ
1234567890 (.,;:?!$ &-*
{ÄÖÜÅØÆŒÇ}

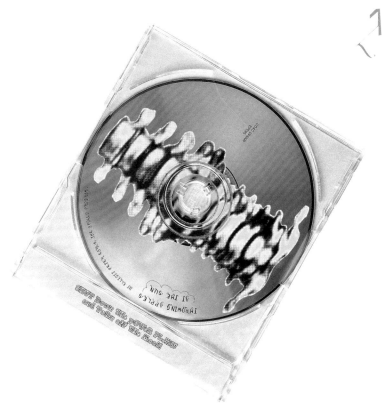

Screenshot and CD case from the
enhanced CD-ROM 'Throwing
Apples at the Sun', 1995

Design | Type design:
Elliott Peter Earls _The Distillation Family
_The Subluxation Family

→
Poster, 1995
63.5 x 94 cm
The poster 'Throwing Apples at the Sun'
was produced to announce the enhanced
CD-ROM. It was recently added to the
permanent collection of the
Cooper-Hewitt National Design Museum.

Design | Type design: Elliott Peter Earls _The Distillation Family
_The Subluxation Family

CAMELOT

The shoes I can never fill

The source

ThRowinG
APPLES aT THE
SuN

grooves
words
and
images

Version (1.0)

July 20, 1995
Release date

Why is Hercules dying of Thirst?

ONLY $20.00
+ $5.00 shipping (2 day priority)
$4.50 take face

Visa, Mastercard or American Express orders only.
To order call:

203.861.7075
the APOLLO program

SHRUGGED

30 MINUTES OF MUSIC + ONE CD-ROM

abcdef

Elsner+Flake

Location_Hamburg, Germany

Established_1985

Founders_Veronika Elsner, Günther Flake

Type designers_Charles Bigelow, Kris Holmes, Achaz Reuss
Hans Eduard Meyer, Manfred Klein
Jessica Hoppe, Frank Baranowski
Lisa von Paczkowski, Ralf Borowiak
Petra Beiße and many more

Distributors_FontShop International (FSI), FontHaus
Linotype Library, Faces, FontWorks
Signum Art and others

Tradition and Trend

In January 1985, after a decade of freelance work in the areas
of font design, typography and digitization, Veronika Elsner
and Günther Flake founded the company Elsner+Flake Design
Studios in order to build up a library of their own fonts. The
library now contains over 1550 font patterns, ranging from
their own exclusive font creations to classical fonts and the
grunge fonts Beasty Bodies dating to the 1990s. Apart from
central-European character sets like Polish, Czech and
Hungarian, Elsner+Flake offers Greek, Turkish, Cyrillic,
Asian, Arabic and Hebrew fonts. Their mail-order house,
Elsner+Flake Fontinform, was established in 1992 to meet the
growing demand for fonts from other libraries and to offer
advice on installation, application or inclusion of fonts in text
and graphic programs. As exclusive partner of the American
font company FontHaus, Elsner+Flake Fontinform offers fonts
from several dozen producers.

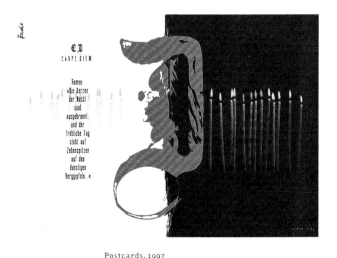

Postcards, 1997
Design: Factor Design
Type design: Verena Gerlach _Aranea Normal, Outline
Jessica Hoppe _Carpediem

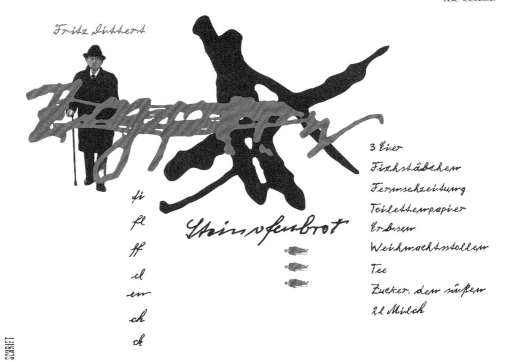

Fritz Dittert

ri j k

3 Eier
Fischstäbchen
Fernsehzeitung
Toilettenpapier
Erbsen
Weihnachtsstollen
Tee
Zucker, den süßen
2l Milch

Steinofenbrot

fi
fl
ff
el
en
ch
ck

SCHRIFT

Postcard, 1997
Fritz Dittert was born in 1903, one
of eleven children. He worked as a
tailor, farmer and construction worker
and experienced two world wars and two
periods of hyperinflation. The font
shows his handwriting, which reflects
his life's experiences. Uwe Melichar
and Manuela Frahm digitized Dittert's
handwriting.

Design: Factor Design
Type design: Uwe Melichar, Manuela Frahm _Fritz Dittert

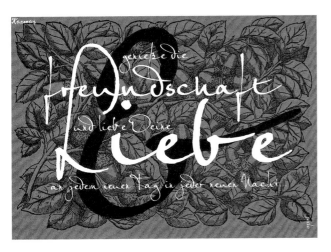

Postcard, 1997

Design: Factor Design
Type design: Petra Beiße _Petras Script

_Typo-matic

Ian Swift

As we move towards the new millennium, styles and fashions come and go like the changing of the wind. Type design, like all creative disciplines, must move with the times and reflect contemporary moods and philosophies. New categories of type design are emerging from the inner depths of our underground movements, from club culture, street life and design fetishism. There will be more styles and options (stencils, interlocks, scripts) and flavours (funky, electic and plain groovy!) available in an already over-saturated market, where type speaks to the hip dudes on the street.

My own attitude towards type is somewhat throwaway. Much to the traditionalists' regret, I'm not about to spend the next ten years designing one font when I could do at least one a week or one a day. In my opinion, type design is addictive and I'm definitely hooked. As a practising graphic and typographic designer I feel the need to draw a new typeface for almost every job that comes into the studio, thus ensuring that different projects receive their own look right down to an exclusive font – for a price! Fonts are used in the studio until they are exhausted, then put on to the pile marked 'to sell'.

Type design is in a revolutionary state. With the right software anyone can design a font, but the industry is still a closed shop when it comes to distribution and marketing. The Internet has opened up the world to independent trading in cyberspace with low overheads, right up there with the major players. Type design is very prominent on the Internet, with over two hundred font foundries at present and increasing all the time. However, the Internet is mostly still dominated by existing font companies going on-line to flex their corporate wings. Yet there are a small number of cutting-edge foundries that offer something a little bit different. Some propose free fonts to entice you on to their pages, others offer packages of competatively priced fonts, others just show fonts that aren't for sale, leading to the inevitable bootlegging.

This is an interesting development for the type design and distribution market. More and more independent type designers will start selling and providing fonts over the Internet, making as much profit as possible on their own product and not selling up to anyone. The age of the entrepreneurial funky font designer is upon us!

The collection known as Typomatic features designs from all over the globe from a vast array of type 'Headz' from all backgrounds. Typomatic has concentrated so far on headline and display fonts, but intends to introduce a few grungy text faces. The viewer is able to select a font, pay for it and receive it on-line, as well as by conventional methods of payment and despatch. Type buying needs to be instant because of the crazy deadlines to which designers have to work – when you need a font you need it quickly!

Cutting-edge type for a cutting-edge market requires obscure ideas as source material. A font can be made from almost anything you find: from rusty old signs that have been discarded to old tickets thrown in the dustbin. We are obsessed and need to feed our obsession on

a constant basis. Stencil fonts are cut out, sprayed, scanned, streamlined and imported. Other letter forms are provided as hand-drawn specimens, which are outlined and thus retain the hand-drawn look. Others are simply drawn as outlines in Freehand and imported.

Texture is very important to type at the moment and better software that offers more options when digitizing fonts is needed. Distressed, manipulated and merged, true creative font design is still in its infancy... there are lots more avenues to explore. Fonts are being submitted from a variety of people, such as graphic designers, students, graffitti artists, illustrators and font 'train spotters' who just fancy having a go!

Emigre

Location Sacramento, California, USA

Established 1984

Founders Zuzana Licko, Rudy Vanderlands

Type designers Mark Andresen, Bob Aufuldish
Jonathan Barnbrook, Barry Deck
Edward Fella, Frank Heine
Jeffrey Keedy, Brian Kelly
Nancy Mazzei, Rudy Vanderlans
Zuzana Licko and others

Distributors Emigre, FontShop International (FSI)

Emigre, based in northern California, is a
digital type foundry, publisher and distri-
butor of graphic design-related software and
printed materials.

Founded in 1984, coinciding with the birth
of the Apple Macintosh, Emigre was one of the
first independent type foundries to establish
itself around personal computer technology. It
holds the exclusive licence to over two hundred
original typeface designs created by a roster
of contemporary designers from around the
world.

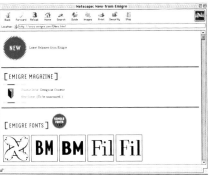

Website, 1998
www.emigre.com

Design: Emigre Graphics
Type design: Zuzana Licko _Hypnopaedia Pattern Illustrations
_Base Monospace
_Filosofia

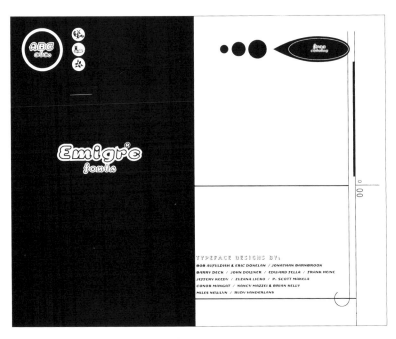

Catalogue, sixty-four pages in black and white
spring 1995
23 x 28 cm

Design: Emigre with Gail Swanlund
Type design: Zuzana Licko _Dogma Outline

→

Poster, summer 1995

Design: Rudy Vanderlans
Type design: Zuzana Licko _Modula Remix

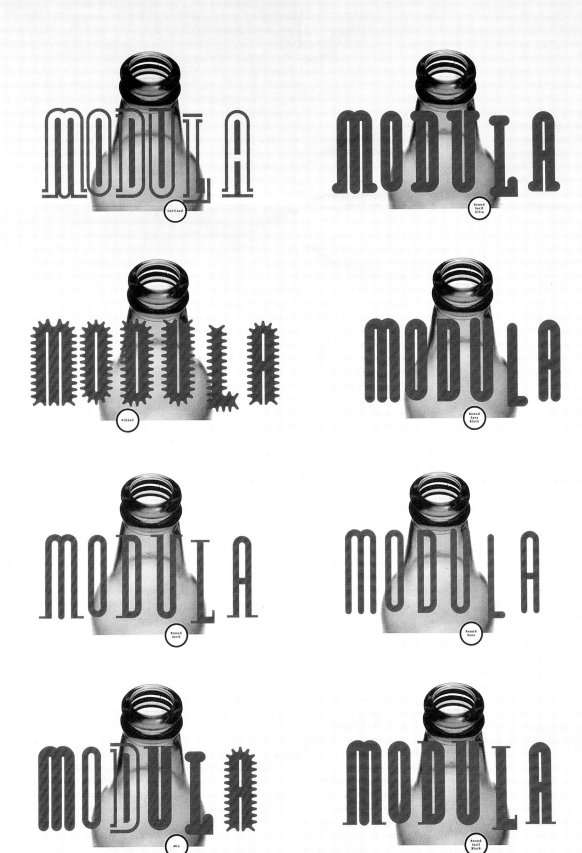

Extended Remix

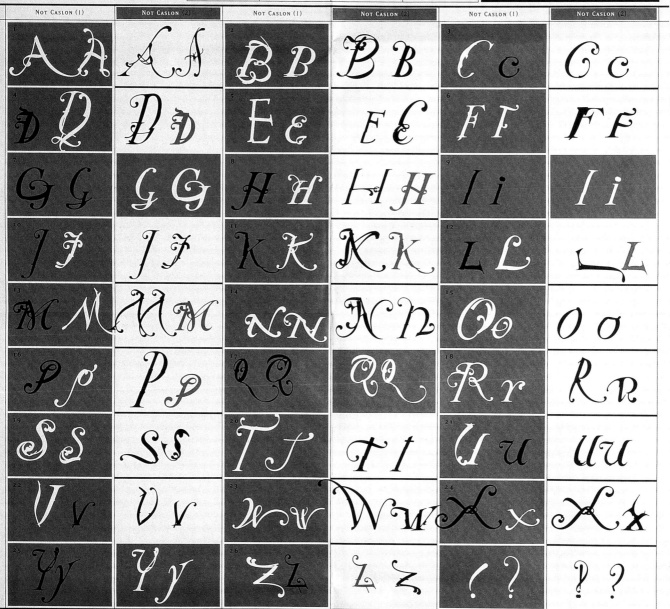

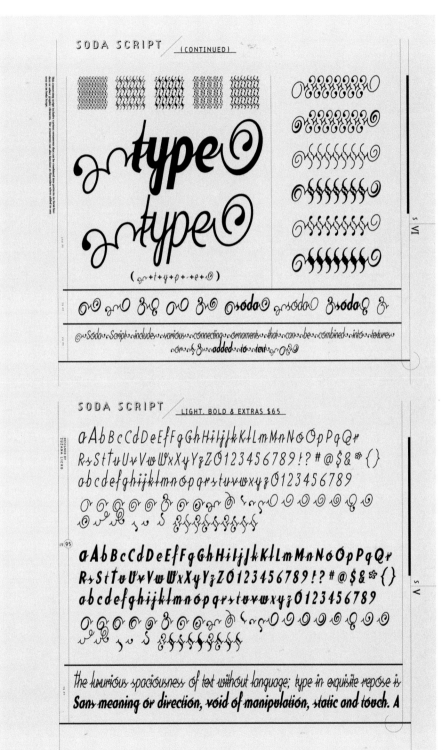

Page from the Emigre
font catalogue, 1995
23 x 28 cm

Design: Emigre with
Gail Swanlund
Type design: Zuzana Licko _Soda Script

←
Poster, 1995
83 x 47 cm

Design: Rudy Vanderlans
Type design: Mark Andresen _Not Caslon

Base-12 / *Base-9*

A series of font families for use in print and multimedia environments, with mutually compatible screen and printer fonts. Available exclusively from Emigre Fonts.

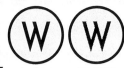

For Print And Screen

BaseTwelve Sans

Regular · *Italic* · **Bold** · ***Bold Italic***

BaseTwelve Sans Small Caps Regular *Italic* **Bold** ***Bold Italic***

Outline — It is ironic that for years, pioneers of emerging computer technologies have been slighting the validity of bitmaps, judging them to be merely **temporary solutions** to a display problem that *would soon be fixed by the introduction of high definition TV*

Bitmap — It is ironic that for years, pioneers of emerging computer technologies have been slighting the validity of bitmaps, judging them to be merely **temporary solutions** to a display problem that *would soon be fixed by the introduction of high definition TV*

BaseTwelve Serif

Regular · *Italic* · **Bold** · ***Bold Italic***

BaseTwelve Serif Small Caps Regular *Italic* **Bold** ***Bold Italic***

Outline — It is ironic that for years, pioneers of emerging computer technologies have been slighting the validity of bitmaps, judging them to be merely **temporary solutions** to a display problem that *would soon be*

Bitmap — It is ironic that for years, pioneers of emerging computer technologies have been slighting the validity of bitmaps, judging them to be merely **temporary solutions** to a display problem that *would soon be*

BaseNine

Regular · *Italic* · **Bold** · ***Bold Italic***

BaseNine Small Caps Regular *Italic* **Bold** ***Bold Italic***

Outline — It is ironic that for years, pioneers of emerging computer technologies have been slighting the validity of bitmaps, judging them to be merely **temporary solutions** to a display problem that *would soon be fixed by the introduction of high definition TV and*

Bitmap — It is ironic that for years, pioneers of emerging computer technologies have been slighting the validity of bitmaps, judging them to be merely **temporary solutions** to a display problem that *would soon be fixed by the introduction of high definition TV and*

BASE 12/9

[EMIGRE FONTS] Emigre designed exclusively for use in the magazine currently available to Macintosh and PC users includes designs by Mark Andresen (USA)...

(1) Detail of opening page from Emigre's electronic catalog on the World Wide Web. The display headlines are composed with a hand-edited 24 point bitmap font that later became a companion font to Base-12 Sans.

(2) Top: a line of type set in a 12 point Helvetica edited screen font with the intended spacing (without using fractional widths). Middle: the same line of type set in the same edited screen font using fractional widths. This method produces a line that matches more accurately the printer output below, but this is detrimental to the legibility of the screen font. Bottom: the same line of type printed out on a high resolution printer.

(3)
10 point Times Roman: Typefaces are not intrinsically legible, rather it is the reader's familiarity with

12 point Times Roman: Typefaces are not intrinsically legible, rather it is the reader's

10 point Times Roman: Typefaces are not intrinsically legible, rather it is the reader's familiarity with

12 point Times Roman: Typefaces are not intrinsically legible, rather it is the reader's

Top: 10 and 12 point screen font of Times Roman. Bottom: 10 and 12 point high resolution printout of Times Roman. The 10 point high resolution printout is at least as easy to read as the 12 point screen font.

(4) BaseTwelve · BaseNine · BaseTwelve · BaseNine

Top: 12 point screen font from Base-12 enlarged 5 times to 56 point. Bottom: 36 point high-resolution printout from Base-12.

Top: 9 point screen font from Base-9 enlarged 4 times to 36 point. Bottom: 36 point high-resolution printout from Base-9.

(5) In this illustration, the dimensions of the circle are harmonized with its corresponding bitmap. In a screen font, shapes of the outline font are approximated by crude building blocks on a grid. The two are best married when the shapes and parameters of the outline font work with the limited possibilities of the bitmap.

(6)
Text
Style ▶
✓ Plain
Bold
Italic
Underline
Outline
Shadow

9 point
10
✓ 12
14
18
24

For ease of use, the Base-12 and Base-9 fonts have been merged into style families.* Therefore, the italic, bold and bold italic faces are accessed through the "style" menu rather than being selected individually from the "fonts" menu. For best screen display, only the edited sizes should be used. The edited sizes are* highlighted (outlined) in the menu.
* At the time of this writing, the edited screenfonts and style features are available for the Macintosh operating system. Support for other platforms, such as Windows, may be available in the future.

Introduction

Having designed Emigre's "Raw Serving" bulletin board environment and, more recently, the electronic "Emigre Catalog" on the Web, we were reminded that the need persists for a comprehensive family of screen fonts with companion printer fonts. We're responding to this need with three families; two families based on 12 point screen fonts (one serif and one sans serif family) named Base-12, and one family based on 9 point screen fonts named Base-9, consisting of a total of 24 individual faces. In fact, the basic concept for the Base-12 family started with the 24 and 36 point screen fonts that I designed for use in the Emigre Web site. [Illustration #1]

To a great degree, in the design process of these faces, the screen fonts dictated the look of the printer fonts, rather than the other way around, because outline fonts have a greater degree of flexibility than do screen fonts. For example, the design of the screen font set the exact character widths within which the outline characters were adjusted to fit. Usually this process is reversed; character widths are normally adjusted to fit around the outline characters.

The Design Problem

The greatest challenge in harmonizing the legibility of screen fonts with printer fonts is that of spacing. Although some existing printer fonts have companion screen fonts that are quite legible on screen, they tend to have two shortcomings. The first problem is that traditional screen fonts are adjusted to fit the shapes and widths of the printer fonts, and therefore have some inherent spacing and character shape problems, since the printer font inevitably forces unnatural widths or shapes on the screen fonts. The other problem is that of spacing inconsistencies on text sizes due to fractional widths. In traditional fonts, the width of a phrase character is a rounded off measurement, calculated from the corresponding outline character. For example, an outline character with a cell width of 620 at an em-square of 1,000 will be rounded to 6 pixels in a 10 point screen font. The information about the remaining 2/10 of a pixel is stored in the fractional width table. When lines of text are composed, many programs (such as page layout programs) match the screen font line length to the printer font line length by calculating the cumulative effect of the character width fractions. For example, if a 10 point line of type was composed of 10 characters, each having a remaining 2/10 of a pixel, as in the example above, then the line of type would need to be increased by 1 pixel in order to match the printer output. As a result, an extra pixel of space would be inserted between two of the characters, thereby causing uneven spacing. In this manner, some characters may be moved a pixel to the left or right, thus avoiding the spacing intentions of the hand-edited bitmap font. [Illustration #2]

The Solution

Rather than deriving the screen font from the printer font, I decided to derive the printer font from the screen font. The first step, therefore, was choosing the most appropriate screen font point size. For various reasons, the 12 point size proved to be the most useful. 12 point is the default size for most applications and Web browsers, and 12 point is clearly scaled to many of the standard sizes to which some applications are limited, namely 14 and 36. Later on in the development process, I added a family based on the 9 point bitmap to facilitate the other popular sizes, 9 and 18.

The popularity of the 12 point screen font is also due to the relatively coarse screen resolution of computer screens, which cause the perceived font size on screen to be smaller than the corresponding high resolution printout. On the screen, 12 point is comfortable to read, 18 point is still readable, 9 point becomes difficult for extensive text and 8 point is difficult to read. In point, however, the comfort level of reading the various sizes shifts down by at least 2 point sizes. [Illustration #3]

To clarify the measurement of typefaces, I should explain here that each point size is generated by scaling the font Em-square. The Em-square is the vertical measurement of the body around the font (top to bottom). The Em-square needs to accommodate some breathing room for accents, descenders, and other protruding elements, and therefore the point size does not relate specifically to any part of the typeface's anatomy. That is, a 12 point size measures 12 points from the top to the bottom of the Em-square, and the actual dimensions of the x-height or cap-height will vary between typeface designs.

That's the physical measurement of the typeface. However, there are various factors that may make a typeface appear larger or smaller within the same physically measurable point size. For example, a large x-height or a wide character with makes a typeface appear larger than a design with a smaller x-height or narrow character width. Since most of the text we read is lower case, the x-height is the most influential element in the perceived size of the typeface. The larger the inside shapes of the x-height (also called "counters"), the larger the face will appear. Therefore, when relating this perceived point size to screen fonts, it needs to be specified that a 12 point screen font is generally one with a 6 pixel x-height, which is the pixel size that I used for the Base-12 family.

The next challenge was that of making the proportions of the screen font and printer font the same. In order to modularly relate the screen font to the printer font, I made the Em-square of the scalable printer font divisible by 12. I chose an Em-square of 1,200 units, thereby making each pixel equal to exactly 100 units in the printer font. This solved the fractional-width problem described earlier.

Since the widths of the printer font had to exactly match those of the 12 point screen font, the process was similar to that of designing a monospaced typeface in that the printer font character outlines had to be adjusted to fit into predefined character cells. Like the size of the Em-square, the size of the character space includes the space around the character; not the measurement of the character itself. The character cell width is the horizontal measurement around a character, including breathing space left to right. The breathing space of one character, when added to the breathing space of the adjacent character, creates the space between those particular two letters. If this is done correctly, words will look recognizable and the typeface will be legible. In most typefaces, this breathing room between characters is further improved by adding kerning pairs between problematic pairs. In the case of the Base-9 and Base-12 typefaces, however, kerning pairs would have destroyed the modularity of the spacing, and so the spacing had to be optimized solely by adjusting the characters shapes.

After resolving the measurement and spacing issues, the design of the printer font could take various departures from that of the screen font. Since the printer font design functions separately from the screen font design, the details of the characters themselves need not exactly follow the structure of the screen fonts; the printer font design need only echo the implied shapes of the screen font. A circle can be implied with as few as 6x6 pixels, [Illustration #4] other shapes may be similarly derived. Since there is room for much interpretation at this point, the Base-9 and Base-12 typefaces are merely one design solution; other interpretations may yet to come.

Intended Usage

When using the Base-9 and Base-12 fonts in situations where character display and spacing on the screen are of primary importance, such as on multi-media, these fonts should be used at point sizes which are multiples of their "Base." [Illustration #5] For example, Base-12 is best used at 12 point, 24 point and above. Base-9 is best used at 9 point, 18 point and above. (carefully hand-edited screen fonts are provided at these sizes for the best possible screen display. Of course, any other point sizes may be used as with any other PostScript or TrueType outline fonts when print is the final product. ATM and TrueType rasterizers will generate acceptable screen fonts at sizes other than the hand-edited ones mentioned above, but such automatically generated screen fonts are not recommended for use where screen display is primary.

When creating on-screen graphics, there is a temptation to use anti-aliased displays of typefaces to make them consistent with the smoothness of full color images. In fact, anti-aliased versions of fonts can be generated by some programs, such as Adobe Photoshop. However, just like standard un-edited screen fonts, these anti-aliased screen fonts will be plagued with distracting irregularities unless they are hand-edited. Therefore we do not recommend using automatically generated anti-aliased screen fonts below 18 point.

The Future of Bitmaps

When I designed my first bitmaps in 1984 for the Macintosh computer (the Emperor, Emigre, Oakland and Universal families), bitmap fonts were the only fonts available for the Macintosh. My intent was therefore to create a series of legible fonts for the computer screen and dot matrix printer. After the introduction of laser printer technology and high resolution outline fonts, I imagined that these bitmaps would be relegated to the status of novelty fonts, as they were in fact for several years. But with the current interest in multimedia CDs, electronic bulletin boards and the World Wide Web, on-screen design has gained importance. In re-evaluating the necessity of screen fonts, I was able to make use of the many lessons that I had learned from my early bitmap experiments.

It is ironic that for years, pioneers of emerging computer technologies have been slighting the validity of bitmaps, judging them to be merely temporary solutions to a display problem that would be fixed by the introduction of high definition TV and computer monitors. Well, a decade later, we're still waiting. It has become obvious that even if such advancements are eventually made, because the user base of today's technology is so huge, we will still be addressing coarse resolution needs for a long time to come. This is especially significant since there is a lot of talk today about the forthcoming multi-media style interactive TV programming, enabling users to view such sources on CD-rom programming or the World Wide Web directly on their existing TV sets. If this happens, then the U.S. TV monitor (even coarser in resolution than most computer monitors) will be our next challenge.

—Zuzana Licko—

Definitions:

Anti-aliased font (also called the "grey scale font"): A bitmap font that uses grey scale or color pixels to blur the stair step pixels and thus creates a smoother, yet "out of focus" appearance. The use of anti-aliased fonts is restricted to computer monitors that support color or multiple levels of grey.

Bitmap font (also called the "screen font," or "resolution-dependent font"): A bitmap is, literally, the "map of bits" on a grid where the smallest increment is a bit.

Cap-height: The vertical measurement of the capital letters. The specific size of the cap-height is determined by its ratio to the font's Em-square when a particular point size is generated.

Em-square: The vertical measurement of the body of a typeface that accommodates all of the font's elements. In a digital font, the Em-square also has a resolution, which is usually close to 1,000 units.

Outline font (also called the "printer font," or "scalable font"): The resolution-independent description of a typeface which is rasterized into a particular size when it is printed to a high resolution printer, such as a laser printer or film setter. Outline fonts can also be rasterized into screen fonts if edited screen fonts do not exist by using Adobe Type Manager (for PostScript fonts) or the TrueType rasterizer built into many operating systems (for TrueType fonts). However, these generated screen fonts are not as legible as edited fonts, especially at small sizes.

Pixel: The smallest increment on a grid used to construct a bitmap.

Printer font (also called the "outline font"): The font that is used by the printer to generate high resolution output on paper, film, or other media.

Rasterizer: An interpreter that translates an outline font into a bitmap font of a particular resolution.

Screen font (also called the "bitmap font"): The font that is displayed on a computer's monitor. The most legible screen fonts are those that have been hand-edited.

X-height: The vertical measurement of the lower-case letters, excluding ascenders and descenders (usually equal to the height of the lower case "x"). The specific size of the x-height is determined by its ratio to the font's Em-square when a particular point size is generated.

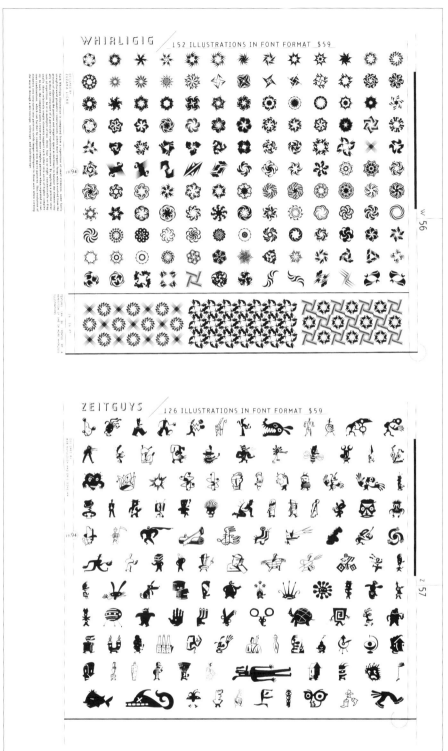

Page from the Emigre
font catalogue, 1995
23 x 28 cm

Design: Emigre with
Gail Swanlund
Type design: Zuzana Licko _Whirligig

Bob Aufuldish, Eric Donelan _Zeitguys

←
Poster, 1996
83 x 47 cm

Design: Rudy Vanderlans
Type design: Zuzana Licko _Base Twelve

_Base Nine

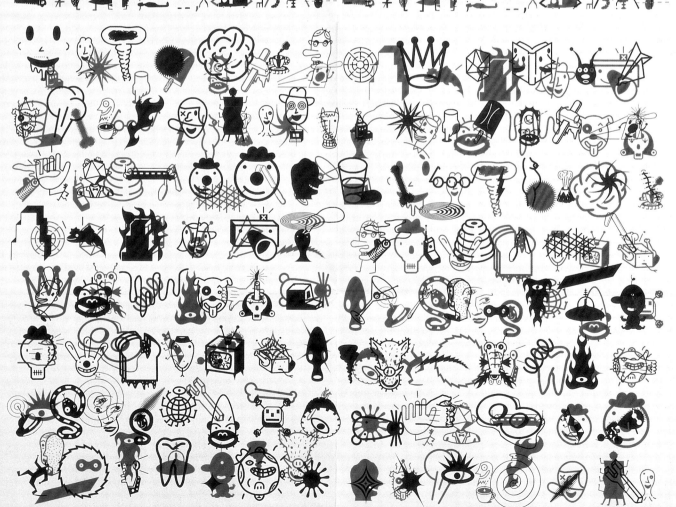

John Hersey's Thingbat and Blockhead Fonts. Available exclusively from Emigre Fonts.

DOGMA / BOLD. SCRIPT & BLACK $95

aAbBcCdDeEfFgGhHiIjJkKlLmMnNoO
pPqQrRʌStTuUvVwWxXyYzZ01234567 8
90123456789!?#@$&❀

aAbBcCdDeEfFgGhHiIjJkKlLm
MnNoOpPqQrRʌStTuUvVwWxXyY
zZ0123456789 0123456789!?#@$&❀

aAbBcCdDeEfFgGhHiIjJkKlLmM
nNoOpPqQrRʌStTuUvVwWxXyYzZ
0123456789 0123456789!?#@$&❀

The luxurious spaciousness of te
Without language; type in exq
Repose sans meaning or dir
OR DIRECTION

DOGMA OUTLINE / OUTLINE & EXTRA OUTLINE $59

aAbBcCdDeEfFgGhHiIjJkKlL
mMnNoOpPqQrRʌStTuUvVwWx
XyYzZ0123456789

aAbBcCdDeEfFgGhHiIjJkK
lLmMnNoOpPqQrRʌStTuUvV
wWxXyYzZ0123456789012345
6789!?#@$&❀

Page from the Emigre
font catalogue, 1995
23 x 28 cm

Design: Emigre with
Gail Swanlund
Type design: Zuzana Licko _Dogma, Dogma Outline

←
Poster, 1995
83 x 47 cm

Design: Rudy Vanderlans
Type design: John Hersey _Blockhead
_Thingbat

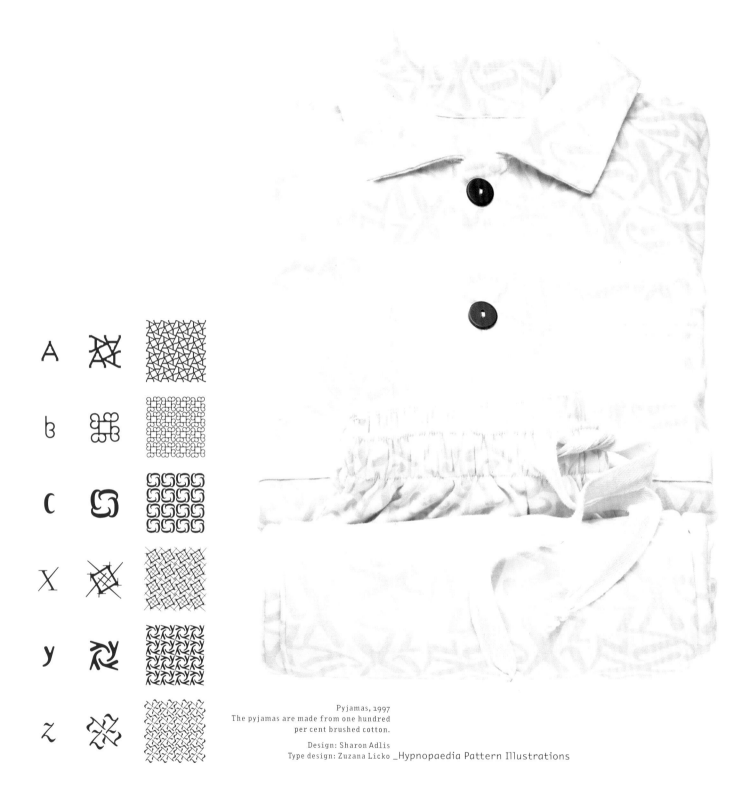

Pyjamas, 1997
The pyjamas are made from one hundred
per cent brushed cotton.

Design: Sharon Adlis
Type design: Zuzana Licko _Hypnopaedia Pattern Illustrations

Illustrations from the
Hypnopaedia booklet, 1997
By rotating the letter forms
of different fonts,
individual patterns were created.

Type design: Zuzana Licko _Hypnopaedia Pattern Illustrations

Hypnopaedia booklet, 1997
32 pages
13.5 x 21 cm
Containing 140 patterns
in full colour.

Design: Rudy Vanderlans
Type design: Zuzana Licko _Hypnopaedia Pattern Illustrations

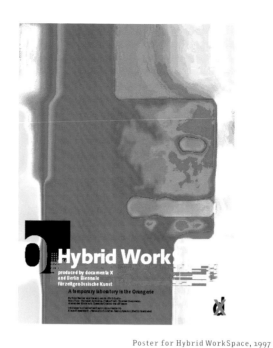

Poster for Hybrid WorkSpace, 1997
Art project at documenta X, Kassel
42 x 59.4 cm
Design: czyk

Face2Face

Location Berlin and Frankfurt, Germany
Established 1993
Founders xplicit ffm, Moniteurs
Type designers Alexander Branczyk, Stefan Hauser
Alessio Leonardi, Thomas Nagel
Heike Nehl, Sibylle Schlaich
Distributors Face2Face, FontShop International (FSI)
Verlag Hermann Schmidt Mainz

Open your font!

Collaborating on anarchistic typography,
font drafting and rejection,
publication of the F2F magazine
and difficult to classify performances.

_Publishing Projects
1994_F2F 1 The Hirsch Issue
1995_F2F 2 The Virtual Issue
1995_F2F 3 LoveBangLove
1996_F2F 4 Alphabeat
1998_F2F 5 Der Typografische Spielfilm

_Art Projects, Performances
1995_The Screen Scream (Fuse 95 Berlin)
1996_Attitudes for the next millennium
(Int. Design Conference, Aspen/USA)
_Type vs. Typo vs. Text (Typo96 Berlin)
1997_Hybrid WorkSpace (documenta X)
_Der Typografische Spielfilm
(The Mind Lounge, Berlin)
_Millennium Countdown
(mind S21 initiation, Stuttgart)
1998_Radio Dazed
(Deutscher Hörfunkpreis, Stuttgart)
_typemotion (typo[media], Frankfurt)
_energija, Münster

_Exhibitions
1994_Flyer Art (Chromapark Berlin)
1995_Frontpage (Chromapark Berlin)
1996_Type//Face (Chromapark Berlin)
_EWerk Medialounge (RedBox Berlin)
1998_Behind the Wall
(mind S21 presentation, Stuttgart)

Websites

www.xplicit.de/f2f
www.xplicit.de
www.moniteurs.de
www.leowol.de

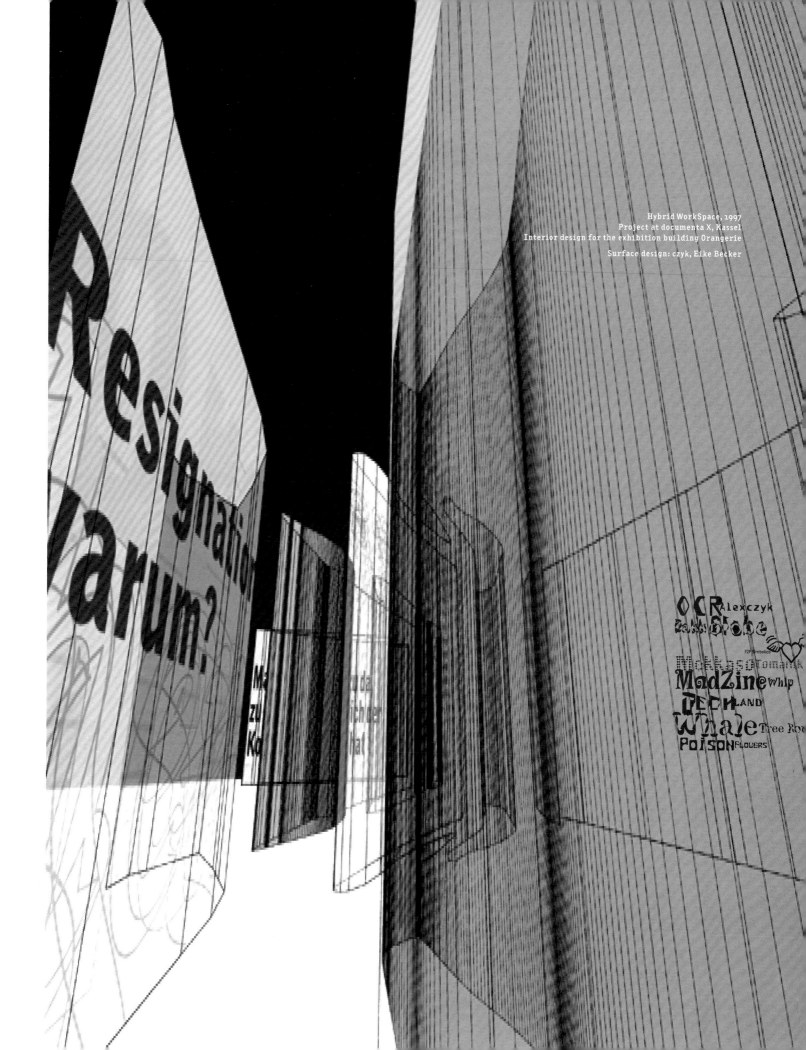

Hybrid WorkSpace, 1997
Project at documenta X, Kassel
Interior design for the exhibition building Orangerie
Surface design: czyk, Eike Becker

F2F 3 LoveBangLove, 1995
32 x 32 cm

Poster design: czyk, Alessio Leonardi
Packaging design: Thomas Nagel
Scarf: Heike Nehl
Type design: czyk _Madzine-Dirt
_OCR-AlexczykShake
Thomas Nagel _Madame-Butterfly
_Shpeetz
_Tyrell-Corp
Heike Nehl _Lego-Stoned
_Twins
Alessio Leonardi _AlRetto

90

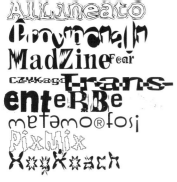

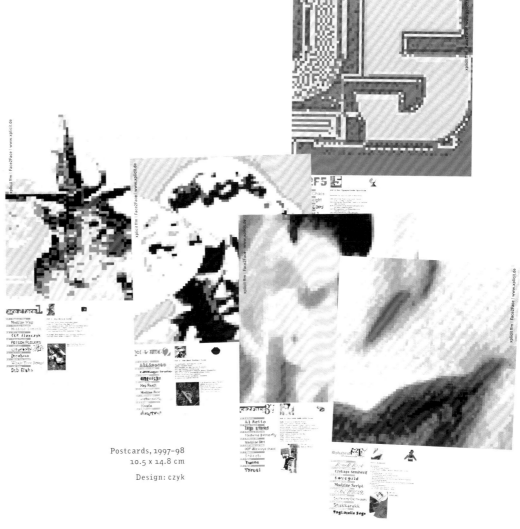

Postcards, 1997–98
10.5 x 14.8 cm

Design: czyk

Performances, 1995–98
70 x 100 cm

Poster design: czyk

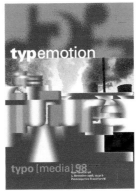
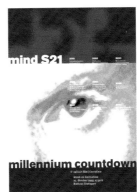
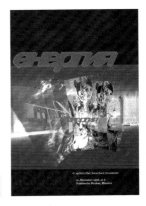

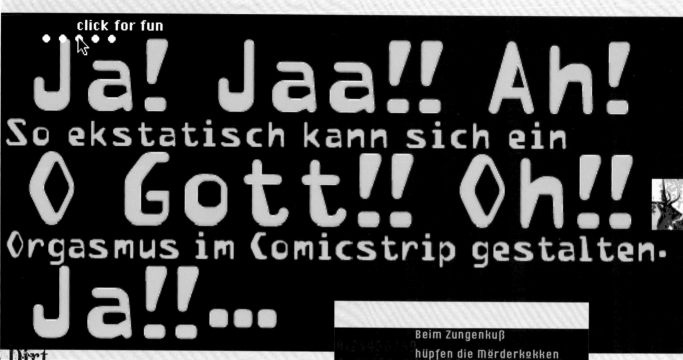

click for fun

Ja! Jaa!! Ah!
So ekstatisch kann sich ein
O Gott!! Oh!!
Orgasmus im Comicstrip gestalten.
Ja!!...

Madzine Dirt
the Butterfly
Al Retlo
Tyrett
Twins
Lego stoned

F2F 5 Der Typografische Spielfilm, 1998
Screenshots from the CD-ROM

Beim Zungenkuß
hüpfen die Mörderkokken
von Mund zu Mund.

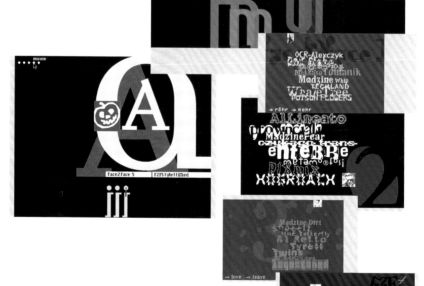

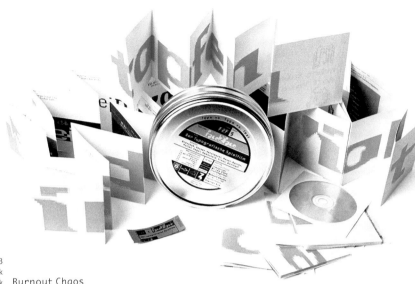

F2F 5 Der Typografische Spielfilm, 1998
Packaging and booklet design: czyk
Type design: czyk _Burnout Chaos

_Czykago Light

_Frontpage Four

_Monako Stoned

Thomas Nagel _El Dee Cons

Heike Nehl _Starter Kid

Alessio Leonardi _Mekanik Amente

Stefan Hauser _Haakonsen

Sibylle Schlaich _Styletti Medium

Font films directed by:
Alexander Branczyk
Stefan Hauser
Andrea Herstowski
Torsten Meyer-Bautor
Annette Müller
Thomas Nagel
Markus Remscheid
Diana Simon
Annette Wüsthoff

Soundtracks by:
Jammin'Unit
Gerard Deluxxe
Glory B.
General Magic
Fact
Interrupt
Akustik Shift

Lyrics compiled by:
czyk & elNag

Special Effects Engineering:
Peter Schmidt

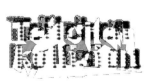

F2F 5 Der Typografische Spielfilm, 1998
Pages from the 12-metre-long leporello
Design: czyk

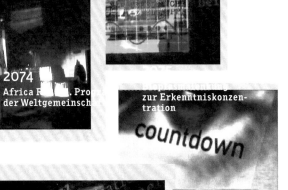

HÖRFUNKPREIS 1998

Radio
countdown
Dazed

2063
80% Heimarbeitsplätze
in den zivilisierten
Staaten

2064
Reanimierung
prähistorischer Tiere
aus Restgenen

2065
Hawaii nach Vulkanaus-
bruch auf Größe von
England gewachsen

2068
Climatech
ermöglicht steuerbares

2069
Große Welt-Religionsre-
form

2070
Gaia II:
Parallelwelt in
erdnaher Umlaufbahn

2073
SETI: Erster Kontakt
mit außerirdischer
Zivilisation über Ultra-
bandwellen

2074
Africa Renata. Prog.
der Weltgemeinsch.

zur Erkenntniskonzen-
tration

countdown

2079
Energiegewinnung
durch Weisse Löcher
theoretisch möglich

2080
Wüsten-Rekultivierung-
programm abgeschlos-
sen

2084
Avatare erwirtsch.
2/3 des Welt-Brutto-
alprodukes

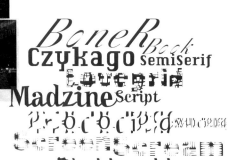

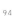

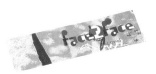

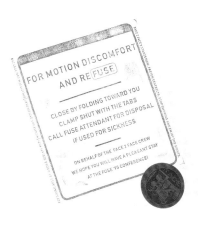

FOR MOTION DISCOMFORT
AND reFUSE

CLOSE BY FOLDING TOWARD YOU
CLAMP SHUT WITH THE TABS
CALL FUSE ATTENDANT FOR DISPOSAL
IF USED FOR SICKNESS

ON BEHALF OF THE FACE 2 FACE CREW
WE HOPE YOU WILL HAVE A PLEASANT STAY
AT THE FUSE '95 CONFERENCE!

→
Performance, 1998
Radio Dazed
70 x 100 cm

Poster design | Type design: czyk _BellczykMonoMed
_MittelczykHole

Face2Face
Performance
RadioDazed
Stuttgart, April 1998

F2F Koetzetuete, 1995
Screen performance
For motion, discomfort and reFUSE
13 x 24 cm

Packaging design: Thomas Nagel
Movie director: Stefan Hauser
Folder design: Alessio Leonardi

BoneR Book
Czykago SemiSerif
Lovegrid
Madzine Script
Procopica
Shakkarakk
Tagliatelle

radiodazed

Bntati

3 Objekte, 251 KB frei

PC PC

~WRDU... RealPlayer: ... aus dem ...ther

▶ / ❚❚

Ne...

Tit... ...Tech

...e : ...e aus de...

...Author : ...isLive (L...

RealPlayer: Live aus d...n fther real

▶ / ❚❚

Mono 01:11.0...

Playing 16.0...ps live stream

F2...5inLegRneu.eps Gestern, 15:32 U...
F2F5-Book...Rneu!! Gestern, 15:21 Uhr
▷ Radio-Perf weitere Mon, 23. Mär 1998, 16
▷ WWW-modif Die, 3. Mär 1998, 21:2...
▷ F2F 5 -> EMAF Don, 26. Feb 1998, 14:40 Uhr
T-Shirt Shiw-01 Fre, 6. Feb 1998, 13:30 Uhr
CD-Nummern.02 Don, 5. Feb 1998, 14:06 Uhr

E-Mail

© VDR 1998
Stand: 26.3.98

F2FBurnoutChaos
F2FCzykagoLight
F2FElDeeCons
F2FFrontpageFour
F2FHaakonsen
F2FMekanikAmente
F2FMonakoStoned
F2FStylettiMedium
F2FSporterKid

Burnout Chaos
Czykago Light
El Dee Cons
Frontpage Four
Mekanik Amente
Monako Stoned
Styletti Medium

Money film
Typonetic Performance at Typo 98 Berlin
9 x 15 cm

Banknote design: Heike Nehl

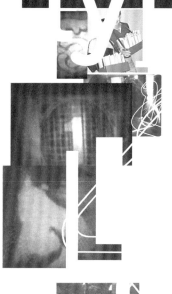

F2F 4 Alphabeat, 1996
16 x 22 cm
poster: 42 x 59.4 cm

Packaging design: Thomas Nagel
Poster design: Heike Nehl, Alessio Leonardi
Type design: czyk _Czykago-SemiSerif
_Madzine-Script
Stefan Hauser _F2FBoneR-Book
Thomas Nagel _Screen-Scream
_Shakkarakk
Heike Nehl _Lovegrid
Alessio Leonardi _Prototipa-Multipla
_Tagliatelle-Sugo

Face2Face Performance
Energija
Münster, November 1998

MoniMoney
Typonetic Performance at Typo 98 Berlin
9 x 15 cm

Banknote design: Heike Nehl

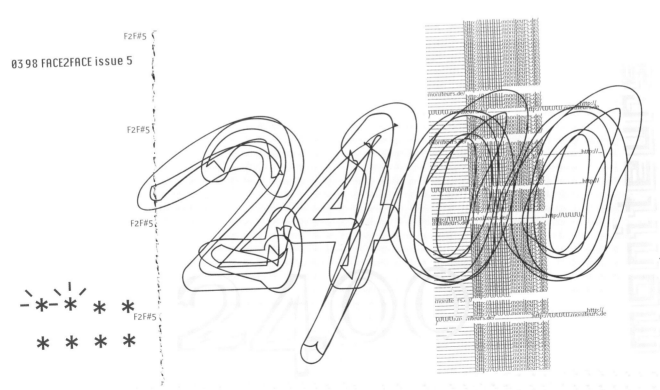

03 98 FACE2FACE issue 5

F2F#5

F2F#5

F2F#5

F2F#5

F2F Datenbank

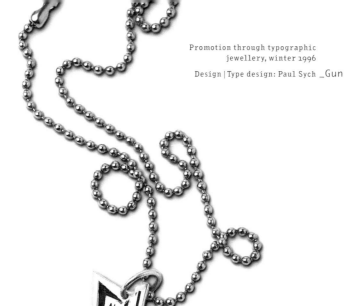

Faith

Location_Toronto, Canada

Established_1990

Founder | Type designer_Paul Sych

Distributors_Thirstype, FontShop
International (FSI)

The work of Paul Sych is testimony to the
parallels between music and art. Sych's basic
training was acquired at Ontario College of
Art (OCA) in Toronto. Due to his interest in
jazz, he also enrolled in the Jazz Studies Pro-
gramme at York University. After completing
his studies, he performed at numerous jazz
establishments as leader of his own trio
ensemble, exploring the art of improvization.
His design firm Faith began operating in the
autumn of 1990 and is introducing a line of
retail products including jewellery, sweaters,
watches and T-shirts.

Flower Power postcard, spring 1996
Design | Type design: Paul Sych _Wit

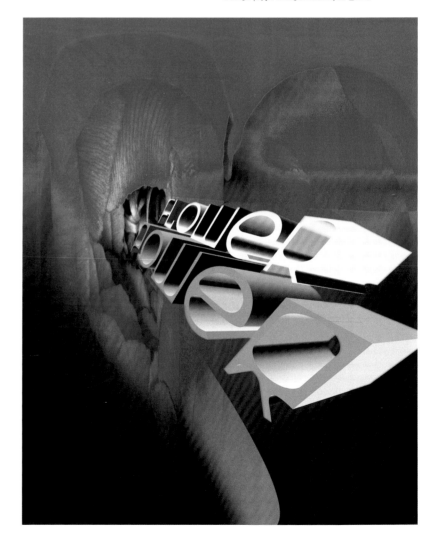

→
Unpublished experimental work
called 'What If?'
spring 1997
Design | Type design: Paul Sych _Fix

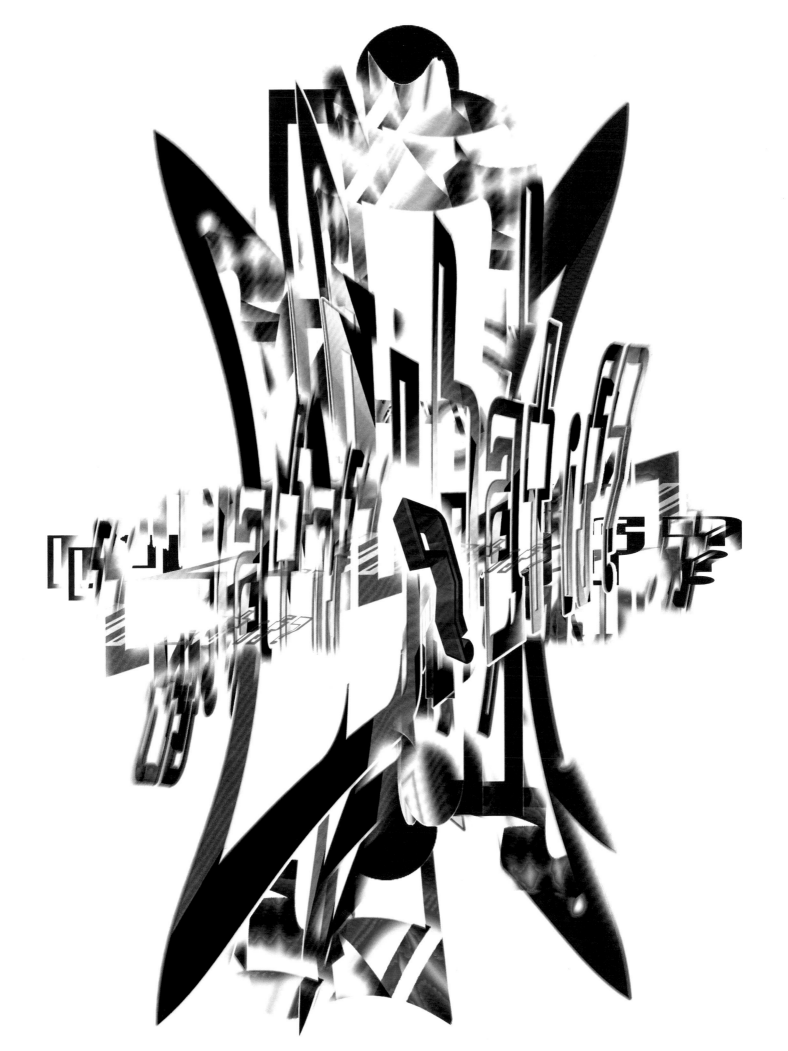

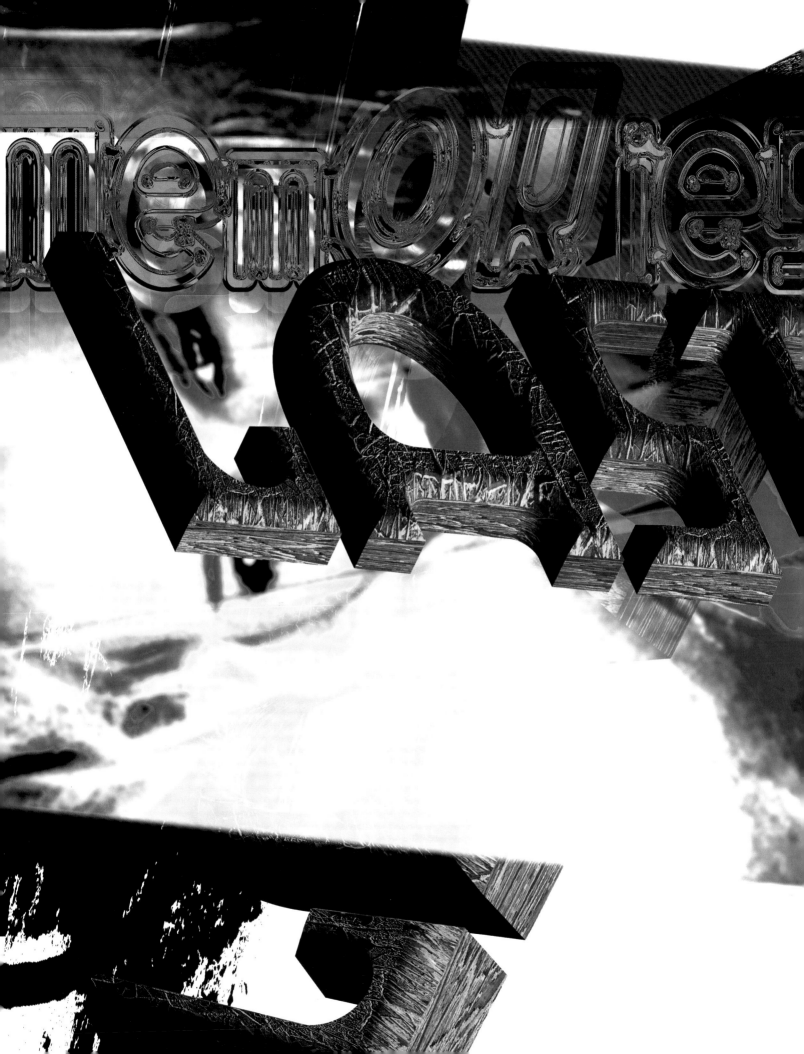

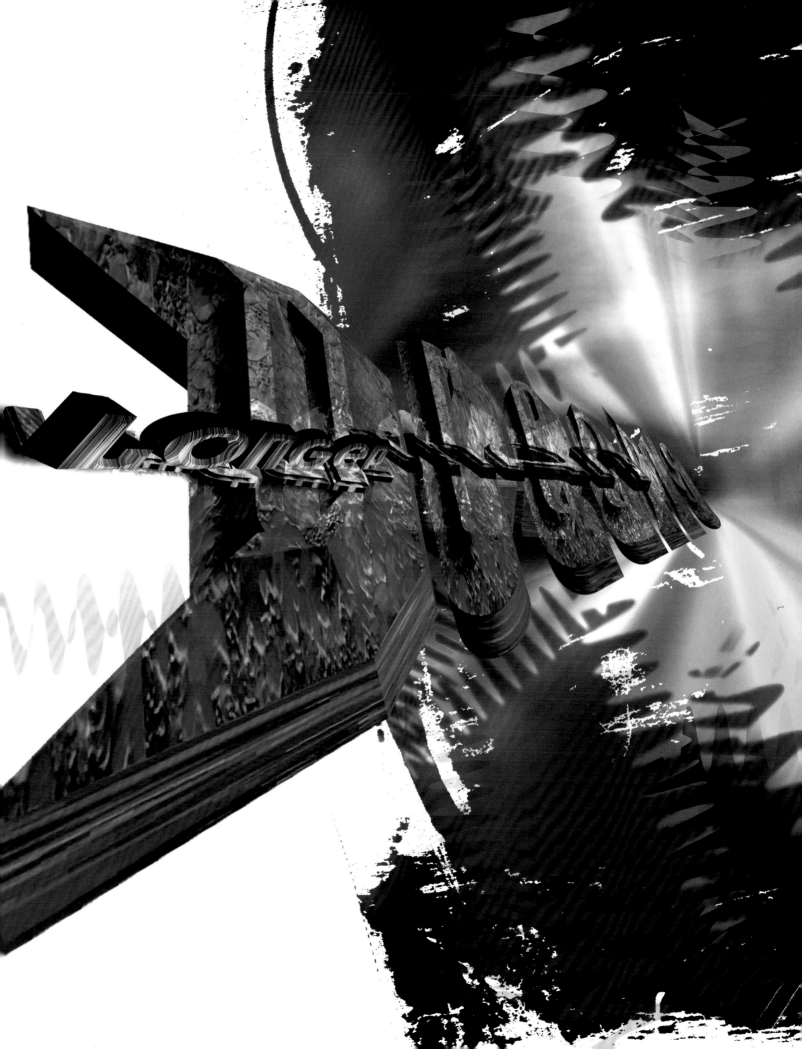

fontBoy

Location_San Anselmo, California, USA

Established_1994

Founder_Bob Aufuldish

Type designers_Kathy Warinner, Bob Aufuldish

Distributor_www.fontBoy.com

Baroque modernism for the new millennium

fontBoy is a product of the vision and explorations of Bob Aufuldish and his partner Kathy Warinner. The foundry has released fonts ranging from the handmade and quirky to the geometrically precise.

A series of dingbat fonts was released between 1995 and 1997; the group now contains 360 dingbats that are all interchangeable and aesthetically interrelated. The current direction of their work incorporates more classical elements into the fonts, using process-oriented techniques to defy the designer's expectations. In addition to fontBoy, the partners run the design office of Aufuldish & Warinner.

fontBoy interactive catalogue, 1995
The catalogue allows the viewer to see samples of fonts, print out bitmapped samples, request information and find out about future releases, all within a warm fuzzy environment of goofy colours, witty words and funny sounds.

Design: Bob Aufuldish
Writer: Mark Bartlett
Sound designers: Scott Pickering
Bob Aufuldish

Screen from the fontBoy
interactive catalogue, 1995

Design: Bob Aufuldish
Type design: Kathy Warinner
Bob Aufuldish _Viscosity

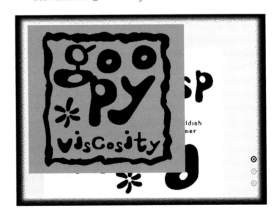

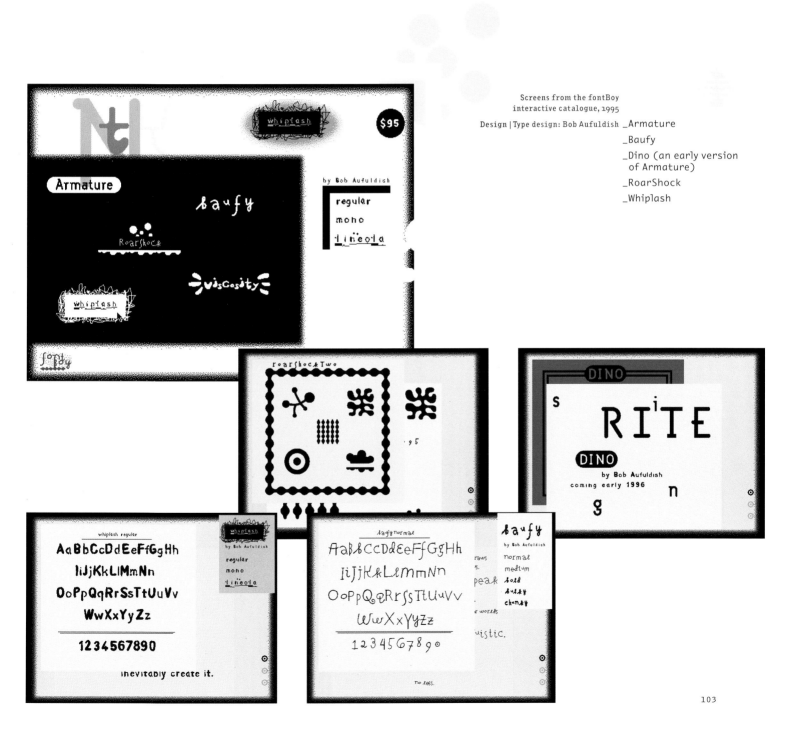

Screens from the fontBoy
interactive catalogue, 1995

Design | Type design: Bob Aufuldish _Armature
_Baufy
_Dino (an early version
of Armature)
_RoarShock
_Whiplash

fontBoy screen saver
The screen saver uses quotes from Mark Bartlett's essay, 'Beyond the Margins of the Page', juxtaposed with a soundtrack of snoring. The screen saver randomly connects ten quotes with ten typefaces and places the quote on the screen. The quotes flash too quickly to read at first glance, but over time, as the same quotes appear again and again, they begin to acquire a certain sense.

Photographer | Design |
Sound design: Bob Aufuldish
Writer: Mark Bartlett
Coding | Programming: David Karam
Dave Granvold

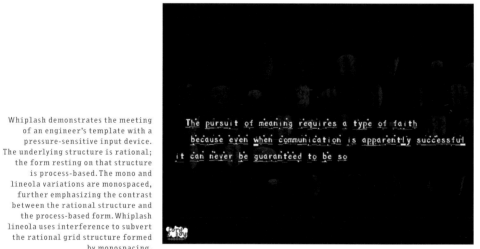

RoarShock one and two are the first two fonts in a series of dingbats/ border/pattern fonts. Traditionally, fonts have had decorative material designed specifically for them; Roar-Shock is contemporary decorative material that relates to the fontBoy aesthetic. The name RoarShock is used to suggest that it is possible to interpret the apparently abstract characters.

Type design: Bob Aufuldish, 1995–97 _RoarShock

Whiplash demonstrates the meeting of an engineer's template with a pressure-sensitive input device. The underlying structure is rational; the form resting on that structure is process-based. The mono and lineola variations are monospaced, further emphasizing the contrast between the rational structure and the process-based form. Whiplash lineola uses interference to subvert the rational grid structure formed by monospacing.

The pursuit of meaning requires a type of faith because even when communication is apparently successful it can never be guaranteed to be so

Type design: Bob Aufuldish, 1994 _Whiplash

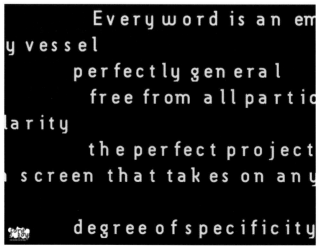

Every word is an empty vessel
perfectly general
free from all particularity
the perfect project
screen that takes on any
degree of specificity

Armature is the result of an interest in typefaces that are constructed, rather than drawn. Although it is basically a monoline design, there are subtle details that compensate for a monoline's evenness. As with all fontBoy fonts, there are dingbats hidden away in the dark recesses of the keyboard. When first designed in 1992, it was called Dino so the dingbats for Armature are dinosaurs.

Type design: Bob Aufuldish _Armature

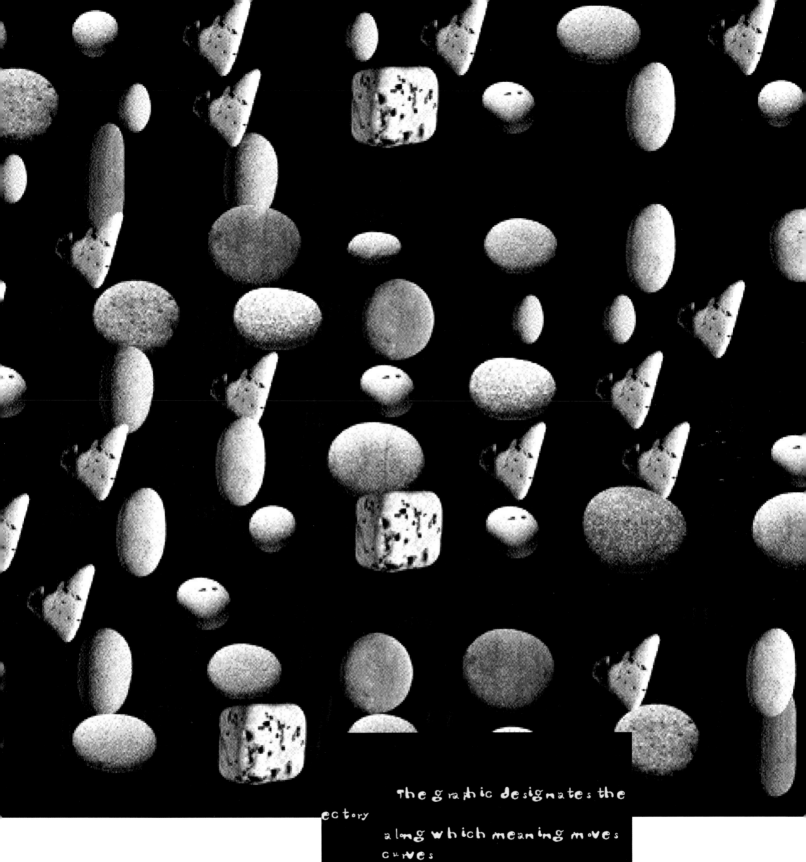

The Viscosity font asks the question, 'Can a typeface be designed without the repetition of any individual part, and still be visually unified?' The two designers – one of whom drew the upper case, and one the lower – think the answer is yes, especially when Viscosity is used as text. The baseline varies to help with the character fit.

Type design: Kathy Warinner
Bob Aufuldish _Viscosity

the graphic designates the

ectory

along which meaning moves

curves

twists

doubles back or orbits

plying its course under the tw

fluences

of both verbal and visual for

_The Future of Bitmaps

Zuzana Licko

After designing the Emigre website, I was
reminded of the need for a comprehensive
family of screen fonts with companion printer
fonts. To address this need, I set out to design
a series of font families, optimized for use
in multimedia environments. The result is the
Base series of font families, consisting of
twenty-four individual faces: two families
based on 12-point screen fonts (one serif and
one sans serif family), named Base-12; and one
family based on 9-point screen fonts, named
Base-9.

Outline fonts have a greater degree of flexi-
bility than screen fonts. Therefore, during
the design process, the screen fonts tended to
dictate the appearance of the printer fonts.
The design of the screen font, for example, set
exact character widths within which the out-
line characters were adjusted to fit. (Usually
this process is reversed; character widths are
normally adjusted to fit around the outline
characters.)

The greatest challenge in harmonizing the
legibility of screen fonts with printer fonts
is that of spacing. Although some existing
printer fonts have companion screen fonts that
are quite legible on screen, they tend to have
two shortcomings: the main problem is that
traditional screen fonts are adjusted to fit
the shapes and widths of the printer fonts. This
causes inherent spacing and character shape
problems, since the printer fonts inevitably
force unnatural widths or shapes on the screen
fonts. The second problem is that of spacing
inconsistencies in text sizes due to fractional
widths.

In traditional fonts, the width of a bitmap character is a rounded-off measurement, calculated from the corresponding outline character. For example, an outline character with a cell width of 620 at an em-square of 1000 will be rounded down to 6 pixels in a 10-point screen font. The information about the remaining 2/10 of a pixel is stored in the fractional width table. When lines of text are composed, many programs (such as page-layout programs) match the line length of the screen font to the line length of the printer font by calculating the cumulative effect of the character-width fractions. For example, if a 10-point line of type was composed of 10 characters and each character had a remaining 2/10 of a pixel, then the line of type would need to be increased by 1 pixel in order to match the printer output. As a result, an extra pixel of space would be inserted between two of the characters, thereby causing uneven spacing. Moreover, some characters may be moved a pixel to the left or right, thus overriding the spacing intentions of the hand-edited bitmap font.

Rather than deriving the screen font from the printer font, I decided to derive the printer font from the screen font. The first step was to choose the most appropriate screen-font point size. For various reasons, the 12-point size surfaced as the most useful. 12 point is the default size for most applications and Web browsers and 24 point and 36 point (standard sizes to which some applications are limited) are multiples of 12 point. Later on in the development process, I added a family based on the 9-point bitmap to facilitate the other popular sizes: 9 and 18.

The popularity of the 12-point screen font is also due to the relatively coarse screen resolution on computers, which cause the perceived font size on screen to be smaller than the corresponding high-resolution print out. On the screen, 12 point is comfortable to read, 10 point is still readable, 9 point becomes difficult for extensive text and 8 point is difficult to read. When printed out, however, the level of legibility in the various sizes shifts down by at least 2 point sizes.

To clarify the measurement of typefaces, I should explain that each point size is generated by scaling the font em-square. The em-square is the vertical measurement of the body around the font (top to bottom) and needs to allow breathing space for accents, descenders and other protruding elements. Therefore, the point size does not relate specifically to any part of the typeface's anatomy, that is, a 12-point size measures 12 points from the top to the bottom of the em-square, and the actual dimensions of the x-height or cap-height will vary between typeface designs.

That's the physical measurement of the typeface. However, there are various factors that may make a typeface appear larger or smaller within the same point size. For example, a large x-height or a wide character width makes a typeface appear larger than a design with a smaller x-height or a narrower character width. Since most of the text we read is lower case, the x-height is the most influential element on the perceived size of a typeface. The larger the inside shapes of the x-height (also called counters), the larger the face will appear. Therefore, when relating the perceived point size to screen fonts, it needs to be specified that a 12-point screen font generally has a 6 pixel x-height, which is the pixel size that I used for the Base-12 family.

The next challenge was to relate the measurements of the screen font to the printer font. In order to relate the screen font character widths to those of the printer font, I made the em-square of the scalable printer font divisible by 12. I chose an em-square of 1200 units, thereby making each pixel equal to exactly 100 units in the printer font (this solved the fractional-width problem described earlier). Since the widths of the printer font had to match exactly those of the 12-point screen font, the process was similar to that of designing a monospaced typeface, in that the printer-font character outlines had to be adjusted to fit into predefined character cells. Like the size of the em-square, the size of the character space includes the space around the character and not the measurement of the character itself. The character cell width is the horizontal measurement around a character, including breathing space (left to right). The breathing space around one character when combined with the breathing space around another character creates the space between those two particular letters. If this is done correctly, then words will be recognizable and the typeface will be legible. In most typefaces this breathing space between characters is additionally optimized by adding kerning pairs between problematic pairs. In the case of the Base-9 and Base-12

BASE12/9

Base Twelve Sans
Base Twelve Serif
Base Nine Sans

typefaces, however, kerning pairs would have destroyed the modularity of the spacing, so the spacing had to be optimized solely by adjusting the character shapes. After resolving the measurement and spacing issues, the design of the printer font could depart from that of the screen font. Since the printer font design functions separately from the screen font design, the details of the characters themselves need not follow exactly the structure of the screen fonts; the printer font design needs only echo the implied shape of the screen font. For example, a circle can be implied with as few as 4x4 pixels and geometrically other shapes may similarly be derived. Since there is room for much interpretation at this point, the Base-9 and Base-12 typefaces are merely one design solution and other interpretations may yet be made.

When I first designed bitmaps in 1984 for the Macintosh computer (the Emperor, Emigre, Oakland and Universal families), bitmap fonts were the only fonts available for the Macintosh and my intent was to create a series of legible fonts for the computer screen and dot matrix printer. After the introduction of laser printing and high-resolution outline fonts, I imagined that these bitmaps would be relegated to the status of novelty fonts, as they in fact were for several years. But, with the current interest in multimedia CDs, electronic bulletin boards and the World Wide Web, on-screen design has gained importance. In re-evaluating the necessity of screen fonts, I was able to make use of the many lessons I had learned from my early bitmap experiments.

It is ironic that for years pioneers of emerging computer technologies have been slighting the validity of bitmaps, claiming that they are only temporary solutions to a display problem that would soon be fixed by the introduction of high-definition TV and computer monitors. Well, a decade later we're still waiting and it has become obvious that even if such advances were eventually made, the huge installed user-base of today's technology would mean that we would be addressing coarse resolution needs for a long time to come. This is especially significant since there is much talk today about the forthcoming multimedia-style interactive TV programming, with users being able to view such sources as CD-ROM programming, or the World Wide Web directly on their existing TV sets. If this happens, then the US TV monitor (even coarser in resolution than most computer monitors) will be our next challenge.

Certainly there is the need and the creative room for many more legible screen fonts and so it is time for all of you legibility-conscious type designers to finally embrace its technology.

||||||||| oooooooooo.
||||||||| oooooooooo.
||||||||| oooooooooo.

Top: a line of type set in a 12-point Helvetica screen font with the intended spacing (without using fractional width). Middle: the same line of type set in the same screen font using fractional width. This method produces a line that matches more accurately the printer output, but is detrimental to the legibility of the screen font. Bottom: the same line of type printed out on a high-resolution printer.

The dimensions of the circle correspond with its bitmap. In a screen font, the shapes of the outline font are approximated by crude building blocks on a grid. The two are best married when the shapes and parameters of the outline font work with the limited possibilities of the bitmap.

BaseMonospace
BaseMonospace
BaseMonospace
BaseMonospace
BaseMonospace
BaseMonospace

The Base Monospace Narrow and Wide families were later added to the series of Base fonts.

monospaced typeface proportional typeface

In a monospaced typeface, such as Base Monospace, each character fits into the same character width (left column). In a proportional typeface, such as Filosofia, each character width is different to accommodate the particular width of each character (right column).

The first step when designing Base Monospace was to choose the model character width. To facilitate a harmonious relationship with the screen fonts, the goal was to select a character width that would have a simple ratio to its em-square. The obvious choice was 100%, or 1:1, the simplest ratio of all, but this idea was discarded since it would have yielded a typeface too wide for practical purposes. Eventually, the 1:2 ratio (50%) was selected as the character width for Base Monospace Narrow and the 3:5 ratio (60%) was chosen for Base Monospace Wide. Since every character in a monospaced typeface must fit into the same space, character shapes become stretched and squeezed accordingly.

c f i l

Some characters, such as c, f, i and l, were made wider than usual to fit into the model character width.

d m w

Other characters, such as d, m and w, were made narrower than usual to fit into the model character width.

il mw

The stretching and squeezing of characters became particularly problematic in the heavier weights; there was usually not enough room to accommodate both the thickness of the stem weight and the complexity of characters such as the m and w. The stem weights therefore had to be adjusted and although the stem weights of the i and l (left) were heavier than the m and w (right), the overall colour density was the same when set in text (below).

AAA WWW

One way to accommodate a bold character is to shift the weight from one part of the letter form to another. The A and W variations above show some of the options. Ultimately, the choice is determined by which is most harmonious within the overall typeface design.

A A

In a monospaced typeface, the spacing can be improved if the characters fill out their spaces evenly. For example, the A with vertical sides (left) is more evenly distributed in the white space within its character cell, and will therefore have fewer spacing problems than the A with diagonal sides (right).

S S

Sometimes the selection of one character variation over another comes down to a choice between the importance of its aesthetic form and its function within the rest of the typeface. Although the open S (right) may have been more appropriate from a formal standpoint, the enclosed S (left) was chosen because of its vertically curved end strokes, which enclose the space more effectively and therefore define more clearly the interior-versus-exterior white space. This reduces spacing problems, as well as giving the appearance of a narrower form that fits more comfortably within the fixed character space.

Cover of <u>Type Specimens</u>, 1995
16.5 x 25.3 cm

Design | Type design:
Richard Lipton _Meno

_Sloop

The Font Bureau

Location_ Boston, Massachusetts, USA

Established_ 1989

Founders_ David Berlow, Roger Black

Type designers_ David Berlow, Roger Black, Leslie Cabarga
Matthew Butterick, Matthew Carter
Tobias Frere-Jones, Richard Lipton
Jim Parkinson, David Siegel, Rick Valicenti
and many more

Distributors_ The Font Bureau, FontShop International (FSI)
Agfa, ITF and others

Cover of <u>Type Specimens</u>
2nd Edition, 1997
18.5 x 26.7 cm

Design: Tobias Frere-Jones
Type design: Richard Lipton _Sloop

Tobias Frere-Jones _Interstate

David Berlow entered the type industry in 1978
as a letter designer for the type foundries
Mergenthaler, Linotype, Stempel and Haas. He
joined the newly formed digital type supplier
Bitstream in 1982.

In 1989 he founded The Font Bureau with Roger
Black, who has rebuilt some of the world's
most prestigious magazines and newspapers
over the last twenty-five years. The Font
Bureau has developed more than three hundred
new and revised type designs for such clients
as <u>The Chicago Tribune</u>, <u>The Wall Street Jour-
nal</u>, <u>Newsweek</u> and <u>Rolling Stone</u>. The Font
Bureau retail library mainly consists of origi-
nal designs and includes over five hundred
typefaces.

Page from <u>Type Specimens</u>
2nd Edition, 1997
18.5 x 26.5 cm

Design: Tobias Frere-Jones
Type design: Leslie Cabarga _NeonStream

→

Page from <u>Type Specimens</u>
2nd Edition, 1997

Design: Tobias Frere-Jones
Type design: Leslie Cabarga _Magneto Bold, Bold Extended,
Super Bold Extended

French Fries

BOLD EXTENDED

Solitude

BOLD

A few moments alone

BOLD EXTENDED

With just me and my bucket of marzipan

BOLD

run

SUPER BOLD EXTENDED

Continental

BOLD EXTENDED

new refrigerator full of krispy veggies

BOLD

ice cubes

BOLD EXTENDED

Kitchen

BOLD

telephones

SUPER BOLD EXTENDED

Delicious Fat-Free Snacks

BOLD EXTENDED

Freon Coils

BOLD

Potato Salad

BOLD EXTENDED

Bold, Bold Extended, Super Bold Extended

Leslie Cabarga has returned to the streamlined scripts prepared by industrial designers at mid-century for the inspiration of his new Font Bureau series. The Magneto trio recall the chrome-strip lettering laid along the rounded shapes of refrigerator doors and automobile trunks in the thirties and forties by a jaunty, self-confident American industry that knew it was going places, doing things, and changing the world; FB 1995.

ABCDEFGH IJKLMNOPQRSTUVWXYZabcdefghijklmnopqrstuvwxyz&fifl
¶§£€¥#ƒ0123456789%¢° =<+>'"/¿?¡!&(/)N{|}*.,:;..«»o""".,,_•†‡@®™

áàâäãåæçéèêëíìîïñóòôöõøœúùûüÿ.ÁÀÂÄÃÅÆÇÉÈÊËÍÌÎÏÑ ÓÒÔÖÕØŒÚÙÛÜÝ
special characters: Ʒfiflꝑꞃeoꝼꞅꞃbꞃꞅ Hᴿ

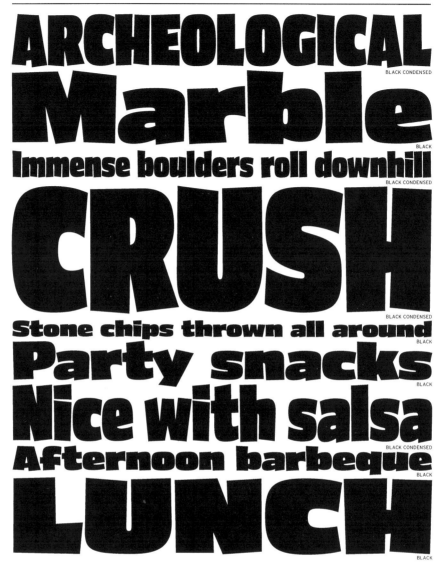

ARCHEOLOGICAL
BLACK CONDENSED

Marble
BLACK

Immense boulders roll downhill
BLACK CONDENSED

CRUSH
BLACK CONDENSED

Stone chips thrown all around
BLACK

Party snacks
BLACK

Nice with salsa
BLACK CONDENSED

Afternoon barbeque
BLACK

LUNCH
BLACK

Black, Black Condensed

Who hasn't admired the energy of Antique Olive Nord? By comparison all other Ultras seem sluggish. Nord exudes Roger Excoffon's animation and Gallic irreverence for typographic rules. Tobias Frere-Jones cross-bred the weight, proportions, & rhythms of Nord with the casual informality and grace of his own Cafeteria, gaining informality, a dancing vitality on the page, in his words, 'a lively if faintly inebriated gyration'; FB 1995.

ABCDEFGHIJKLMNOPQRSTUVWXYZabcdefghijklmnopqrstuvwxyzß ﬀﬁﬂﬃﬄ
¶$$£¥#ƒ0123456789%¢º=⟨+⟩'"/¿?¡!&[/][\]{|}*.,:;—«»⟨⟩""''·‚„_°@♪‡
áàâãäåæçéèêëíìîïñóòôõöøœúùûü ÿ ¡ÁÀÂÃÄÅÆÇÉÈÊËÍÌÎÏÑÓÒÔÕÖØŒÚÙÛÜŸ

Page from <u>Type Specimens</u>
2nd Edition, 1997

Design/Type design: Tobias Frere-Jones _Asphalt Black,
Black Condensed

NEIGHBORHOOD
REGULAR
LOCAL playgnound opens at 8:30 AM
ALTERNATE
RHYTHMS
REGULAR
New style of jazz improvisation
ALTERNATE
No coven change on tuesdays, wednesdays & thursdays
ALTERNATE
SAXOPHONE
REGULAR & ALTERNATE
All performances sold out!
REGULAR & ALTERNATE
The ban was filled to bunsting with music lovens from all over the city
REGULAR
legendany jazz artists, take the stage
REGULAR
enthusiastic cheens
REGULAR & ALTERNATE
COLORFUL MELODIES AND ENERGETIC PERCUSSION FILL THE SMOKY AIR
REGULAR
Finst set lasts an unbelievable 3 hours
REGULAR & ALTERNATE
BARTENDER
ALTERNATE

Regular, Alternate

Font Bureau Dizzy pays homage to that great bebop legend John Birks 'Dizzy' Gillespie. Samples of his hand inspired Jean Evans, a family and long time personal friend, to design this font. The suggestive shapes and peculiar rhythms of these deceptively casual letters produce a characteristic cadence within and between words. The type brings to paper the syncopated musical innovation of this man of incredible genius; FB 1995.

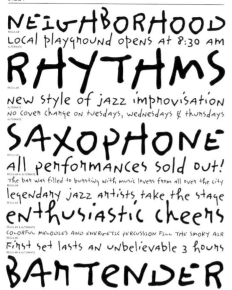

special characters ←———→

Assembled Masses
LIGHT
Crowds
LIGHT
Rushing to get home soon
LIGHT EXTENDED
New television show has viewers glued to their sets
LIGHT
Adhesive
LIGHT EXTENDED
3-part miniseries
LIGHT EXTENDED
Tale of love and double sided tape
LIGHT EXTENDED
Set in Spain
LIGHT EXTENDED
Actress
LIGHT
Environment of the past is carefully reconstructed
LIGHT
Period Setting
LIGHT EXTENDED
With commas & semicolons too
LIGHT
Grammar
LIGHT EXTENDED

Light, Light Extended

Leslie Cabarga loves mid-century letterforms. Streamline carries us back to the joining scripts of the forties. American industrial designers brought these to life in chrome strips flowing across rounded white enamel on each new appliance shipped from factories just emerging from the great depression. Symbol of the times, these scripts forever call up the world of the 1939 New York World Fair, and all that was to follow; FB 1995.

special characters ←———→

LOOKOUT POST
INLINE
Perched on a hill outside the town
SOLID
Visible for 326 kilometers
INLINE
ALL-NIGHT VIGILS
SOLID
REPORTS FILED HOURLY
INLINE
SEARCH
SOLID
I WAS HOPING THAT MY CAR KEYS WOULD COME HOME SOON
SOLID
Description of a metal object
SOLID
LOCAL NEWSPAPERS
INLINE

Inline, Solid

Weak ovals replace powerful circular forms in the condensed form of most geometric slabserifs. In Citadel Tobias Frere-Jones follows a stronger alternative, substituting straight strokes for the curved sides of round characters. Flat horizontal curves play against the variety of serifs in counterpoint to the repeating rhythm of verticals. The inline stripe adds to the rhythm of a type that offers a powerful and stylish geometry; FB 1995.

ABCDEFGHIJKLMNOPQRSTUVWXYZabcdefghijklmnopqrstuvwxyz0ffiffifl
¶§$£¥#ƒ0123456789%‰¢°™···""''¿?!¡G(/)[\]{}*·,.:;--«»‹›""··•·‡¦@®©℗™√ı̇h
àáâãäåæçèéêëìíîïñòóôõöøùúûüýÿÀÁÂÃÄÅÆÇÈÉÊËÌÍÎÏÑÒÓÔÕÖØÙÚÛÜÝŸ

MOLECULAR STRUCTURE
BOLD CONDENSED
Carbon 'n' Hydrogen Flavored Soda
LIGHT WIDE
REARRANGEMENT OF ATOMIC ELEMENTS MAKES SILK PURSE OF SOW EAR
REGULAR COMPRESSED
Gold discovered in landfills
REGULAR
NEW PROSPECT
BLACK EXTENDED
358 local residents stake their claims
THIN COMPRESSED
Neighbors clash over pile of trash
BOLD WIDE
National Guard called in to restore order
LIGHT CONDENSED
INTERNATIONAL MEDIA COVERAGE
REGULAR EXTENDED
VOLATILE POLITICAL INCIDENT
BLACK COMPRESSED
Public calls on leaders for action
THIN
SENATORS RUMMAGE THROUGH TRASH
THIN EXTENDED
EMPTY MILK CARTON WINS ELECTION
BLACK

Thin, Thin Wide, Thin Extended, Thin Condensed, Thin Compressed, Light, Light Wide, Light Extended, Light Condensed, Light Compressed, Regular, Regular Wide, Regular Extended, Regular Condensed, Regular Compressed, Bold, Bold Wide, Bold Extended, Bold Condensed, Bold Compressed, Black, Black Wide, Black Extended, Black Condensed, Black Compressed

ABCDEFGHIJKLMNOPQRSTUVWXYZabcdefghijklmnopqrstuvwxyz0ffiffifl
¶§$£¥#ƒ0123456789%‰¢°™···""''¿?!¡G(/)[\]{}*·,.:;--«»‹›""··•·‡¦@®©℗™√ı̇h
àáâãäåæçèéêëìíîïñòóôõöøùúûüýÿÀÁÂÃÄÅÆÇÈÉÊËÌÍÎÏÑÒÓÔÕÖØÙÚÛÜÝŸ

Type design: Jean Evans _Dizzy Regular, Alternate
Tobias Frere-Jones _Citadel Inline, Solid

Type design: Leslie Cabarga _Streamline Light, Light Extended
David Berlow _Agency Thin, Light, Regular,
Bold and Black weights
each in Extended, Wide, Normal,
Condensed, and Compressed widths

BIG HUGE MOVING TRUCK

REGULAR

All my possessions stuffed into cardboard boxes

BLACK

CONTINENT

BLACK

From one coast to the other in 35 hours

THIN

I WAS PULLED OVER FOR CARRYING A FUTON WITHOUT A LICENSE

REGULAR

Sleeping with intent to snore

BOLD

HEAVY PENALTY

THIN

After buying a quilt, I was released on my own recognizance

THE EPIC JOURNEY CONTINUED

BLACK

Still in Transit

REGULAR

I asked locals for directions to the highway

BLACK

They sang Sinatra's "My Way" instead

RECORD CONTRACT

THIN

I offered them a twelve-album deal, with tour dates in 4,821,975 cities

Dance Hall

BOLD

INTERNATIONAL RADIO SMASH

Thin, Regular, Bold, Black

ABCDEFGHIJKLMNOPQRSTUVWXYZabcdefghijklmnopqrstuvwxyzßfffififlffiffl
¶$$£¥#†0123456789%‰¢°"‡º«»‹›""/¿?¡!&()[]{}*.,.-_«»¡""'·,..•†‡@®©™√/œ
abcdefghijklmnopqrstuvwxyz¶$$£¥#f0123456789%‰¢¿?¡!(/)[\]{|}
áàâãäåæçéèêëíìîïñóòôõöøúùûüyıAÁÀÂÃÄÅÆÇÉÈÊËÍÌÎÏÑÓÒÔÕÖØŒÚÙÛÜŸ

LANDLORD

REGULAR

NEW RENOVATIONS

REGULAR

LATE

REGULAR

THE ELEVATORS REMOVED

REGULAR

DIVING BOARDS

REGULAR

NEW POOL

REGULAR

ELEVATOR SHAFTS FILLED WITH WATER

REGULAR

OLYMPICS

REGULAR

INTERNATIONAL DIVING

REGULAR

MEDAL

REGULAR

Regular

Brok appeared in 1925 as powerful characters in a magnificent portrait poster cut in wood by Chris Lebeau for the Willem Brok Gallery in Hilversum, Holland. Brok works its figure ground magic when negative leading reduces the white stripes that separate lines to the slender size of those that separate letters, bringing out the dark and blocky shapes. Elizabeth Holzman understood Lebeau's letters, and designed this typeface, FB 1995.

ABCDEFGHIJKLMNOPQRSTUVWXYZabcdefghijklmnopqrstuvwxyz#f0123456789
%¢°"‡º«»‹›""/¿?¡!&()[\]{|}*.,.-_«»¡""'·,..•†‡@®©™√/√
ÁÀÂÃÄÅÆÇÉÈÊËÍÌÎÏÑÓÒÔÕÖØÚÙÛÜ

DIPLOMAT

ROMAN

Arranges historic summit meeting

ROMAN

Overtures

ROMAN

Debate & Discuss

ROMAN

A COUNTERPROPOSAL IS SENT

ROMAN

Final Details

ROMAN

All sides agree on Chinese for lunch

ROMAN

DELICATE TRUCE

ROMAN

TREATY

ROMAN

HANDSHAKES, SMILES & SIDE ORDERS

ROMAN

Press Conference

ROMAN

Roman

In 1921 Walter Tiemann designed Narcissus for Klingspor after a suave set of ornamental inline capitals first cut by Simon Pierre Fournier circa 1745. In 1925 Mergenthaler Linotype produced Tiemann's type, calling it Narciss. The elegance of Fournier's Louis XVI design created a vogue in late eighteenth century Paris, Narciss and Narcissus sparked a revival in the twenties. Brian Lucid's cut reflects the urbane air of a master, FB 1995.

ABCDEFGHIJKLMNOPQRSTUVWXYZabcdefghijklmnopqrstuvwxyzßfffififlffiffl
¶$$£¥#f0123456789%‰¢°"‡º«»‹›""/¿?¡!&()[\]{|}*.,.-_«»¡""'·,..•†‡@®©™√/√
áàâãäåæçéèêëíìîïñóòôõöøúùûüyıAÁÀÂÃÄÅÆÇÉÈÊËÍÌÎÏÑÓÒÔÕÖØŒÚÙÛÜŸ

Stratosphere

REGULAR

Realistic Moon Landing Play Set

REGULAR

deluxe

REGULAR

Astronaut Helmet

REGULAR

Guided Tour of Cape Canaveral

REGULAR

New Souvenir Shop

REGULAR

Unidentified

REGULAR

the miracles of science

REGULAR

Oxygen

REGULAR

Movements of the Planets

REGULAR

elliptical orbit

REGULAR

chemistry

REGULAR

Regular

Rocket – at last, an ultra-Atomic connected script for the nineties – brought to us from the fifties by Leslie Cabarga. He based this typeface on logos from the second wave of the All American diner, those gleaming buildings which spread across the land after the war. The greasy fries and gas guzzling automobiles may be the fabulous fifties' downside. He finds the upside in these hugely exuberant hand-lettered scripts, FB 1995.

ABCDEFG#77KLMNOPQRSTUVWXYZabcdefghijklmnopqrstuvwxyzßfffifi
¶$£¥#f0123456789%‰¢°"‡º«»‹›""/¿?¡!&()[\]{|}*.,.-_«»¡""'·,..•†‡@®©™/œ
ÁÀÂÃÄÅÆÇÉÈÊËÍÌÎÏ????ÑÓÒÔÕÖØÚÙÛÜŸ

Type design: Matthew Butterick _Hermes Thin,
Regular, Bold, Black

Brian Lucid _Narcissus

Type design: Elizabeth Cory Holzman _Brok

Leslie Cabarga _Rocket

BICYCLE MESSENGERS
SQUARE LIGHT NARROW

CROSSTOWN RUSH DELIVERY
SQUARE BLACK

Gears
ROUND BLACK

Rivets, Chains & Sprockets
SQUARE LIGHT

CANVAS BAG FULL OF PRECIOUS VALUABLES
ROUND BLACK NARROW

Contract
SQUARE LIGHT

Enormous Office Complex
SQUARE BLACK NARROW

NEW SECURITY CAMERAS
ROUND LIGHT

Escalators
SQUARE BLACK

RECEIPT REQUIRED
ROUND LIGHT NARROW

Heavy Traffic Jam
ROUND BLACK

I COLLIDED WITH A GARBAGE TRUCK
SQUARE BLACK NARROW

Gridlock
ROUND LIGHT

Square Light, Square Black, Square Light Narrow, Square Black Narrow,
Round Light, Round Black, Round Light Narrow, Round Black Narrow

This sharp-edged, industrial design from the hand of Richard Lipton was initially inspired by the sight of a single square 'O' in a magazine. Shimano Square and Shimano Round are each drawn in four styles, light & black, for wide & narrow widths. Shimano provides starkly geometric images in contrasting combinations of weight and size, intended for logos, posters, advertising display, and covers for books and records; FB 1995.

ABCDEFGHIjKLMNOPQRSTUVWXYZabcdefghijklmnopqrstuvwxyzßfffffffffa

¶§£¥#ƒ0123456789‰‱¢'·‹‹›'"/¿?¡!6(/)()[]{}*·,;:…«»‹›""''·,„_·†‡

áàâäãåæçéèêëíìîïñóòôöõøœúùûüÿ·ÁÀÂÄÃÅÆ₣ÇÉÈÊËÍÌÎÏÑÓÒÔÖÕØŒÚÙÛÜŸ
special characters: MNVWXvwx

Type design: Richard Lipton _Shimano Light and Black weights
in Normal and Narrow widths
each in Square and Round forms

FontFabrik

Promotional postcard
for Jesus Loves You All, 1997

Design | Type design:
Luc(as) de Groot _Jesus Loves You All

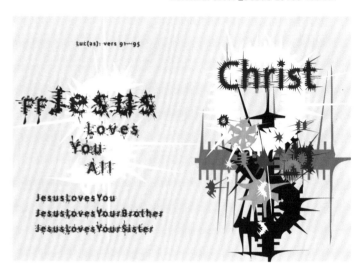

Location_Berlin, Germany

Established_1997

Founders | Type designers_Luc(as) de Groot, Othmar Motter

Distributors_FontShop International (FSI)
TheTypes

FontFabrik aims to enrich the typographic cli-
mate. It offers services such as typeface- and
logo-development and digital implementation
to design bureaus and advertising agencies.

Luc(as) de Groot and Othmar Motter enjoy
microtypographic nit-picking and finding ele-
gant solutions to typographic problems. They
work on Mac and PC, from not so early in the
morning until late at night, but primarily
they put their trust in their eyes, hands, brains
and experience. De Groot and Motter design,
kern and hint by hand and have a good knowl-
edge of bitmap, Type-1, MultipleMaster and
TrueType fonts in many different languages
and on various systems.

Agrofont

design Luc(as) de Groot 1
<luc@fontfabrik.com>
commisioned by Studio Du
<studio@dumbar.nl>

Agrofont Mager
Mager cursief ae

Agrofont Norma
Normaal cursie

Agrofont Vet $£
Vet cursief ?!&

Font commissioned by
Studio Dumbar, for the
Ministry of Agriculture, 1997

Type design: Luc(as) de Groot _Agrofont

Multiple master font
for <u>FUSE</u> 11, 1994, which was devoted
to pornography.

Type design: Luc(as) de Groot _MoveMe

Promotional postcard
for TheTypes, 1998

Design: Irene de Groot
Type design: Luc(as) de Groot _TheSans Black
_Rondom

Promotional postcard
for Nebulae, 1994

Design | Type design:
Luc(as) de Groot _Nebulae

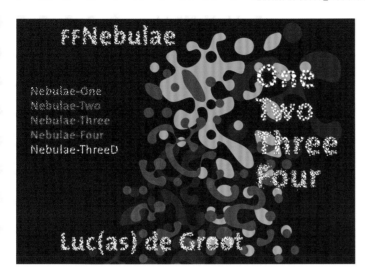

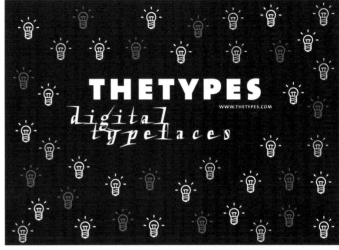

STASI

kes frühe Sünden

„Wozu das alles?"
den ohne Alibi

„Ich glaube, Vera
ist da angekommen, wo
sie hingehört"

Riesengroßes Fragezeichen

2/1996, Titel: Lust am Bösen – Der göttliche
el; SPIEGEL-Gespräch mit dem Philosophen
diger Safranski über die Aktualität des
; SPIEGEL-Umfrage: Gott verliert Mehrheit)

Spiegel Headline AaBbCcDd123
Spiegel Book AaBbCcDd123
Spiegel Bold AaBbCcDd123
Sp. Condensed Book AaBbCc123
Sp. Condensed Book Italic EeFfGg
Sp. Condensed SemiBold AaBbCc
Sp. Condensed Bold AaBbCc123

Spiegel Rotation AaBb12345
Sp. Serif Italic AaBbCc12345
Sp. Small Caps der spiegel

Font for the news magazine
<u>Der Spiegel</u>, 1997

Type design:
Luc(as) de Groot _Spiegel

Promotional brochure, 1997
18 pages in four-colour
10.6 x 14.8 cm

Design: Luc(as) de Groot
Silke Schimpf
Type design: Luc(as) de Groot _Lucpicto

Promotional poster for
Thesis family, 1994
14.8 x 21 cm (folded)

Design | Type design:
Luc(as) de Groot _TheSans, TheSerif, TheMix

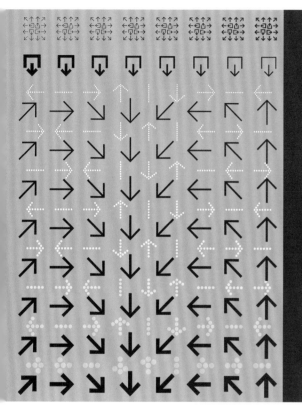

Thesis

Han & Alleman
Labora et amora
V & V + R & D
Mother & Child
Silvius & Arbor
For Her & Him
K & R Clo & Avé
Masters & Mind
You & Me k & k
the Sans & Serif
Uit & in & er om
Pen & Potloden

AaaAaaAaaAaaA
AaaAaaAaaAaaA
AaaAaaAaaAaaA
AaaAaaAaaAaaA
AaaAaaAaaAaaA
AaaAaaAaaAaaA
AaaAaaAaaAaaA
AaaAaaAaaAaaA

TheSans
TheSerif
TheMix

→
Promotional postcard for
Jesus Loves You All, 1997

Design | Type design:
Luc(as) de Groot _Jesus Loves You All

Luc(as): 91—95

JESUS
Loves
You
All

JesusLovesYou

JesusLovesYourBrother

JesusLovesYourSister

Promotional postcard, 1997

Design: Alessio Leonardi
Type design: Alessio Leonardi _Elleonora d'un Tondo

Fabrizio Schiavi _Amsterdam

Fontology

Location_Piacenza, Italy
Berlin, Germany
Established_1995
Founders_Fabrizio Schiavi, Fabio Caleffi
Dina Cucchiaro
Type designers_Fabrizio Schiavi, Alessio Leonardi
Distributor_Happy Books

Lettere made in Italy

Fontology intends to revive the tradition of
Italian typography. The font designers Alessio
Leonardi and Fabrizio Schiavi want to develop a
new typography that is specifically Italian.
They are also investigating how to combine this
research with current impulses from outside
Italy. They believe that many designers in Italy
draw indiscriminately on their country's typo-
graphical tradition and often use established
fonts like Bodoni without ever questioning
their use. Leonardi and Schiavi would like
to promote a critical attitude towards these
traditions without overturning them.

The Fontology project is primarily directed at
the international type scene and not just at
Italian designers. Its objective is to make clear
that much is happening in typography in Italy
today that can stimulate global communication.

Lettere Made in Italy

→
Poster included in the
Fontology catalogue, 1995
43 x 54 cm

Design | Type design:
Fabrizio Schiavi _Washed

Logo for Fontology, 1996
Alessio Leonardi designed this logo
for Fontology's business papers.
It shows that Fontology stands for a
relaxed discussion about fonts that
people can have over a cup of coffee.

Design: Alessio Leonardi

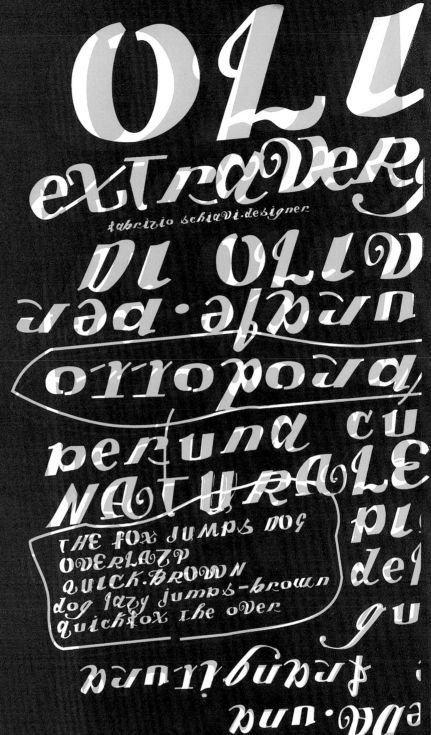

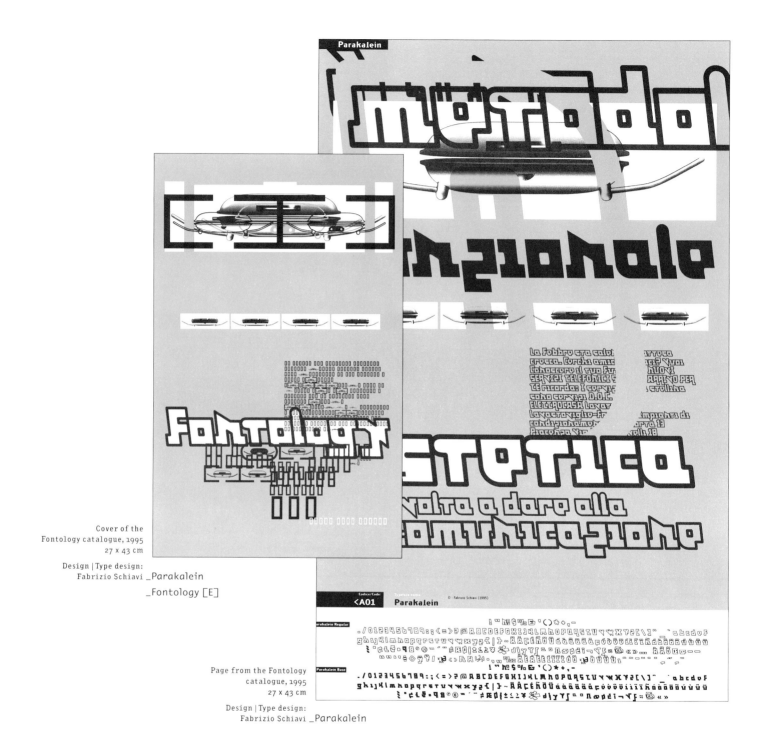

Cover of the
Fontology catalogue, 1995
27 x 43 cm

Design | Type design:
Fabrizio Schiavi _Parakalein

_Fontology [E]

Page from the Fontology
catalogue, 1995
27 x 43 cm

Design | Type design:
Fabrizio Schiavi _Parakalein

Pages from the Fontology
catalogue, 1995
27 x 43 cm

(From left to right)
Design | Type design:
Fabrizio Schiavi, Alessio Leonardi _Aurora Nintendo

_Aurora CW

_Cratilo

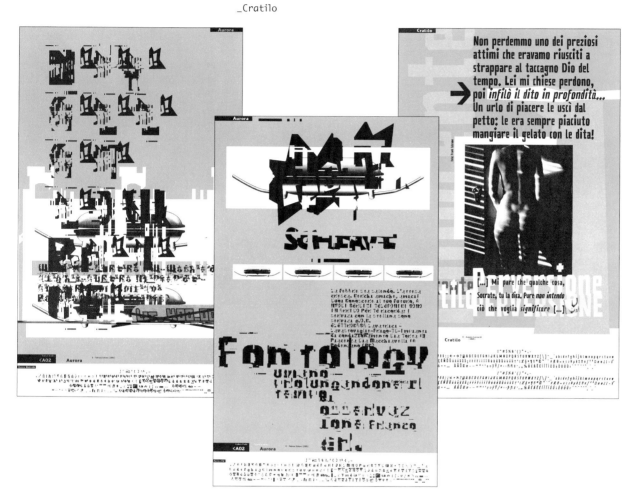

Catalogue supplement, 1995
21.5 x 12 cm (folded)
The leaflet shows the keyboard layouts
for the Fontology fonts.

Design | Type design:
Fabrizio Schiavi _Amsterdam

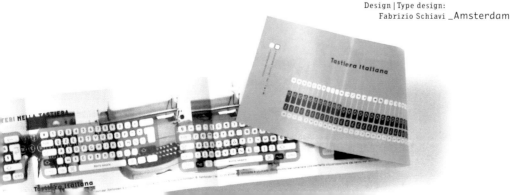

FontShop International (FSI)

Location_Berlin, Germany

Established_1990

Founders_Erik Spiekermann, Joan Spiekermann
Neville Brody

Type designers_David Berlow, Erik van Blokland, Neville Brody
chester, Luc(as) de Groot, Max Kisman, Martin Majoor
Just van Rossum, Pierre di Sciullo, Fred Smeijers
Erik Spiekermann, Peter Verheul and many more

Distributors_FontShop International (FSI), Type-Ø-Tones, Happy
Books, Compress Typewaft, Agfa, FontHaus and
others

The most versatile collection of contemporary typefaces

One of FontShop International's main objectives is to build and
nurture the FontFont library of typefaces. FSI also regularly
releases <u>FUSE</u>, the award-winning experimental typographic
publication that has pioneered new territory in the evolution
of type design. In addition, FSI also publishes the <u>FontBook</u>,
the world's most comprehensive reference book on digital type-
faces. FSI is the licensor of the FontShop franchise in many
countries around the world, the first branch of which was
opened in 1989 by Joan and Erik Spiekermann in Germany and
continues to flourish.

FSI released the first edition of FontFonts in 1990 under the
title 5 Dutch Designers (Erik van Blokland, Max Kisman,
Martin Majoor, Just van Rossum, and Peter Verheul). Still enor-
mously popular, these first typefaces set the standard for the
FontFonts that were to follow. They represent the genesis of a
typeface library that now holds nearly 1300 fonts and that is
internationally known for innovative, contemporary typefaces
of the highest quality. What makes the FontFont library unique
is its wide variety of original typeface designs. The spectrum of
styles ranges from tasteful, high-quality text faces to striking
display fonts, to fun fonts that initially reflect the moods of
the time and frequently set new typographic trends. The Font-
Font library is the largest collection of original, contempo-
rary typeface designs in the world.

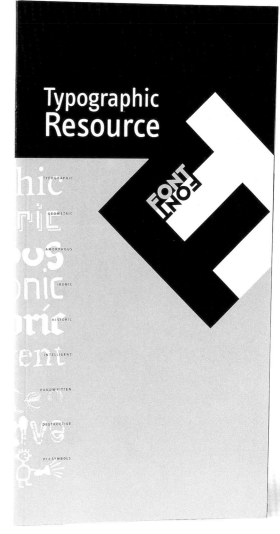

Cover of the FontFont catalogue, 1998
15.2 x 29.7 cm

Design: Moniteurs, Berlin
Type design: Erik Spiekermann
Ole Schäfer _Info
Fred Smeijers _Quadraat
Pierre di Sciullo _Minimum
Peter Warren _Amoeba
John Siddle _Boomshanker
Just van Rossum _Brokenscript
Just van Rossum
Erik van Blokland _Beowolf
John Critchley _Bull
Alessio Leonardi _Graffio
_Letterine Archetipetti

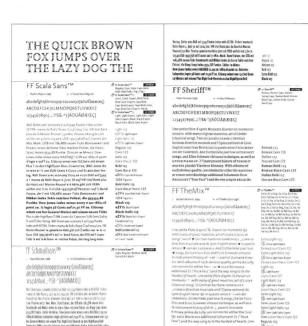

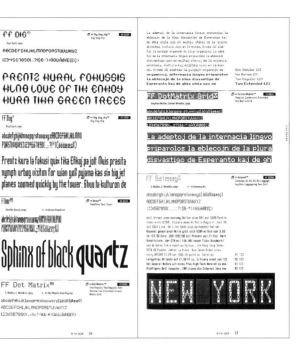

Spreads from the FontFont catalogue, 1998
30.4 x 29.7 cm

Design: Moniteurs, Berlin
Type design: Martin Majoor _Scala Sans

Hans Reichel _Schmalhans

Peter Verheul _Sheriff

Luc(as) de Groot _TheMix

Paul Sych _Dig

_Dog

Neville Brody _Dome

Stephan Müller, Cornel Windlin _Dot Matrix

_Gateway

FontFont CD postcard, 1998
14.7 x 10.5 cm

Design: Jürgen Siebert
Type design: Martin Wenzel _Rekord

Tony Booth _Sale

Erik van Blokland _Trixie Plain

Just van Rossum _Confidential

_Stamp Gothic

Cover of the FontFont CD-ROM, 1996
13.8 x 12.4 cm

Design: Erik Spiekermann, Jürgen Siebert
Type design: Erik Spiekermann _Meta

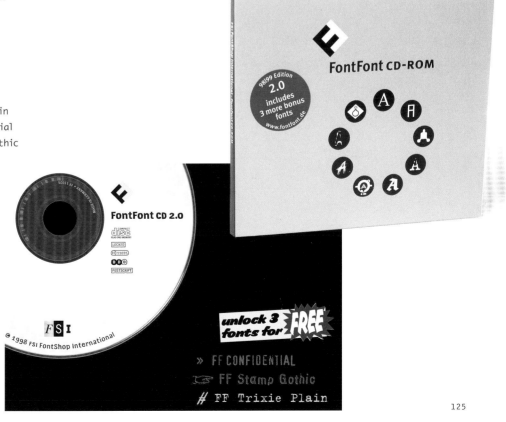

→
Font cards
14.7 x 10.5 cm

Design (1996): Erik Spiekermann
Type design: Erik Spiekermann, Ole Schäfer _Info

Design (1995) | Type design: Pierre di Sciullo _Minimum

Design (1996) | Type design: Tony Booth _Sale

Design (1995) | Type design: John Critchley _Bull

Design (1996): Richard Buhl
Type design: Luc(as) de Groot _TheSans Typewriter

Design (1996) | Type design: Alex Scholing _Engine 2

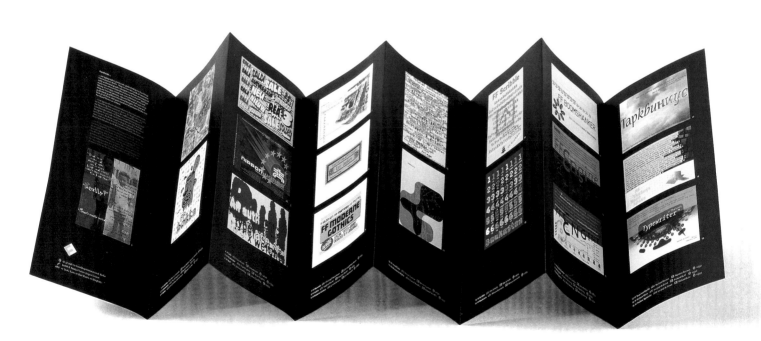

Font card leaflet, 1998
29.7 x 118.4 cm

Design: Judith & Nadja Fischer, Jürgen Siebert
Type design: Martin Majoor _Scala Sans

Johannes Erler, Olaf Stein _Dingbats

Stephan Müller, Cornel Windlin _Dot Matrix

← Autobahn

↑ Infobahn

Info Normal : Info Book : Info Medium : Info Semibold : Info Bold

All is for the best
Tout va pour le mieux
in the best of all
dans le meilleur
possible worlds.
des mondes possibles

FFEngine **2** ⟶ a supplement to FFEngine, containing **5** extra weights: Light, Light Italic, **Bold Italic**, Caps Bold and Caps Italic. Together with the weights in the first package (Regular, Italic, Bold and Caps) they form a coherent set of contemporary general purpose type. Some characteristics : : For simplicity's sake there is no contrast in the characters. **This means FFEngine is what you could call a monoline** (well, almost...). To enhance balance & legibility small serif-like bulges were added at the ends of some lines.

FFEngine

(Mono SPACED LINING- FIGURES ARE INCLUDED FOR TABLES)

package Regular Italic Bold
[1]

package [2]

→ Light
→ Light Italic
→ Bold Italic
Caps
→ Caps Italic
→ Caps Bold

DIMENSIONS INCREASE WITH WEIGHT

a a a a a a a a a a a

ULTRA LIGHT light regular bold ULTRA BLACK

SALE SALE SALE SALE SALE SALE SALE SALE SALE SALE SALE

SALDI SALE 35% AUSVERKAUF UITVERKOOP NEU THE REA 3 NIEUW NOUVEAU SALE SOLDES

FF SALE

FF SALE - DESIGNED BY TONY BOOTH 1996-DISTRIBUTED EXCLUSIVELY BY FONTSHOP INTERNATIONAL

For use on high resolution laser printers the «Typewriter» version of TheSans Mono was developped. This allows you to output complete letterheads from your high quality laser printer; the design elements are sharp, *the content is sympathetic and personally.*

FFTheSans
Typewriter™

Luc(as) de Groot
Berlin
February 1996

An authentic typeface set in six weights

FF Transit Print	FF Transit Front	FF Transit Back	FF Info Text	FF Info Display
Normal	Positiv	Positiv	Normal, CAPS	Normal
Italic	*Positiv Italic*	*Positiv Italic*	Book, CAPS	Book
Bold	**Positiv Bold**	**Positiv Bold**	Medium, CAPS	Medium
Bold Italic	Negativ	Negativ	**Semi Bold, CAPS**	Semi Bold
Black	*Negativ Italic*	*Negativ Italic*	**Bold, CAPS**	**Bold**
	Negativ Bold	**Negativ Bold**		

FF Transit™

Fonts and Pictograms for Information and Orientation Design

Poster for FF Info and FF Transit, 1997
59.4 x 42 cm

Design: MetaDesign Berlin
Nadja Lorenz

Type design: MetaDesign Berlin, BVG _Transit

Erik Spiekermann, Ole Schäfer _Info

MetaDesign Berlin, BVG, Ole Schäfer _Info Pict

_Info Produkt

Poster for Dirty Faces 3, 1995
42 x 59.4 cm

Design: Neville Brody

LITTLES

Metaplus Boiled

Metaplus Subnormal

Motive light

Motive normal

Motive bold

FF Dirty Faces 3 specimen, 1995

Type design: Simone Schöpp _A Lazy Day

_Littles

Erik Spiekermann, Neville Brody _Metaplus Boiled, Subnormal

Stefan Hägerling _Motive

DIRTY FACES

Continuing the FF Dirty
Faces Series. Published
quarterly, this third
set of processed
outlines has been

FF Dirty Faces 3 includes 7 crunchy fonts
from Simone Schöpp, Erik Spiekermann/Neville
Brody and Stefan Hägerling, with
accompanying digital poster. FF Dirty Faces
1 and 2 available from the FontShop

FF Dirty
FACES

FF LITTLES
SIMONE SCHÖPP

FF Meta+Subnormal
FF Meta+Boiled
Erik Spiekermann/Neville Brody

FF Motive
FF Motive
FF Motive
Stefan Hägerling

Font Shop

Packaging for FUSE, 14, 15, 16, 17, 1995–97
17.8 x 22.8 cm

Design: Neville Brody
Type design: Morris Fuller Benton _Franklin Gothic

→
F Synaesthesis poster,
FUSE 14, 1995
42 x 59.4 cm

Design | Type design: xplicit ffm _Synaesthesis

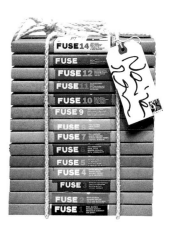

synaesthesia by soundfilm

FUSE 14
Propaganda specimen, 1995

Type design: Moniteurs _MMMteurs Real, Cyber
Brett Wickens _Crux95
xplicit ffm _Synaesthesis
Tom Hingston _Chaos Light, Bold
Francis Stebbing, Vera Daucher _Trinity
Neville Brody _Cyber Static

FUSE 15
Cities specimen, 1996

Type design: Paul Elliman
Tobias Frere-Jones _Bits
Frank Heine _Microphone
Peter Grundy _Determination
Darren Scott _DIY Foundation, Skeleton
John Randle _Berliner
Sam Jones _Mayaruler 1
Neville Brody _Smog 1
_City

FUSE 16
Genetics specimen, 1997

Type design: Alexei Tylevich _Cicopaco
David Crow _Mega-Family
Naomi Enami _Kilin
Tom Hingston, Jon Wozencroft _Condition Birth,
Conception, Mutated, Pulse
Neville Brody _Genetics Second Generation

FUSE 17
Echo specimen, 1997

Type design: Florian Heiß _Surveillance Date And Time,
Scenes, Suspicious People,
Victims, Witness
Function _Where The Dog is Buried
Mountain, Top
_Where The Dog is Buried
Sea, Bottom
_Shinjuku
Pierre di Sciullo _Spell Me
Anna-Lisa Schönecker _White No Sugar
Neville Brody _Echo Downloaded, Page Three

Editorial poster for FUSE 17, 1997
42 x 59.4 cm

Design: Neville Brody
Type design: Neville Brody _Echo
Function _Where The Dog is Buried
_Shinjuku
Pierre di Sciullo _Spell Me
Florian Heiß _Surveillance
Anna-Lisa Schönecker _White No Sugar

The Foundry

Location_London, UK

Established_1989

Founders | Type designers_David Quay, Freda Sack

Distributors_The Foundry, Elsner+Flake
Fontbolaget, FontHaus

Reduce to the maximum

The aim of The Foundry is to develop durable, high-quality typeface designs that are readable, useable and which good designers will choose to use – today's classics. The Foundry studio also develops typefaces for corporate clients such as NatWest Bank, Bg plc (formerly British Gas) and Yellow Pages. It has designed signage typefaces for Railtrack in the UK and for the Lisbon metro system in Portugal.

A secondary range of fonts, the Architype series, has also been developed alongside the main range. Architype concentrates on presenting the work of artists and designers of the European avant-garde. Architype 1 and 2 covers the period from 1919 to 1949, whereas Architype 3 presents the work of a living designer, Wim Crouwel, with whom The Foundry collaborated in the development of six of his designs, from the late 1960s until the early 1970s.

In recent years The Foundry has concentrated on the design of humanistic sans serif typefaces. David Quay and Freda Sack both lecture in type design and are Joint Chairs and Fellows of the Society of Typographic Designers. David is a professor of typography at the Fachhochschule, Mainz and teaches at the London School of Printing.

Type design: Wim Crouwel
The Foundry, Jürgen Weltin _Foundry Gridnik

Information folder entitled
Society of Typographic Designers
TypoGraphic Awards, held in London, 1996
14.2 x 21.3 cm (folded)

Design: David Quay
Type design: David Quay, Freda Sack _Foundry Sans Extra Bold

archityp∈ 1

ar<hityp∈ volvm∈ 1

Flyers for Architype 1 and 2, 1998
10 x 21 cm
Architype volumes 1 and 2 are collections
of avant-garde typefaces. Architype Tschichold
(flyer 1) was derived from an experimental, single
alphabet by Jan Tschichold in 1929, which was
influenced by Bayer's earlier attempt at a
universal alphabet. Architype Albers (flyer 2)
draws upon Josef Alber's attempt to design a
geometrical stencil alphabet in 1926.

Design: David Quay, Tim Lam Tang
Digitization: The Foundry
Type design: Josef Albers, Jan Tschichold _Architype Albers
_Architype Tschichold

abcdefghijklm

Flyer, 1997
10 x 21 cm
Foundry Journal derives its name from its
intended use in magazines and brochures, where
the narrow column measurements require
a more condensed typeface that is
economical with space.

Design: David Quay
Type design: David Quay, Freda Sack _Foundry Journal

abcdefghijklm

Flyer, 1997
10 x 21 cm
The idea behind The Foundry Sans came from
a conversation between David Quay and
Hans Meyer, the designer of the Syntax family.
Meyer revealed that Sabon, designed by Jan
Tschichold, was the inspiration behind Syntax.
Meyer's approach forms the basis of The
Foundry's design for a sans serif
typeface family. Foundry Sans draws its
inspiration from Stempel Garamond.

Design: David Quay
Type design: David Quay, Freda Sack _Foundry Sans

abcdefghijklm

Flyer, 1997
10 x 21 cm
Foundry Old Style is a transitional roman
typeface in the classical tradition. The
inspiration behind the typeface lay in the pen
stroke in incunabula printed type.

Design: David Quay
Type design: David Quay, Freda Sack _Foundry Old Style

_RobotFonts

Erik van Blokland/Just van Rossum

Typefaces are wonderful things. Besides allowing communication through written language, they have become communication devices in their own right. Typographers are always looking for new letter forms and type designers are always trying to make new letter forms. Digital tools have been very important in making both typography and type design much more accessible and flexible. Anything is possible, and – if anything is possible – everything will be tried out. And when everything has been tried, one cannot help but notice that everything is not possible. The end of 'Toolspace' (as we call the imagined space that contains all possibilities for tools) has been reached. Toolspace is by definition a finite area: there are always things you cannot do with a tool. The only way to break out of Toolspace is to create a new Toolspace by producing new tools or expanding existing ones.

Image-manipulation tools (such as Photoshop or Illustrator) offer so-called filters, small pieces of software that perform certain effects. The more specific the effect, the easier it can be recognized as the result of a certain filter. And since half the world uses the same filters, there is not much room for originality.

Font tools that offer filtering are not yet very common, and filters as plug-ins for font editors do not exist at all. A lot of type-filtering designers use graphics software to modify their fonts. However, Altsys (now Macromedia) once made a tool called Fontomatic that was designed

to modify existing fonts. It offered some effects that were not terribly useful (for example, it filled all letters with a cow pattern), and never became a success. A more recent attempt – ParaNoise by ParaType – seems to be a bit cleverer: there are lots of parameters and one can layer different effects. Still, the effects are all preprogrammed and therefore quite predictable, and predictability is the last thing a designer should want!

Modifying existing typefaces (preferably one's own!) can be an interesting process. It would be a fast way to experiment with different shapes, but since we don't want to use filters made by others, we have to make our own. Unfortunately, until very recently, there were no tools on the market to do this easily. Petr van Blokland (Erik's brother), who has been developing his own font-editing tools since the early 1980s produced the fully programmable font editor. Macromedia gave their permission for him to use the source code of Fontographer 3.5 and by adding a scripting language, van Blokland (with some help from us) transformed the old program RoboFog.

RoboFog is the name of the new incarnation of old faithful Fontographer 3.5. It has become a two-headed bionic dragon (Fontographer and a full fledged programming language), merged into a single application, with lots of wires running between the two heads. The programming language is Python (powerful, yet easy to learn), which was (and is) developed by Guido van Rossum (Just's brother). It allows one to automate many parts of the type-design process – which involves many repetitive tasks – and to experiment with modifying or creating fonts. Finally individual font filters can be created! The process involves writing a code that modifies an outline and then applying that code to all outlines in the font, or even to all fonts in a folder.

RoboFog is (s)lightly marketed to a professional audience, so others besides us can benefit from its almost endless possibilities (note: some programming skills required!).

Now that designers can program their own filters, there is no need to recycle old ones or to wait for a programmer to come up with ideas for you. Just write a new filter when you need one! Make tools you only need once! Whether you take an existing filter and add something new to it, or you start from scratch, a small change in the code of the filter produces big graphic effects in the type. The homemade filters work as tireless robots in your own font factory, where existing fonts are refitted with new outlines, taken apart and reassembled. The filters can be adjusted either to amplify the good results or to reduce unwanted effects. The filter is the design, the font is just the medium.

Is it really type design? Perhaps filtering type has more to do with typography – the application of type. All filtered fonts are derived works and have to credit the original design, even if it has changed beyond recognition. However, the filter itself can be an original design.

Even with handmade filters, things will begin to look repetitive and predictable at some point. Eventually, new unfiltered typefaces will have the edge over filtered ones. But, in the meantime, there is plenty of opportunity to have fun.

The filters are dead, long live the filters!

Type Design: Nancy Mazzei, Brian Kelly _Teenager

Garagefonts

Location_Del Mar, California, USA

Established_1993

Founders_Betsy Kopshina, Norbert Schulz

Type designers_Mike Bain, Timothy Glaser
Mary Ann King, Betsy Kopshina
Brian Kelly, Nancy Mazzei
Rodney Shelden Fehsenfeld
Gustavo Ungarte and many more

Distributors_Agosto Inc., FontShop
International (FSI), ITF Phil's Fonts

Putting a good face on the future

Garagefonts was created in 1993 primarily as
a vehicle to distribute the experimental fonts
used in Ray Gun magazine, when art direction
was by David Carson Studios. During the period
from 1994 to 1998, the font collection grew
substantially and took on a noticeably more
international flavour. The library illustrates
the trend in experimental design and provides
an alternative to traditional type. Most of the
fonts are created by professional designers
and art students from countries around the
world including Australia, Canada, Iceland,
Italy, Germany and Singapore. Each font comes
complete with international characters and
all spacing, kerning and construction have
been thoroughly tested. Garagefonts will be
introducing new fonts regularly and present-
ing limited-edition faces.

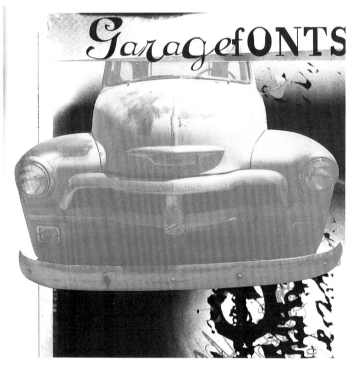

Font catalogue, 1994
18 pages, 2-colour
14 x 14 cm

Design: Betsy Kopshina
Type design: Rodney Shelden Fehsenfeld _Radiente

_Canadian Photographer Script

Pages from the font catalogue, 1994

Design: Betsy Kopshina
Type design: Nancy Mazzei
Brian Kelly _Gladys

Mike Bain _Tooth

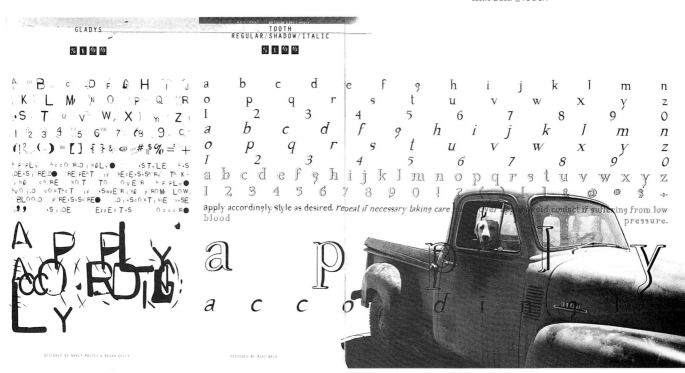

Type design: Rodney Shelden Fehsenfeld _Canadian Photographer Script

ABCDEFGHIJKLMNOP

QRSTUVW

Type design: Nancy Mazzei, Brian Kelly _Gladys

GarageFONTS
ORDER FORM

THE EVOLUTION OF TYPE

PRODUCT NAME		PRICE	IF YOU PURCHASE:
			2-4 FONT FAMILIES: DISCOUNT 10%
			5-10 FONT FAMILIES: DISCOUNT 15%
			10-15 FONT FAMILIES: DISCOUNT 20%
			15 OR < FONT FAMILIES: DISCOUNT 25%

DISCOUNT (SEE DISCOUNT SCHEDULE)
ADD 7% STATE TAX IF IN CALIFORNIA:
SUBTOTAL:
SHIPPING (SEE RATES CHART):
□ ECONOMY □ EXPRESS □ OVERNIGHT □ MY OWN FED-EX #
TOTAL:

FONT FAMILIES MAY CONSIST
OF ONE TO SIX FONT FACES.
IT DEPENDS ON THE PARTICULAR FAMILY.

GARAGEFONTS T-SHIRT: $15
OR FREE WITH THE PUCHASE OF
5 OR MORE FONTS.

FONT FORMAT (CHECK ONE)
□ MACINTOSH POSTSCRIPT □ MACINTOSH TRUETYPE □ IBM/PC
DELIVERY ADDRESS:
NAME:
COMPANY:
ADDRESS:
CITY: STATE: ZIP:
PHONE: FAX:

MAIL ORDERS: MAIL CHECK OR MONEY ORDER IN US FUNDS. PAYABLE TO
GARAGEFONTS THROUGH A US BANK. (WIRE ALL FUNDS THROUGH A US BANK.) COMPLETE
AND ENCLOSE THIS FORM (OR A COPY OF THIS FORM) TO:

703 STRATFORD COURT #4, DEL MAR, CA 92014
PHO & FAX 619-755-4761

U.S. SHIPPING	
U.S [ECONOMY] 1-2 WEEKS	$3.00
U.S [EXPRESS] 2 DAY	$6.00
U.S. [EXPRESS] OVERNIGHT	$15.00
FOREIGN SHIPPING:	
CANADA [ECONOMY] 2-5 WEEKS	$4.00
CANADA [EXPRESS] 2-4 DAYS	$25.00
EUROPE [ECONOMY] 2-5 WEEKS	$8.00
EUROPE [EXPRESS] 2-4 DAYS	$40.00
ASIA [ECONOMY] 2-5 WEEKS	$11.00
ASIA [EXPRESS] 2-4 DAYS	$45.00

DESIGN/PHOTOGRAPHY/PRODUCTION BY BETSY KOPSHINA
PREPRESS/PRINTING BY CONKLIN LITHO

Pages from the font catalogue, 1994

Design: Betsy Kopshina
Type design: Rodney Shelden Fehsenfeld _Radiente
_Canadian Photographer Script
_Pure

XYZ

Letterhead for Garagefonts, 1995

Design: Betsy Kopshina
Type design: Mike Bain _Tooth 31 Shadow

Rodney Shelden Fehsenfeld _Pure Capital

garagefonts

✎ 2478 CARMEL VALLEY ROAD , DEL MAR CA 92014

1994© garagefonts
THE EVOLUTION OF TYPE
703 STRATFORD COURT #4
DEL MAR, CA 92014

Back cover of the font catalogue, 1994

Design: Betsy Kopshina
Type design: Rodney Shelden Fehsenfeld _Pure Capital

SWANSEA COLLEGE
LEARNING CENTRE
LLWYN-Y-BRYN
77 WALTER RD., SWANSEA SA1 4RW

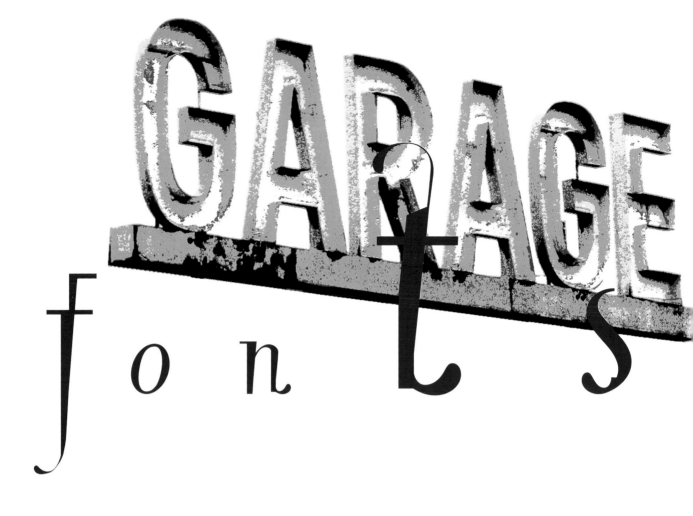

GARAGE fonts

WHEN ITS LATE AND YOU NEED THE **PERFECT FONTS** *RIGHT NOW* TO MAKE YOUR PROJECT WORK, GO TO **WWW.GARAGEFONTS.C** AND EXPERIENCE

ELECTRICHIDE TRANSMISSION

WE DON'T KEEP YOU WAITING BY THE MODEM OR THE MAIL
BROWSE, ORDER, CHARGE IT (SECURELY) AND DOWNL
THEN GO—CREATE—WIN AWARDS—MAKE MONEY—WHATE
JUST COME BACK WHEN YOU HAVE MORE

See the winners of the first international font design
contest sponsored by GarageFonts and Macromedia.

We're offering special deals on the Ray Gun Classics
as we prepare to put them out to pasture.
Get 'em while you can.

SeEk FULFILLMENT

144

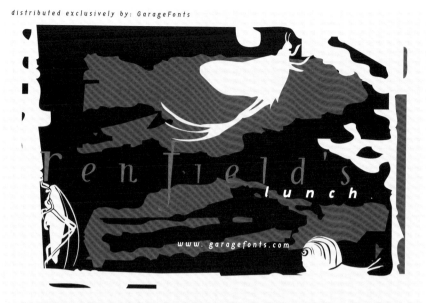

renfield's
lunch.

www. garagefonts.com

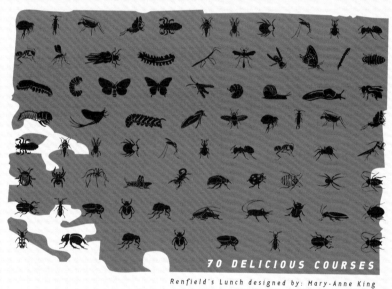

70 DELICIOUS COURSES

Renfield's Lunch designed by: Mary-Anne King

Flyer to promote Renfield's
Lunch, spring 1998

Design: Betsy Kopshina
Type Design: Mary Ann King _Renfield's Lunch Dingbats

Thomas Schnaebele _Café Retro Bold, Black

Timothy Glaser, Josh Darden _Index Italic

Christine Taylor _Hegemonic

←
Poster advertising on-line
ordering system, 1998

Design: Betsy Kopshina
Type design: Christine Taylor _Hegemonic

Timothy Glaser, Josh Darden _Index Italic

Gustavo Ungarte _Conectdadots Interleave

Thomas Schnaebele _Café Retro Bold

_Dualis Italic

Interactive design for the multimedia piece In Search of the Next Big Whatever, about the Design Contest, spring 1998, organized by Garagefonts/Macromedia.

Design: Betsy Kopshina

146

FIRST PLACE HEADLINE

CONNECT DADOTS

GUSTAVO ENRIQUE UGARTE

FIRST PLACE DINGBAT

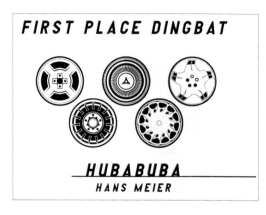

HUBABUBA

HANS MEIER

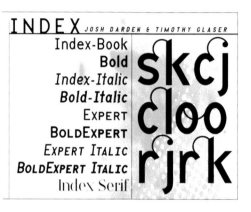

INDEX *JOSH DARDEN & TIMOTHY GLASER*

Index-Book
Bold
Index-Italic
Bold-Italic
EXPERT
BOLDEXPERT
EXPERT ITALIC
BOLDEXPERT ITALIC
Index Serif

skcj cloo rjrk

HONORABLE MENTION HEADLINE

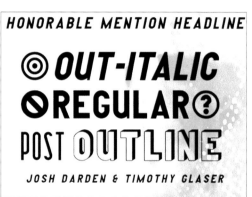

◎ *OUT-ITALIC*
⦸ REGULAR ⦾
POST OUTLINE

JOSH DARDEN & TIMOTHY GLASER

Garagefonts and Macromedia joined forces to sponsor a major international font design contest. Entries were judged by internationally acclaimed graphic designers Neville Brody and David Carson and by authors Steven Heller and Robin Williams. Submissions were accepted in three categories: text, headline/experimental and dingbats. In addition to cash prizes and Macromedia software, winners were offered licensing agreements for worldwide distribution through Garagefonts.

THIRD PLACE DINGBAT

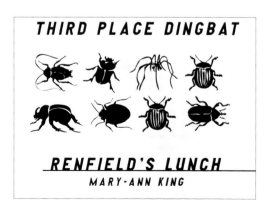

RENFIELD'S LUNCH

MARY-ANN KING

niños sueltos

Typo ruler (useless) 1994
5 x 20 cm
Based on the measuring system garcia

Design: Typerware
Type design: Andreu Balius _Playtext

Typerware _Tiparracus

_Ozó Type

garcia fonts & co.

Location_ Barcelona, Spain

Established_ 1993

Founders_ Andreu Balius, Joan Carles P. Casasín

Type designers_ Laudelino L.Q., Estudi Xarop
Alex Gifreu, Pablo Cosgaya
Peter Bil'ak, Agente Doble
Malcolm Webb, David Molins
Typerware, Andreu Balius

Distributors_ garcia fonts & co., ITC, FontShop
International (FSI)

Type is not sacred. Type is POPULAR!

garcia fonts & co. is a digital typeface project,
founded in spring 1993 by Andreu Balius and
Joan Carles P. Casasín in Barcelona. The fonts
are obtained by exchange with a personally
designed font. Everyone who sends in a font
receives material from the library, but only
the most interesting contributions are shown
in the frequently published brochures. The
fonts are exclusively distributed for experi-
mental and personal use. If studios or agen-
cies want to use fonts for commercial purpo-
ses, they can buy the ones designed by Andreu
Balius and Joan Carles P. Casasin, which are
published under the name Tw®Font Foundry,
affiliated with their design studio Typerware
(see p. 272).

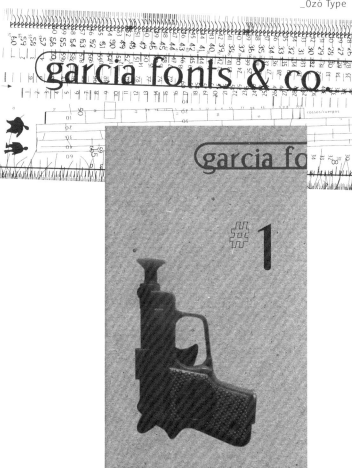

Catalogue 1, Library #1–#6, 1995
Brochure, 40 pages
10 x 21 cm

Design: Typerware
Type design: Andreu Balius _Playtext

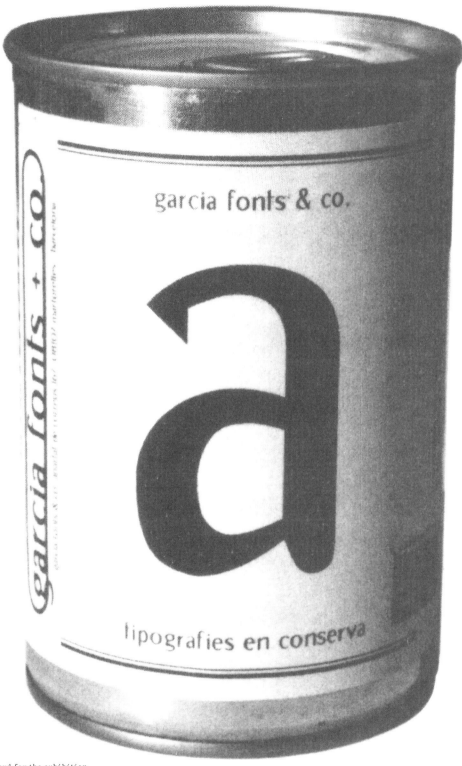

Invitation postcard for the exhibition
<u>garcia fonts & co. tipografies en conserva</u>
in Vic, 1995.

Design | Type design: Andreu Balius _Playtext

Tiparracus type specimen
included in Library #5, 1994.
10 x 21 cm

Design: Andreu Balius
Type design: Andreu Balius _Playtext

Typerware _Tiparracus

Pages from Library #5, 1994
40 x 42 cm
Matilde Script type specimen

Design | Type design: Andreu Balius _Matilde Script

tiparracus 1

garcia fonts & co.
(a font affair)

Matilde Script

Aa Bb Cc Çç Dd Ee
Ff Gg Hh Ii Jj Kk
Ll Mm Nn Ññ Oo
Pp Qq Rr Ss Tt Uu
Vv Ww Xx Yy Zz

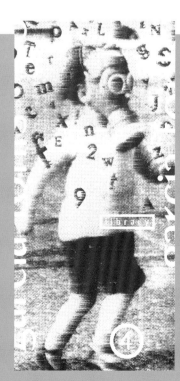

Library #4, 1994
10 x 21 cm
Ozó type specimen

Design: Andreu Balius
Type design: Typerware _Ozó type

Andreu Balius _Playtext

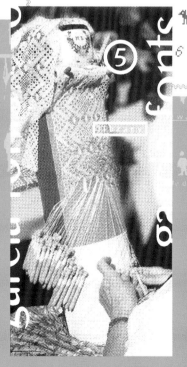

Library #5, 1994
10 x 21 cm
Matilde Script type specimen

Design | Type design: Andreu Balius _Playtext

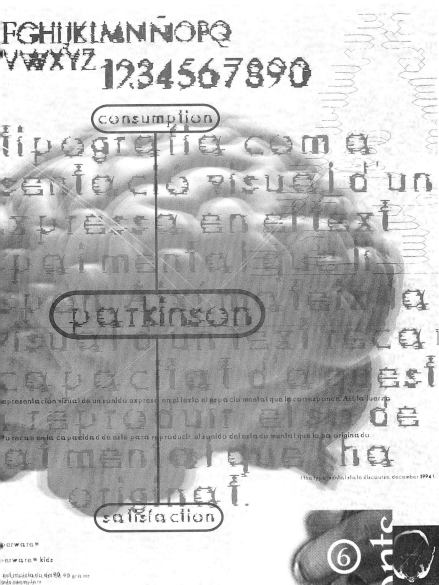

FGHIJKLMNÑOPQ
VWXYZ 1234567890

consumption

tipografia com a
sentido visual d'un
xpressa en el text
pai mental qual s
visual d'un text ca
c apacial d'aquest
c reproduir el so de
al mental qual e ha
original.

parkinson

presentación visual de un sonido expresa en el texto el espacio mental que le corresponde. Así la fuerza

o recae en la capacidad de este para reproducir el sonido del estado mental que lo ha originado.

satisfaction

(the type mental z is la discourse december 1994)

parware™

arware™ kids

st recicla de de 90, 90 grams
xís exemplars

Pages from Library #6, 1994
40 x 42 cm
Parkinson type specimen

Design: Andreu Balius
Type design: Typerware _Parkinson

Type specimen for
FontSoup light, regular,
boiled, extraboiled, vomited
and Garcia Snacks, 1995
10 x 21 cm
FontShop now exclusively
distributes the redesigned
version.

Design: Andreu Balius
Type design: Typerware _FontSoup
_Garcia Snacks

Andreu Balius _Playtext

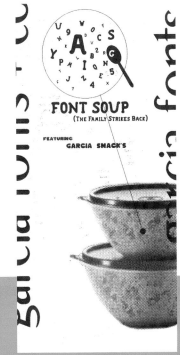

FONT SOUP
(THE FAMILY STRIKES BACK)

FEATURING GARCIA SNACK'S

garcia fonts

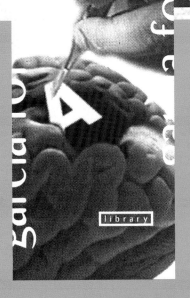

⑥

a fonts

library

Library #6, 1994
10 x 21 cm
Parkinson type specimen

Design | Type design: Andreu Balius _Playtext

Pages from Library #7, 1995
40 x 42 cm
Belter type specimen folder,
now exclusively distributed by ITC.

Design: Andreu Balius
Type design: Typeware _Belter Regular, Outline,
Extra Outline

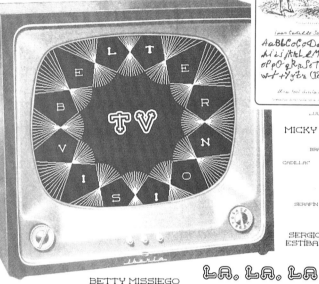

Pages from Library #8, 1995
40 x 42 cm
Juan Castillo Script type
specimen. The typeface is
based on the handwriting of
an old man from Albacete

Design: Andreu Balius
Digitization: Typeware _Juan Castillo
Script Fina,Regular

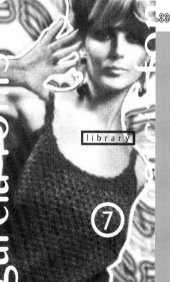

Cover for Library #7, 1995
10 x 21 cm
Belter type specimen

Design: Andreu Balius
Type design: Typeware _Belter

Andreu Balius _Playtext

Cover for Library #8, 1995
10 x 21 cm
Juan Castillo Script type specimen

Design | Type design: Andreu Balius _Playtext

Page from Library #11, 1996
40 x 42 cm

Design | Type design:
Malcolm Webb _Network

Library #11, 1996
10 x 21 cm
Network and Jam Jamie
type specimen

Design: Malcolm Webb, Alex Gifreu
Type Design: Andreu Balius _Playtext

Library #12, 1998
10 x 21 cm
Inmaculatta and Euroface
type specimen

Design: Agente Doble, Peter Bil'ak
Type design: Andreu Balius _Playtext

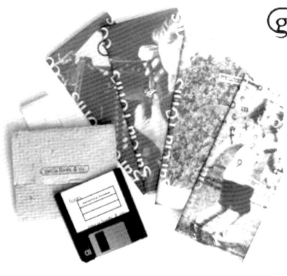

garcia for

Quicktime shows with music,
1996
The shows are distributed
with the fonts (on floppy disk).
They begin with a photo-
graph of the brochures and
packaging and go on to
present pictures and illus-
trations to promote the fonts.

Design: Andreu Balius

Digitization: Typerware _Vizente Fuster

Type design: Andreu Balius _Matilde Script

garcia bitmap

Type design: Andreu Balius _Garcia Bitmap

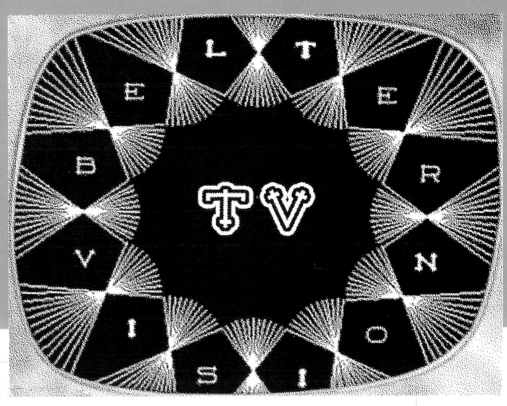

Promotional film for Belter, with music from the Sixties, 1996

Design: Andreu Balius
Type design: Typerware _Belter

THE BELTER SHOW

BELTER

Pictures from
the Quicktime show, 1996

Design: Andreu Balius
Type design: Typerware _Belter

ABCDEFGHI
JKLMNOPQ
RSTUVWXYZ

155

House Industries

Location_ Wilmington, Delaware, USA

Established_ 1993

Founders_ Andy Cruz, Rich Roat

Type designers_ Andy Cruz, Allen Mercer
Ken Barber, Jeremy Dean
Kristen Faulkner, Nicole Michels
David Coulson, Tal Leming

Distributors_ House Industries,
FontShop International (FSI), Atomictype

Slapping a reference book on the scanner
and boosting images isn't our bag.

After a modest beginning in 1993, House Industries'
reputation for dependability, integrity, stubbornness
and overpackaging has grown to put them at the
forefront of the display typographic trade.

All House Industries merchandise is unique and is created
to the highest level of craftsmanship. The most popular font
collections begin where display type should – as pencil
sketches on paper. Only after diligent artists have finessed
each complete character set in pen and ink does it enter the
digital realm. There aren't any computer-enhanced filter fonts
or overused designer clichés in the House Industries library,
just revivals of all the cool old stuff that everyone else is too
lazy to draw these days. The same work ethic goes into House
Industries' commercial illustration projects, T-shirt collec-
tions and product packaging. All illustrations, paintings and
type treatments are exhaustively refined by the overworked
and underpaid House Industries staff.

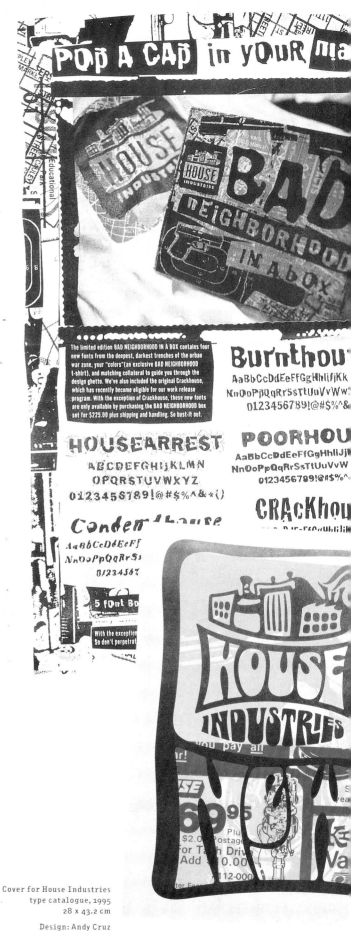

Cover for House Industries
type catalogue, 1995
28 x 43.2 cm

Design: Andy Cruz
Hand lettering: Andy Cruz, Allen Mercer _Custom type

T-SHIRTS

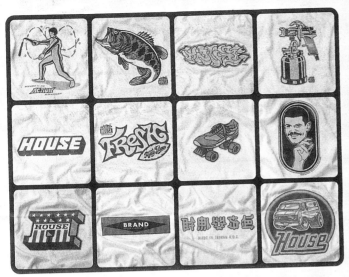

HOUSE MULTI-COLOR DESIGNER T'S ON 100% PRE-SHRUNK COTTON. (L TO R)
HOUSE OF FU, BASS, GRAFITTI, METALFLAKE, STOCKCAR, FRESH, SKATE, HANDSOME,
SPIRIT OF '76, BRAND, TAIWAN, AND VAN. THESE SHIRTS ARE PERFECT FOR CLIENT
MEETINGS AND THEY MATCH ALMOST ANY SOCK COLOR. ONLY $20 BUCKS EACH.

FACTORY-T

THE ORIGINAL HOUSE INDUSTRIES FACTORY LOGO T-SHIRT IS AVAILABLE IN A WIDE
VARIETY OF FABRIC AND INK COLORS, AND IT'S STILL A STEAL AT JUST $12. THE
HOUSE FACTORY LOGO T-SHIRT IS FREE WITH THE PURCHASE OF 10 OR MORE FONTS.

HATS

HOUSE INDUSTRIES HEAD GEAR. BLACK HATS
EMBROIDERED WITH WHITE HOUSE LOGO. AVAIL-
ABLE IN CAP AND SNOW SHOVELER FORMATS.
GUARANTEED TO FIT ANY HEAD. $15 EACH.

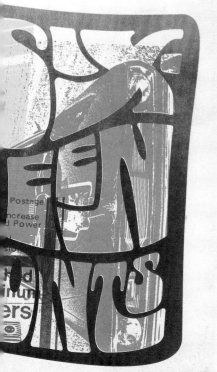

Logo for Paper Line
(Custom Papers Group), 1995

Design | Hand lettering: Andy Cruz
Allen Mercer _Custom type

House Industries type catalogue, 1995
28 x 43.2 cm

Design: Andy Cruz
Hand lettering: Andy Cruz
Allen Mercer, Ken Barber _Custom type

Type design: Jeremy Dean _Burnthouse
_Poorhouse
_Crackhouse
_Condemnedhouse
_Housearrest

15

Super Riegel Custom shop
manual paper promotion, 1995
14 x 21.6 cm
Several of the headlines and type
treatments in this piece and
the Super Riegel Custom logo
were the inspiration behind the
House Street Van font collection.

Design: Andy Cruz, Rich Roat, Allen Mercer
Hand lettering: Andy Cruz, Allen Mercer _Custom type

Type design: Allen Mercer _Horatio

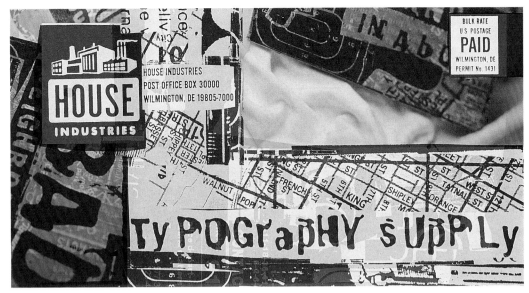

Bad Neighbourhood catalogue, 1995
15.3 x 28 cm

Design: Andy Cruz, Jeremy Dean
Hand lettering: Jeremy Dean _Custom type

Dragster catalogue, 1996
15.3 x 28 cm

Design: Andy Cruz, Allen Mercer, Ken Barber
Hand lettering: Andy Cruz, Allen Mercer _Custom type

Minty Fresh catalogue, 1995
15.3 x 28 cm

Design: Andy Cruz, Allen Mercer
Jeremy Dean
Hand lettering: Andy Cruz, Allen Mercer _Custom type

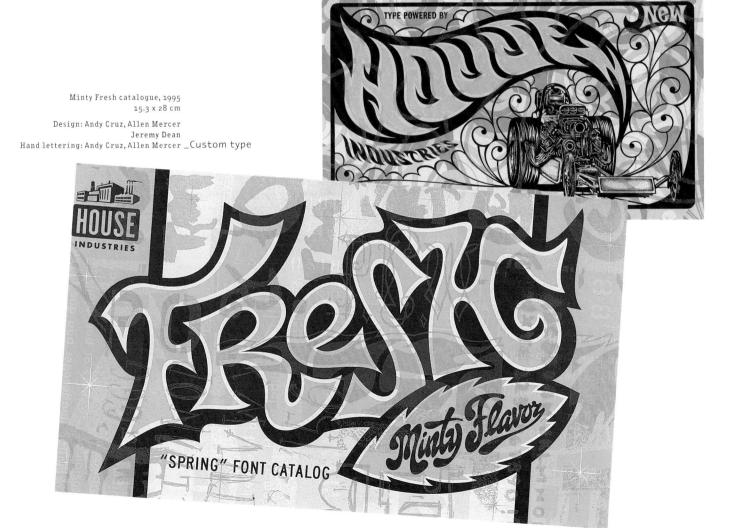

Black Leatherette catalogue cover, 1994
15.3 x 28 cm

Design: Andy Cruz
Hand lettering: Andy Cruz, Allen Mercer _Custom type

FUNKHOUSE

ABCDEFGHIJ
KLMNOPQRST
UVWXYZ
1234567890

KATHOUSE

AaBbCcDdEeFfGg
HhIiJjKkLlMmNnOo
PpQqRrSsTtUuVv
WwXxYyZz
1234567890

SCÜBYZHOUSE

AaBbCcDdEeFfGgHhIi
JjKkLlMmNnOoPpQq
RrSsTtUuVvWwXxYyZz
1234567890

CRACKhouse

AaBbCcDdEeFfGgHh
IiJjKkLlMmNnOoPpQq
RrSsTtUuVvWwXxYyZz
1234567890

WAREHOUSE

ABCDEFGHIJ
KLMNOPQRST
UVWXYZ
1234567890

Rougfhouse

AaBbCcDdEeFfGgHh
IiJjKkLlMmNnOoPpQo
RrSsTtUuVvWwXxYyZz
1234567890

Spread from black Leatherette
catalogue, 1994
15.3 x 28 cm

Design: Andy Cruz
Type design: Allen Mercer _Funkhouse
_Kathouse
Kristen Faulkner _Scübyzhouse
Jeremy Dean _Crackhouse
Andy Cruz _Warehouse
_Rougfhouse

Housemaid

AaBbCcDdEeFfGgHh
IiJjKkLlMmNnOoPpQq
RrSsTtUuVvWwXxYyZz
1234561890

TREEHOUSE

AaBbCcDdEeFfGgHhIi
JjKkLlMmNnOoPpQqRr
SsTtUuVvWwXxYyZz
1234567890

CHOPHOUSE

AaBbCcDdEeFfGgHhIi
JjKkLlMmNnOoPpQqRr
SsTtUuVvWwXxYyZz
1234567890

FUNHOUSE

ABCDEFGHIJ
KLMNOPQRST
UVWXYZ
1234567890

"HEADS OF THE HOUSEHOLD"

Doghouse

AaBbCcDdEeFfGgHh
IiJjKkLlMmNnOoPpQq
RrSsTtUuVvWwXxYyZz
1234567890

Spread from black Leatherette
catalogue, 1994
15.3 x 28 cm

Design: Andy Cruz
Type design: Kristen Faulkner _Housemaid

Ken Barber _Heads of the Household

Allen Mercer _Chophouse

_Treehouse

_Funhouse

Nicole Michels _Doghouse

ITC

Location New York, USA

Established 1973

Founders Herb Lubalin, Aaron Burns

Type designers Herb Lubalin, Ed Benguiat, Aldo Novarese
Mark Jamra, David Farey, Robert Slimbach
Hermann Zapf, Matthew Carter, Sumner Stone
David Quay, José Mendoza and many more

Distributors Adobe, Agfa, Bitstream, Elsner+Flake
FontShop International (FSI), FontWorks
Linotype Library, Monotype Typography
Precision Type, Treacyfaces

Inform and inspire the design community

An international leader in typeface design and
marketing for over twenty-five years, ITC col-
laborates with world-class designers to pro-
vide a library of over 1200 classic typefaces
and innovative new designs, as well as comple-
mentary products for digital design. ITC
licenses its typeface library to more than 130
companies in the graphic design, computer and
printing technology fields throughout the
world . As part of its commitment to informing
and inspiring the design community, ITC pub-
lishes the award-winning quarterly publica-
tion U&lc (Upper & Lower Case: The Interna-
tional Journal of Graphic Design and Digital
Media), where new ITC typefaces are introduced
and shown in use. The on-line edition of the
journal can be found at www.uandlc.com. ITC's
website, located at www.itcfonts.com, provides
typographic information, resources and tools,
as well as an on-line type shop.

U&lc cover, volume 25
number 2, Fall 1998
21.2 x 27.5 cm

Design: Mark van Bronkhorst
MvB Design

: 3317-18TH AVENUE SOUTH

SE : THE INTERNATIONAL JOURNAL OF GRAPHIC DESIGN AND DIGITAL MEDIA
EFACE CORPORATION : VOL.25 NO.2 : FALL 1998 : $5 US $9.90 AUD £4.95

U&lc back cover, volume 25
number 2, Fall 1998
21.2 x 27.5 cm

Design: Mark van Bronkhorst
MvB Design

U&lc inside pages, volume 25
number 2, Fall 1998
21.2 x 27.5 cm
Essay about the type designer
Phill Grimshaw.

Design: Mark van Bronkhorst
MvB Design
Type design: Phill Grimshaw

a particular interest, I encouraged them to pursue it rather than try and teach them within the rigid course structure." Grimshaw's regular truancy, which almost saw him expelled, was easily explained: to make enough money to get by, he had taken a part-time job stacking shelves at a local supermarket. He would do that, catch up on sleep for a couple of hours, and then work at home. "He reappeared," says Forster, "with an amazing portfolio of work. I couldn't understand how he did it, other than having an exceptional talent." At the close of the course, Forster suggested that Grimshaw take his portfolio to the Royal College of Art. The College practically fell over themselves to help him. "They were so stunned by the quality of the work," says Forster, "that they asked Phill who he wanted as his tutor."

Grimshaw studied for his master's degree in design at the Royal College of Art between 1972 and 1975. His pas-

A sampling of typeface designs and experimental sketches by Phill Grimshaw

1 ARRIBA
2 BENDIGO
3 GRAVURA
4 ITC GRIMSHAW HAND
5 HAZEL
6 ITC KALLOS
7 ITC KENDO
8 ITC KLEPTO
9 ITC NOOVO
10 ITC OBELISK
11 ITC OBERON
12 ITC BRAGANZA
13 PRISTINA
14 ITC SCRIPTEASE
15 SHAMAN
16 ITC STOCLET
17 ITC TEMPUS
18 ZAMAGOZA
19 ZENNON

sage was not without its hiccups. One winter he was so broke that he slept in a makeshift bed in the boiler room of the College. (So resourceful was his hibernatory activities the College may only discover his whereabouts on reading this piece.) On another occasion, Grimshaw and a group of like-minded rascals took a walk through the College and onto the roof of the Victoria and Albert Museum, through which one of the party fell, directly into a packed lecture theatre. His own claim to fame from the Royal College was that he once shared a sink (though not simultaneously) with David Hockney.

By and large, this was a fruitful period. Forster recalls the design of a poster for a summer dance at the College that Grimshaw created around this time. "I knew he needed a solution, and I stood and watched as he found this window that hadn't been washed for about fifteen years. He fixed his gaze, wet the end of his finger, and in the grime wrote a simple message: 'Fuck art – let's dance.'"

From the beginning he worked with a variety of implements on a variety of surfaces, only recently turning to the computer to make the final stages of application and creation a more efficient solution – almost as if, when the real joy of creation had given way to mere extension of the letterform's basic idea, he was keen to get moving on to the next one.

Many of Phill's typeface designs evolved in a similar way. Drawings were often produced while he sat in front of the television (though it was unlikely that he was concentrating on anything but the design). With a glass of single malt in one hand and a drawing implement in the other, he would cause gestural shapes, curves, sweeps, and forms to manifest themselves on as many different surfaces. Taking the short journey upstairs to his studio in a ... Phill would then work up the designs

only possible but beneficial to his own development to work in both sides."

Grimshaw also pursued a love of calligraphy which crossed over into his more "formal" typographic designs. Despite being self taught, he would often excuse his lack of a formal calligraphic training by saying, "I'm not a calligrapher, but I know how a pen handles." His work was broadly speaking experimental, and he was a regular at workshops, including one memorable visit to a session hosted by renowned lettering artist Werner Schneider. As usual Grimshaw used every implement other than a broad-edged nib to realise his ideas, much to the delight of Schneider himself, who stood wide-eyed at Phill's more "experimental" ideas. One tool Phill did favour on such occasions was a pair of pencils tied together, to create the interior and exterior shapes of letters simultaneously. Because of his enthusiasm for both areas of letterform creation, his typographic work was influenced by calligraphy and vice-versa, and he himself was influenced and encouraged by experienced practitioners in both fields. Eventually, his more calligraphic work, examples of which adorn the walls of his home, became popular with art directors in the London advertising industry, and along with half a dozen other scribes he became a founder member of Letter Exchange.

The last few years of his life were perhaps his most productive – among his most recently completed projects was the Rennie Mackintosh typeface for ITC, on which he collaborated with both Brignall and Forster, being joined ... various research trips and gallery visits. Forster

Both Forster and Brignall speak of Phill's being able to identify gaps in the typeface market. Says Brignall, "The typeface designs he produced remain high in the popularity stakes. There has always been something of a stigma attached to the fact that he created display typefaces. But in commercial terms, Phill produced work that was very successful." Phill began work for ITC at a time when sales of display type were far outstripping those of the text faces, and it happened that his personal aptitude was for the more expressive and calligraphic designs. "If profitability is a dirty word – and I know it is to some – then that was the arena that Phill worked in, and I probably influenced that," admits Brignall. Phill continually embraced, even when he wasn't practicing, the two aspects of type design. According to Brignall, "Phill always recognized the two sides of the industry, and that is not

UPPER AND LOWER CASE : THE INTERNATIONAL JOURNAL OF GRAPHIC DESIGN AND DIGITAL MEDIA
PUBLISHED BY INTERNATIONAL TYPEFACE CORPORATION : VOL. 25 NO.1 : SUMMER 1998 : $5 US $9.90 AUD £4.95

.U&lc

U&lc cover, volume 25
number 1, Summer 1998
21.2 x 27.5 cm

Design: Mark van Bronkhorst
MvB Design

newfromITC

ITC Officina® Sans & Serif

When ITC Officina was first released in 1990, as a paired family of serif and sans-serif faces in two weights with italics, it was intended as a workhorse typeface for business correspondence. Its robust structure was meant to work when printed on 300-dpi office printers, and it had the no-frills legibility of a typewriter face, although much subtler in its design. But the typeface proved popular in many more areas than correspondence. It's been used as a corporate typeface, especially by high-tech companies and car manufacturers. Erik Spiekermann, the founder of MetaDesign in Berlin, who designed the original version, says, "Once Officina got picked up by the trendsetters to denote 'coolness', it had lost its innocence. No pretending anymore that it only needed two weights for office correspondence. As a face used in magazines and advertising, it needed proper headline

text · john · berry

weights and one more weight in between the original Book and Bold. And they would all have to be available in Sans and Serif, Roman and Italics, with Small Caps and Old Style figures." To add the new weights and small caps, Spiekermann collaborated with Ole Schäfer, who is Director of Typography and Type Design at MetaDesign in Berlin. "We started work," says Schäfer, "in 1994, sending drawings and comments between Gütersloh (where I was living) and Berlin." After Schäfer started working at MetaDesign, he continued working on the Officina project with Erik on weekends. "We always work this way," says Schäfer. "Both of us draw and redraw the characters, talk about it, and put in the corrections. The digital side is mostly my part."

Spiekermann observes: "The original concept meant that Officina turned out to be a very rugged typeface, which is now proving its worth in the newest medium, online communication. I've long had the theory that faces designed to address one problem end up becoming classics – and not just these days, when the trend towards 'industrial' faces is a trend against over-designing, against decoration and all sorts of other social implications. Look at the present hits: Bell Gothic, DIN, OCR-B, Letter Gothic, Frutiger (designed for one signage project), Interstate, Officina... Even Times New Roman was designed for one project originally: rough paper, worn type, platen printing. All those faces have survived and are being used again."

See more of the new ITC Officina at
http://www.itcfonts.com/itc/fonts/index.html

ITC Officina® Serif

Officina OFFICINA Officina
Officina OFFICINA Officina
Officina OFFICINA Officina
Officina OFFICINA Officina
Officina OFFICINA Officina

ITC Officina® Sans

Officina OFFICINA Officina
Officina OFFICINA Officina
Officina OFFICINA Officina
Officina OFFICINA Officina
Officina OFFICINA Officina

Try before you buy Set your own text samples in ITC fonts with Euripides at www.itcfonts.com/itc/fonts/euripides.html

a a a a a a a a a a a a a a a a a a a a

24

25

Pages from U&lc, volume 25
number 1, Summer 1998
21.2 x 27.5 cm

Design: Mark van Bronkhorst
MvB Design
Type design: Erik Spiekermann _Officina Sans & Serif

166

Pages from U&lc, volume 25
number 1, Summer 1998
21.2 x 27.5 cm

Design: Mark van Bronkhorst
MvB Design
Type design: Slobodan Miladinov _Coconio

_Beorama

Teri Kahan _Holistics

Phill Grimshaw _Stoclet

U&lc cover, volume 21
number 4, Spring 1995
27.5 x 37.3 cm

Design: Rhonda Rubinstein

newfromITC

ABCDEFGHIJKLMNOPQRSTUVWXYZ
1234567890abcdefghijklmnopqrsturwxyz

ITC Coconino™

ITC Coconino™

ITC Coconino was created by Serbian designer Slobodan Miladinov. "The initial impulse for creating this mono-stroked typeface," says Miladinov, "was the idea of translating certain auditory impressions into type—in this case, the surprising and confusing music of the Serbian hiphop musician Voodoo Popeye." Miladinov works as an art director in Belgrade, Yugoslavia, where he is planning a new typographic magazine, to be called Typegrams. He created Coconino using a "freemouse" technique with Adobe Illustrator's freehand drawing tool. Miladinov calls this a kind of "pseudo-selflimiting computer calligraphy, which allows for a specific directness and immediacy in notation. I wanted to show a continuous transforming sensuousness of tone - from gravity via irony and burlesque to a completely idiotic tone - through the medium of type." The strokes of Coconino are simple and direct, each beginning and ending abruptly. The letters look playful, but in fact they're subtly disturbing. "The result," says Miladinov, "is an informal but not-so-funny font which, when applied, gives a specific note to the text." The typeface was named in honor of the home of the Krazy Kat comic strips.

http://www.itcfonts.com/itc/fonts/full/ITC2418.html

ITC Beorama™

Slobodan Miladinov, who designed ITC Coconino, also created the enigmatic, surreal, deceptively simple-looking drawings that make up ITC Beorama. The seeds of this font were a few colored icons done for a web issue of the cultural magazine Beorama: "decorative, almost abstract images with strong associative potential." When Miladinov expanded this into a font, he saw that he would have to "keep the directness and simplicity of style, but make them much more associatively precise, to achieve easier recognition of signs." To vary the rhythm, he combined square icon shapes with unframed illustrations. "During the work on Beorama," he says. "I found out that for me, the signs I've done are pictures, thoughts and emotions that can be touched. The choice of themes was personal, in fact it was a spontaneous, almost unconscious process with minimal intellectual attention but with the idea that it has to work in commercial use. Often, after hours of working, I achieved a different state of mind, where the idea and the realization arose simultaneously and automatically."

http://www.itcfonts.com/itc/fonts/full/ITC4058.html

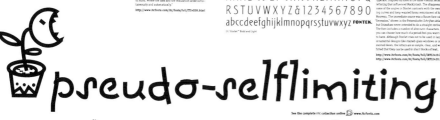

MOUNTAIN PINES CENTER FOR ETHNIC STUDIES

ITC Holistics™

AAABCDEFGHIJJKLMNOPQ
RSTUVWXYZ&1234567890
abccdeefghijklmnopqrsstuvwxyz
AAABCDEFGHIJJKLMNOPQ
RSTUVWXYZ&1234567890
abccdeefghijklmnopqrsstuvwxyz

ITC Stoclet™ Bold and Light

ITC Holistics™

California/Hawaii designer Teri Kahan, who created ITC ConnectiMiles in 1996, developed ITC Holistics to fill the need for a set of versatile symbols and iconic images that might be loosely called "new age." "Some of the pictures," she says, "come from images that I've collected all my life - found on churches or fountains. Others are things that I've never drawn before." Kahan would go through certain rituals before starting to work on each image, occasionally even saying a prayer for inspiration. She'd get her original ideas at the beach, where she took her sketchpad; then she would scan the sketches and refine them in Adobe Illustrator - always while listening to the music of Mozart. Kahan put a lot of herself into Holistics: the hands are her hands, the eye is her eye, the hair on the mermaid is her hair. "And this is the first DesignFont to incorporate type into some of its images," she says. "I used my own typefaces - the numerals from ITC Surfboard here, a bit of ITC Cherie there - and where new lettering was needed, it was my own calligraphy."

http://www.itcfonts.com/itc/fonts/full/ITC4039.html

ITC Stoclet™

ITC Stoclet is another offshoot of the research and experimentation that British type designer Phill Grimshaw did while developing ITC Benzie Mackintosh. As in the Mackintosh project, Grimshaw worked closely with Colin Brignall on this face. Stoclet is a condensed, angular typeface, inspired by some of the same Vienna Secession lettering that influenced Mackintosh. The sharpness of some of the angles in Stoclet contrasts with the sweeping curves and long-waisted forms reminiscent of Art Nouveau. The immediate source was a Bauer face called "Secession," shown in the Petersdorfer Schriften Atlas, but Grimshaw never intended to do a straight revival. The font includes a number of alternate characters, so you can choose how much of a period feel you want it to have. Although Stoclet cries out to be used in large, ornamental designs like stained-glass windows or ornamented doors, the letters are so simple, clear, and well-fitted that they can be used in short blocks of text.

http://www.itcfonts.com/itc/fonts/full/ITC2419.html
http://www.itcfonts.com/itc/fonts/full/ITC2420.html

pseudo-selflimiting

See the complete ITC collection online www.itcfonts.com

U&lc covers
volume 22, 1995
number 1, Summer
27.5 x 37.3 cm

Design: Rhonda Rubinstein

number 2, Fall
27.5 x 37.3 cm

Design: Michael Ian Kaye

number 3, Winter
27.5 x 37.3 cm

Design: Rhonda Rubinstein

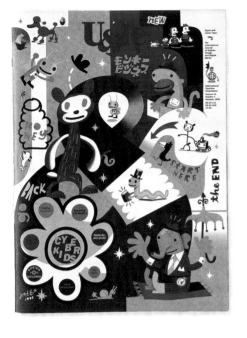

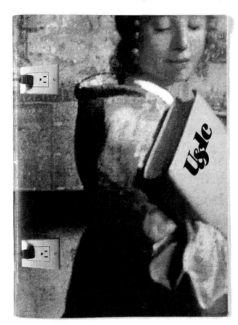

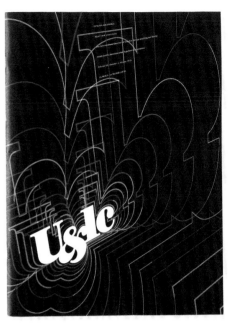

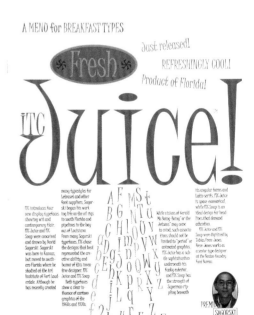

Page from U&lc, volume 21
number 4, Spring 1995
27.5 x 37.3 cm

Design: Rhonda Rubinstein
Type design: David Sagorski _Juice

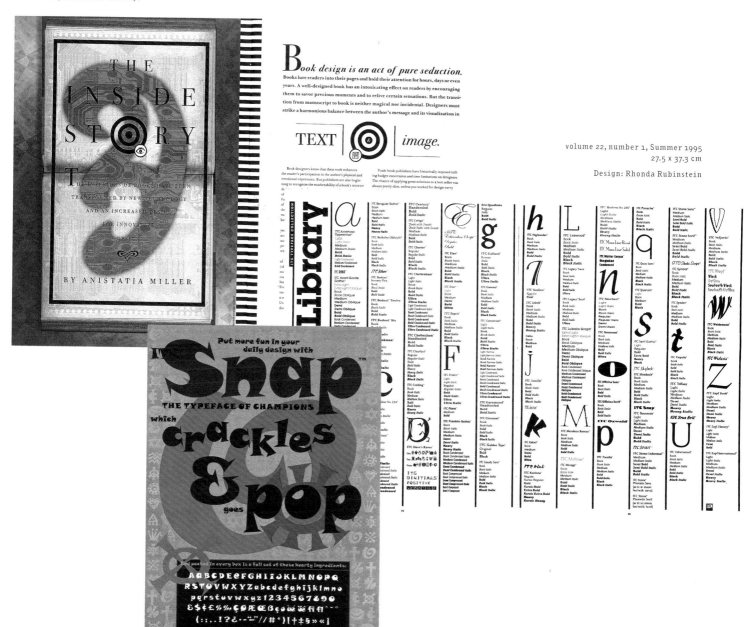

volume 22, number 2, Fall 1995
27.5 x 37.3 cm
Design: Michael Ian Kaye

volume 22, number 1, Summer 1995
27.5 x 37.3 cm
Design: Rhonda Rubinstein

Volume 21, number 4, Spring 1995
Design: Rhonda Rubinstein
Type design: David Sagorski _Snap

Pages from U&lc, volume 21 number 4, Spring 1995
27.5 x 37.3 cm
Illustration showing an album cover of the band Underworld designed by John Warwicker/Tomato.

Design: Rhonda Rubinstein

Inner sleeve for Underworld's 1993 album dubnobasswithmyheadman. "In black and white," says Tomato designer John Warwicker, "the sleeve seemed to be much more colorful, more about space and t...

By Peter Hall

Short

It's a wonder there's anything good to look at on the shelves at Tower Records. For starters, there's little money in it. The general consensus from designers is that sleeve art budgets are generally set by record companies at the lowest practical level, in case the release or the band flops miserably. If a sizeable budget is allocated, high design and production costs will often be viewed as penalty points against the band the sleeve is promoting, and offset against sales, a further disincentive against lavish packaging. Then there's the disappointing format of the CD sleeve. The old 12" record sleeve was the tactile face of rock 'n' roll, coveted by fans, as former A&M Records art director John Warwicker puts it, like "a flag of allegiance." In comparison, the CD package sometimes seems little better than a postage stamp behind scratched plexiglass. The final slap in the face is that if a piece of music sells millions, rarely will a penny in royalties go to the creator of the sleeve.

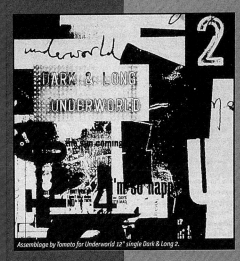

Assemblage by Tomato for Underworld 12" single Dark & Long 2.

And yet for some reason, the spirit of cover design is as alive as it ever was. A sampling of recent sleeves produced in Britain reveals a startling array of innovations and styles: deeply textured, painterly images of spaceships and dolls, assemblages of digital detritus,

The Underworld flag of allegiance.

A fresh approach to designing the incredible shrinking album cover, imported from Britain.

Sleeves

15

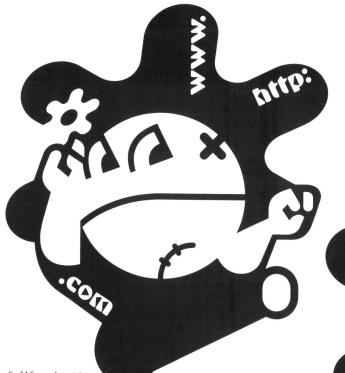

kametype

Location_ San Francisco, California, USA

Established_ 1993

Founder | Type designer_ Joachim Müller-Lancé

Distributors_ Adobe Systems, FontShop
International (FSI)

Hissatsu kozo-ken! This is the Shuriken Boy's battle cry ...

Joachim Müller-Lancé underwent a four-year training period in traditional type design with Christian Mengelt and André Gürtler at School of Design Basel, Switzerland before starting to work on Macintosh in 1987. His first digital font family (Lancé Condensed) received the Gold Prize in the 1993 Morisawa Awards, Japan. He has published three fonts with Adobe so far (Shuriken Boy, Ouch!, Flood) and one family with FontShop International (FSI) (Lancé Condensed). Kametype concentrates mainly on sans-serif display types in order to offer fonts that are definitely modern and sometimes experimental.

The mascot for the font Shuriken Boy, available under the key command shift-option-2, was used for the release of Shuriken Boy on Adobe's website, winter 1996. The Shuriken Boy and his sis are harsh pups. In their fight against legibility they've received a couple of punches in the (type)face, but they keep going.

Type design:
Joachim Müller-Lancé _Shuriken Boy

Sample art used for the release of Ouch! on Adobe's website, winter 1996. Ouch! was inspired by a sprained ankle during AtypI 95 in Barcelona. It hopes to help patients and medical professionals accept their suffering and their work with humour.

Design | Type design:
Joachim Müller-Lancé _Ouch!

→
Sample art used for the release of Shuriken Boy on Adobe's website, winter 1996. Shuriken's shapes can be used in many ways, for example, as Triangulito, a new cyberstyle construction toy for the young engineer.

Design | Type design:
Joachim Müller-Lancé _Shuriken Boy

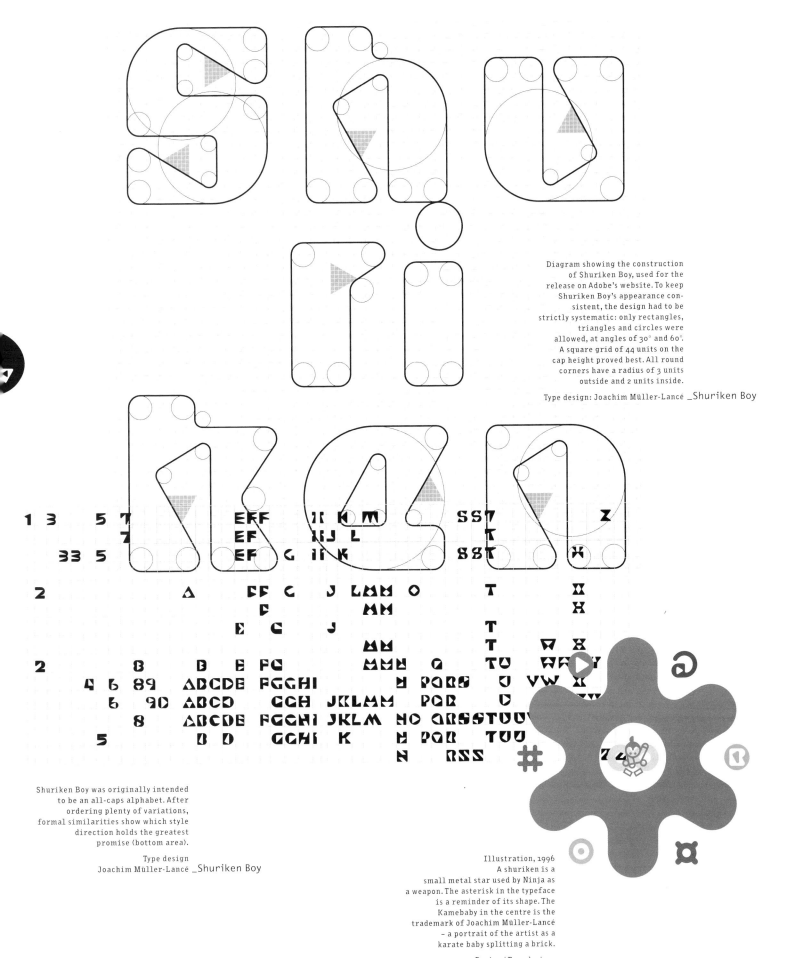

Diagram showing the construction of Shuriken Boy, used for the release on Adobe's website. To keep Shuriken Boy's appearance consistent, the design had to be strictly systematic: only rectangles, triangles and circles were allowed, at angles of 30° and 60°. A square grid of 44 units on the cap height proved best. All round corners have a radius of 3 units outside and 2 units inside.

Type design: Joachim Müller-Lancé _Shuriken Boy

Shuriken Boy was originally intended to be an all-caps alphabet. After ordering plenty of variations, formal similarities show which style direction holds the greatest promise (bottom area).

Type design
Joachim Müller-Lancé _Shuriken Boy

Illustration, 1996
A shuriken is a small metal star used by Ninja as a weapon. The asterisk in the typeface is a reminder of its shape. The Kamebaby in the centre is the trademark of Joachim Müller-Lancé – a portrait of the artist as a karate baby splitting a brick.

Design | Type design:
Joachim Müller-Lancé _Shuriken Boy, Girl

173

_A Word from the Laboratory of the Visual

Rian Hughes

Design is about making maps. First, maps using signs and symbols from the cultural background the designer finds her/himself in. Second, maps using colour, shape and composition for their raw aesthetic impact. The first comes from the outside in, the second from the inside out. The first is informed by observation, the second by intuition. The first can be taught, the second, well…

A successful piece marries these two sides together, like lyrics and song, into a satisfying whole. A lot has been written about the first, because it has as its source history, culture and politics and it is easy for the journalist to draw out influences and structure a critique. The second is only made understandable and concrete by carrying it out. It's the difference between reading about a song in a music review, and the experience of the hairs on the back of your neck rising at that certain chord change. If everything that made design important could be written down, there would be nothing left for design to do.

If design is about making maps, it's obvious what kind of mapmaking we are doing in the first instance. We are using familiar signs, whether they be words, type styles, logos or even national flags to communicate something about the outside world, for example, to sell a product, campaign for a cause or to rally for an ideology. Communication has to be direct and powerful – there is little room for anything but the familiar, the iconic.

The maps that we produce in the second instance are an altogether more subtle and, I feel, more interesting affair. The process of making a piece of new design or the process of creating any art form, is the mapping of uncharted territories. These lands are, on the obvious level, geometrical or mathematical; they certainly have an internal logic, but it does not derive from the cultural, social world. They lie beyond that – they are places of elemental form and shape, harmony, beauty and proportion, law and number.

However, in the making, the maps become physical and, to those with the eyes to see them, serve as windows in the real world that look out on to these unknown lands. Once brought into actuality, however, any piece becomes part of the culture, another reference point that informs the next round of creation. A feedback loop exists wherein ideas or discoveries are commodified and become recognized symbols, surviving until, like last year's fashions, the deeper ideas that informed them become discredited or transformed into something new. All of a sudden, what seemed like a work of genius will seem facile and hollow; but it's time will come around again, and as an icon with a culturally acknowledged meaning it will have power once more.

This is a macrocosm of the process that goes on when an individual piece of work is produced: various avenues are explored, colour combinations are tried out and layouts are changed around to see what happens. Some arrangements will say what you set out to say, some will say something else, or something confused, or even nothing at all. The process of sketching, changing and refining happens in a much shorter space of time, but is still reflected in the aesthetic evolution of the world at large.

Like all maps of the more familiar kind, any piece of design has to be self-consistent. It also has to define what it is trying to achieve (whatever that may be) and be rigorous in its assessment of the success or failure of individual elements to carry, expand upon and elucidate the whole. This applies to both the threads mentioned above but, of course, judging how you are doing on the first count is easier than judging how you are doing on the second.

An example: red can mean several things by connection to its historical use or by analogy. It can mean blood, it can mean Communism, it can mean anger. But put red next to orange or lilac, or within an amorphous blob, and its symbolism is less obvious. At some stage, we move beyond implied meaning and into new territory where our only guide is a gut feeling that is impossible to break down into a series of set rules (the ones so loved by marketing types), where x inevitably leads to y. At this point, you are writing in the ur-language, the meta-language of nature in the raw. Even at this stage, it is impossible to discard completely all the baggage the first approach brings. The challenge is to use this constructively, to make it work for you.

I see no distinct division between typography and illustration or illustration and graphic design; the same universal aesthetic concerns underlie them all. However, type design seems the sharpest tool of all with which to probe this subatomic realm of form and shape, like a physicist in the laboratory of the visual. The essentials of curve and line, vertical and horizontal are immediate concerns that, on larger real-life scales, can still convey a specific atmosphere, ranging from a futuristic twenty-year-old TV optimism to yesterday's cracked Paris Métro vinyl warning sign.

Typography illustrates both sides in a pure manner, and the historical and cultural connotations are merely a starting point. A font is available to other designers and the use (and abuse) it gets after leaving its creator will shape its perceived future meaning in ways that are impossible to foresee. Type evolves after escaping the design laboratory and the most virulent strains that end up articulating the Zeitgeist have a life of their own.

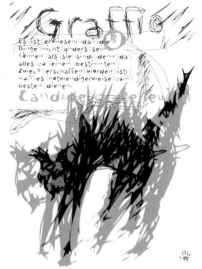

Postcard for FF Graffio, 1995
Graffio means scratching: it seems to
go deep into the flesh, leaving behind
marks, inciting aggression and fear.
But in the end it is only the scratching
of a nice little cat that needs a little
sleep. There is also a pictogram series
for non-verbal communication that
matches the font.

Design | Type design: Alessio Leonardi _Graffio

Alessio Leonardi

Location Berlin, Germany

Established 1990

Distributors FontShop International (FSI)
Linotype Library, Fontology

The important thing is to travel. Even if
one finally ends up in familiar towns again,
one sees them through different eyes.

For Alessio Leonardi, the teachings of the old masters are the
starting points for new journeys and discoveries: one should
first question the typographical inheritance of the past in
order to use it. Instead of merely imitating it, one must really
understand this geneology in order to create design innova-
tions that build on it.

Catholic priests and nuns guided his upbringing during the
first eighteen years of his life. He learned from them that one
should not believe in an ideology without being able to discuss
it. The religious way of thinking has since taken a place in his
life similar to that of a counterpunch of a letter.

After studying visual communications at the ISIA in Urbino,
Alessio Leonardi went to MetaDesign in Berlin in 1990 where
he was introduced to many new aspects of typography. This
brought structure to the ideas and impulses that he brought
from Italy.

Alessio Leonardi has been working as a self-employed designer
and font-maker since 1994. With Priska Wollein, he founded the
design studio Leonardi. Wollein in 1997. The intensive analysis
of the interplay of form and content and their respective
functions within communication stand at the centre of his
commercial and experimental work.

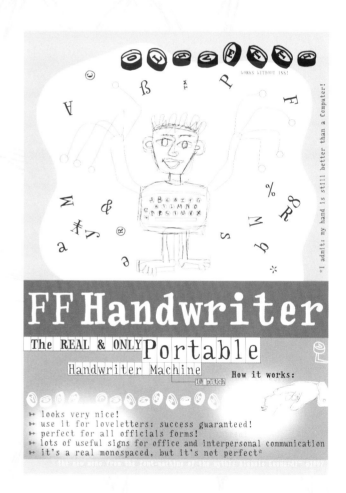

Postcard for FF Handwriter, 1998
Handwriter is a hand-written
monospace font: the perfection of the
digital is questioned in an ironic
way through the imperfection of the
characters. The Handwriter
pictograms are useful for
communication between people
and love letters.

Design | Type design: Alessio Leonardi _Handwriter

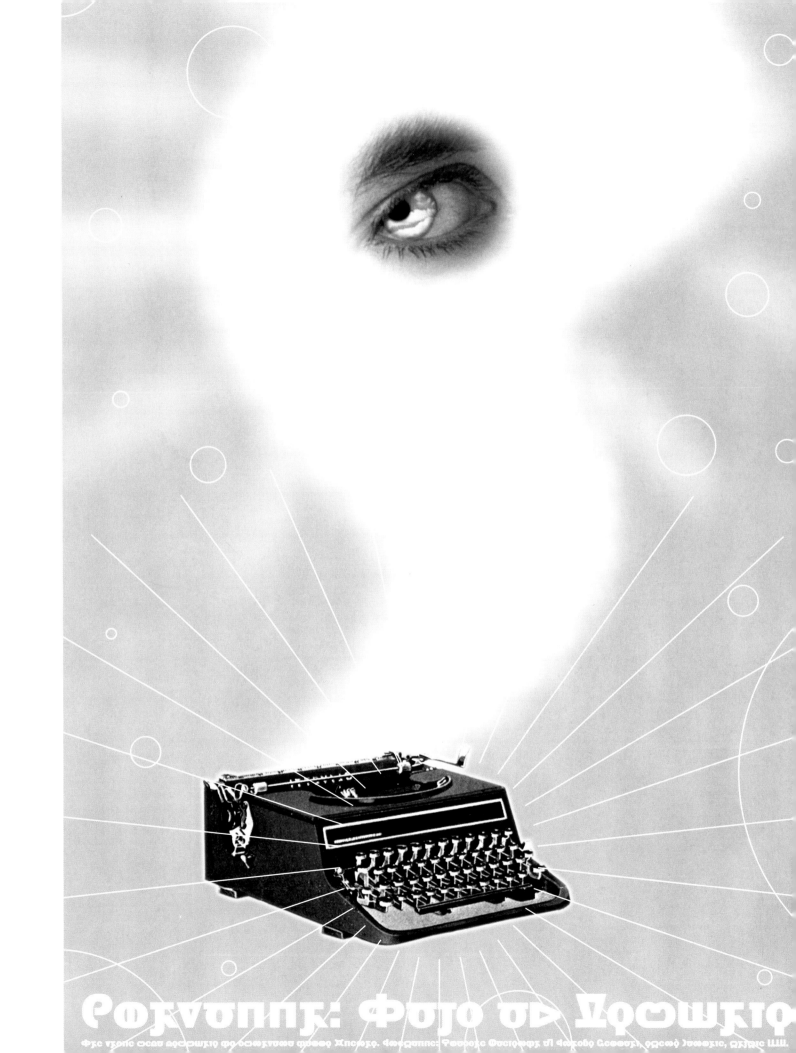

Alessio Leonardi developed the fictitious poster <u>Deus ex machina</u> for Olivetti as an experiment for the 13th Forum Typografie in 1996. He used a font from the series Alternativo Fonts: variations on Omnia, Bodoni, Franklin Gothic and Frutiger, among others. The series was developed in a single afternoon by reconstructing and changing Latin script. This shows that our alphabet would look quite different if the Phoenicians had used other characters.

Design | Type design: Alessio Leonardi _Alternativo Franklin Gothic

Page from the magazine <u>Climax</u> no. 2, 1997 The picture serves as the lead for an article by Alessio Leonardi on the relationship between typography and religion. What his experiment shows is not only a formal exercise, but also the result of looking critically at our beliefs on readability and the untouchable Holy Scriptures allegedly given by God.

Design/Type design: Alessio Leonardi _Cratilo Sans

Postcard for FF Matto, 1997 Matto actually means crazy, but this name stands for a completely normal font with four serif, four sans serif and four Porco cuts. Medieval numbers and a genuine italic make it suitable for all corporate-design uses – as long as there is no objection to the Porco cuts making the pages a bit dirty.

Design | Type design: Alessio Leonardi _Matto, Matto Sans, Matto Porco

Website, 1997-98. www.leowol.de/alessio Apart from the homepage and the typepage, the example for the Baukasten font clearly shows how the fonts are presented.

Design | Type design: Alessio Leonardi _Matto _Baukasten

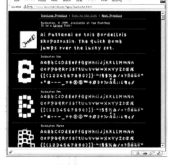

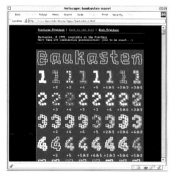

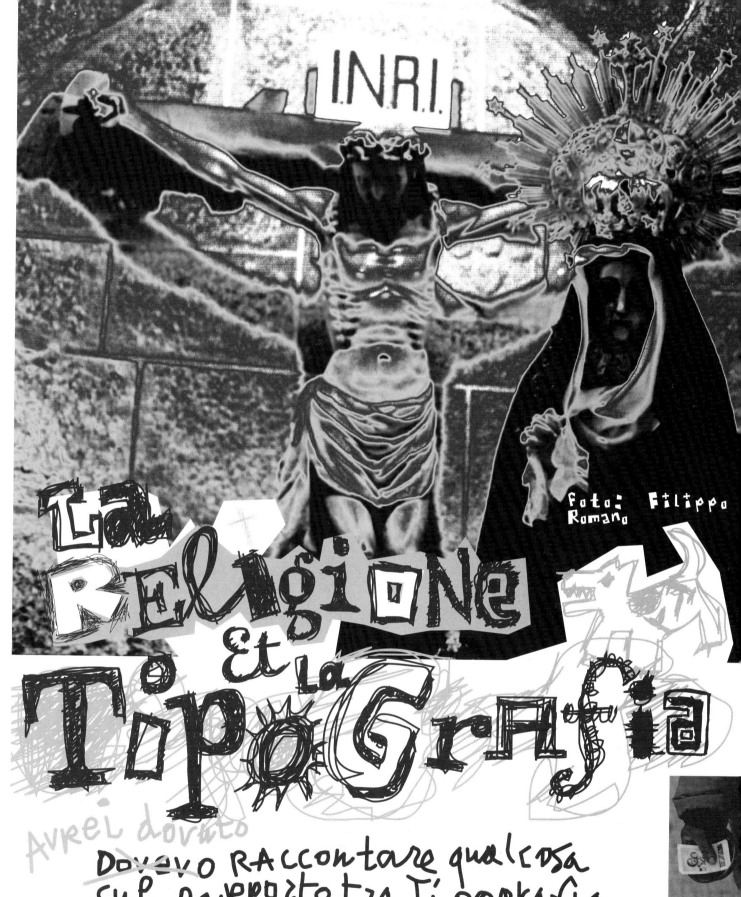

I.N.R.I.

foto: Filippo Romano

La Religione o Et la Tipografia

Avrei dovuto

Dovevo raccontare qualcosa sul rapporto tra Tipografia e Religione e questo è quanto (ed è quello) che mi è venuto in mente.

Commemorative medal, Italy, 1441
Garrett Boge and Paul Shaw used
the medal as an illustration in the
reprinted monograph, <u>Sans Serif</u>
<u>and Other Experimental Inscribed</u>
<u>Lettering of the Early Renaissance</u>
by Nicolete Gray, which they published
in 1997. The monograph, designed by
Paul Shaw, documents the historical
background for the Florentine font set
and accompanies the release of the
Collector's Edition.

LetterPerfect

Location_Seattle, Washington, USA

Established_1986

Founder_Garrett Boge

Type designers_Garrett Boge, Paul Shaw

Distributors_Adobe, Agfa, Creative Alliance
FontShop International (FSI), Precision Type
FontHaus, ITF

LetterPerfect is committed to the vision of making historical lettering styles accessible to today's graphic designers

Garrett Boge and Paul Shaw have more than forty years of combined professional lettering and type design experience. Boge worked first at Hallmark cards, then as a contract designer for companies such as Monotype Typography, Apple Computer and Microsoft Corporation. Paul Shaw worked as a lettering artist for such clients as NBC, Campbell's Soup, Revlon and Rolex. When Shaw and Boge met at an industry forum in New York City in 1987, they realized that their work shared many influences. After a few years of collaborating on freelance lettering projects and type commissions, they became partners in LetterPerfect, founded in 1986 by Garrett Boge originally in Kansas City, and since 1988 in Seattle.

Since 1988, LetterPerfect has been supplying original display fonts to designers and desktop publishers after a process of careful research, thoughtful design and meticulous font craftsmanship. The company now offers over fifty unique designs in two distinctive lines: Vive la Fonts, a collection of lively, contemporary display designs and Legacy of Letters, a series of interpretations of historical designs. Their affiliated tour programme, Legacy of Letters Tour of Italy, now in its third year, introduces other designers and lettering professionals to the original lettering sources that have inspired LetterPerfect's historical type programme.

·PONTIF·
A TYPE DESIGN INSPIRED BY ROMAN BAROQUE INSCRIPTIONS

full character set

ABCDEFGHIJKLMNOPQRSTUVWXYZ&0123456789
ABCDEFGHIJKLMNOPQRSTUVWXYZ&MMNNRR#$¢
@£¥ƒ%°©™ÀO··!?¿¡*-.,.;;.,,°«»'''""(—)[-]{_}¶†§ "'+÷·/^~\|/
ÁÂÀÄÃÅÆÇÉÊÈËÍÎÌÏÑÓÔÒÖÕØÙÛÜÙŸÏ̧
ÁÂÀÄÃÅÆÇÉÊÈËÍÎÌÏÑÓÔÒÖÕØQÚÛÜÙŸ Lucas Orfeus Farensis

30 pt caps

BAROQUE INSCRIPTIONS STILL ABOUND IN ROME AS TESTIMONY TO THE INFLUENCE OF THE RENAISSANCE POPES.

PAVLVS·QVINTVS·PONTIFEX·MAXIMVS
AQVAMIN·AGRO·BRACCIANENSI
SALVBERRIMISE·FONTIBVS·COLLECTAM
VETERIBVS·AQVAE·ALSIETINAE·DVCTIBVS·RESTITVTIS
NOVISQVE·ADDITIS
XXXV·AB·MILLIARIO·DVXIT

12 pt caps & small caps The inscription on the Acqua Paola fountain in Rome (shown in background photograph) set in Pontif: top line, 18 pt caps; following lines, 15 pt caps

"PONTIF" WAS DESIGNED AFTER CAREFUL STUDY OF SOURCE MATERIAL IN ROME
AND AT THE VATICAN. ITS USE AS A TYPEFACE CAN MODEL THIS HISTORICAL PERIOD.
OR IMBUE ANY DESIGN WITH ITS QUALITIES OF REFINEMENT & AUTHORITY.

42 pt caps, with flourished 'Q'

SENATVS POPVLVS QVE ROMANVS

©1996 Garrett Boge & Paul Shaw. All rights reserved. Pontif is a trademark of LetterPerfect 526 First Ave. S. #227, Seattle, WA 98104 · (800) 929-1951 LEGACY LETTERS

The photo by James Mosley of the St Bride Printing Library in London shows the mosaic lettering surrounding the base of the cupola of St Peter's in Rome, which was the inspiration for the design of the Pietra typeface. It was used to accompany his essay, 'The Baroque Inscriptional Letter in Rome', designed by Paul Shaw, which documents the historical background of the Baroque font set. The essay was published by LetterPerfect in 1996 and accompanies the release of the Collector's Edition.

Single-sheet type specimens, used to publicize the Baroque font set, 1996
21.6 x 27.9 cm
The sheets were initially published in poster format (45.7 x 61 cm) to announce the release of the Baroque font set at the Boston Seybold Publishing Conference in 1996.

Design: Garrett Boge
Type design: Garrett Boge, Paul Shaw _Pontif
_Cresci
_Pietra

·CRESCI·

BASED ON THE LETTERING OF GIOVANNI FRANCESCO CRESCI

full character set

A B C D E F G H I J
K L M N O P Q
R S T U V W X Y Z
·~·.,.:;'""'()!?

22 pt caps

CRESCI WAS THE PRE-EMINENT VATICAN SCRIBE OF THE LATE FIFTEENTH CENTURY.

22 pt caps

HIS LETTERS EPITOMIZE THE REFINED AESTHETIC OF THE RENAISSANCE, PRESAGING

60 pt caps

THE EXHUBERANCE OF THE BAROQUE.

©1996 Garrett Boge & Paul Shaw. All rights reserved. Cresci is a trademark of LetterPerfect · 526 First Ave. S. #227, Seattle, WA 98104 · (800) 929-1951 · LEGACY LETTERS

✛PIETRA✛

MODELED ON THE BAROQUE LETTERING IN ST. PETER'S BASILICA

full character set

ABCDEFGHIJKLMNOPQRSTUVWXYZ&OI23456789
ABCDEFGHIJKLMNOPQRSTUVWXYZ& ‰®#$¢
@£¥ƒ%°©™AO·.!?¿¡*-„.:;,.,,◊«»'"""(–)[–]{_}¶†§ "'+=÷/~~\|/
ÁÂÀÄÃÅÆÇÉÊÈËÍÎÌÏÑÓÔÒÖÕØÚÛÙÜŸŒ`ˆˇ˜¨˚˛¸
ÁÂÀÄÃÅÆÇÉÊÈËÍÎÌÏÑÓÔÒÖÕØŒÚÛÙÜŸℙ

Large type, 44 pt caps; small type, 14 pt caps & small caps

THE MASSIVE 5-FOOT TALL
THE PIETRA TYPEFACE, BASED ON THIS SOURCE, CONSISTS OF BOTH
MOSAIC LETTERS IN THE
FULL-SIZE CAPITALS & SMALL CAPITALS WITH A SLIGHTLY WIDER
INTERIOR OF SAN PIETRO
PROFILE. PIETRA JOINS THE OTHER LEGACY OF LETTERS
IN ROME ARE ONE OF THE
HISTORICALLY-INFORMED FONTS FROM LETTERPERFECT IN
MOST COMPELLING USES
PROVIDING DESIGNERS A RICH TYPOGRAPHIC TITLING PALETTE.
OF BAROQUE LETTERING.

✛TV ES PETRVS ET SVPER HANC PETRAM AEDIFICABO✛
ECCLESIAM MEAM ET TIBI DABO CLAVES REGNI CAELORVM

Text from the inscription around the base of St. Peter's Dome — as seen in background photograph, 18 pt caps

©1996 Garrett Boge & Paul Shaw. All rights reserved. Pietra is a trademark of LetterPerfect · 526 First Ave. S. #227, Seattle, WA 98104 · (800) 929-1951 · LEGACY LETTERS

Graphics from the covers of the
specimen sheets and order forms
for the Baroque and Florentine font
sets, 1996–97.
Design: Garrett Boge
Type design: Garrett Boge, Paul Shaw

_Pontif
_Pietra
_Cresci
_Beata
_Donatello
_Ghiberti

ANNOUNCING

3 BAROQUE FACES

PONTIF ✦ PIETRA ✦ CRESCI

The first in the new LEGACY OF LETTERS series
of historically-informed typefaces from LETTERPERFECT

OSSA VILLAN
IN HOC CELEBF
THE BONES OF THE MOST BLESSED WIFE VILLAN

Announcing

THE FLORENTINE SET

BEATA · DONATELLO · **GHIBERTI**

The second set in the LEGACY OF LETTERS series
of historically-inspired typefaces from LETTERPERFECT

A rubbing of the inscription on the
tomb of Beata Villana by the sculptor
Bernardo Rossellino, dated 1451, in
the church of Santa Maria Novella in
Florence. The rubbing was made by
Garrett Boge in 1995 and was used as an
illustration in the Nicolete Gray
monograph. The rubbing was also
reprinted in a duotone offset limited
edition to accompany the release of the
Collector's Edition of this font set.

©1997 LETTERPERFECT

SANCTISSIME
REQVIESCVNT

AVE FOUND THEIR REST IN THIS HONORED TOMB

183

LettError

Location_ The Hague, The Netherlands
Established_ 1989
Founders | Type designers_ Erik van Blokland, Just van Rossum
Distributor_ FontShop International (FSI)

Programming = Design

LettError started when Just van Rossum and
Erik van Blokland discovered a way to make
letters move inside the printer and needed
a magazine to tell people about it.

They work independently, in separate offices
and each has his own clients. But they develop
new projects together, write code, create tools,
animations, clickable design and, of course,
fonts.

LettError's typefaces range from utterly
silly experiments with scanners, where they
inadvertently invent grunge type via BitPull
and RobotFonts, to large corporate typeface
families (GAK) and fonts made for television
(MTV).

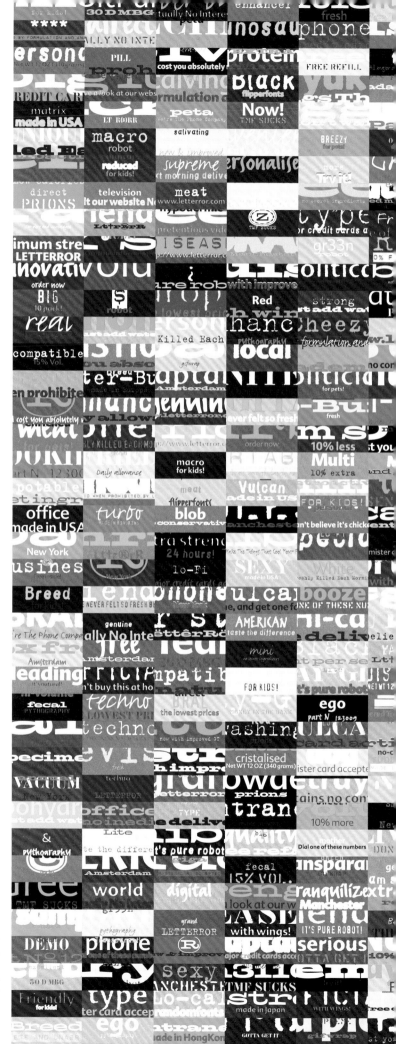

RobotFonts & EPSmachines, 1998
The collage was created using
all LettError fonts and faked
advertising copy.

Design | Type design: Just van Rossum
Erik van Blokland, Python

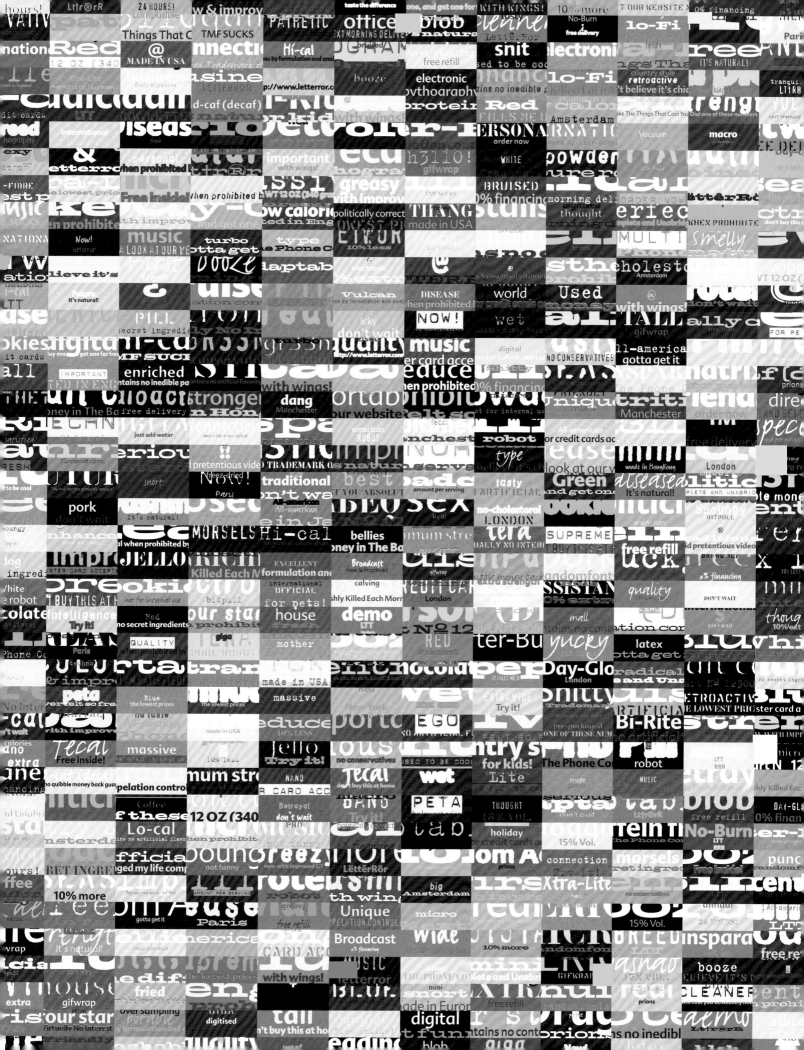

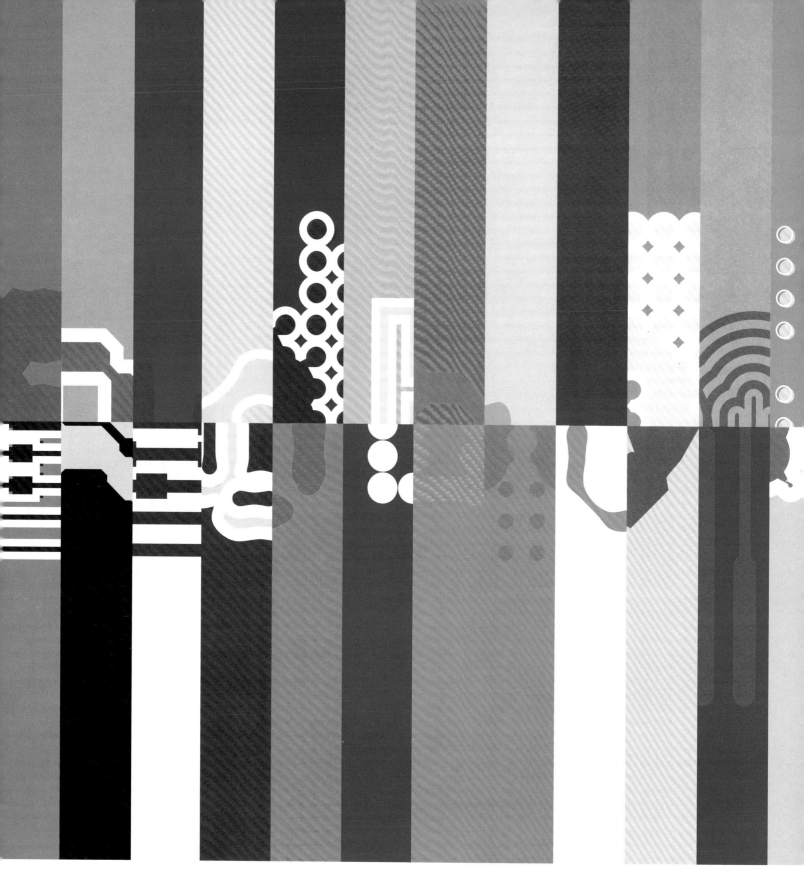

RobotFonts & EPSmachines, 1998
The fonts are generated from bitmaps by creating
various filters and then the illustrations are
generated by another program. These examples
are selected from hundreds of iterations.

Design | Type design: Just van Rossum, Erik van Blokland, Python

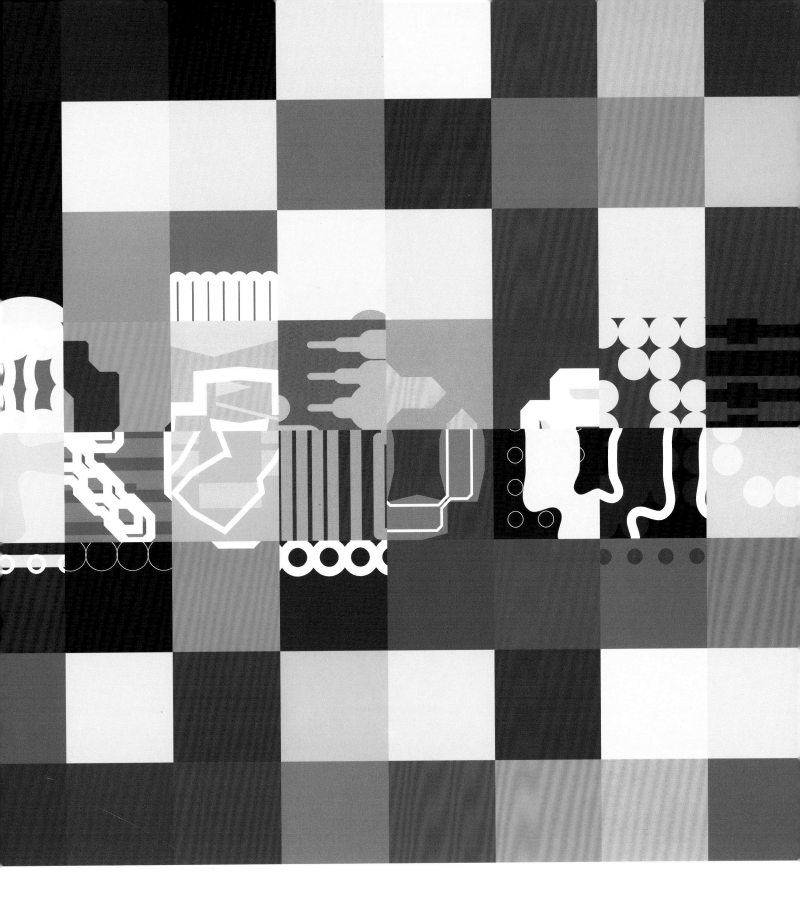

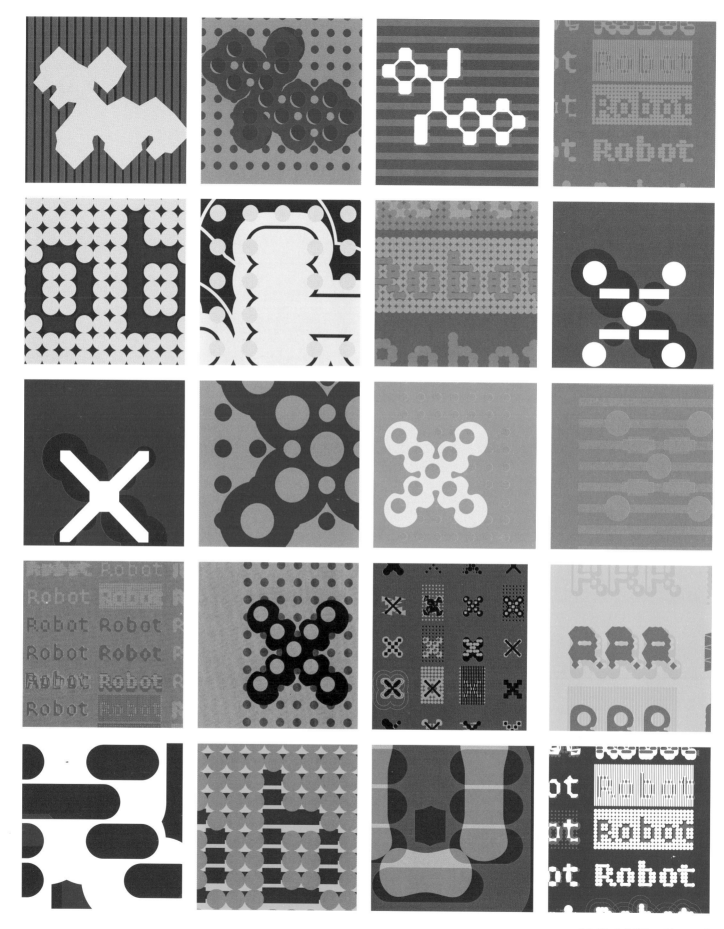

RobotFonts & EPSmachines, 1998
Typography made with a game console.

Design | Type design: Just van Rossum, Erik van Blokland, Python

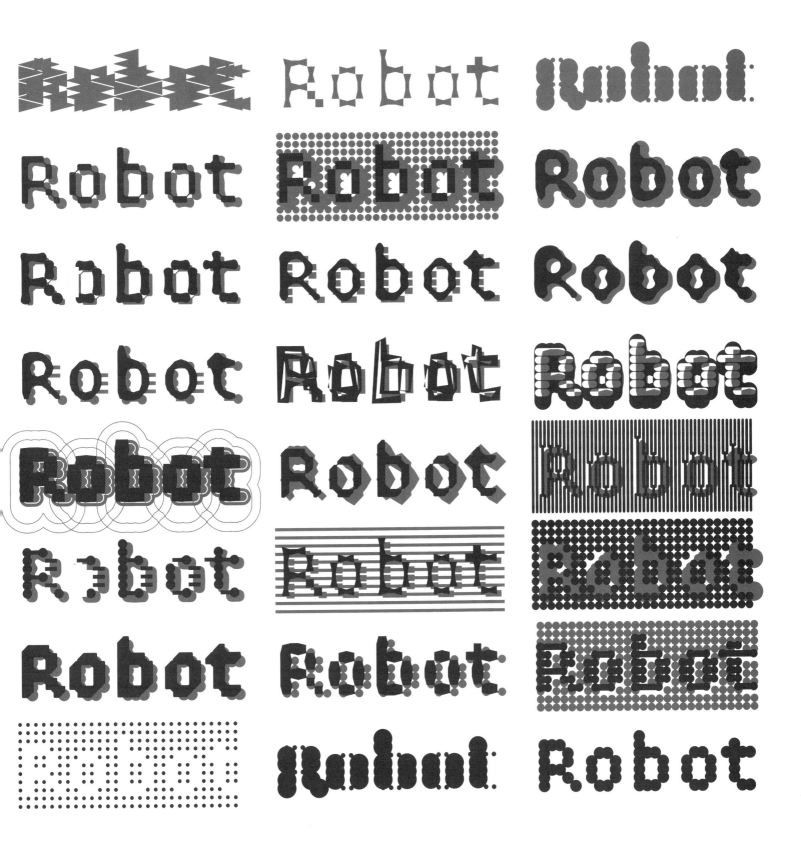

RobotFonts & EPSmachines, 1998
Instead of making one single item, Just van Rossum
and Erik van Blokland define a set of rules and
write a program to generate a series of variations.
They evaluate the results, modify the program
and the rules, then generate the next step.

Design | Type design: Just van Rossum
Erik van Blokland, Python

lineto

Location_Zürich, Switzerland
Berlin, Germany

Established_1994

Founders_Stephan Müller, Cornel Windlin

Type designers_Stephan Müller (a.k.a Pronto)
Cornel Windlin

Distributors_www.lineto.com, FontShop International (FSI)

'When was the deadline?'

Cornel Windlin and Stephan Müller work independently as designers and art directors in Zürich and Berlin. Their typeface designs are mostly by-products of design projects, brought to the appropriate standards for public use. The lineto label, named after a PostScript™ code, was formed as a loose partnership to release their typefaces.

Windlin and Müller have always been fascinated by applied typography in public spaces – shopping centres, airport terminals, traffic signage, massage parlours, corporate identity – and a big part of their type design focuses on making such designs available. They publish various fonts based on LCD displays, dot-matrix technology, thermal printers and car registration plates. However, many of their type designs are more refined and quite a few have not been released, some are now available on the lineto website: www.lineto.com.

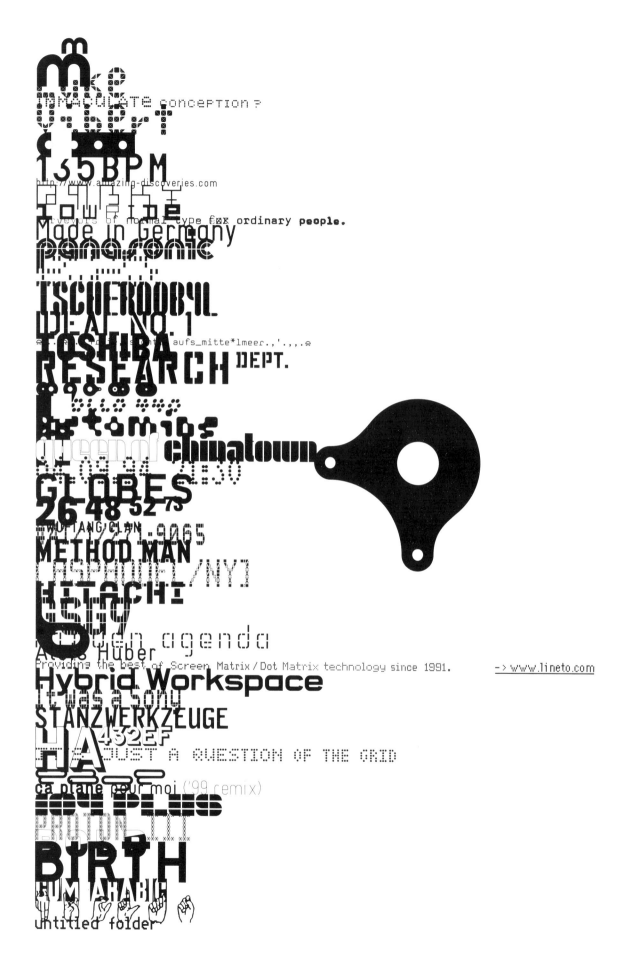

mike
IMMACULATE CONCEPTION ?
Uebert
135BPM
http://www.amazing-discoveries.com
Towline
Purveyors of normal type for ordinary people.
Made in Germany
panasonic
TSCHEROOBYL
DEAL NO. 1
TOSHIBA
RESEARCH DEPT.

Butomine
queen of chinatown

GLOBES
26 48 52 73
WU-TANG CLAN
METHOD MAN
[STAPLDORF/NY]
HITACHI
Isty
screen agenda
Aoris Huber
Providing the best of Screen Matrix / Dot Matrix technology since 1991.
Hybrid Workspace
it was a song
STANZWERKZEUGE
HA432EF
JUST A QUESTION OF THE GRID
ça plane pour moi ('99 remix)
surplus
BIRTH
GUM ARABIC
untitled folder

-> www.lineto.com

Selection of lineto typefaces, 1998

Design: lineto
Type design: Stephan Müller
Cornel Windlin

193

Photographs by Stephan Müller, Cornel Windlin, Melanie Hofmann, Laurent Benner and Sylvie Meylan

→
Page from the
FontExplorer catalogue, 1998
21 x 28 cm

Design: Leonardi.Wollein
Type design: Adrian Frutiger
Linotype Designstudio _Linotype Univers

Linotype Library

Location_Bad Homburg, Germany

Established_1886

Founder_Ottmar Mergenthaler

Type designers_Adrian Frutiger, Hermann Zapf, Gerard Unger
Peter Matthias Noordzij, Reinhard Haus
Franco Luin, Marco Ganz, Hans Eduard Meier
Gary Munch

Distributors_Linotype Library, Heidelberg, FontShop
International (FSI), fundición tipográfica
Bauer, Type Associates Esselte Letraset and
many more

CD-ROM packaging
and booklet for Univers, 1997
The Linotype Univers has been
completely redesigned by Adrian
Frutiger and the Linotype Library team
to become a full type family with fifty-
nine weights. The thickness of the
strokes has been configured so that the
various widths can be mixed effort-
lessly in a single weight.

Design: Leonardi.Wollein
Type design: Adrian Frutiger
Linotype Designstudio _Linotype Univers

Extending and expanding the consistent reworking
of original and innovative font design

Linotype fonts have been an established name for over one
hundred years. During this time, typesetters the world over
have benefited from both the technical innovations of Linotype
typesetting machines and the numerous quality types developed
for professional applications. The Linotype Library – a Heidel-
berg Group company – now includes more than 3600 types by
over 350 well-known international type designers. Typefaces
like Times and Helvetica, Hermann Zapf's Palatino or Adrian
Frutiger's Univers are milestones in type creation and have
become bestsellers worldwide. And, there is no shortage of new
material either: the International Type Design Contest,
initiated by Linotype Library, attracts type designers from all
over the world, coming to make their mark and knowing that
the winning entries will enter the Linotype Library. The
company is also the initiator of the international specialist
congress typo[media] which takes place in Frankfurt/Main.

196

the new face: Linotype Univers®

See also page

Cover of the FontExplorer catalogue, 1998
168 pages
21 x 28 cm
The catalogue includes a CD-ROM
containing the software FontExplorer, a
navigation system that helps to locate types
of all classes and specifications in an
interactive database. After selecting and
combining from a whole range of para-
meters, FontExplorer provides the user
with a list of suitable fonts in real time.

Design: Leonardi.Wollein
Type design: Adrian Frutiger
Linotype Designstudio _Linotype Univers

Website, 1998
www.LinotypeLibrary.com

Design: PointUp, Nürnberg
Type design: Gary Munch _Ergo

→
Page from the
FontExplorer catalogue, 1998
21 x 28 cm

Design: Leonardi.Wollein
Type design: Linotype Designstudio
Max Miedinger _Neue Helvetica

Cover of the Take Type 1 catalogue, 1995
31 pages
10.7 × 21 cm

Design: xplicit ffm
Type design: Dieter Kurz _Matthia

Alessio Leonardi _HaManga

Dariusz Nowak-Nova _NoveAteny

Adrian Frutiger _Frutiger

Lutz Baar _Balder

Sine Bergmann _Giacometti

Svenja Voss _Schwennel lila + negro

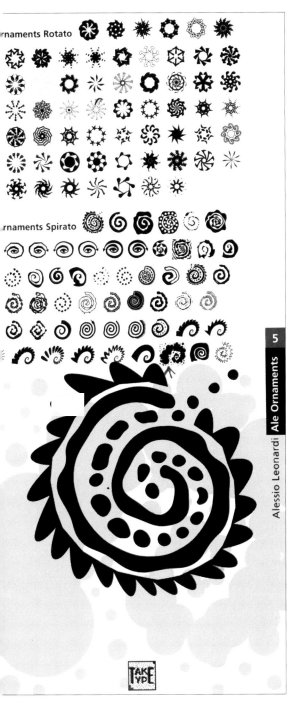

5

Alessio Leonardi | Ale Ornaments

CD-ROM included in the Take Type 2
catalogue, 1998

Design: Christoph Burkardt
Albrecht Hotz, Büro für
Gestaltung (Offenbach am Main)
Type design: Thomas Leif _Traffity

Andreas Karl _Mail Box Heavy

Thorsten Weisheit _Irish Text

Svenja Voss _Schwennel lila + negro

Thomas Hoffmann _Ho Tom

Dan-André Niemeyer _Vision regular

Alexej Chekoulaev _Bariton

Hans Jürgen Ellenberger _Beluga

Page from the
Take Type 1 catalogue, 1995
10.7 x 21 cm

Design: xplicit ffm
Type design: Roland John Goulsbra _Agrafie

_Alexie

Alessio Leonardi _Ale Ornaments
Rotato, Spirato

___Make it yourself, sell it yourself

Gerard Unger

Have we gone so far that fonts make and sell themselves? Is it possible for fonts to mutate on their own in computers? Whatever the answers, many of my colleagues, when looking at their font collection, ask themselves, 'How did I get this font?'.

Developments since the mid-1980s have brought font designers certain advantages. In the pre-digital era, there were setting-machine manufacturers who faced us font designers with strict selection committees. This meant that many designs stayed on the shelves gathering dust because each new font required heavy investments. Fonts can now be brought into the world for less money and the committees no longer exist. Or do they? We could say that all potential customers now make up the committee. Actually, even the investments have only been transferred: font designers who produce and sell their own fonts must now convince the selection committee they themselves have created.

I use the advantage obtained from the much faster and easier design and production of fonts to experiment more, to follow each experiment to its limits. I have not won time, but rather room for thought. On average, I still need two years to bring a font to maturity – about as long as in the pre-digital era.

Many believe that the computer is causing inflation in font quality, or even the fall of type culture. Personally, I see everything quite differently. The earlier, mostly conservative, evaluation committees let many experiments die, and the limits remained invisible. These

have become clearer after almost fifteen years of digital experimentation with fonts and typography. New typographical continents have risen out of the fog, and typographical cartography has been partially redefined. In addition, font designers have more potential customers than ever before: customers who have grown up with the new richness in fonts, who have become more and more critical, who can formulate their desires better and know how to separate the wheat from the chaff.

But how do we reach this huge evaluation committee? There have already been many attempts: different designers have joined together to share costs and work the market together. Not a bad idea, but I believe that appearing on the market independently offers the most advantages: direct contact with the customer, interaction, cross-pollination, a drive to undertake new projects, improvements and extensions and a more precise knowledge of the market. What remains true is that we first need the customers before we can exchange thoughts with them.

Offering extras or gifts are proven means to win customers: a carrot in front of the nose. Fabulous! That is what this book is about. If you have a good font, you can include good documentation, an enchanting font sample book, fantastic explanations, inspiring application examples or simply humorous items. These things are often too expensive to give away. Perhaps an additional sale at a discount with the purchase of fonts? Again, a good idea that benefits both designers and customers, and is fun.

Another way to reach customers is by cutting prices. This is probably the worst idea of the century, since quality suffers. There will then be no money to make carrots or beautiful font documentation, unless we finance font production through other activities, such as graphic design. Font design as a hobby? Font designers certainly do not want their work to be on the same level as the do-it-yourself construction of a rabbit hutch!

Fonts certainly do not sell themselves. Marketing them is damn hard work, requiring much stamina: you are not just the artist, but also the merchant. You stand in the marketplace and have to yell to be heard. Just as with selling bananas and watches, this certainly works better with humour.

The prejudice still remains that font design and commerce do not readily mix. It would, however, be very stupid to work on a font for two years and never think about the market. You can, of course, make money with pure beauty (Claudia Schiffer), but it sells better when you offer several advantages.

From the start of the digital era, font sellers have had their eyes on mass markets. The concept of exclusivity remains completely ignored. However, it is still not possible to please every customer with a font design. Therefore, it is probably easier to reach a small group of customers with a common interest – this works best with specialized fonts. You then can write to customers directly or communicate with them through appropriate specialist publications. I have had mixed results with advertising – sometimes there was much interest, sometimes none at all. Best of all is when you develop such a good or original font that the specialist publication writes about it on its own. You can also work as an author for specialist publications, which creates quite a bit of publicity – the fonts virtually sell themselves.

There are not yet any fonts that can mutate without the intrusion of designers. There should not be any fonts that get into a computer by themselves, but there are. Maybe publications like this one can contribute to increasing the honesty of font buyers or font users. At any rate, those who contributed to this book will certainly reach an interested audience. Hopefully it will inspire others to think up new variations of the carrot. I wish all my colleagues many sold fonts.

abcdefghijklmnopqrstuvwxyz

abcdefghijklmnopqrstuvwxyz

Type design: Jeroen Barendse, 1994-95 _LUSTBlockbuster
Blockbuster bold

ABCDEFGHIJKLMNOPQRSTUVWXYZabcdefghijklmnopqrstuvwxyz

Type design: Thomas Castro
Jeroen Barendse, 1996-97 _LUSTPure

ABCDEFGHIJKLMNOP

Type design: Thomas Castro, 1995 _LUSTBlowout One, Blowout Two
BlowoutThree, Blowout Four
Blowout Five

LUST

Location_The Hague, The Netherlands

Established_1996

Founders|Type designers_Jeroen Barendse, Thomas Castro

Distributors_LUST, FontWorks and soon [T-26]

LUST, in a nutshell, is the missing piece of the puzzle.

LUST is a small design studio in The Hague, started in August 1996 by Thomas Castro and Jeroen Barendse. On the one hand, they realize commissioned projects (such as books, posters, business correspondence, websites and CD-ROMs) for architects, art groups, designers and publishers. On the other hand, they work on self-initiated, independent projects, which also include type design. LUST concentrates on the difference between ratio and coincidence, between vision and urge. Examination of these terms has resulted in designs that often have an autonomous character, but are related to previous LUST designs.

LUST's designs and philosophies do not follow a set style, but come from interpretation and conceptualization of an assignment. Castro and Barendse are mainly interested in context and association, which means that their type-faces can only be made within this framework. The fonts are a part of their work as graphic designers in the same way that their design work is a part of their typeface design. Everything comes together to serve their ideology.

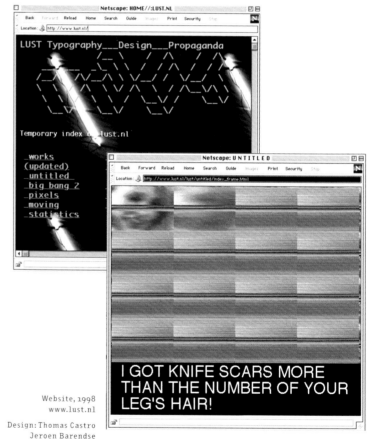

Website, 1998
www.lust.nl

Design: Thomas Castro
Jeroen Barendse

Type design: Thomas Castro _LUSTBlowout

Jeroen Barendse _LUSTIncidenz

LUST font poster, 1996
84.1 x 118.9 cm

Design|Type design: Thomas Castro
Jeroen Barendse

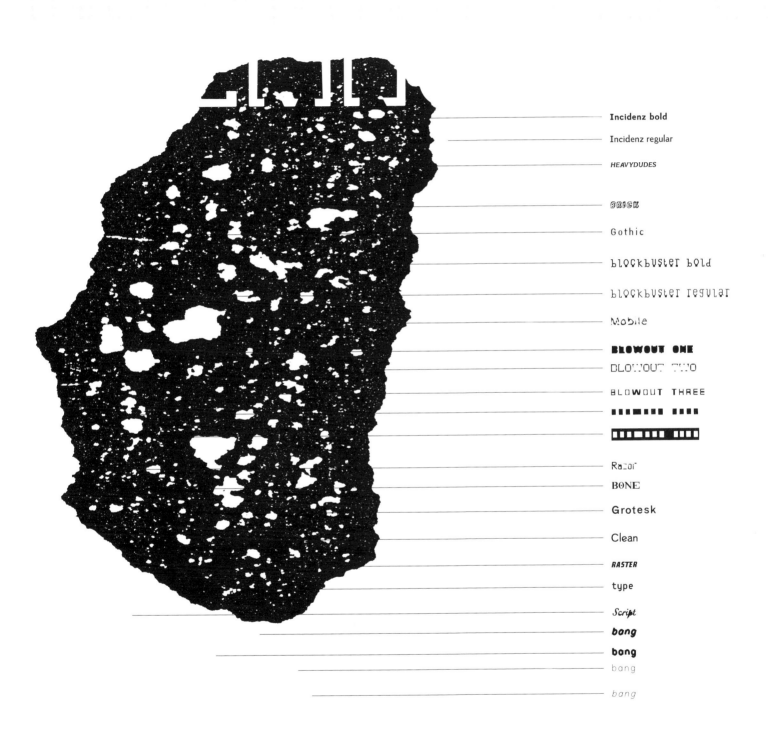

Incidenz bold

Incidenz regular

HEAVYDUDES

𝐵𝑅𝐼𝐶𝐾

Gothic

blockbuster bold

blockbuster regular

Mobile

BLOWOUT ONE

BLOWOUT TWO

BLOWOUT THREE

■■■■■■■ ■■■■

▥▥▥▥▥▥ ▥▥▥

Razor

BONE

Grotesk

Clean

RASTER

type

Script

bong

bong

bong

bong

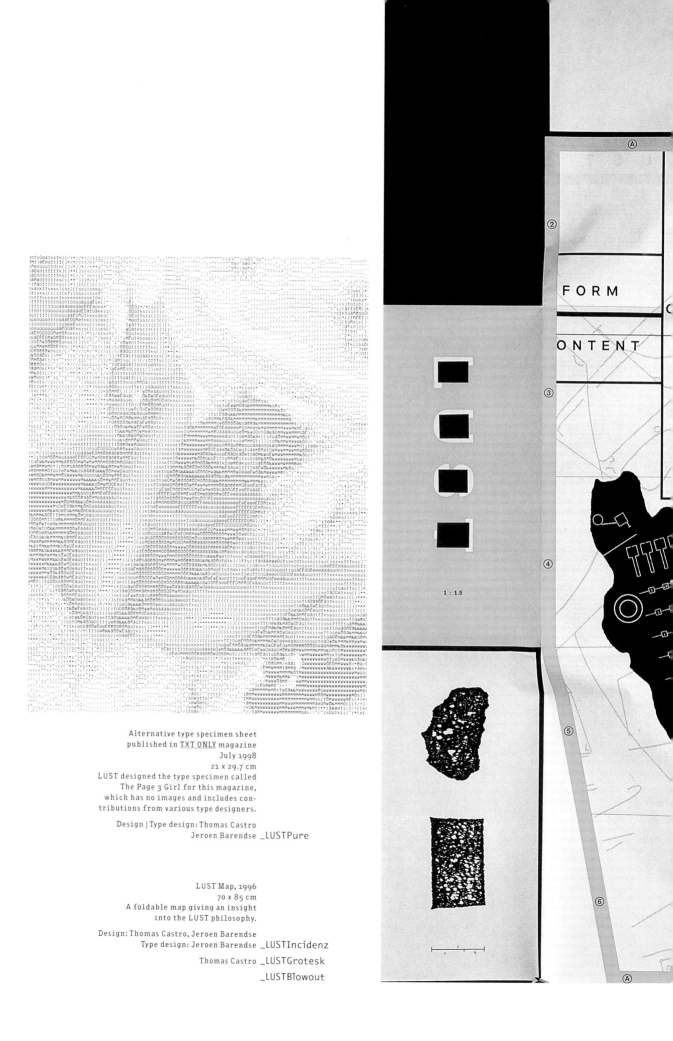

Alternative type specimen sheet
published in <u>TXT ONLY</u> magazine
July 1998
21 x 29.7 cm
LUST designed the type specimen called
The Page 3 Girl for this magazine,
which has no images and includes con-
tributions from various type designers.

Design | Type design: Thomas Castro
Jeroen Barendse _LUSTPure

LUST Map, 1996
70 x 85 cm
A foldable map giving an insight
into the LUST philosophy.

Design: Thomas Castro, Jeroen Barendse
Type design: Jeroen Barendse _LUSTIncidenz
Thomas Castro _LUSTGrotesk
_LUSTBlowout

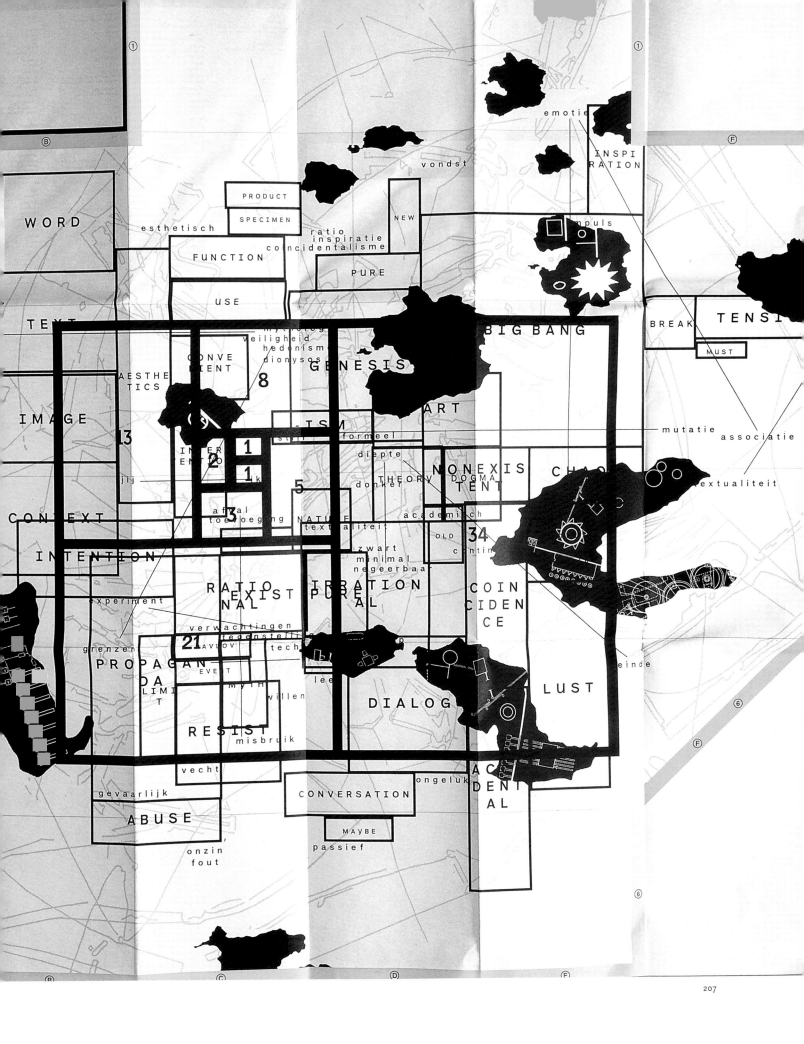

Monotype Typography

Location_Redhill, Surrey, UK

Established_1887

Founder_Tolbert Lanston

Type designers_Albert Boton, Matthew Carter, Ong Chong Wah
Vincent Connare, Carolyn Gibbs, Michael Harvey
Jean Lochu, Luiz Da Lomba, Brian Lucid
Steve Matteson, Robin Nicholas, Joe Nicholson
Ian Patterson, Rosemary Sassoon
Patricia Saunders and many more

Distributor_Monotype Typography

Monotype Typography is one of the oldest and most respected companies in the typographical field. It made history as the inventor of the Monotype hot-metal typesetting machine and for more than one hundred years, the company has continued to develop high-quality typographical products for the graphics industry. Today, the company develops and sells fonts and software for computer systems and peripheral equipment. Monotype is considered to be the market leader in multilingual font solutions and Unicode implementations, and has extensive know-how in non-Latin and expanded Latin alphabets.

The Agfa-Gevaert Group took over Monotype Typography in 1998 after the two firms had cooperated closely for five years. In 1997 they worked together to produce and distribute the font collection Creative Alliance 8.0 (see p. 42), which contains more than 6500 fonts from their combined font libraries.

Type design: DS Design, Jake
Scott, Jane Scarano _Kid Type Paint
Frederic Goudy, Steve Matteson _Truesdell
Luiz Da Lomba _Pierre Bonnard
Chank Diesel _Mr. Frisky

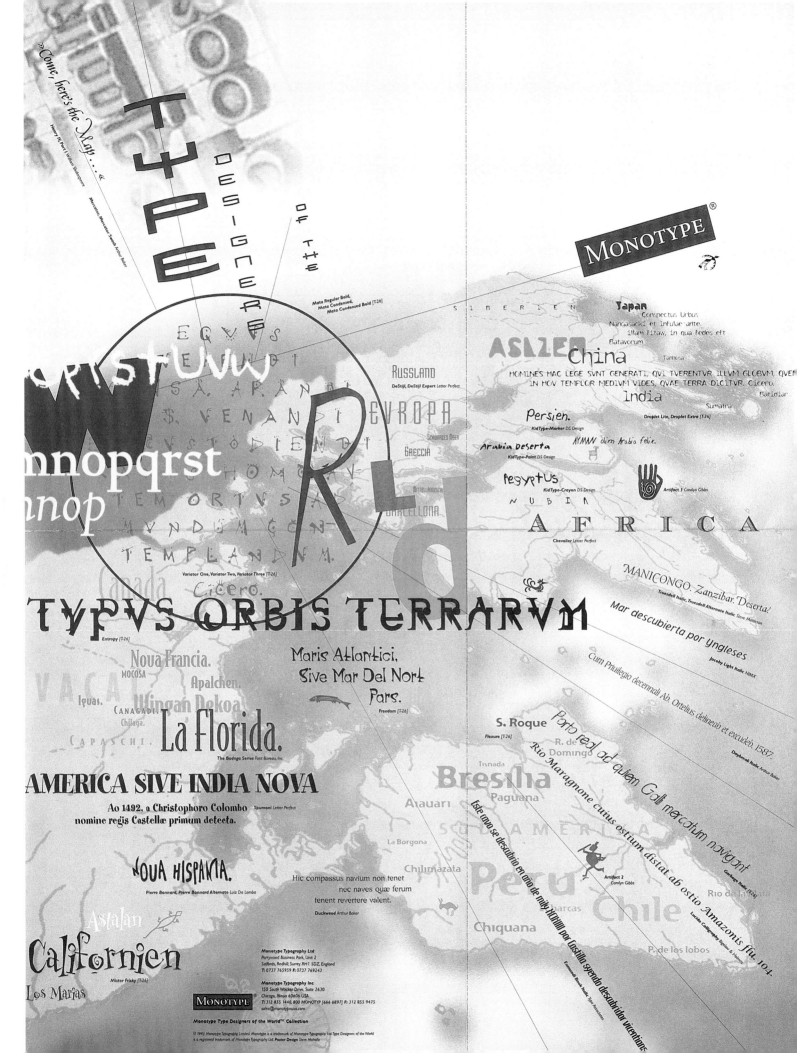

Folder for Monotype Bulmer, 1994
14.3 x 21 cm
Monotype Bulmer is based on the type-
cut by William Martin in 1792, used by
the printer William Bulmer at the
Shakespeare Printing Office,
London.

Leaflet Design: Robin Nicholas
Digitization: Monotype Typography _Monotype Bulmer

The chase I Sing, hounds, and their various breed,
And no less various use. O thou, great Prince!
Whom Cambria's towering hills proclaim their lord,
Deign thou to hear my bold, instructive song.
While grateful citizens, with pompous show,
Rear the triumphal arch, rich with the exploits
Of thy illustrious house; while virgins pave
Thy way with flowers, and as the royal youth
Passing they view, admire, and sigh in vain;
While crowded theatres, too fondly proud
Of their exotick minstrels, and shrill pipes,
The price of manhood, hail thee with a song.

From *The Chase* by William Somerville
Printed by WILLIAM BULMER. 1796
Wood-engraving by THOMAS BEWICK

Monotype Bulmer™ [PACKAGE 1247]

Roman	ABCDEFGHIJKLMNOPQRSTUVWXYZ abcdefghijklmnopqrstuvwxyz 1234567890
Italic	*ABCDEFGHIJKLMNOPQRSTUVWXYZ abcdefghijklmnopqrstuvwxyz 1234567890*
Semi bold	**ABCDEFGHIJKLMNOPQRSTUVWXYZ abcdefghijklmnopqrstuvwxyz 1234567890**
Semi bold italic	***ABCDEFGHIJKLMNOPQRSTUVWXYZ abcdefghijklmnopqrstuvwxyz 1234567890***
Bold	**ABCDEFGHIJKLMNOPQRSTUVWXYZ abcdefghijklmnopqrstuvwxyz 1234567890**
Bold italic	***ABCDEFGHIJKLMNOPQRSTUVWXYZ abcdefghijklmnopqrstuvwxyz 1234567890***
Display roman	ABCDEFGHIJKLMNOPQRSTUVWXY abcdefghijklmnopqrstuvwxyz 1234567890
Display italic	*ABCDEFGHIJKLMNOPQRSTUVWXYZ abcdefghijklmnopqrstuvwxyz 1234567890*
Display bold	**ABCDEFGHIJKLMNOPQRSTUVWX abcdefghijklmnopqrstuvwxyz 12345678**
Display bold italic	***ABCDEFGHIJKLMNOPQRSTUVWXY abcdefghijklmnopqrstuvwxyz 123456789***

TRUESDELL

This release of F. W. Goudy's *Truesdell* typeface by *Monotype* Typography marks the 55th year since the tragic fire that consumed Goudy's studio early on the morning of 26 January 1939. ¶ *After the* fire at Marlboro-on-Hudson, it was impossible for Goudy to fill any more orders for the Truesdell font which he had completed in 1931. Monotype's new PostScript version of Truesdell was digitized by Steve Matteson in 1993 from letterpress proofs of the 16-point fonts which reside at the ROCHESTER INSTITUTE OF TECHNOLOGY. ¶ To increase the versatility of the Truesdell family, a bold and bold italic have been designed. Original swash letters, leaves & paragraph marks are also included in the family to offer the designer a full range of typographic effects.

Copyright © 1994 Monotype Typography Ltd. Truesdell and Artifact are trademarks of The Monotype Corporation. All rights reserved.

Truesdell Roman & Alternate

AÆBCDEFGHIJKLMNOŒPQRSTUVWXY&Z
aæbcdefghijklmnoœpqrsßtuvwxyz fi fl ff ffi ffl & st ([{/}])
ABCDEFGHIJKLMNOPQRSTUVWXYZ • 0123456789 · 0123456789
*‡†§%#$¢ƒ£¥@ ©®™ ¿¡?'""".:;о«»

Truesdell Bold & Alternate

AÆBCDEFGHIJKLMNOŒPQRSTUVWXY&Z
aæbcdefghijklmnoœpqrsßtuvwxyz • fi fl ff ffi ffl & st ([{/}])
0123456789 · 0123456789

Truesdell Italic & Alternate

AÆBCDEFGHIJKLMNOŒPQRSTUVWXY&Z
aæbcdefghijklmnoœpqrsßtuvwxyz • fi fl ff ffi ffl & st h
ABCDEFGMPRT ThU a/ d/ e/ b/ m/ n/ v
0123456789 · 0123456789

Truesdell Bold Italic & Alternate and Sorts

AÆBCDEFGHIJKLMNOŒPQRSTUVWXY&Z
aæbcdefghijklmnoœpqrsßtuvwxyz • fi fl ff ffi ffl & st h
0123456789 · 0123456789 • ▼ ❧ ✦ ❧ ((((✿ ❀ ❧ ❧ ❧

THE TRUESDELL FAMILY INCLUDES NINE fonts – regular, bold, italic, bold italic, alternate fonts for each style, and sorts. Truesdell's friendly design quirks add to its charm & interest without limiting its legibility or functionality. Truesdell makes an excellent choice as the principal text type for a wide variety of uses, and it looks quite handsome in display sizes too. [101]

The Truesdell family includes nine fonts – regular, bold, italic, bold italic, alternate fonts for each style, and sorts. Truesdell's friendly design quirks add to its charm & interest without limiting its legibility or functionality. Truesdell makes an excellent choice as the principal text type for a wide variety of uses, and it looks quite handsome in display sizes too. [101]

Truesdell was Goudy's 47th type design and carries his mother's maiden name. He cut the 16-point size in February 1931. Goudy completed Truesdell to compose a two-page prefatory he wrote for *The Colophon* No. 5 after discovering that his 18-point Kaatskill design overran his allotted space. [101]

Truesdell was Goudy's 47th type design and carries his mother's maiden name. He cut the 16-point size in February 1931. Goudy completed Truesdell to compose a two-page prefatory he wrote for The Colophon No. 5 after discovering that his 18-point Kaatskill design overran his allotted space. [101]

Leaflet for Truesdell, 1994
14.3 x 21 cm

Design: Steve Matteson
Type design: Frederic Goudy
Steve Matteson _Truesdell

Monotype Bulm[er]

Roman expert	ABCDEFGHIJ
alternative	J 12345678
sc osf	ABCDEFG
	ABCDEFGHIJ
Italic expert	ff fi fl ffi ffl 12
alternative	JJKNOQTY
Semi bold expert	ABCDEFGHIJ
alternative	J 1234567890£$ ' "
sc osf	ABCDEFGHIJKLMNOPQRSTUVWXYZ
	ABCDEFGHIJKLMNOPQRSTUVWXYZ 1234567890
Semi bold italic expert	ff fi fl ffi ffl 1234567890
alternative	JJKNOQTY 1234567890£$ ' "
Bold expert	ff fi fl ffi ffl 1234567890
alternative	J 1234567890£$ ' "
Bold italic expert	ff fi fl ffi ffl 1234567890
alternative	JJKNOQTY 1234567890£$ ' "
Display Roman alt	J ff fi fl ffi ffl 1234567890 1234567890£$ ' "
Display Italic alt	JJKNOQTY ff fi fl ffi ffl 567890 123456£$ ' "
Display Bold alt	J ff fi fl ffi ffl 1234567890 1234567890£$ ' "
Display Bold italic alt	JJKNOQTY ff fi fl ffi ffl 567890 123456£$ ' "

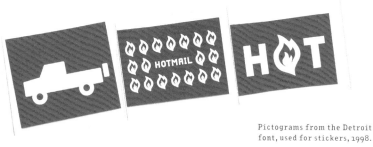

Pictograms from the Detroit
font, used for stickers, 1998.

Design: David Rust, Stéphane
Delgado, Gilles Gavillet

Optimo

Location_Lausanne, Switzerland

Established_1997

Founders | Type designers_Stéphane Delgado, Gilles Gavillet
David Rust

Distributor_www.optimo.ch

**Keep in circulation the rumour
that typography is alive.**

After finishing his studies at the École
Cantonale d'Art de Lausanne, David Rust was
invited by Peter Scott-Makela, director of the
Cranbrook Academy of Art, to complete a post-
graduate programme. Stéphane Delgado and
Gilles Gavillet also participated in the pro-
gramme, although they were still students at
the École Cantonale d'Art de Lausanne. Whilst
at Cranbrook, they created the multiple master
font Detroit, inspired by American neon adver-
tisements, which led to the decision to found
Optimo. In the future, it will not only be a type
label, but also a forum where photographers,
musicians and students can present their work.

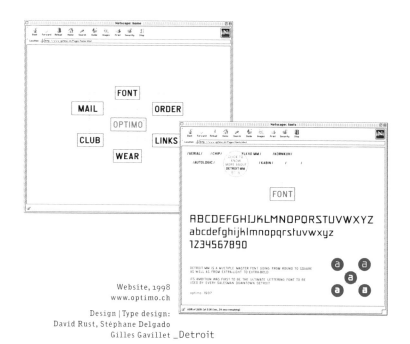

Website, 1998
www.optimo.ch

Design | Type design:
David Rust, Stéphane Delgado
Gilles Gavillet _Detroit

The font Autologic enables the user to quickly
and automatically generate logos.
Spring, 1998

Type design: Gilles Gavillet _Autologic

Type design: Gilles Gavillet _Chip

Type design: Gilles Gavillet
Stéphane Delgado _Kabin

Type design: Stéphane Delgado
Gilles Gavillet _Kornkuh

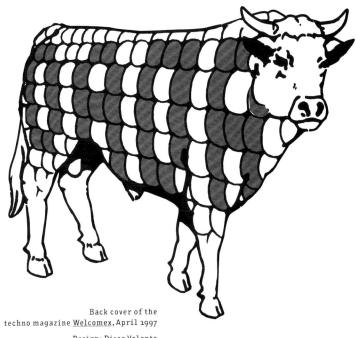

Back cover of the
techno magazine <u>Welcomex</u>, April 1997

Design: Disco Volante
Type design: Stéphane Delgado
Gilles Gavillet _Kornkuh

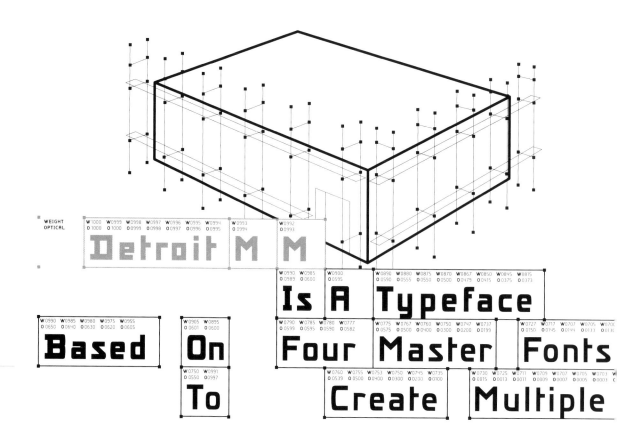

WEIGHT
OPTICAL

W 1000	W 0999	W 0998	W 0997	W 0996	W 0995	W 0994	W 0993	W 0992
O 1000	O 1000	O 0999	O 0998	O 0997	O 0996	O 0995	O 0994	O 0993

Detroit M M

W 0990	W 0985	W 0900	W 0890	W 0880	W 0875	W 0870	W 0867	W 0850	W 0845	W 0815
O 0989	O 0600	O 0595	O 0590	O 0555	O 0550	O 0500	O 0479	O 0415	O 0375	O 0373

Is A Typeface

W 0990	W 0985	W 0980	W 0975	W 0955
O 0650	O 0640	O 0630	O 0620	O 0605

W 0905	W 0895
O 0601	O 0600

W 0790	W 0785	W 0780	W 0777	W 0775	W 0767	W 0760	W 0750	W 0747	W 0737	W 0727	W 0717	W 0707	W 0705	W 070[
O 0599	O 0595	O 0590	O 0582	O 0575	O 0500	O 0400	O 0300	O 0200	O 0199	O 0150	O 0145	O 0145	O 0133	O 013[

Based | **On** | **Four Master Fonts**

W 0750	W 0991
O 0550	O 0997

W 0760	W 0755	W 0753	W 0750	W 0745	W 0735	W 0730	W 0725	W 0711	W 0709	W 0707	W 0705	W 0703	W
O 0539	O 0500	O 0400	O 0300	O 0200	O 0100	O 0015	O 0013	O 0011	O 0009	O 0007	O 0005	O 0003	O

To | **Create Multiple**

W 0700
O 0010

&

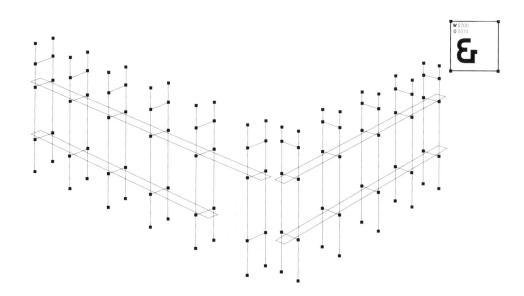

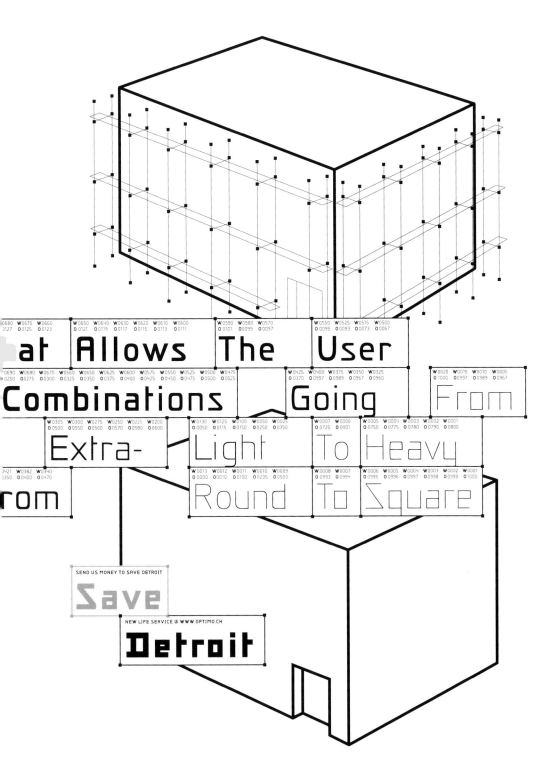

Detroit multiple master font
was created during a visit to Cranbrook
Academy of Art, Michigan in 1997. The designers
wanted it to be the ultimate font used
by every salesman in downtown Detroit,
and to then become a very flexible
universal type.
Type design: Stéphane Delgado
Gilles Gavillet, David Rust _Detroit

Dennis Ortiz-Lopez

Location_New York, USA

Established_1981

Distributors_FontHaus, Phil's Fonts
International Typefounders ITF

I specialize in revivals of old masters and try to be faithful to the original designs

Dennis Ortiz-Lopez completed a course in typography and font design at California State University in Long Beach, where he became aware of the importance of typography for visual communication. After working from 1979 to 1981 as a hand-letterer for <u>Rolling Stone</u> magazine, he founded his own studio with an emphasis on editorial design. He mostly uses his own fonts and his goal is to develop solutions that transmit their message with the least amount of internal conflict. In addition, Ortiz-Lopez offers typographic services for advertising agencies.

In designing fonts, he specializes in revivals of old masters. He selects as models fonts that can be used in display sizes, and always places great value in creating an exact translation of the model (mostly phototypositor versions) into the Postscript format.

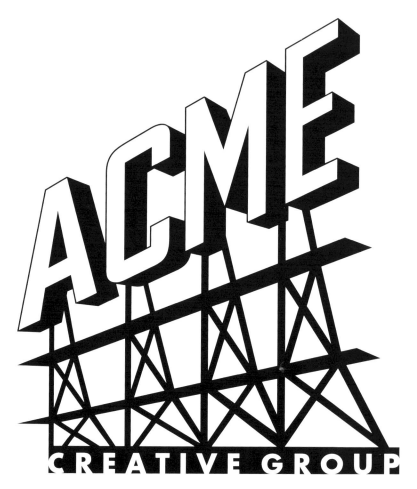

ACME Creative Group logo, shown in the catalogue of services, 1997. The logo was produced for Nickelodeon Television.

Design | Type design: Dennis Ortiz-Lopez

Pages from the catalogue
of services, 1997
14 x 21.6 cm

Design | Type design:
Dennis Ortiz-Lopez

O-L Smokler Deco Initials

ABCDE FGHIJ KLMNO PQRST UVWX YZ1234 567890

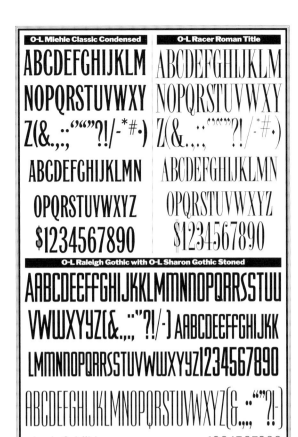

O-L Miehle Classic Condensed

ABCDEFGHIJKLM NOPQRSTUVWXY Z(&.,.;'"""?!/-*#•)

ABCDEFGHIJKLMN OPQRSTUVWXYZ $1234567890

O-L Racer Roman Title

ABCDEFGHIJKLM NOPQRSTUVWXY Z(&.,.;'"""?!/-*#•)

ABCDEFGHIJKLMN OPQRSTUVWXYZ $1234567890

O-L Raleigh Gothic with O-L Sharon Gothic Stoned

AABCDEEFFGHIJKKLMMNNOPQRRSSTUU VWWXYYZ(&.,.;"?!/-] AABCDEEFFGHIJKK LMMNNOPQRSTUVWWXYYZ1234567890

ABCDEFGHIJKLMNOPQRSTUVWXYZ(&.,.;'"""?!-)

abcdefghijklmnopqrstuvwxyz$1234567890

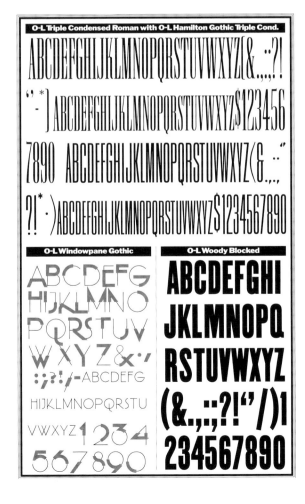

O-L Triple Condensed Roman with O-L Hamilton Gothic Triple Cond.

ABCDEFGHIJKLMNOPQRSTUVWXYZ(&.,.;?!
'"-*] ABCDEFGHIJKLMNOPQRSTUVWXYZ$123456
7890 ABCDEFGHIJKLMNOPQRSTUVWXYZ(&.,.;
?!*·)ABCDEFGHIJKLMNOPQRSTUVWXYZ$1234567890

O-L Windowpane Gothic

ABCDEFG HIJKLMNO PQRSTUV WXYZ&·' :;?!/-ABCDEFG HIJKLMNOPQRSTU VWXYZ1234 567890

O-L Woody Blocked

ABCDEFGHI JKLMNOPQ RSTUVWXYZ (&.,.;?!"/)1 234567890

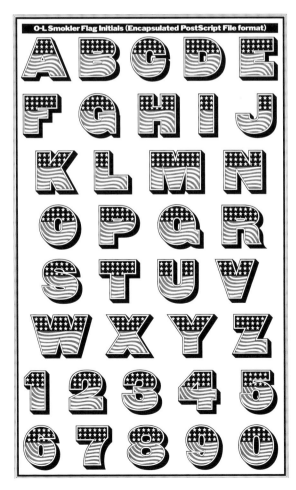

O-L Smokler Flag Initials (Encapsulated PostScript File format)

ABCDE FGHIJ KLMNO PQR STUV WXYZ 12345 67890

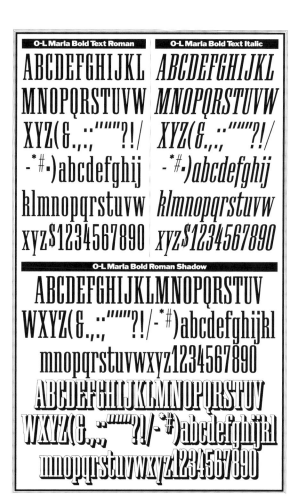

O-L Maria Bold Text Roman

ABCDEFGHIJKL MNOPQRSTUVW XYZ(&.,:;"""?!/ -*#-)abcdefghij klmnopqrstuvw xyz$1234567890

O-L Maria Bold Text Italic

ABCDEFGHIJKL MNOPQRSTUVW XYZ(&.,:;"""?!/ -*#-)abcdefghij klmnopqrstuvw xyz$1234567890

O-L Maria Bold Roman Shadow

ABCDEFGHIJKLMNOPQRSTUV WXYZ(&.,:;"""?!/-*#)abcdefghijkl mnopqrstuvwxyz1234567890 ABCDEFGHIJKLMNOPQRSTUV WXYZ(&.,:;"""?!/-*#)abcdefghijkl mnopqrstuvwxyz1234567890

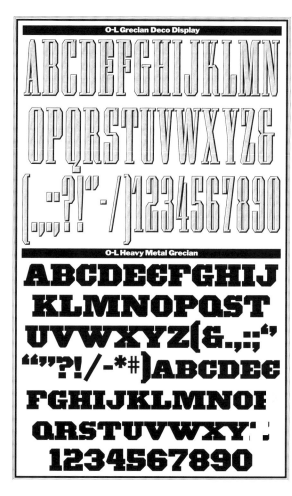

O-L Grecian Deco Display

ABCDEFGHIJKLMN OPQRSTUVWXYZ& (.,:;?!"-/)1234567890

O-L Heavy Metal Grecian

ABCDEFGHIJ KLMNOPQST UVWXYZ(&.,:;" """?!/-*#)ABCDEC FGHIJKLMNOI QRSTUVWXY! 1234567890

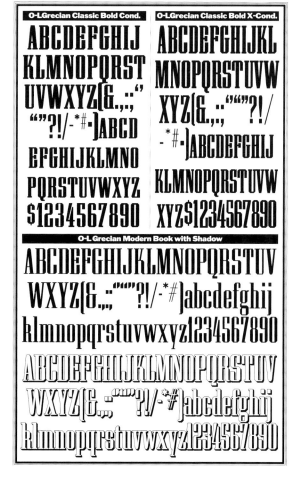

O-L Grecian Classic Bold Cond.

ABCDEFGHIJ KLMNOPQRST UVWXYZ(&.,:;" """?!/-*#-)abcd EFGHIJKLMNO PQRSTUVWXYZ $1234567890

O-L Grecian Classic Bold X-Cond.

ABCDEFGHIJKL MNOPQRSTUVW XYZ(&.,:;"""?! -*#-)abcdefghij KLMNOPQRSTUVW XYZ$1234567890

O-L Grecian Modern Book with Shadow

ABCDEFGHIJKLMNOPQRSTUV WXYZ(&.,:;"""?!/-*#)abcdefghij klmnopqrstuvwxyz1234567890 ABCDEFGHIJKLMNOPQRSTUV WXYZ(&.,:;"""?!/-*#)abcdefghij klmnopqrstuvwxyz1234567890

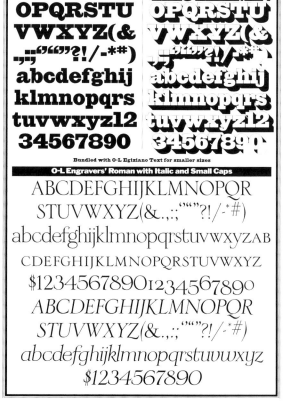

O-L Egiziano with Text Special and Shadow

ABCDEFG HIJKLMN OPQRSTU VWXYZ(& .,:;""""?!/-*#) abcdefghij klmnopqrs tuvwxyz12 34567890

ABCDEFG HIJKLMN OPQRSTU VWXYZ(& .,:;""""?!/-*# abcdefghij klmnopqrs tuvwxyz12 34567890

Bundled with O-L Egiziano Text for smaller sizes

O-L Engravers' Roman with Italic and Small Caps

ABCDEFGHIJKLMNOPQR STUVWXYZ(&.,:;"""?!/-*#) abcdefghijklmnopqrstuvwxyzAB CDEFGHIJKLMNOPQRSTUVWXYZ $12345678901234567890 ABCDEFGHIJKLMNOPQR STUVWXYZ(&.,:;"""?!/-*#) abcdefghijklmnopqrstuvwxyz $1234567890

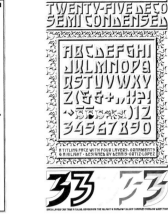

Pages from the catalogue
of services, 1997
14 x 21.6 cm

Design | Type design:
Dennis Ortiz-Lopez

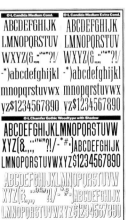

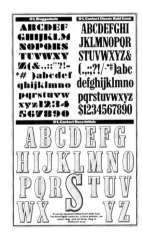

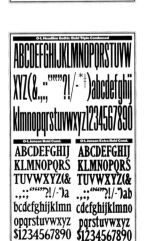

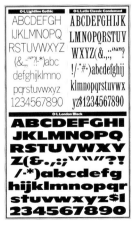

219

ParaType

Location_Moscow, Russia

Established_1989

Founder_ParaGraph

Type designers_Vladimir Yefimov, Tagir Safaev
Lyubov Kuznetsova, Manvel Shmavonyan
Alexander Tarbeer and many others

Distributors_FontShop International (FSI)
FontWorks, FontHaus

Welcome to the world of One Hundred Language Fonts

In 1989 ParaType was established by ParaGraph to unite the best Russian type designers and to license practically all typefaces existing at that time in Russia – about twenty families. The 1998 ParaType font catalogue consists of about five hundred fonts and presents the best work of Russian type designers within the last fifty years. In 1998 ParaType became independent and continued as a private company, registered in the USA and in Russia. ParaType font library is now the world's largest library of Cyrillic fonts.

ParaType font library also typesets the languages of Eastern and Western Europe, Asia and the former USSR. The more popular fonts have an expanded character set with special diacritics, phonetic spelling and unusual characters, including Old Russian (pre-1917) letters. ParaType aims to act as a catalyst in the formation of typographic culture in modern Russia and in presenting the Russian typographic tradition to the world. At the same time, its interest in multilingual fonts contributes to intercultural communications. People are becoming closer and ParaType serves these changes.

Catalogue with invitation card for the
Five Year Anniversary of ParaType exhibition
at IMA art gallery in Moscow, 1994.
22 x 29 cm

Design | Type design: Alexander Tarbeev _ITC Garamond Cyrillic

→
Poster for PT Rodchenko typeface, 1995
60 x 90 cm
The font is inspired by works of
Russian Constructivists Alexander
Rodchenko, Varvara Stepanova Stenberg
brothers, in 1920s and 1930s.

Design | Type design: Tagir Safaev _Rodchenko

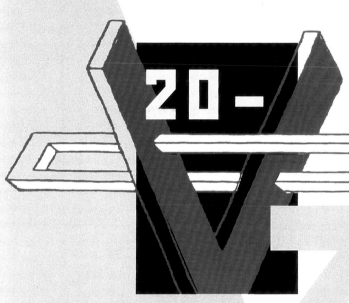

РОДЧЕНКО
RODCHENKO

20 –
30

1234567890

ABCDEFGHIJ

ABCDEFGHIJK

АБВГДЕЁЖЗИ

АБВГДЕЁЖЗИЙ

@ # $ & † () § № ! ?

«РОДЧЕНКО» разработан на основе отечественной типографики 20-30 годов в фирме «ParaGraph». Дизайнер Тагир

Poster for PT Pollock typeface, 1995
60 x 90 cm
The poster was created after the
international conference FUSE 95 in Berlin.

Design | Type design: Alexander Tarbeev _Pollock

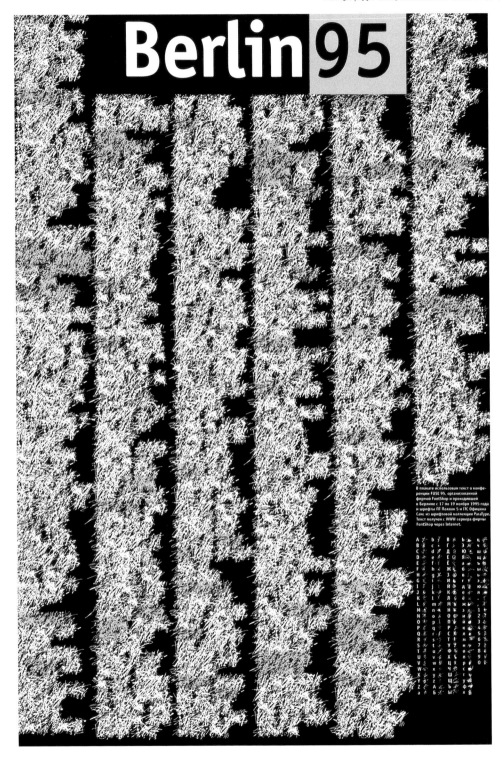

→
Poster for ParaType Arabic project, 1995
60 x 90 cm
Design: Tagir Safaev

Type design: Lyubov Kuznetsova _Mariam
_Naskh Ahmad

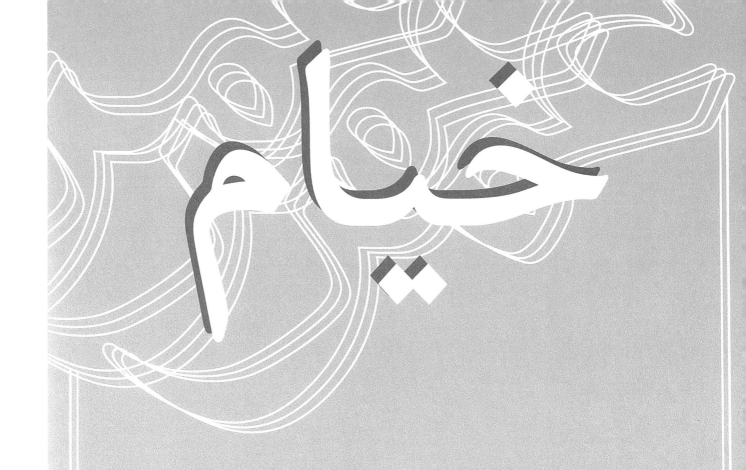

خیام

هر سبزه که بر کنار جوئی بودست
گوئی که خط فرشته خوئی بودست
تا بر سر سبزه پا به خواری ننهی
کان سبزه ز خاک لاله رویئی بودست

RUBAYAT by Omar Hayam

Typefaces: PT Mariam, PT Naskh Ahmad

Type designer: Lyubov Kuznetsova

Design: Tagir Safayev

© ParaGraph 1995

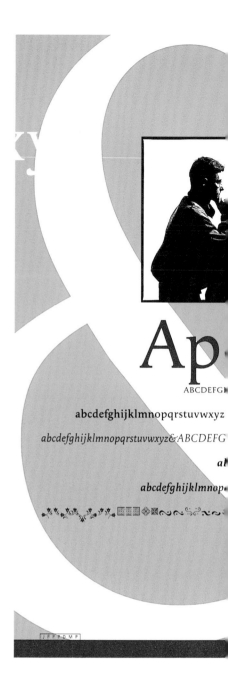

Porchez Typofonderie

Location_Malakoff, France

Established_1994

Founder | Type designer_Jean-François Porchez

Distributors_Agfa, FontBureau
FontShop International (FSI)

High-quality typefaces for adventurous digital typographers

After training at the Atelier Nationale de Recherche Typographique (ANRT), Jean-François Porchez worked as a typeface designer and consultant at Dragon Rouge. His first two type designs, Angie and Apolline, were prize-winning entries at the international Morisawa typeface competition. By 1994 he had created the new typeface for Le Monde and, in 1996, he created Parisine (intended for the corporate identity of the Paris Métro) and Anisette (designed with reference to the French poster designers of the 1930s). He has since finished the Le Monde family, which is made up of four basic styles.

Porchez Typofonderie is the biggest independent type foundry in France and is devoted to continuing the French tradition of typography. It specializes in the production of custom typefaces and digitizing work. Jean-François Porchez teaches typography at École Nationale Superieure des Arts Décoratifs (ENSAD) and École de Communication Visuelle (ECV), in Paris. He is typographic correspondent for the magazine Étapes Graphiques, a member of the Rencontres Internationales de Lure and the French representative of the Association Typographique Internationale and the Typographic Circle.

Jeune créateur de caractères, Jean-François Porchez, 30 ans, a été formé dans une école d'arts graphiques & à l'Atelier National de Création Typographique. Il a travaillé comme créateur & conseiller typographique chez Dragon Rouge. Ses deux premières créations, le FF Angie & l'Apolline ont été primées au concours international de création de caractères Morisawa awards.

réé par Jean-François Porchez

Mais sa plus belle réussite est le caractère Le Monde créé pour la nouvelle formule du quotidien du même nom. Depuis il exerce en indépendant, une activité de créateur de caractères & enseigne la typographie.

§ 7/9pt REGULAR — L'Apolline, un caractère de texte qui allie sensibilité & rythme a déjà reçu le prix d'honneur au concours international de création de caractères MORISAWA AWARDS 1993 au Japon. La famille a été dessinée en 3 graisses, romain & italique. Des petites capitales ainsi que des jeux de chiffres bas-de-casse, capitales et de nombreuses ligatures complètent les séries. *Le bas-de-casse romain marque l'horizontale, il tire sa dynamique de l'écriture. Par ses différences de-proportions, l'asymétrie de ses empattements, le texte est plus rythmé. Il fait référence aux caractères*

§ 9/11pt REGULAR — humanistiques. Les capitales sont lapidaires par leurs proportions, écrites par la forme de leurs empattements. L'italique est lui, plus contemporain dans son dessin. Il peut rappeler les italiques d'ERIC GILL, de JAN VAN KRIMPEN. L'Apolline, un caractère de texte qui allie

§ 12/14pt REGULAR — La famille a été dessinée en 3 graisses, romain & italique. Des petites capitales ainsi que des jeux de *chiffres bas-de-casse, capitales & de nombreuses ligatures*

§ 12/14pt SEMI-BOLD — **La famille a été dessinée en 3 graisses, romain & italique. Des petites capitales ainsi que des jeux** *de chiffres bas-de-casse, capitales & de nombreuses*

§ 12/14pt BOLD — **La famille a été dessinée en 3 graisses, romain & italique. Des petites capitales ainsi que des jeux** ***de chiffres bas-de-casse, capitales & de nombreuses***

ne

fb

APOLLINE ALTERNATE ITALIC
a e ę rt z ct st fb ff fh fi fj ffi fl ffl ft Q Q

APOLLINE ALTERNATE REGULAR
a e rt z ct st fb ff fh fi fj ffi fl ffl ft Q Q

APOLLINE EXPERT ITALIC
fff ffl ffffl ½ ⅓ ¼ ⅛ ⅔ ¾ ⅘ ⅞ 0123456789

APOLLINE REGULAR SMALL CAPS
wxyz&ABCDEFGHIJKLMNOPQRSTUVWXYZ0123456789

APOLLINE EXPERT REGULAR
ABCDEFGHIJKLMNOPQRSTUVWXYZ&fff ffl ffffl ½ ⅓ ¼ ⅛ ⅔ ¾ ⅘ ⅞ 0123456789

APOLLINE SEMI-BOLD, SEMI-BOLD LF
LMNOPQRSTUVWXYZ0123456789 0123456789

APOLLINE BOLD, BOLD LF
abcdefghijklmnopqrstuvwxyz&ABCDEFGHIJKLMNOPQRSTUVWXYZ0123456789 0123456789

APOLLINE ITALIC, ITALIC LF
TUVWXYZ0123456789 0123456789

APOLLINE BOLD ITALIC, BOLD ITALIC LF
rstuvwxyz&ABCDEFGHIJKLMNOPQRSTUVWXYZ0123456789 0123456789

APOLLINE SEMI-BOLD ITALIC, SEMI-BOLD ITALIC LF
DEFGHIJKLMNOPQRSTUVWXYZ0123456789 0123456789

APOLLINE ORNAMENTS

APOLLINE REGULAR, REGULAR LF
cdefghijklmnopqrstuvwxyzABCDEFGHIJKLMNOPQRSTUVWXYZ
Œ&æœfiflß0123456789 0123456789%‰$¢£¥ƒ
àáâãçéêèéíîïñóôòöúûùüÿÁÂÀÃÄÅÇÉÊÈÍÎÏÌÓÔÒÖÕÑÚÛÙÜŸ
?¿¡(I)•[/]{/}\°«‹'",.;:""",,»»#*†‡§¶@®©™——_

§ 16/18pt REGULAR — L'Apolline, un caractère de texte qui allie sensibilité & rythme a déjà reçu le prix d'honneur au concours international de création de caractères MORISAWA AWARDS 1993 au Japon. La famille a été dessinée *en 3 graisses, romain & italique. Des petites capitales ainsi que des jeux de chiffres bas-de-*

Plus de 500 nouvelles créations représentant un choix équilibré de caractères de texte et de titrage ont été ajoutées à la collection Agfatype. Ces nouveautés portent la collection à un total de 1300 polices de caractères.

Les polices Agfatype sont disponibles au format Mac et/ou PC. Pour commander des polices de caractères ou obtenir les différents spécimens des caractères de nos dessinateurs:
(1) 40 99 87 68 téléphone
(1) 40 99 87 64 fax

AgfaType

AGFA Agfa

Agfa Gevaert
BP 72
92152 Suresnes cedex

Postcard/specimen, 1995
38 x 23 cm

Design | Type design: Jean-François Porchez _Apolline

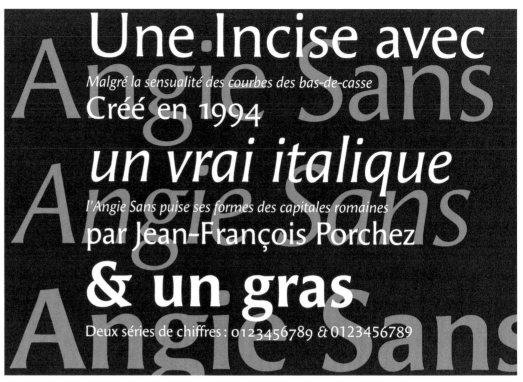

Postcard/specimen, 1994
15 x 10.5 cm

Design | Type design:
Jean-François Porchez _Angie Sans Roman, Italic, Bold

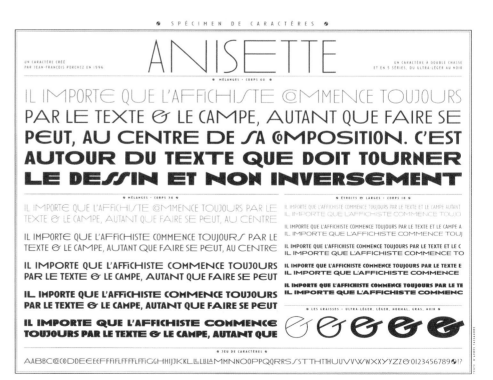

Postcard/specimen, 1997
15 x 10.5 cm

Design | Type design:
Jean-François Porchez _Anisette Thin, Light,
Medium, Bold, Black

FFAngie
1995
Angie Sans
1994
ANISETTE
1996
Apolline
1995
Le Monde Journal
1997
Le Monde Sans
1997
Le Monde Livre
1997
Le Monde Courrier
1997

Type design:
Jean-François Porchez

Parisine
1996

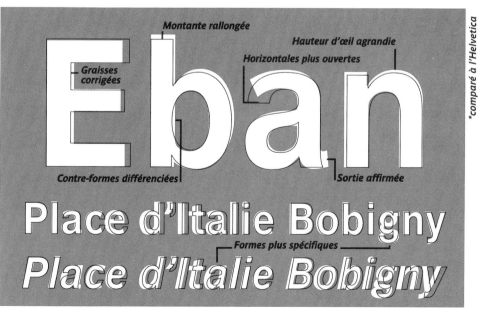

Montante rallongée

Hauteur d'œil agrandie

Horizontales plus ouvertes

Graisses corrigées

compare à l'Helvetica

Contre-formes différenciées

Sortie affirmée

Place d'Italie Bobigny

Formes plus spécifiques

Place d'Italie Bobigny

Le Parisine*par* **Jean-François Porchez**

Postcard/specimen, 1997
15 x 10.5 cm
The postcard compares Helvetica
condensed at 90% and Parisine,
the new face for the Paris Métro.

Design | Type design:
Jean-François Porchez _Parisine Bold, Bold Italic

Top left column:

Le Monde Journal est le caractère de base de toute la famille. Par définition il est destiné à la presse & aux petits corps. Il est destiné à la même couleur que le Times, il paraît néanmoins plus ouvert. La lecture en est facilitée, moins saccadée. Les contre-formes des signes sont plus larges comme s'il y avait « de la lumière à

l'intérieur. » La forme marquée des empattements reste encrée dans notre mémoire visuelle.

Pour tenir compte des problèmes d'impression, le gras contraste franchement avec le romain. Le demi-gras est lui plus adapté au titrage ou à l'édition soignée. Des italiques accompagnent Le Monde Journal. D'un

Le Monde Journal Normal

abcdefghijklmnopqrstuvwxyz
abcdefghijklmnopqrstuvwxyz
ABCDEFGHIJKLMNOPQRSTUVWXYZ
ABCDEFGHIJKLMNOPQRSTUVWXYZ
ABCDEFGHIJKLMNOPQRSTUVWXYZ
ABCDEFGHIJKLMNOPQRSTUVWXYZ
0123456789 && 0123456789 ßfifl,.;:!?
0123456789 && 0123456789 ßfifl,.;:!?

Il y a bien évidemment des rapp
ORTS ENTRE LE MONDE & LE TIM
es New Roman précédemment uti
LISÉ PAR LE JOURNAL. LE TIMES ES

Il y a bien évidemment d
ES RAPPORTS ENTRE LE M
onde & le Times New Rom
AN PRÉCÉDEMMENT UTILISÉ

(top right)
abcdefghijklmnopqrstuvwxyz
abcdefghijklmnopqrstuvwxyz
ABCDEFGHIJKLMNOPQRSTUVWXYZ
ABCDEFGHIJKLMNOPQRSTUVWXYZ
0123456789 && 0123456789 ßfifl,.
0123456789 && 0123456789 ßfifl,..

abcdefghijklmnopqrstuvwxyz
abcdefghijklmnopqrstuvwxyz
ABCDEFGHIJKLMNOPQRSTUVWXYZ
ABCDEFGHIJKLMNOPQRSTUVWXYZ
ABCDEFGHIJKLMNOPQRSTUVWXYZ
0123456789 && 0123456789 ßfifl,..
0123456789 && 0123456789 ßfifl,..

Le Monde Journal

Le Monde Journal Semibold

abcdefghijklmnopqrstuvwxyz
abcdefghijklmnopqrstuvwxyz
ABCDEFGHIJKLMNOPQRSTUVWXYZ
ABCDEFGHIJKLMNOPQRSTUVWXYZ
ABCDEFGHIJKLMNOPQRSTUVWXYZ
0123456789 && 0123456789 ßfifl,.;:!?
0123456789 && 0123456789 ßfifl,.;:!?

Le Monde Journal Bold

abcdefghijklmnopqrstuvwxyz
abcdefghijklmnopqrstuvwxyz
ABCDEFGHIJKLMNOPQRSTUVWXYZ
ABCDEFGHIJKLMNOPQRSTUVWXYZ
ABCDEFGHIJKLMNOPQRSTUVWXYZ
0123456789 && 0123456789 ßfifl,.;:!?
0123456789 && 0123456789 ßfifl,.;:!?

dessin plus maigre & d'un rythme différent, ils restent présents lorsqu'ils sont utilisés avec les romains. Le Monde Journal est décliné en trois graisses romain, italique & petites capitales.

Le Monde Journal is the typeface on which the entire family is based. By definition, it is intended for newspaper use & at small sizes. Even though it has the same colour as Times, it appears more open. The reading flow has been made more fluent & less abrupt. The counters in the glyphs are bigger, as if they were « illuminating the interior. » The form, characterized by its serifs, remains embedded in our visual memory.
To accommodate any problems in newspaper printing, the bold sharply contrasts with the roman. The demi weight is better suited to titling or more careful printing. Italics accompany Le Monde Journal. With a more delicate design & a distinctive rhythm, they remain noticeable when used with the romans. Le Monde Journal is available in three weights, each in roman, italic & small capitals.

– sept au total – en romain, italique & petites capitales pour faire face à toute sorte de situations. Vue la largesse d'utilisation des linéales, c'est aujourd'hui indispensable. Malgré tout, les trois graisses standarts sont conçues pour parfaitement fonctionner avec le reste des styles.

Le Monde Sans is a lineale type family – one which has been derived from serifed types – a practice that has now become commonplace. As applied before to italics, this type of variation expands typographic possibilities, differentiating of the status of each text. This is fundamental to contemporary documents and the press, where comments & analyses must be distinguished subtly from news.
The design of Le Monde Sans continues the basic common structure found in the members of the Le Monde family: its proportions, a relatively narrow width, a fairly oblique axis, etc. The typographer can, at all times, switch between Sans & Journal without any disruption in the composition.

Le Monde Sans is offered in numerous weights – seven in total, in roman, italic & small capitals to meet all kinds of situations. Given the common usage of lineale sans serif typefaces today, this is indispensable. In spite of all this, the three standard weights function perfectly with the remaining subfamilies.

Il y a bien évidemment des rapports entre Le Monde & le Times New Roman précédemment utilisé par le journal. Le Times est devenu par son usage l'équivalent d'un véritable cliché culturel. Il est donné comme premier caractère, par défaut, à presque tous les micro-ordinateurs en même temps que l'Helvetica. Le Times représente le caractère à empattements, traditionnel par excellence, l'Helvetica, le caractère sans empattement connotant une modernité datant d'un autre siècle. Les lecteurs de j

Il y a bien évidemment des rapports entre Le Monde & le Times New Roman précédemment utilisé par le journal. Le Times est d EVENU PAR SON USAGE L'ÉQUIVALENT D'UN VÉRITABLE CULturel. Il est donné comme premier caractère, par défaut, à presque t ous les micro-ordinateurs en même temps que l'Helvetica. Le Times REPRÉSENTE LE CARACTÈRE À EMPATTEMENTS, TRADITIONNEL PAR EX

Il y a bien évidemment des rapports entre Le Mond e & le Times New Roman précédemment utilisé pa R LE JOURNAL. LE TIMES EST DEVENU PAR SON USAG e l'équivalent d'un véritable cliché culturel. Il est donn é comme premier caractère, par défaut, à presque tou S LES MICRO-ORDINATEURS EN MÊME TEMPS QUE L'HELV

Il y a bien évidemment les rapports entre L E MONDE & LE TIMES NEW ROMAN PRÉCÉD *emment utilisé par le journal. Le Times est d* EVENU PAR SON USAGE L'ÉQUIVALENT D'UN VÉ

Le Monde Sans Sans Bold

abcdefghijklmnopqrstuvwxyz
abcdefghijklmnopqrstuvwxyz
ABCDEFGHIJKLMNOPQRSTUVWXYZ
ABCDEFGHIJKLMNOPQRSTUVWXYZ
ABCDEFGHIJKLMNOPQRSTUVWXYZ
ABCDEFGHIJKLMNOPQRSTUVWXYZ
0123456789 && 0123456789 ßfifl,.;:!?
0123456789 && 0123456789 ßfifl,.;:!?

Le Monde Sans Bold

abcdefghijklmnopqrstuvwxyz
abcdefghijklmnopqrstuvwxyz
ABCDEFGHIJKLMNOPQRSTUVWXYZ
ABCDEFGHIJKLMNOPQRSTUVWXYZ
ABCDEFGHIJKLMNOPQRSTUVWXYZ
ABCDEFGHIJKLMNOPQRSTUVWXYZ
0123456789 && 0123456789 ßfifl,.;:!?
0123456789 && 0123456789 ßfifl,.;:!?

Le Monde Sans Extra Light

abcdefghijklmnopqrstuvwxyz
abcdefghijklmnopqrstuvwxyz
ABCDEFGHIJKLMNOPQRSTUVWXYZ
ABCDEFGHIJKLMNOPQRSTUVWXYZ
0123456789& 0123456789 ßfifl,.;:!?
0123456789& 0123456789 ßfifl,.;:!?

Le Monde Sans Light

abcdefghijklmnopqrstuvwxyz
abcdefghijklmnopqrstuvwxyz
ABCDEFGHIJKLMNOPQRSTUVWXYZ
ABCDEFGHIJKLMNOPQRSTUVWXYZ
0123456789 & 0123456789 ßfifl,.;:!?
0123456789 & 0123456789 ßfifl,.;:!?

Le Monde Sans Normal

abcdefghijklmnopqrstuvwxyz
abcdefghijklmnopqrstuvwxyz
ABCDEFGHIJKLMNOPQRSTUVWXYZ
ABCDEFGHIJKLMNOPQRSTUVWXYZ
0123456789 && 0123456789 ßfifl,.;:!?
0123456789 && 0123456789 ßfifl,.;:!?

Le Monde Sans Extrabold

abcdefghijklmnopqrstuvwxyz
abcdefghijklmnopqrstuvwxyz
ABCDEFGHIJKLMNOPQRSTUVWXYZ
ABCDEFGHIJKLMNOPQRSTUVWXYZ
0123456789 & 0123456789 ßfifl,.;:!?
0123456789 & 0123456789 ßfifl,.;:!?

Le Monde Sans Black

abcdefghijklmnopqrstuvwxyz
abcdefghijklmnopqrstuvwxyz
ABCDEFGHIJKLMNOPQRSTUVWXYZ
ABCDEFGHIJKLMNOPQRSTUVWXYZ
0123456789 & 0123456789 ßfifl,.;:!?
0123456789 & 0123456789 ßfifl,.;:!?

LE MONDE SANS est la version linéale, déclinaison des versions à empattements. Aujourd'hui, c'est une chose devenue courante. Comme le faisait auparavant l'italique, ce type de variation enrichit les possibilités typographiques en permettant de différencier le statut

de chaque texte – ce qui est fondamental dans les documents contemporains & la presse, où les commentaires & analyses doivent se démarquer subtilement de l'information elle-même.
Le dessin du Le Monde Sans reprend la structure de base commune aux membres de la famil-

le Le Monde: proportions, chasse relativement étroite, axe oblique moins appuyé, etc. À tout moment, sans bouleverser la composition du texte, le typographe peut échanger les versions Sans & Journal.
Ce style est décliné dans de nombreuses variantes de graisses

Liste des caractères, character sets: Standard, Osf, SC.

abcdefghijklmnopqrstuvwxyz
ABCDEFGHIJKLMNOPQRSTUVWXYZ
ABCDEFGHIJKLMNOPQRSTUVWXYZ
æœðfiflßŁßÆœÆŒÐŁÞ
0123456789&0123456789&0123456789
$$¢£¥€£ƒ¹²³½¼¾%‰!¿?¡()[]{}|/
·*''‡§¶#@®©®™ªº µ\<+×=÷>‹›¬|
·.,'''"""»«»‹›=‹›=
áàâãäåąçčéëèê íìîïñóôòõöøúûüÿ
ÁÀÂÃÄÅĄÇČÉËÈÊ ÍÌÎÏÑÓÔÒÕÖØÚÛÜŸ
ÁÀÂÃÄÅĄÇČÉËÈÊ ÍÌÎÏÑÓÔÒÕÖØÚÛÜŸ

Le Monde Sans

Specimen for Le Monde family, 1997
29.7 x 41.8 cm
The specimen includes texts from
Laurent Greilsamer, Gérard Blanchard
Sumner Stone and Allan Haley.
Le Monde family consists of thirty-two
weights in four different styles:
Le Monde Journal, Le Monde Sans
Le Monde Livre, Le Monde Courrier.

Design | Type design: Jean-François Porchez _Le Monde

Le Monde

Lire neuf, grand & beau

A type family story

Parcourt

Echoing old style faces

La Totale typographie

Laurent Greilsamer,

Allan Haley,

e Monde Livre

Monde

Le Monde Courrier

la tua ruota

Fabrizio Schiavi Design

Location_Piacenza, Italy

Established_1998

Founder | Type designer_Fabrizio Schiavi

Distributors_[T-26], FontShop International (FSI),
Fontology

Post-design

Fabrizio Schiavi has worked as a self-employed designer
and font maker since 1994. He places conceptual work in the
foreground of developing projects and does not believe that
innovation exists in aesthetic aspects. Instead he feels that it
results from removing familiar elements from their usual
context and integrating them into a new context so they receive
an unfamiliar, new meaning. Schiavi rejects the idea that a
font only serves as the bearer of a specific message; he believes
a font communicates its own information as a result of its
visual qualities.

Schiavi devotes more and more time to Web design. His goal is
not only to translate the contents of print media, but also to
create a truly interactive experience so users can obtain infor-
mation in an entertaining way and experience new contexts.

Fabrizio Schiavi is also one of the founders of the Fontology
font project which began in 1995 in collaboration with Happy
Books in Modena (see p. 120).

Typeface name: Post
Style name: Regular
Type/face Designer: Fabrizio Schiavi

GARAGE
Ken ishi
displayed
stop→post
post-bahaus
avantgarde
no more grunge
intelligent techno

Specimen, 1997
The font was exclusively designed
for the record company
Expanded Music Srl.

Design | Type design: Fabrizio Schiavi _Post

Website, 1998
www.agonet.it/fabrizioschiavi/
On his own website Fabrizio Schiavi
pays homage to the people responsible
for his career development.
He also demonstrates his ideas about
interactive communication and
presents information in a playful way by,
for example, using a type quiz.

Design: Fabrizio Schiavi

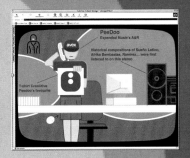

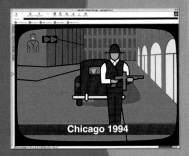

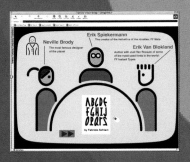

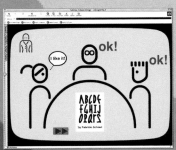

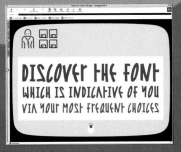

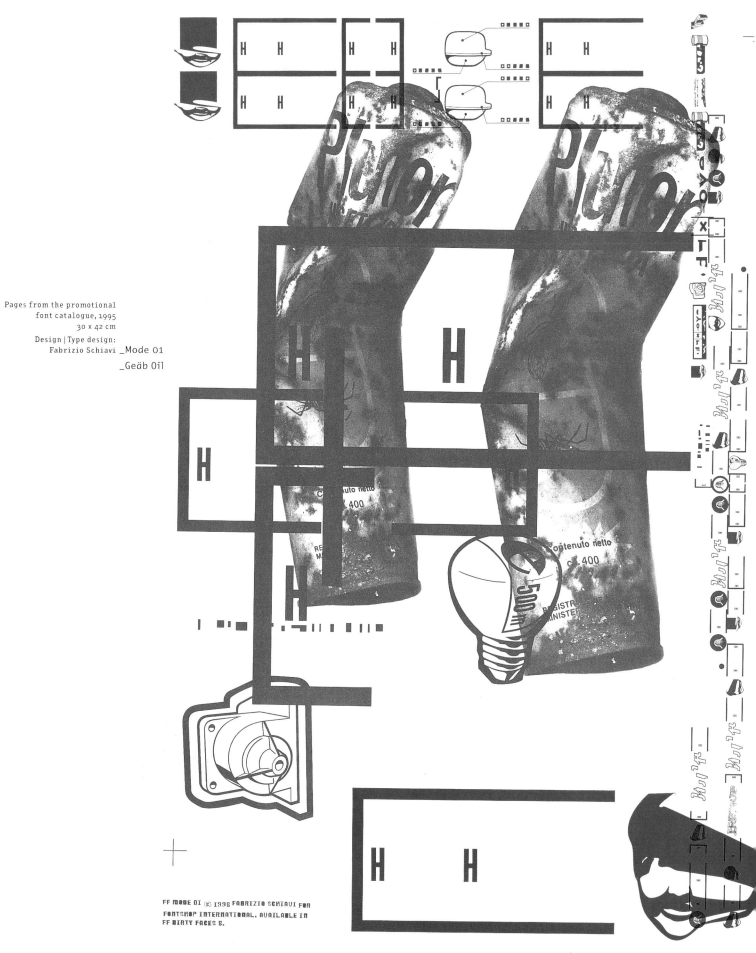

Pages from the promotional
font catalogue, 1995
30 x 42 cm
Design | Type design:
Fabrizio Schiavi _Mode 01
_Geäb Oil

FF MODE 01 © 1995 FABRIZIO SCHIAVI FOR
FONTSHOP INTERNATIONAL. AVAILABLE IN
FF DIRTY FACES 6.

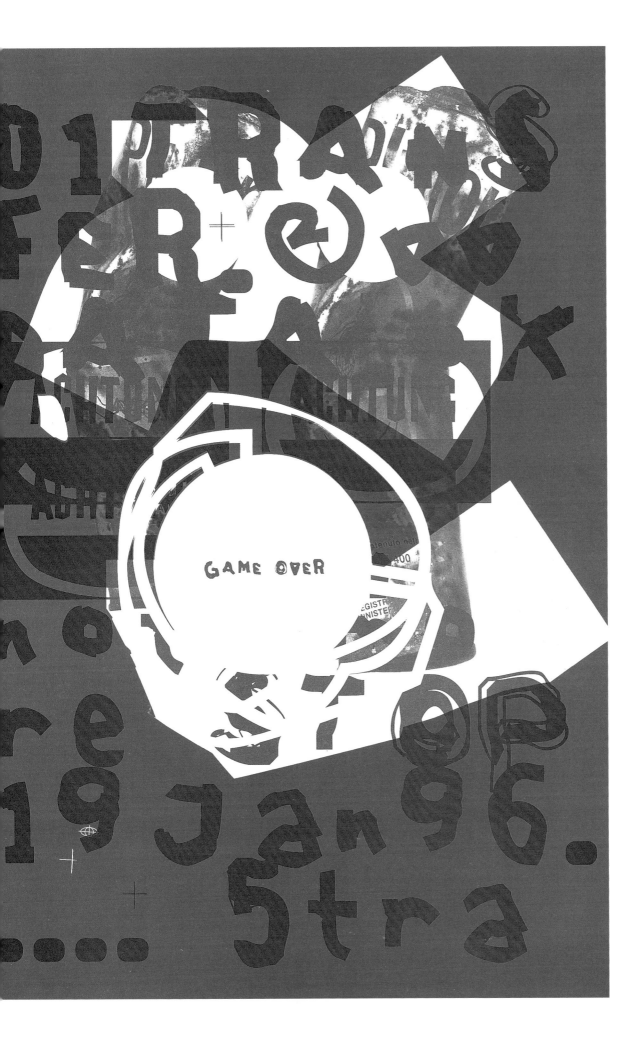

GAME OVER

235

Dot Gain or The Endless Repetition of Dot

Michael Horsham

I can't remember when I stopped watching the soap opera 'Eastenders'. I only know that I did. The reasons for deserting what had become something of a ritual for a couple of evenings a week were complex. The show hadn't become worse. If anything, it was in the process of becoming a more concentrated version of itself. Story lines were tight and compelling. The characters, if not completely believable, were sufficiently strong to induce care or hissing fits depending or their perceived capacity for good or evil.

It was pantomime, but good pantomime. Wilmott-Brown, for example, our Kaff's rapist/nemesis was quite the Victorian villain. He was posh and a landlord to boot, and was only missing the moustache to twirl and a convenient railway track on which to strap the heroine. Sympathetically, or maybe just pathetically, I cared what happened next. But, if I can't remember when I stopped watching, I can remember why – it was Dot.

Dot Cotton, with her infernal internally rhyming name, had long begun to take the pleasure out of watching for me. It wasn't just her appearance – the haggard face and the cigarette held aloft, the receded gums and the long teeth – it was her role. Even though I had dreamed of having sex with Dot (surely a turning point), it was her functional omnipresence that began to put me off the show. Dot was like the Greek chorus; she commented on the action all the time. Preceding her pronouncement with the absurd, 'Well, yes, you know me, I'm

not one to gossip, but...', she goes on to assassinate the traits of one of her fellow characters. It was comic at first, of course it was, but the endless and repeated use of Dot as a device for moralizing or mediation grew wearisome. The grotesqueness of her appearance coupled with her role as a mediatrix who never actually produced anything by way of plot or development, was ultimately alienating. She just reproduced the action and that act of reproduction held an implicit criticism of what had occurred. There was little in the way of good or originality within her; a secondary character with a secondary function. She was no Hilda Ogden.

Now, I'm told, she is back in the show (I hadn't realized she'd been away) and I can only surmise that 'Eastenders' will continue to churn out its depressing mixture of low drama and government-inspired 'issue-based' stories. Stories featuring single parents, illiteracy, AIDS awareness, etc., all without swearwords and all tinged with the all-knowing, utter fake functionality of Dot's two-dimensional character.

The issues are dimensionality and filtering; an idea of truth, or authenticity and an idea of the real. The link between 'Eastenders' and the real subject of this piece is tenuous, and I am the first to admit that I would be stuck for an opening if Dot were named otherwise. It's lucky she isn't and it's equally lucky that she is so crap. But still, I think there is a point here.

To illustrate the case of the dot a little further. Around 1966 Rover cars launched their replacement for the highly regarded P5 model. For those of you that need a reference point, the P5 was a ministerial barge, which also doubled as a gangster wagon. For instance, James Fox's chemically unbalanced character was driven about in a P5 in Cammel & Roeg's film Performance. The P5 is generally regarded by afficionados as the last real Rover. The replacement was the P6, the car I drive today; an altogether more modern and angularly aerodynamic design. The P6 has an atmosphere of Rover authenticity that stems not from the lavish use of walnut and leather as did its predecessor's, but from its mechanical excellence and reliability.

Unwilling to break completely with the traditions of the marque, the designers at Rover eschewed real wood in favour of a suggestion of the same. The result was the inclusion of some very nasty 'wood veneers' printed with a half-tone colour image of rosewood grain. Look closely at the door trim or the dashboard and the whole thing is dots of different colours. The effect is kitsch and the P6 is consequently – at the moment at least – a very cool car, but then I would say that. You don't disrespect your own ride, after all.

The car's appeal lies partly in the fact that it comes from a tradition not of craftsmanship and coachbuilding as its predecessors did, but of modern reproduction. It is therefore modern in its self-reflexive reliance on technology for its identity. In that sense it's very 1970s. It's also curious to think that the P5s and the P4s before them all enjoyed a modicum of uniqueness, delivered by the minute inconsistencies and quality of grain and colour in the woods used in their construction. The Rover P6 was among the first British cars to be serially replicated both decoratively and mechanically – because the organic nature of the decoration was mechanically derived. On the Rover's dash and panelling, tone had become type. Culturally and technologically, the grain had become The Dot.

The same idea works with photography. Although a chemical and therefore modern method of reproduction, the grain of photographic emulsion and the grain of photographic papers (or indeed any medium that has been made photosensitive) is the element which adds – to some degree – the grain of authenticity, even the grain of truth, to the image as manufactured object. Reproduce a photograph using a dot-screen and print it in a newspaper and the act of publishing is a matter of documentary reproduction rather than one of individual authorship.

The dot – the unitary, mechanistically derived element of the whole image is therefore a signifier of the process of mass mediation. See a dot, this theory goes, and see the sign of reproduction and not authorship. Ah! I hear you say, but what about those painters and artists for whom the dot is central to their work? Well, even when the dot is deployed as part of the method of authorship, say, in a Lichtenstein or at a push a Chuck Close, its presence unfailingly marks the product as modern, and in some way the product of a filtered or mediated aesthetic that is not so far removed from that formica coffee table or my dashboard.

We know that Lichtenstein's Benday-style dots, long the underpinning of cheap reproductive technology, mark those works as self-conciously robust reproductions of reproductions. So, at first glance the issue becomes one of scale and meaning rather than an obvious analysis of or reliance on painterly technique. Chuck Close is at the other end of the spectrum. The laborious accretion of colour and tone in the manufacture of his seemingly 'photo-real' heads of the 1970s was achieved by using the airbrush, pastels, oils and seemingly a whole raft of traditional artists' materials to replicate and enlarge the characteristics of his sitters originally captured on polaroid. In much of Close's work the dot is there as evidence of a modern pointillist modus operandi: technique is everything, albeit mind-numbingly repetitious. The presence of the artist, not the machine, is the filter which turns the act of reproduction into what has been identified as a relationship between units and unity, the parts and the whole. The point is this: within the world of painting and made marks we end up with work that is modern, filtered and distanced and, as in 'Eastenders', we recognize it as such by the presence of the Dot.

It's our ability to break the close tonal range of the grain of the world into the specifics of unit and unity (and in the process highlight the relationship of the parts to the whole) that makes the presence of the dot in the culture of reproduction worthy of note. And, at the heart of the issue is the transference of the qualities of tone and grain to those of typology and unit. It's a mechanistically simple process. Dot screening works by dividing any image or complex tonal field into a field of typological units: the dots. These units are then given colour and tonal values, but the dominant values are always the conditions and qualities of the dots.

Until recently one of the printer's greatest enemies to quality was the occurrence of 'dot gain', the phenomenon whereby ink would leach into the print medium and smudge the dots, so altering the supposedly stable typology and lending the image tonal values that were outside the printer's controllable parameters. That is, the quality of the dots would change by accident and there would be a tonally complex, but shitty image. Newer techniques, such as stochastic screening, recognize the ludicrous inflexibility of the traditional dot and use a more complex interwoven geometry. It seems that the dot may have run its course as a visible component of reproductive technology.

However, the humble dot is far from dead largely because it has the capacity to deliver both power and beauty. Thomas Ruff's giant composite portraits of seemingly perfectly featured people are presented on gallery walls in all their lilac-hued dotty magnificence. As products of modern photographic techniques involving – I am told – police Photofit cameras, the presence of the dot is utterly subservient to the effect of the picture's ethereal

otherness. But, the dot is a crucial part the notion that the images have been manufactured. The artifice of reproduction is almost the whole point. Jenny Holzer's dot matrixes are also worthy of note, in that they are perhaps the purest expression of the power of the dot when effectively deployed at the art end of the spectrum. The clarity and luminosity of the dot matrix as an information carrier is not compromised by the task it is being asked to perform.

And, there is the rub and the power. Wherever the dot is identifiable as evidence of filtering, wherever the dot-as-type replaces the grain-as-tone, wherever the dot is simply the identifiable mark of reproduction technology, the result is arguably removed from the authentic or the real experience.

Quite where this takes us in terms of value is difficult to determine. The experience of my car is no less enjoyable because the wood effects are cheesy, but for some reason a bad reproduction of a painting, say in a 1970s art anthology, wherein the dots are visible, unarguably destroys the quality of the image and in turn the experience of the image. Unless used as a pure form and not as a way of approximating complex tonal qualities, the dot is doomed to the cultural nether world of cheese repro. At the moment this has its own currency, but just how long that lasts is anyone's guess...

Stone Type Foundry

Location_Palo Alto, California, USA

Established_1990

Founder | Type designer_Sumner Stone

Distributors_Agfa, Stone Type Foundry

The design of letter forms is both practical and magical

Stone Type Foundry creates, produces and markets designs for the professional typographer. The company also offers custom-made typeface design and identity and signage programmes for public and private institutions. Mobil Corporation, General Motors, Stanford University, San Francisco Public Library and Scripps College are all customers.

Sumner Stone is fascinated by written forms because they do not exist in a vacuum. Instead, they occupy a position at the confluence of many different streams of human life such as language, visual perception, intellect, kinaesthesia, emotion and social structure. From his point of view, typeface design involves the knowledge and practice of many disciplines, the underpinnings of which are drawing and the history of letter forms. His practice and study of these disciplines for more than thirty years helps him to solve typeface design problems such as designing a text typeface at the limits of condensation (Print) or a humanistic slab serif drawn entirely on a computer screen (Silica). However, there are also many other influences. Each new project is a challenge to old aesthetics and received wisdom for Sumner Stone. It is a new window on some part of society, an active journey through his own eyes, mind, hands and spirit to unite the past and the future.

Specimen for Arepo, Cycles, Print, Silica and ITC Stone, 1995
21.6 x 27.9 cm

Design: Jack Stauffacher
Type design: Sumner Stone _Arepo Roman, Italic

ITC STONE VERSION 2.0

Part of an advertisement for ITC Stone,
version 2.0., that appeared several
times in 'U&lc' in 1995.
8 x 24 cm

Design | Type design: Sumner Stone _ITC Stone, Version 2.0

S A T O R
A R E P O
T E N E T
O P E R A
R O T A S

The early Christian latin palindrome above was painted on a wall at Pompeii.
This broadside was printed at Stone Type Foundry, Palo Alto, California
as a keepsake for Sumner Stone's lecture
"The Future of Typeface Design"
given for The Associates of the Stanford University Libraries on January 11, 1996.
The typeface, Arepo, was designed by Mr. Stone.

Keepsake from a lecture given at
Stanford University, 1996.

Design | Type design: Sumner Stone _Arepo

Judith Sutcliffe:
The Electric Typographer

Location_Audubon, Iowa, USA

Established_1986

Founder | Type designer_Judith Sutcliffe

Distributors_FontShop International (FSI)
Agfa, Monotype, Type Founders
International, Daniel Will-Harris

Judith Sutcliffe founded The Electric Typographer in 1986 in Santa Barbara, California. She publishes and markets her own fonts exclusively under this name. When she began to work with Fontographer in 1985, she digitized various fonts by Frederic Goudy (Newstyle, Oldstyle, Italian), which are still included in The Electric Typographer's catalogue today. Since there were no scanners back then, she drew the fonts by hand – intensive training for eye and hand. Later, she began to draw her own fonts, which were mostly based on calligraphic ideas. She especially enjoys designing dingbats, particularly those based on petroglyphs. Judith Sutcliffe's best known fonts go back to manuscripts by Leonardo da Vinci and Giovanni Antonio Tagliente. Calligraphy, handwriting and hand-lettering remain her never-ending source of inspiration. In 1996 Judith Sutcliffe moved from Santa Barbara to Audubon, Iowa.

Catalogue cover, 1996
14 x 21.5 cm
The cover shows several dingbat fonts and typefaces, for example, Daly Hand (based on the casual handwriting of a sculptor named Daly), Greene (based on architectural lettering of the Arts & Crafts architects Greene and Greene), and Kiilani (based on nineteenth-century letters carved into Hawaii rocks).

Design | Type design: Judith Sutcliffe _Insecta
_Oldstyle Chewed
_Petroglyph Hawaii
_Electric Stamps
_Daly Hand
_Greene
_Kiilani

Pages from the catalogue, 1996
14 x 21.5 cm

Design | Type design: Judith Sutcliffe _Daly Hand
_Insecta
_Oldstyle Chewed
_Daylilies

Daly Hand is based on the casual calligraphy of Pacific Northwest artist George Daly.

It's a lively, elegant, fanciful hand in small or large sizes. There are quite a few alternative characters, but they're not necessary for general composition. With a qualm, the jolly first mate expected a song about the grizzly viking. After I did this font, I created another, simplified, straighter, more regularized version.

Daly Text is a more regularized version.

This is what Daly Text looks like in smaller text size. This is a very pleasant sans serif font. I like to use Daly Hand for titles and Daly Text for text. The quick brown fox jumps over the lazy dog while the wicked peon quivered gazing balefully skyward.

Single fonts are $45 each. Daly Set (Daly Hand and Daly Text) is $79.95

INSECTA A font of 28 bugs lifelike enough to swat.
OLDSTYLE CHEWED A font the insects have eaten. Plus Goudy Oldstyle Bold/Italic.
Insecta Set includes Insecta, Oldstyle Chewed, Goudy Bold/Italic for $45.00

Daylilies
Daylilies Initials uses Goudy Oldstyle capitals.

LEAVES based on Goudy Oldstyle. Goudy Oldstyle included!
Daylilies Set includes Daylilies, Leaves, Goudy Oldstyle & Italic for $45.00
GARDEN VARIETY—Both Insecta & Daylilies Sets for $79.95

Now you can write with a
Flourish

For elegant Typesetting, for calligraphic display & titling. With cap and lower case flourishes, alternative letter forms, double and tied letters. And a bold version. Many calligraphers use this font for envelope addressing. A handsome font with many uses.
This is the bold version of Flourish.
A A BB C CD D E E F F GG H H I J J L M M N N
abcdefghijklmnopqrstuvwxyz th tt ll pp ss zz a y Kußchen
Flourish with Bold is $79.95.

GREENE AND GREENE
BASED ON ARCHITECTURAL
HAND LETTERING
OF PASADENA ARCHITECTS IN EARLY 1900'S
CAPS AND SMALL CAPS
Nº 123 FOR 45 AT 67890TH

THESE ARE TITLING FONTS AND WILL WORK BEST IN LARGER SIZES AS THEY ARE DELICATE PENCIL LINE SIMULATIONS. THIS IS THE BOLD AT 14 PT
ARTS AND CRAFTS

GREENE AND ITS BOLD VERSION ARE $45

Leonardo Hand

Leonardo da Vinci's calligraphic hand is just one of the unique & original typefaces available from The Electric Typographer. Vigorous and distinctive, with many alternative characters. A B C D E F G H I J K L M N O P Q R S T U V W X Y Z abcde f gh hijkkl mnopqrstuvwxyz 1234567890

Tagliente with ABC

Tagliente is based on the copybooks of a renowned 16th century Italian writing master. Many alternative characters. Quite a distinctive face. A B C C CD E F G H I J K L M M N N O P Q R S T U V W X Y Z the quick brown fox jumps over the lazy dog here! 1234567890 tunes

Single fonts $45 each or $79.95 for Leonardo Set (all three above)

Schampel Black
Die geschwinde, braune Füchsin springt den fauler Hund über. Or something like that. My first Black Letter face, named for Grant Schampel, who thought my catalog was incomplete without one. There will be more.
Schampel Black is $25.00

Design | Type design: Judith Sutcliffe _Flourish
_Greene

Design | Type design: Judith Sutcliffe _Leonardo Hand
_Tagliente
_Schampel Black

Website, 1998
www.t26font.com
Carlos Segura worked for a year to
develop a new look for the
[T-26] products. Viewers have been
able to see initial samples
since November 1998.

Design: [T-26]

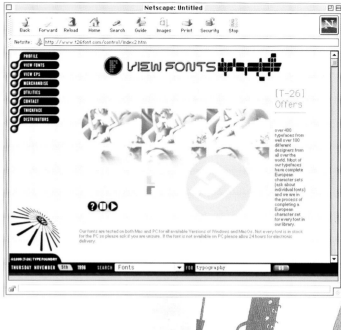

[T-26]

Location_ Chicago, Illinois, USA

Established_ 1994

Founder_ Carlos Segura

Type designers_ Carlos Segura, Jim Marcus, Hat Nyugen
Stephen Farrell, Peter Bruhn, Alan Green
Darren Scott, Damien Mair, Chank, Greg Samata
Frank Heine, Rodrigo Cavazos, Margo Chase
John Wiese and many more

Distributors_ [T-26], FontHaus, alt.Type, Atomic Type
Faces, FontWorks, Phil's Fonts, Precision Type
ITF, Agfa, Monotype, Creative Alliance
and many more

Change Your Face

When he was twelve years old, Cuban-born Carlos Segura already
played the drums in a band in Miami. He stayed there until the
age of nineteen working as a drummer and taking care of promo-
tion for the band. He published a book presenting the material
that he had designed during this time and was hired immediately
as a production artist at an envelope company. His job was to
design the return addresses for bank deposit envelopes. In 1980 he
went to Chicago and worked for agencies such as Marsteller, Foote
Cone & Belding, Young & Rubicam, Ketchum and DDB Needham,
before founding the studio Segura Inc. in 1991. His intention was
to merge fine and commercial art in his work.

Three years later he opened the foundry [T-26] to explore the
typographical side of the business. The collection today contains
eight hundred fonts. [T-26] also began the AIDing® project: a
font released every quarter, consisting of a set of dingbats (each
keystroke containing a design by a different contributor) to
benefit AIDS research. Interested font designers send in their
own contributions and the proceeds are donated to organizations
that help and care for those afflicted by the disease.

In 1996 Carlos Segura also founded the experimental record label
THICKFACE, which supports a mixed collection of art forms.

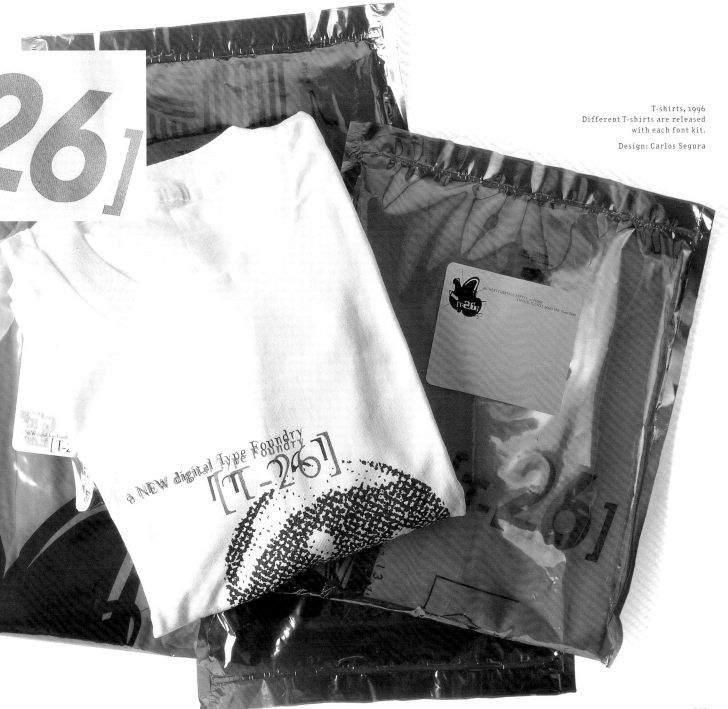

T-shirts, 1996
Different T-shirts are released
with each font kit.

Design: Carlos Segura

AMPLIFIER
NEW FONTS
2 WEIGHTS +
SMALL CAPS
ly figattqures b
€⊗ofeñ$í↑ ns
MORE THAN
new 00 CHA-
RACTERS SUCH AS:
№ ¢ t b 🖫 % ~ &
ke ℮ ℅ % 30 →⟶ * § ²
1 [different] ,000

An exclusive [T-26] release.
Designed by Frank Heine.

2 WEIGHTS/8 FONTS: Amplifier Light & Bold + Small Caps, Ligatures and
Extensions for each weight. Basic package (Light & Bold only) $ 69, complete package
$ 169. To order, or get "the best font kit in the world," ($ 7 national or $ 20 global),
call 773.862.1201, or fax us at 773.862.1214, or e-mail us at T26FONT@aol.com. It's
your only chance **TO CHANGE YOUR FACE!** *** [T-26] Chicago, Il, USA.

Design: Frank Heine, U.C.R.G.

amplifier

☐ Tick here,
and there ⊠.
(x shift-x)

←
Pages from the catalogue
included in the Atypl box set, 1997
58 x 45 cm
It was produced to identify a shift
in the corporate direction of
[T-26], and was launched at the
Atypl conference in Reading, 1997.

Design: Carlos Segura
Susana DeTembleque
John Rousseau
Christine Hughes
Type design: Frank Heine _Amplifier

Type design: Monib Mahdavi _Flux

Type design: Mauro Carichini _Babymine

Type design: Rodrigo Cavazos _Oculus regular, oblique

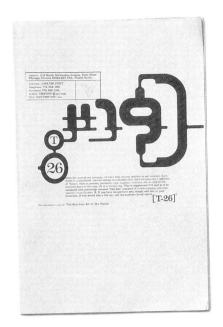

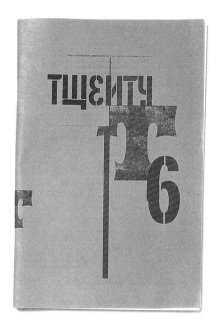

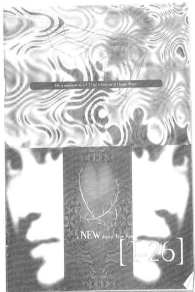

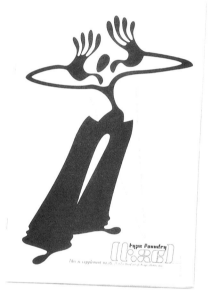

Catalogue supplements
1994–95
17.8 x 26.7 cm

Design: Carlos Segura
Type design: Peter Bruhn _Pizzicato
_Unica
James Closs _Lunar Twits
Luiz Da Lomba _Lomba
Adam Roe _Dumpster
Dennis Dulude _Plastic Man
Marcus Burlile _Six Gun Shootout
_Telegraph Junction

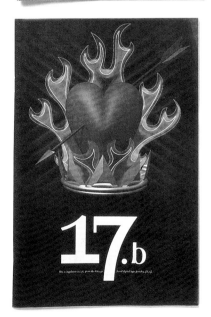

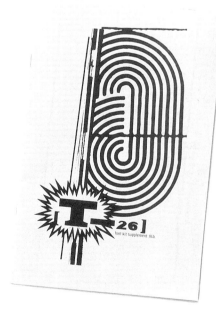

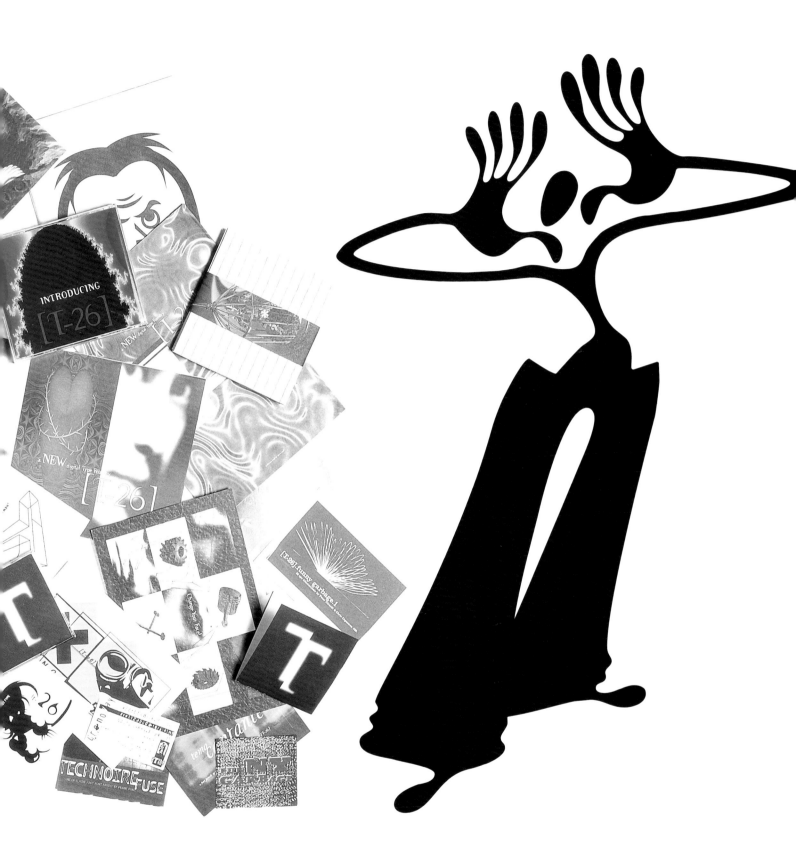

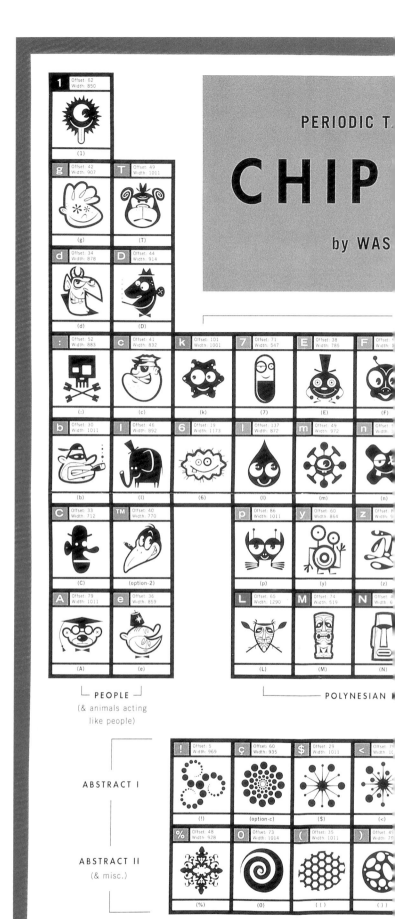

Chippies poster, 1997
61 x 45.8 cm

Design: Scott Stowell
Type design: Chip Wass _Chippies

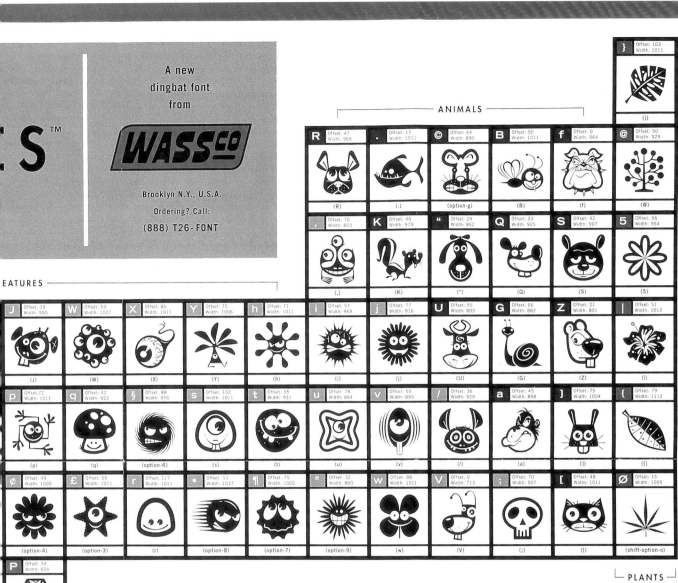

TM

A new
dingbat font
from

WASSCO

Brooklyn N.Y., U.S.A.
Ordering? Call:
(888) T26-FONT

FEATURES

ANIMALS

PLANTS

INSTRUCTIONS FOR USE: These 108 Chippies™ may be accessed by purchasing a copy of the Chippies by Wassco™ font from T-26, 1110 North Milwaukee Avenue, Chicago, Illinois 60622, U.S.A. Orders may also be placed by telephone at (773) 862-1201, or by fax at (773) 862-1214. Orders received before 3:00 pm C.S.T. will be fulfilled the same day. Refer to this chart for keyboard placement of Chippies™. For external use only.

ALSO FROM WASSCO: Logotypes, character design, icons, book and compact disc jackets, posters, editorial and advertising illustration, as well as custom Chippies™ made to your exact specifications. For more information, or to obtain an estimate, contact your sales representative, Kirby "Chip" Wass, via telephone or fax at (718) 596-0864. Inquiries also accepted by electronic mail at chipwass@aol.com. Serious inquiries only, please.

SCOTT STOWELL: DESIGN

©1997 WASSCO, BROOKLYN, N.Y.

Type design: Patric King, 1997 _Bad Excuse Solid, Outline

Front and back of poster, 1994
55.9 x 43.2 cm
Design | Type design: Barry Deck _Cyberotica
_Truth

Thirstype

Location_ Barrington, Illinois, USA

Established_ 1993

Founder_ Rick Valicenti

Type designers_ chester, Barry Deck, Frank Ford
Patrick Giasson, Patric King, Paul Sych
Greg Thompson, Rick Valicenti

Distributors_ Thirstype, FontShop Germany
FontShop Norway

www.3st.com ... come on buy and see us

After working in Chicago as a graphic designer for The Design
Partnership, Rick Valicenti founded his own company in 1981.
In 1987 he set out to reinvent himself and the pursuits of his
consultancy by creating Thirst, a firm devoted to art with func-
tion. His passion for design and the advent of new technology
resulted in a dynamic marriage of imagery and inspiration.
Thirst's creative versatility enables the exploration of elusive
ideals of intelligence and beauty within today's world of
commerce.

In 1993 Rick founded Thirstype, a foundry devoted to individual
expression. Over the years, Valicenti has served as President
of the Society of Typographic Art (American Center for Design),
been a board member on the AIGA Chicago chapter and has
jurored the President's Design Awards (Bush and Clinton),
National Endowment for the Arts. He has also been nominated
twice for the prestigious Chrysler Design Awards and was
chosen to appear in the first list of top forty designers in
I.D. magazine. The GGG and DDD Galleries in Osaka and Tokyo,
respectively, have held one-man exhibitions of Valicenti's
design and imagery. In 1997 the Canon Gallery in Tokyo ex-
hibited Thirst's digital imagery, and selected Thirst works have
also been included in the permanent collection of the Cooper-
Hewitt National Design Museum. Most recently, Valicenti
has formed 3st2, a firm devoted to design excellence in all
digital media, with a focus on the Internet.

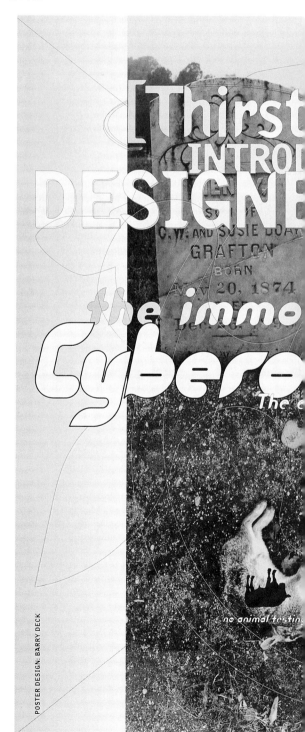

POSTER DESIGN: BARRY DECK

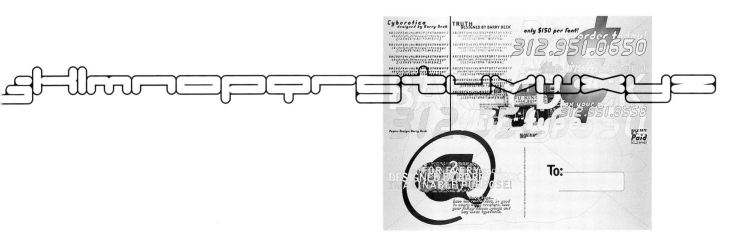

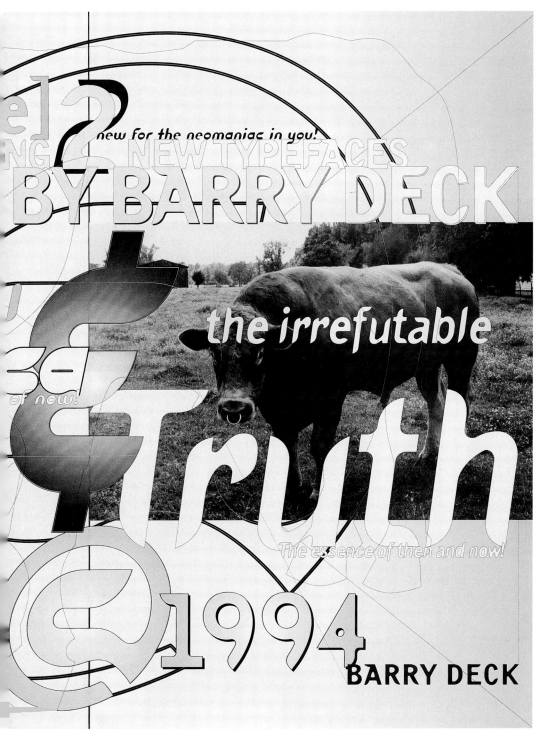

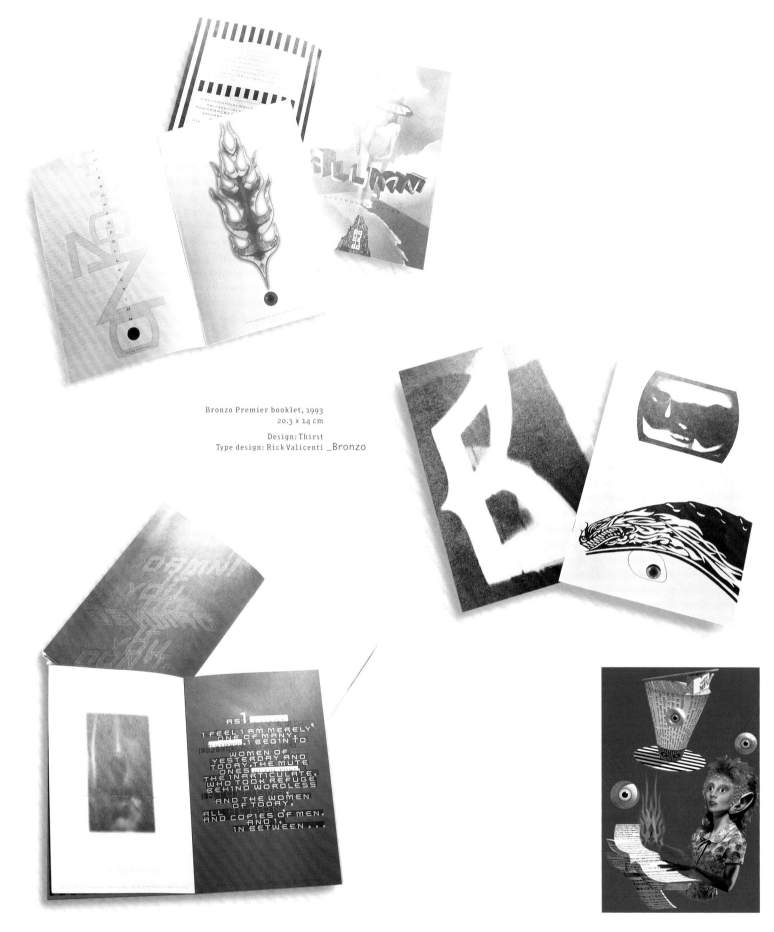

Bronzo Premier booklet, 1993
20.3 x 14 cm

Design: Thirst
Type design: Rick Valicenti _Bronzo

Card from Kulture Kit, 1996
20.3 x 14 cm

Design: Rick Valicenti
Type design: chester _Hate Note

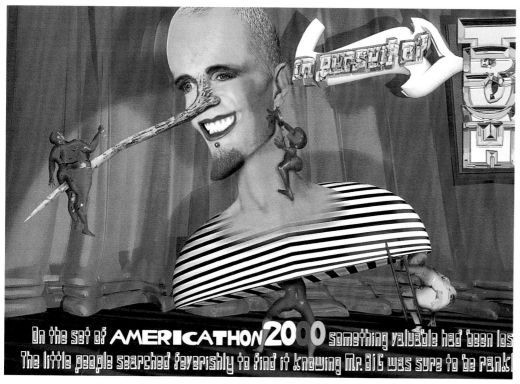

Card from Kulture Kit, 1996
20.3 x 14 cm

Design: Rick Valicenti, Patric King
Type design: Rick Valicenti _Ooga Booga

Paul Sych _Fix

Type design: Patric King, 1997_Smile

chester, 1997_Rheostat °Fahrenheit
_Rheostat °Celsius

Design: Rick Valicenti, Patric King

Design: Rick Valicenti
Type design: Rick Valicenti _Bronzo

Barry Deck _Cyberotica

Design | Type design: Paul Sych _Useh

Design: Rick Valicenti, chester
Type design: Frank Ford _Stroke

Feeling THE TINGLE OF OPTIMISM...

It's 2:06 Friday before Memorial Day.

I'm writing on the Hub of my steering
wheel exiting Chicago... heading Home
Rush has just signed off but for his final
word. My meeting today seemed enlightened.
Those times of stupidity, committees, and paranoia
bore me to no end. Fortunately my intolerance
is fairly visible. It must look like Ebola to those
with money. Oh well. Tonite Linda and I
take the Post Gemkers, we live with to LA
for the Venice Beach, Bundy Residence. Meanwhile
Universal Studio Tour '95. Free Tickets. Thank God!

THIRSTYPE
117 S COOK BARRINGTON IL 60010

←
Envelope for Thirstype press kit, 1995
20.3 x 14 cm

Design: Rick Valicenti

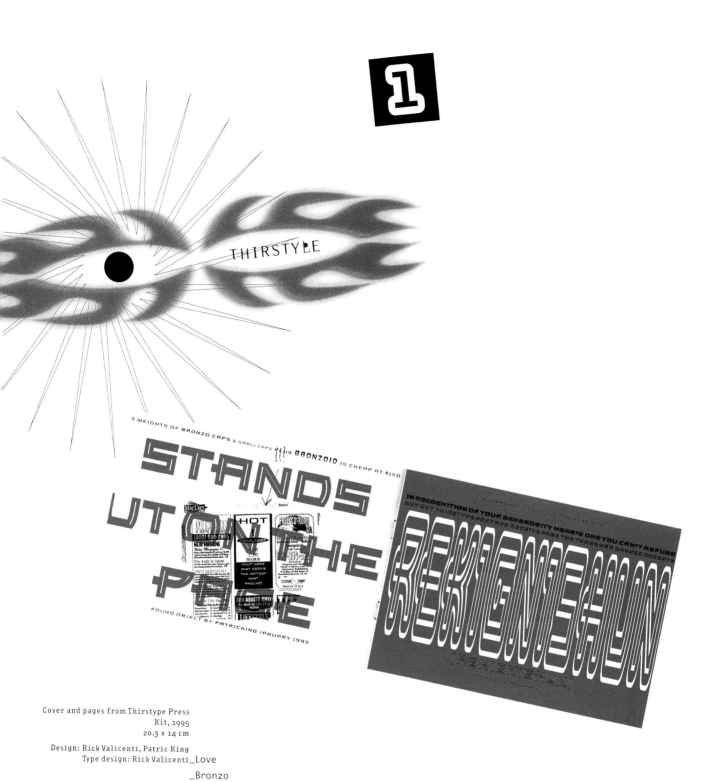

THIRSTYPE

3 WEIGHTS OF BRONZO CAPS & SMALL CAPS PLUS BRONZOID IS CHEAP AT $150

STANDS
UT ON THE
PL E

FOUND OBJECT BY PATRICKING JANUARY 1995

Cover and pages from Thirstype Press
Kit, 1995
20.3 x 14 cm

Design: Rick Valicenti, Patric King
Type design: Rick Valicenti_Love

_Bronzo

Barry Deck_Truth

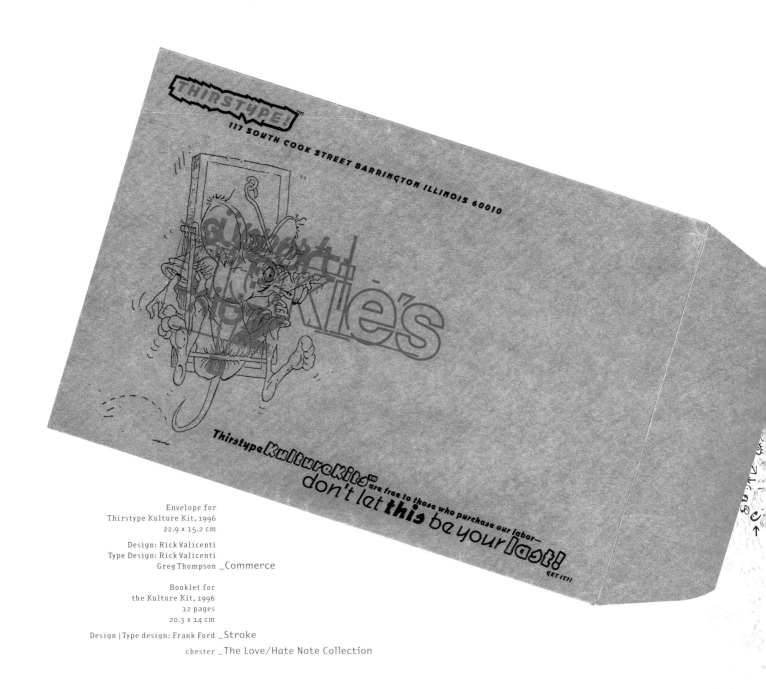

Envelope for
Thirstype Kulture Kit, 1996
22.9 x 15.2 cm

Design: Rick Valicenti
Type Design: Rick Valicenti
Greg Thompson _Commerce

Booklet for
the Kulture Kit, 1996
12 pages
20.3 x 14 cm

Design | Type design: Frank Ford _Stroke

chester _The Love/Hate Note Collection

adore burn crave
desire ego favour
goddess humble
illicit jilted kiss
mistress naïve obey
post quiver room
sex tacit undulate
vulnerable want x
yearn zealous

arsenic battery CRUELTY
death extort lovable rod
hate id JAGGED kill
lacerate my muzzle
opportunist police QUASH
glander inhuman usury
vicious war XENOPHOBE
yoke zeal

Type-Ø-Tones

Detail from the folder/poster
Welcome to Southern Europe
October 1996
Design | Type design: Type-Ø-Tones

Location_Barcelona, Spain

Established_1990

Founders_Joan Barjau, Enric Jardí
Laura Meseguer, José M. Urós

Type designers_Joan Barjau, Enric Jardí, Laura Meseguer
José M. Urós, Juan Dávila, Adela de Bara
Miguel Gallardo, Jaume Ros, Ivà, Mariscal
Pere Torrent and many more

Distributors_Type-Ø-Tones for Spain, Andorra and Portugal
FontShop International (FSI) for all other
countries

Poster Welcome to Southern
Europe, October 1996
43.5 x 59.4 cm
It was published by FontShop
Benelux and FontShop France
to promote the library
of Type-Ø-Tones.

Design | Type design: Type-Ø-Tones

Our fonts correspond to a simple philosophy – the passion for typography

Type-Ø-Tones was founded by four graphic designers who shared
the same passion for typography. Their fonts normally derive
from individual ideas, but later become common projects.
Type-Ø-Tones offers display, script and picture fonts. As a
service for clients with specific needs, José M. Urós also devel-
ops custom typefaces. Type-Ø-Tones generates the fonts with
Fontographer and uses various software to scan and draw the
characters, most of which have their origin in drawings on
paper. The foundry is preparing its fonts to be available on PC.

Over the last years Type-Ø-Tones has had the chance to colla-
borate with other designers, artists and illustrators, all of
whom have made fabulous contributions to the expansion of the
typeface library. In several exhibitions in Spain and France,
Type-Ø-Tones has presented its work to the public. John Barjau,
Enric Jardí and Laura Meseguer are now running their own
graphic design studios, while José M. Urós is working as a
freelance desginer for Mariscal.

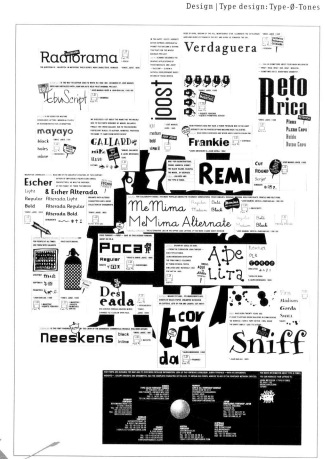

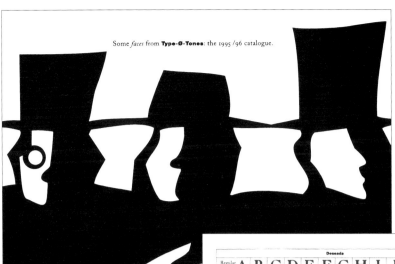

Some *faces* from **Type-Ø-Tones**: the 1995/96 catalogue.

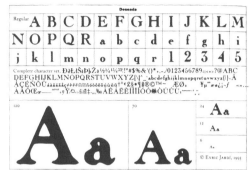

We desired **Deseada** making minor changes to a CASLON OPEN FACE.

Cover of the
Type-Ø-Tones catalogue 1995–96
48 pages
10 x 14 cm
The cover shows a detail of the
Type-Ø-Tones logo designed by
Joan Colomer, Estudi Propaganda.
The catalogue plays with the double
signification of the word face,
referring to typeface and to anatomy.

Design: Type-Ø-Tones

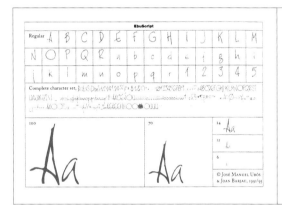

EbuScript *is the* way its author used to write in 1990-1991. Designed by JOSÉ MANUEL URÓS and digitalized with JOAN BARJAU's help. First *original* project.

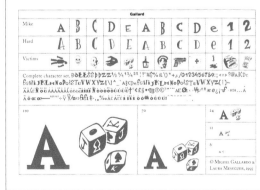

Pages from the
Type-Ø-Tones catalogue, 1995–96

Design: Type-Ø-Tones
Illustration: Leo Mariño
Adela de Bara
Type design: Enric Jardí _Deseada

José M. Urós _EbuScript

Miguel Gallardo _Gallard

We discussed a lot about the name that *we would give* to the fonts designed by MIGUEL GALLARDO. *Finally*, we chose **Gallard**, due to the encoding PostScript rules. Its author, however, preferred the name *"It came from outer space"*.

263

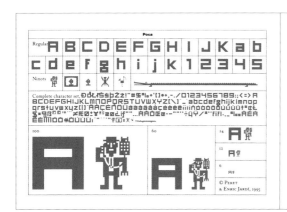

Pere Torrent —Peret— gave us this design *thinking* about De Stijl.

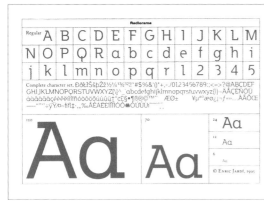

The question is... Helvetica. In mutation. *Thick serifs*. New characters. Humour.

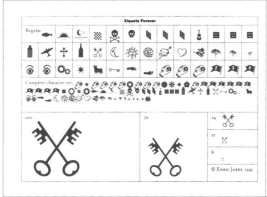

Xiquets Forever *our first sketchbook*

Pages from the
Type-Ø-Tones catalogue, 1995–96

Design: Type-Ø-Tones
Illustration: Leo Mariño
Adela de Bara
Type design: Pere Torrent _Poca

Enric Jardí _Radiorama

_Xiquets Forever

Samples from the Xiquets Primis,
a series of dingbats or thematic
drawings of an anthropological
and historical nature, 1995.

Type design: Joan Barjau _Xiquets Primis

→
Illustration to promote
the font Frankie, used in the
exhibition of Spanish typography
at the Atypl conference in 1995,
Barcelona. It's a caricature
of the font designers Laura Mese-
guer and Juan Dávila generating
the new typeface by making bad
quality photocopies of sheets
showing Franklin Gothic letters.

Design: Enric Jardí
Type design: Laura Meseguer
Juan Dávila _Frankie

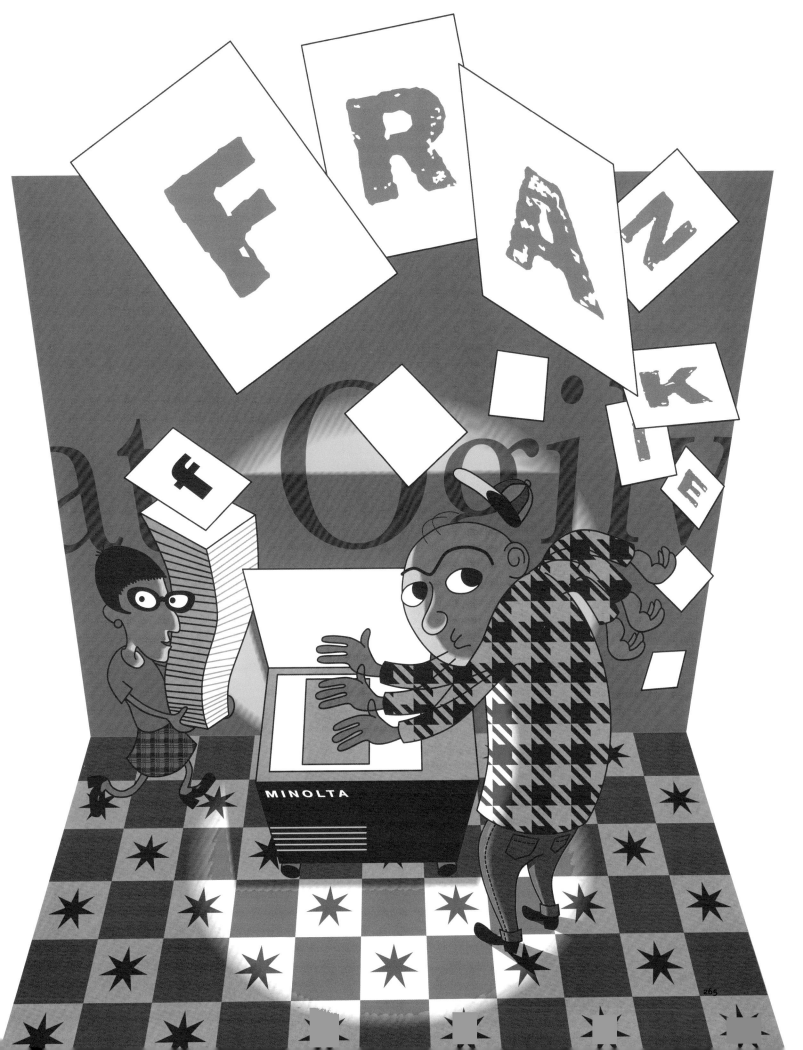

En els feliços anys 20 Herbert Bayer va crear un alfabet d'estructura modular que va esdevenir un dels trets característics del projecte de la Bauhaus. Joost Schmidt en va dissenyar les aplicacions gràfiques i Joost —la font— és la versió feta per J. M. Urós el 1995 basant-se en un d'aquests treballs. "Bauhaus Dessau im Gewerbemuseum Basel". La família completa està formada per tres pesos —light, medium i bold— i una versió trepada molt característica de la seva època.

En los felices años veinte Herbert Bayer creó un alfabeto de estructura modular que se convirtió en uno de los rasgos característicos del proyecto de la Bauhaus. Joost Schmidt diseñó las aplicaciones gráficas y Joost —la fuente— es la versión hecha por Josema Urós en 1995 basándose en uno de estos trabajos: "Bauhaus Dessau im Gewerbemuseum Basel". La familia completa está formada por tres pesos —light, medium y bold— y una versión estarcida muy característica de la época.

In the merry 20s Herbert Bayer defined a modular alphabet that was to become one of the distinctive traits of the Bauhaus project. Joost Schmidt designed the graphic applications of these modules. In 1995, Josema Urós developed Joost —the font— based on one of those works: "Bauhaus Dessau im Gewerbemuseum Basel". The family is composed of three weights —light, medium and bold—, and a stencil version very characteristic of the Bauhaus age.

Si teniu la sort que al vostre barri hi ha una d'aquelles papereries antigues, busqueu-hi una petita impremta manual de cautxú. Si teniu la sort de trobar-la, compreu-la, endueu-vos-la a casa i amb paciència feu una impressió de cadascun dels caràcters. Deixeu-los assecar i porteu-los a l'escàner. Un cop convertits a mapa de bits, passeu-los a vectors un a un, doneu-los nom i traslladeu-los tots a un editor de fonts. Editeu-ne les caixes altes, les baixes, els números, els caràcters especials, les fraccions, etc.; doneu-li widths i feu parelles de kerns. Feu tot això i us sentireu com Jaume Ros, el jove grafista de Terrassa que ha creat la Despatxada.

Si tenéis la suerte de tener en vuestro barrio una de aquellas papelerías antiguas, id y preguntad si tienen una pequeña imprenta manual de caucho. Si tenéis la suerte de encontrarla, compradla, llevaosla a casa y, con paciencia, haced una impresión de cada uno de los caracteres. Dejadlos secar y llevadlos al scanner. Una vez convertidos en mapa de bits, pasadlos a vectores uno a uno, dadles nombre y trasladad todos a un editor de fuentes. Editad las cajas altas, las bajas, los números, los caracteres especiales, las fracciones, etc.; dadles widths y haced parejas de kerns. Haced todo esto y os sentiréis como Jaume Ros, el joven grafista de Terrassa que ha creado la Despatxada.

If you are lucky enough to have an old fashioned stationer in the area, go and ask for a manual rubber press. If they have one, buy it, take it home and patiently print each one of the characters on paper. Let them dry, then scan them. Once they have been transformed into bitmaps, turn them into vectors, one by one, give them a name and transfer them all onto a font editor. Then edit the upper cases, the lower cases, the numbers, the special characters, fractions, etc.; give them widths and make kern couples. Do all of this, and you will feel just like Jaume Ros, the young graphic designer from Terrassa who has created Despatxada.

Fixa-t'hi bé, la Mayayo no serveix per a notes de condol de bon to. Ni per a ser gravada sobre el marbre en plaques commemoratives. Ni per a cartes que reclamen el pagament del rescat d'un segrest i que pretenguin que algú se les cregui. Ni per a fer la declaració de la renda. Ni per a signar armisticis. Ni per a manifestos. Ni per a violentes cartes al director. Ni per a protestes enèrgiques. Ni per a comiats. Ni per a assegurances a tot risc. Ni per a comprar lletres del tresor. Ni per a declaracions de guerra. Ni per a decisions de la reunió de veïns. Ni per a campanyes del PP. Ni per a cartes bomba. Ni per a advertir dels efectes secundaris. Ni per a encícliques papals. Ni per a diumenges al vespre. Mayayo serveix, però, per a tota la resta.

Fíjate bien. Mayayo no sirve para notas de consuelo de buen tono. Ni para ser grabada sobre el mármol de placas conmemorativas. Ni para cartas que reclamen el pago del rescate de un secuestro pretendiendo que alguien se las crea. Ni para hacer la declaración de renta. Ni para firmar armisticios. Ni para manifiestos. Ni para violentas cartas al director. Ni para protestas enérgicas. Ni para despedidas. Ni para seguros a todo riesgo. Ni para comprar "Letras del Tesoro". Ni para declaraciones de guerra. Ni para decisiones de la reunión de vecinos. Ni para campañas del PP. Ni para cartas-bomba. Ni para advertir de los efectos secundarios. Ni para encíclicas papales. Ni para los domingos por la tarde. Mayayo sirve, sin embargo, para todo lo demás.

Pay close attention: Mayayo is no good for writing letters of condolence in ... sober ... Nor for carving inscriptions on ... marble plaques. Nor for letters ... payment of the ransom for ... been kidnapped, if these are ... trusted by anyone. Nor for the ... return. Nor for signing armistices ... manifests. Nor for angry letters ... Nor for impassioned complaints ... farewells. Nor for comprehensive ... policies. Nor for buying shares ... Conservative Party campaigns ... bombs. Nor for warnings about ... Nor for encyclicals from the ... Sunday evenings. Mayayo is good, though, for ...

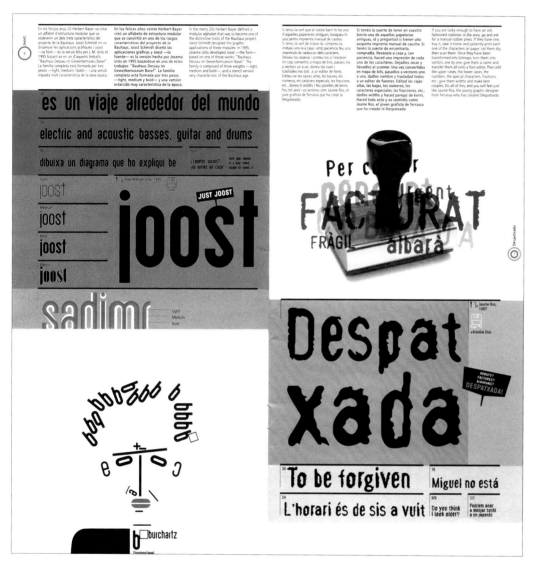

Pages from the Type-Ø-Tones
catalogue, 1998
14.5 x 29.7 cm

Design | Illustration: Enric Jardí
Type design: José M. Urós _Joost
Jaume Ros _Despatxada
Enric Jardí _Mayayo
_Peter Sellers
Adela de Bara, Laura Meseguer _Adelita
Juan Dávila, Laura Meseguer _Frankie, Frankie Dos

Cada vez que los Type-O-Tones miramos con atención las formas de los Peter Sellers, nos sentimos transportados a los escenarios de aquellas películas de los años cincuenta y sesenta en las que Dean Martin pedía margaritas en un bar de Acapulco, o Mario Moreno enseñaba a bailar cha-cha-chá a las turistas norteamericanas.

Peter Sellers es un homenaje particular al grafismo de la época de Saul Bass. Se trata de una familia compuesta de dos partes pensadas para estar superpuestas, creando así un efecto de volumen; tiene aspecto irregular, como hecha a mano y con poca geometría. No es una tipografía apta para galeradas. Componedla y retocadla a vuestro gusto.

Each time Type-O-Tones take a close look at the Peter Sellers outlines, we are transported off to the settings made for those films of the 50s and 60s where Dean Martin asked for daisies in an Acapulco bar, or Mario Moreno taught American turists how to dance cha-cha-chà.

Peter Sellers is our peculiar homage to the graphism of Saul Bass' time. The family is composed of two different parts conceived to be superimposed, thus creating a threedimensional effect. This font has an irregular aspect about it, as if hand made and with little geometrical structure. It is not a good typography to print proofs. You can compose and retouch it as you like.

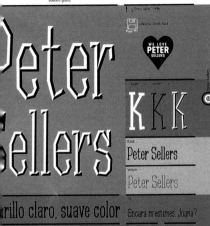

¿Qué hi fa aquest nom inconfusiblement mexicà en una lletra del nostre catàleg? Adela de Bara —que és nascuda a Barcelona i no té res a veure amb Mèxic— és membre de la Fundació Joan Tabique i, a més, és l'autora de l'Adelita.

Què que és la Fundació Joan Tabique? Ens és difícil definir-vos-la. Tot i que els considerem com els cosins dels Type-O-Tones, de ben segur que no l'encertaríem: són els descendents adoptius de Joan Miró? Precursors artesans del multimèdia? Poetes poca-soltes? Genis infantilistes? Soroll? Melodia?... En tot cas, nosaltres en som fans i recomanem a tothom que min d'aconseguir algun exemplar de la seva meravellosa mini-revista "Fijate", o que s'hi connecti per Internet a http://www.iua.upf.es/tabique/

Les quatre parts que componen la col·lecció de l'Adelita son la Regular, l'Olé, la Topos i la Dibuixitos. La primera i la tercera, que parteixen del mateix dibuix però amb diferents pesos, estan creades com a versals i versaletes, mentre que l'Olé està feta de caixes altes i baixes. Els dibuixos són una col·lecció de X dingbats extrets de l'univers gràfic intim d'Adela de Bara.

Aquesta font display va néixer l'any 1993 amb l'ajut del mouse de Laura Meseguer, una admiradora entusiasmada de la Fundació Joan Tabique.

¿Qué hace este nombre inconfundiblemente mexicano en una tipografía de nuestro catálogo? Adela de Bara —que nació en Barcelona y no tiene nada que ver con México— es miembro de la Fundación Joan Tabique y, además, autora de la Adelita. ¿Qué es la Fundación Joan Tabique? Nos resulta difícil definirla. A pesar de que los consideramos como primos de los Type-O-Tones, seguramente no acertaríamos: ¿son los descendientes adoptivos de Miró? ¿precursores artesanos del entorno multimedia? ¿poetas alocados? ¿genios infantilistas? ¿ruido? ¿melodía?... En cualquier caso, nosotros somos sus "fans", y le recomendamos a todo el mundo que intente conseguir un ejemplar de "Fijate", su maravillosa mini-revista, o que se conecte a través de Internet a http://www.iua.upf.es/tabique/

Las cuatro familias que componen Adelita son Fina, Olé, Topos y Dibujitos. La primera y la tercera están basadas en el mismo dibujo original de Adela de Bara, pero fueron creadas con diferentes pesos y como versales y versalitas, mientras que la Olé está construida a base de cajas altas y bajas. Dibujitos es una colección de dieciocho dingbats extraídos del universo gráfico íntimo de Adela de Bara. Esta tipografía display nació en 1993, a través del mouse y la inspiración de Laura Meseguer, una admiradora deslumbrada de la Fundación Joan Tabique.

What is this unmistakably Mexican name doing in our catalogue? Adela de Bara — who was born in Barcelona and has nothing to do with Mexico— is a founding member of the Fundación Joan Tabique, and is also Adelita's creator.

You may be wondering what the Fundación Joan Tabique is. It is difficult for us to define. Even though we consider them "cousins" of the Type-O-Tones, we are probably not able to hit the mark: are they adopted descendants of Joan Miró? Artesanal forerunners of the multimedia environment? Crazy poets? Childlike geniuses? Noise? Melody?... In any case, we are their fans and recommend everybody to get hold of an issue of "Fijate", their amazing mini-magazine, or to connect through Internet to the following page: http://www.iua.upf.es/tabique/

The four families that make up Adelita are Fina, Olé, Topos and Dibujitos. The first and the third are based on the same original drawing by Adela de Bara, but are edited with different weights and as capitals and small caps; Olé consists of upper and lower cases. Dibuixitos is a collection of 18 dingbats taken from the personal graphic realm of Adela de Bara. This display typeface was born in 1993, thanks to the mouse and inspiration of Laura Meseguer, a fervent admirer of the Fundación Joan Tabique.

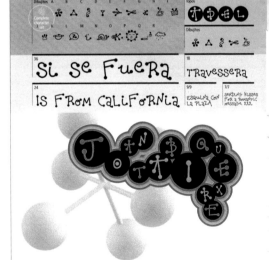

Te'n recordes? "No és que la teva impressora tingui problemes de tòner ni que la fotocopiadora tingui la intensitat mal ajustada..."

Doncs ara la Frankie, el nostre best-seller, ja no està sola. Com si fos el germà bessó que va ser separat de la família i enviat a un país llunyà, un dia va aparèixer la parella de la Frankie. Gràcies a la paciència de Jaume Ros ara està disponible al catàleg dels Type-O-Tones la Frankie Dos, clavada a sa germana (una mica més prima, això sí).

¿Recuerdas? "Ni tu impresora tiene problemas de tóner ni la intensidad de la fotocopiadora está mal ajustada..." Pues bien, ahora Frankie, nuestra best-seller, ya no está sola. Como si se tratase de un hermano gemelo que fue separado de la familia y enviado a un país lejano, un día apareció la pareja de Frankie. Gracias a la paciencia de Jaume Ros, ahora está disponible en el catálogo de los Type-O-Tones la Frankie Dos, clavada a su hermana (un poco más delgada, eso sí).

Remember? "Your printer doesn't need more toner nor is the light intensity on the photocopying machine badly adjusted..." Well, now Frankie, our best-seller, is no longer alone. Just like a twin sibling torn away from the family and sent to a distant country, who suddenly reappears one day, Frankie's twin font has come out. Thanks to Jaume Ros' patience, now Frankie Dos —the spitting image of her sister, only a little thinner— is available in the Type-O-Tones catalogue.

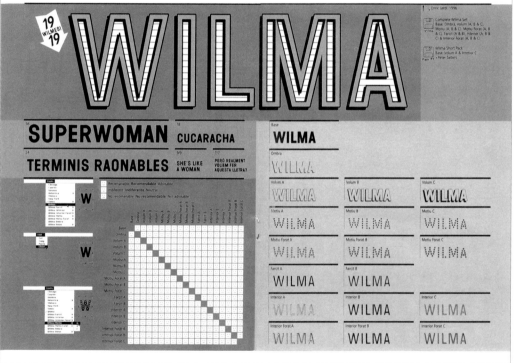

Pages from the Type-Ø-Tones
catalogue, 1998
14.5 x 29.7 cm

Design | Illustration |
Type design: Enric Jardí _Wilma

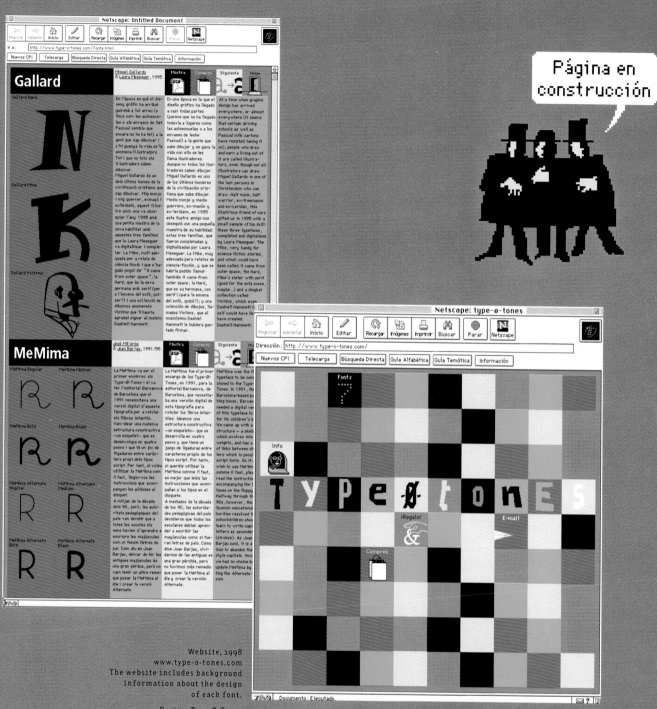

Website, 1998
www.type-o-tones.com
The website includes background
information about the design
of each font.

Design: Type-Ø-Tones
Type design: Miguel Gallardo _Gallard

José M. Urós, Joan Barjau _MeMima

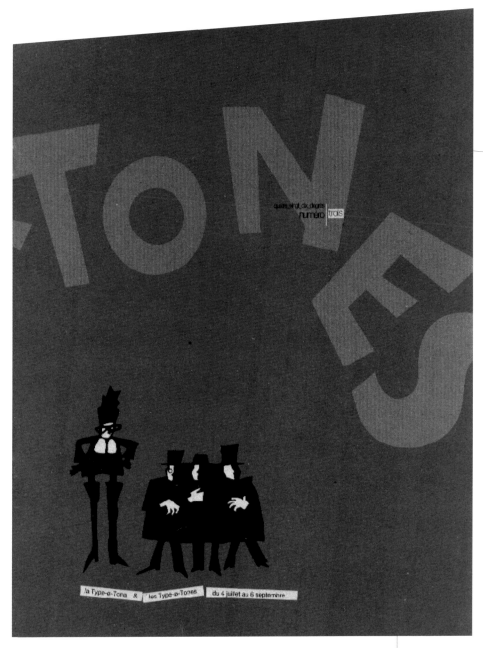

Adelita dibujitos

Exhibition catalogue
La Type-Ø-Tona & les Type-Ø-Tones, 1996
12 pages
21.5 x 26.4 cm
The exhibition took place in the gallery
Association 90 degrés of the graphic
studio art_est_net in Bordeaux, France,
in summer 1996. The catalogue was
printed and distributed by the gallery
and worked as promotional material
for both the gallery and Type-Ø-Tones.

Design: art_est_net
Logo design: Joan Colomer
Estudi Propaganda
Illustration: Enric Jardí
Type design: Adela de Bara
Laura Meseguer _Adelita dibujitos
Enric Jardí _Deseada
_Escher
Laura Meseguer _Cortada
José M. Urós _EbuScript
Juan Dávila, Laura Meseguer _Frankie

Cortada: signifie coupé... et la recette est :
des feuilles de papier noir, des pairs de
ciseaux ou des cutters, beaucoup de
plaisir et de rires. Coupez donc !

Deseada: Nous avons désiré Deseada en
faisant des petits changements sur une
Calson Open face.

Adelita: des
fondation J
Laura Mese
suivi par 3
Naturelleme

Cortada: means cut and... its ingredients
are: sheets of black paper, unlimited
scissors or cutters, lots of fun and laughs.
Cut away!

Deseada: we desired Deseada making
minor changes to a Casion Open Face.

Adelita: dra
Fundación J
Laura Mese
followed by
and, naturali

Cortada: Sus ingredientes son : hojas de
papel negro, montones de tijeras y cutters
y ganas de divertirse. ¡No te cortes!

Deseada: Deseamos Deseada experimen-
tando con pequeños cambios sobre
una calson Open Face.

Adelita: Dif
por Adela d
Tabique. La
familia Fina
Topos, Dibu
Art en 1993

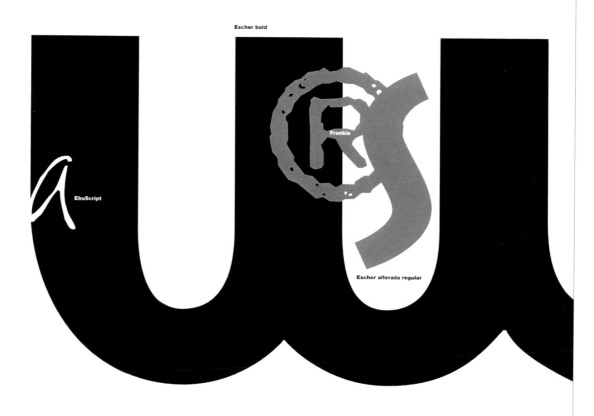

Escher bold

EbuScript

Frankie

Escher alterada regular

EbuScript: C'est la façon dont l'auteur écrivait en 1990-1991. Dessinée par José Manuel Urós et digitalisé avec l'aide de Joan Barjau. Premier projet original.

EbuScript: is the way its author used to write in 1990-1991. Designed by José Manuel Urós and digitalized with Joan Barjau's help. First original project.

Ebuscript: Es la manera en que su autor escribía en 1990-1991. Diseñada por josé Manuel Urós y digitalizada con la ayuda de Joan Barjau. Primer projecto original.

Escher: Mauritius Cornelius Escher fût un des plus grands créateurs de ce siècle. L'auteur des figures impossibles et des perspectives irréelles, était l'inspirateur de cette famille de trois épaisseurs.

Escher: Mauritius Cornelius Escher was one of the greatest creators of this century. Author of impossible figures and unreal perspectives, he was the inspirer of this family of three thicknesses.

Escher: Mauritius Cornelius Escher fue uno de los grandes creadores de este siglo. Autor de figuras imposibles y perspectivas irreales, es al inspirador de este familia con tres ojos tipográficos diferentes.

Escher alterada: Des variantes aux caractères transformés et une brève collection d'ornements.

Escher alterada: variants with altered characters and a brief collection of ornaments.

Escher Alterada: Variaciones con characteres alterados y una coleccion breve de ilustraciones.

Frankie: Votre imprimante n'a pas de problème de toner et l'intensité de lumière de la photocopieuse n'est pas non plus mal réglée. Frankie est né corrodé et effacé, malgré une encre fraiche.

Frankie: your printer does not have a toner problem nor is the light intensity on the photocopying machine badly adjusted. Frankie was born corroded and worn away, despite fresh ink.

Frankie: Ni tu impresora tiene un problema de toner, ni la intensidad de tu fotocopia-dora está mal ajustada. Frankie nacío corroida y desgastada, a pesar de la tinta fresca.

→

Back of promotional postcard, 1996
10 x 15 cm
In this letter soup the reader can
find the word Typerware. FontSoup,
based on noodle forms from the
company El Pavo, is used by Typerware
as corporate typography.

Design | Type design: Andreu Balius
Joan Carles P. Casasin _FontSoup

Typerware Font Foundry

Location_Barcelona, Spain

Established_1993

Founders | Type designers_Andreu Balius, Joan Carles P. Casasín

Distributors_Typerware, Font Foundry

Type is a real living thing!

Andreu Balius studied Sociology at Barcelona
University and Graphic Design at IDEP in
Barcelona. Together with Joan Carles P. Casasin,
who studied graphic design at Elisava and BAU
in Barcelona, he founded Typerware in 1993. The
studio has designed display type for magazines,
improved type for screen, animated poems for a
CD-ROM about contemporary Catalan poetry and
created a typographic identity for a Spanish
book publisher.

Apart from the non-commercial experimental
type project garcia fonts & co. (see p. 148),
Andreu Balius and Joan Carles P. Casasin set up
their own label in 1998. The Tw®Font Foundry
publishes and distributes the fonts they have
developed for graphic projects or just for
pleasure.

The illustration, representing
Andreu Balius and Joan Carles P. Casasin,
is part of the corporate design for
Typerware. It's used for informal
applications, for example on postcards
and on T-shirts for friends. The figure
is taken from a plaster package and is
used as a mascot. It also refers to the
use of thumbprints on Spanish pass-
ports and the corresponding digital
code in the computer system.

The din (the music)
A huge stethoscope has taken over the space allowing us to feel the beat of the play. Music is not an illustration, but rather a cadence in which each rhythm brings us closer to the physiology of the show. An acid journey to the light hemisphere of the brain.

EL CORRAL (el actor y su entorno)

"If the eye could see the devils that live the Universe the existence would be impossible."

¿qué nos explica Manes?

LAS SOMBRAS
(La iluminación)

El cloqueig (el text)

Personatges separats per llengües comunes. Babel polifònic de

la incomunicació en què el text adquireix l'estatut de gest, més

que de discurs. És un cloqueig en què no importa el que es diu

sinó el que no es diu.

Manes
no és una ideologia
No hi ha una veritat per ser descoberta.

Si no hi ha veritat primigènia, què ens explica Manes? **Res.**
Manes construeix i
destrueix, busca i no troba, fa
preguntes les
respostes de les quals
Plora de riure i riu desesperadament.
desconeix,
no resol problemes, en crea.
Manes són múltiples emocions que es
comuniquen, vertiginoses, mitjançant
diverses narracions que es creuen,
es freguen,
i que al seu torn generen més emocions.
Manes invoca els dimoniets del Caos que,
disfressats
de pollastre, juguen a la
desorganització
per fer incomprensible allò que sembla lògic,
com en un somni.

Fem invisible el que se'ns fa
inexplicable? Vet aquí una
pregunta legítima, sense resposta:

una pregunta-**Manes**

Publication for the show MANES by
the experimental theatre company
La Fura dels Baus, 1996
21.2 x 28 cm
Typerware developed the graphic
design for this show and created
a special font family for it.

Design | Type design: Andreu Balius
Joan Carles P. Casasin _FaxFont

_NotTypeWriterButPrinter-9 needles

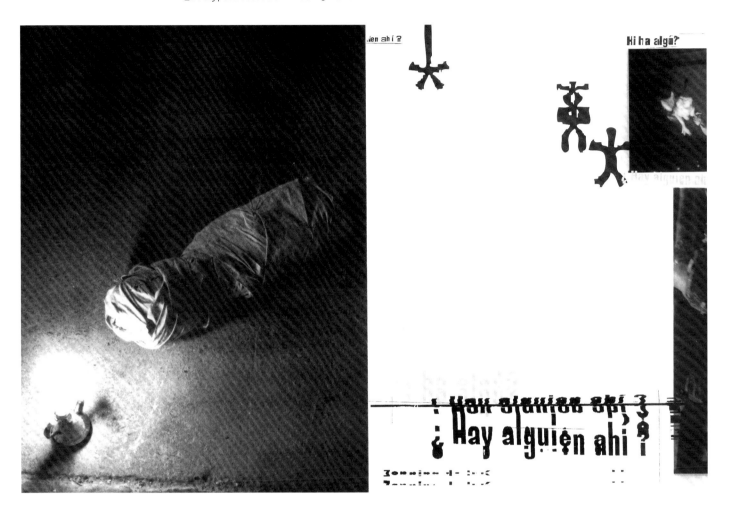

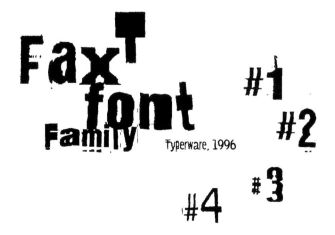

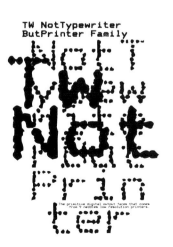

Examples from the information folder,
1997
21 x 29.7 cm
Typerware developed this font at the
request of Osoxile studio for the Uni-
versity of Salamanca's orientation
system. Andreu Balius and Joan Carles P.
Casasín first researched and analyzed
the inscriptions on the walls of the
university. Since its founding in the
Renaissance, doctoral students have
recorded their names and graduation
dates for eternity. They used ox blood
until the nineteenth century and
natural earth pigments thereafter.
Typerware photographed the inscrip-
tions and developed a digital font
that retains the handwritten
characteristics of the different styles.

Design | Type design: Andreu Balius
Joan Carles P. Casasín _Universitas Studii Salamantini

Una tipografía diseñada para la Universidad de Salamanca / por encargo de Osoxile

ABCDEFGHIJKLMN

50

OOPQRSTVVWXYZ

35

©ÇÑÑiiioOOOoLvyW®

LIGADURAS

ALA

VITI

NTV

TOS

GAS

Las ligaduras entre carácteres facilitan la creación de palabras más compactas.

100

MERCATVS

35

VNIVERSIDAD DE SALAMANCA

20

CENTRO DE INVESTIGACIONES ALFONSO X EL SABIO

45

HOSPITAL DEL ESTVDIO

24

DEPARTAMENTO DE HISTORIA Y GEOGRAFIA

115

DERECHO

La letra «a» dispone de un "rabillo" más largo respecto la letra «A», para unirla al caràcter que le antecede.

44

SALA DE LAS TORTVGAS

_Typotheses

Günter Gerhard Lange

1. The carrier of visual information is the typeface, and with it typography. When writing informs, characters are largely static. When writing animates, form and expression are dynamic. When writing declares, bold demands come forward.

2. The printed textbook needs clear organization and appropriate proportions to achieve comprehensibility. The designer can use conservative type criteria that have existed for a long time.

3. Font selection depends on the competitive environment and the target audience. Together with picture choice, font selection ensures acceptance of the communicated contents.

4. As a source of pleasure and beauty fonts are always based on personal handwriting. They are, in fact, a form of self-expression. But the greater the personal statement, the less likely the fact is to be accepted. While it may receive applause from the like-minded, it prevents access by the general public, since it is too élitist.

5. In the visual communications of large institutions and companies, categorical font requirements as part of the CI program are necessary to ensure that they can be recognized; individual initiative must be excluded. Despite the need for standardization, however, a certain amount of freedom for individual applications should remain.

6. Just as in music, theatre and literature, there will continue to be different interpretations when adapting the classics. The modern stands in contrast to the classical and is driven by the demand for individuality, drawing its form from the programs and capabilities of the latest digital technology. Its freedom of design leads to the boundaries of understanding.

7. For today's younger generation, action and visual animation are what count. They stimulate initiative and access to the text. The permanent desire is for something new, even if it is only the old viewed from a new perspective and in a different form. The conflict between generations does not begin with the declining power of sight alone (characters that are too small remain unread by older people), but rather with emotional, expressive design.

8. The ever-growing share of pictures reduces the volume of text. This apparently meets the needs of the majority, but requires a rhythmic change in form and size and a dynamic, free design, up to and including collage. Both younger and older readers react to visual wasteland in text and conventional picture-making with disinterest.

9. The mission of the designer and conceiver must not be restricted to the aesthetic alone. Assignments and requirements must be carried out and designed in a manner appropriate to the subject and the target group. We are first and foremost service providers and have a human, economic mission to carry out. Still, profit maximization and practical work are not everything.

10. We must continually exceed ourselves in our creativity. We may, should, even must, leave the well-trodden paths and open ourselves to experimentation. In brief, we should be innovative, provocative when necessary, to adequately express our beliefs – new and different and/or better than before.
Note: Change is the only constant.

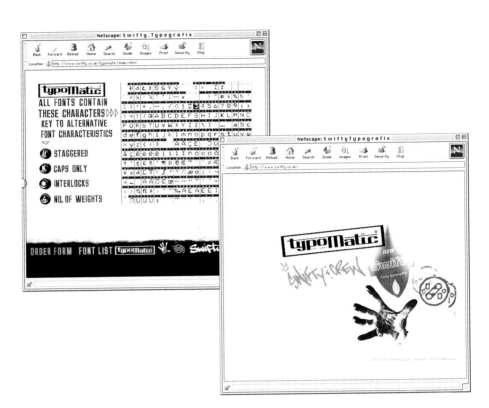

Website, 1998
www.swifty.co.uk
Design: Swifty

Typomatic

Location_London, UK

Established_1998

Founder_Ian Swift (Swifty)

Type designers_Ian Swift, Mitch, Robbie Bear, Fred

Distributor_www.swifty.co.uk

Funky, eclectic, dope, distressed, interlocked, out-erlocked, staggered, flim-flammed and plain groovy! With a touch of cooool man ... yes Daddio.

Swifty was trained as a graphic artist from 1981–86 and later worked at Face and Arena magazines. He joined Neville Brody Studios as designer from 1988 to 1990 before estab-lishing his own studio Swifty Typografix in London, where he has become a major force in British type design. Since 1994 he has been publishing Command Z, a project which includes Swifty Fanzine and Postscript Fontz (see p. 36). In 1997 he founded Typomatic, a font foundry launched on the Internet by a new generation of type designers (www. swifty.co.uk). The site also acts as a showcase for Swifty's work and features font designs from up-and-coming type designers from various image-making backgrounds – from graffiti to illustration and back again.

Samples of ongoing type designs, 1997–98
These visuals for stickers and posters were originally developed for an exhibition in France. They were pub-lished on the Typomatic website and as small bubblegum cards for the press release, 1998. Some of the fonts are still unfinished.

Design | Type design:Swifty

_License Plate

_Cut It Out

_Skrawl

_Slice of Cake

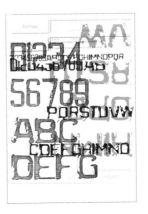

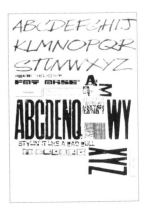

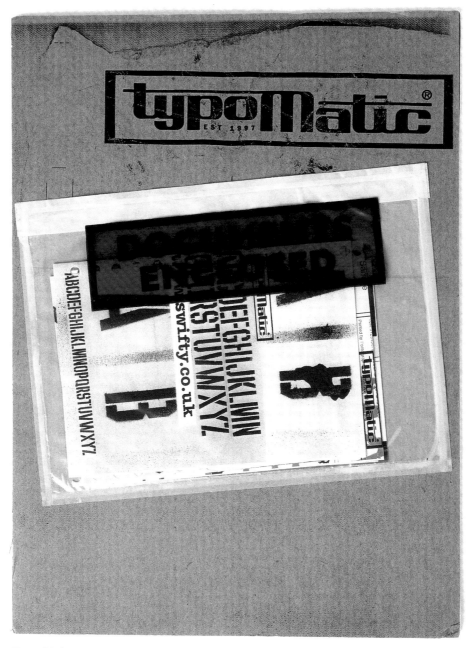

→
Press release, 1998
A4 tracing paper folded to A6 size,
mounted on to A5 corrugated card-
board with small bubblegum cards
showing screen grabs from the
Internet site.

Design | Type design: Swifty _Slice of Cake

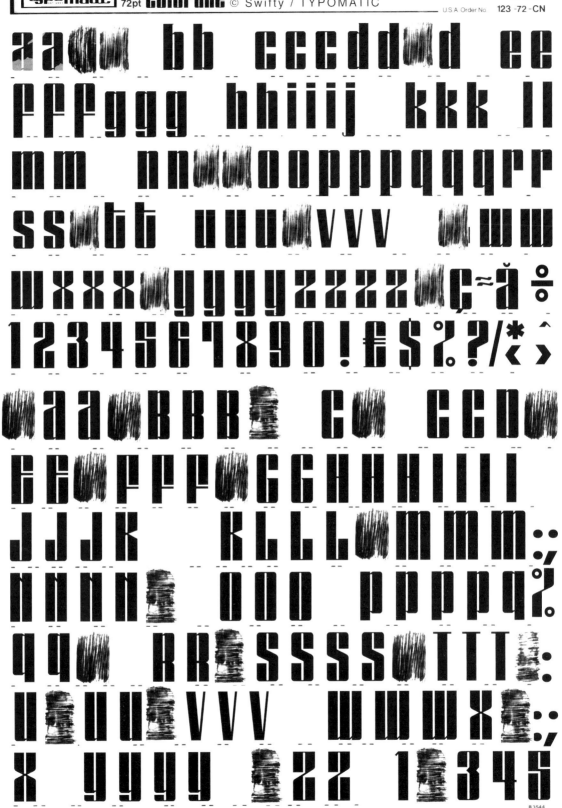

B 3544

Typomatic products are protected widely by patents and patent applications throughout the world

heat resistant ©TYPOMATIC INTERNATIONAL LTD 1998 PRINTED IN ENGLAND U.S.A Order No **123 -72 -CN**

Coltrane typeface sample, published
on the Typomatic website, 1998.
The layout was inspired by the style
of old Letraset sheets.

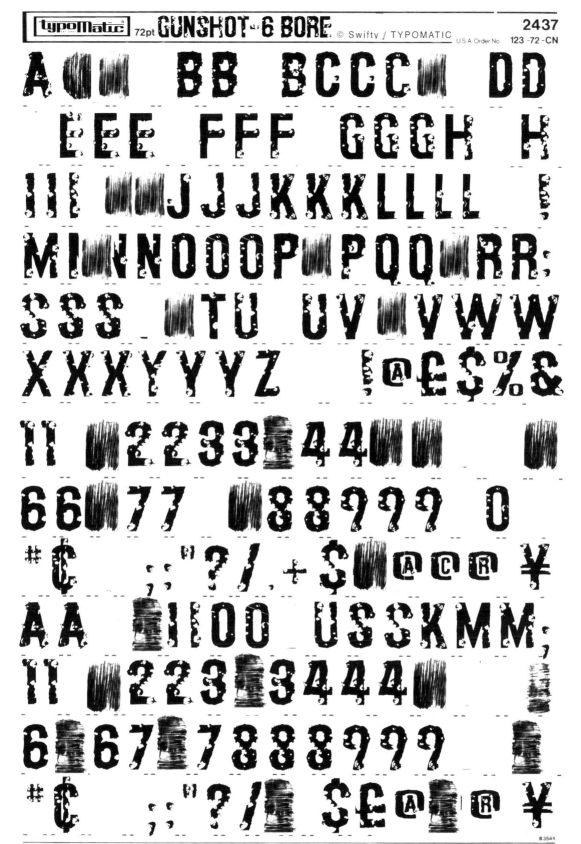

Gunshot 6 Bore typeface sample, pub-
lished on the Typomatic website,
1998.

heat resistant ©TYPOMATIC INTERNATIONAL LTD 1998 PRINTED IN ENGLAND U.S.A Order No **123-72-CN**

Fat Arse typeface sample, published
on the Typomatic website, 1998.
The typeface grid is based around the
plan of an old leather sofa from the
Seventies (see capital A).

Design: Swifty
Type design: Mitch _Fat Arse

typoMatic 72pt REPO-THIN © MITCH

2437

U.S.A. Order No. 123 -72 -CN

A A A B B B C C D E E
F F F G G H I I I J J J K ;
K K L L M M M N N N O O O
P P P Q Q Q R R R S S S T T T
U U U V V V W W X X Y
Y Z Z Z a a b b c c
d e e f f g h h h i i i j
j j K K K l l l m m m m n n n ;
o o o p p p q q q r r r s
t u v v v v w w w w x ;
x x y y y z z z ; () ' / | \ " — ;
) () (% ! ! ? ? c C
0 1 2 3 4 5 6 7 8 9 § £ S ?

B 3544

Typomatic products are protected widely by patents and patent applications throughout the world

heat resistant ©TYPOMATIC INTERNATIONAL LTD 1998 PRINTED IN ENGLAND U.S.A Order No. **123 -72 -CN**

Repo-Thin typeface sample, published
on the Typomatic website, 1998.

Design: Swifty
Type design: Mitch _Repo-Thin

JONATHAN SWIFT
Gulliver's Travels
A Voyage to Lilliput

<u>Gulliver's Travels</u>, 1995
4.2 x 6.5 cm
(shown here in original size)
The publication, designed and
produced by Unger, shows that the
font Gulliver is easy to read even in
a very small point size.

Design | Type design: Gerard Unger _Gulliver

Gerard Unger

Location_Bussum, The Netherlands

Established_1972

Distributors_Gerard Unger, Elsner+Flake, Linotype Library
ITC, Bistream, (URW)++, Dutch Type Library

Small font manufacturers of the world, unite!

Gerard Unger initially worked for fifteen years as a font
designer with the Hell company. In the mid-1970s, he was among
the first designers to develop digital fonts, along with Her-
mann Zapf, Adrian Frutiger and Matthew Carter. Unger has
repeatedly adapted to technological changes and requirements
when designing fonts – from lead type-setting to photosetting,
digital CRT-setting, laser-setting and now to the monitor
and 300-dpi printer. Today he uses the computer's potential,
but places value on determining the forms of letters not from
digital tools, but from his feel for form and the reading
process. Gerard Unger not only works as a font designer, but
as an independent graphic designer and author. Ideas for new
fonts often result from going between his several activities.
He has published various books that present his own fonts in
their applications and simultaneously deal with readability.

Unger has been marketing his own fonts since 1993. He is
currently working on the Paradox font, but also has plans for a
new sans serif. In addition, he wants to expand the Capitolium
family, developed for the 2000-year celebration of the city of
Rome.

Gulliver

regular, 100pt

Gulliver

regular italic

Gulliver

book

Gulliver

book italic

Gulliver

semi bold

Gulliver

semi bold italic

Gulliver

bold

Gulliver

bold italic

Pages from <u>Gulliver's Travels</u>, 1995
4.2 x 6.5 cm
Through numerous experiments, Unger has
increased the readability of this font.
According to Unger, Gulliver is like a
Volkswagen for cross-country driving,
a kind of car for reading, almost a type
of techno font.

Design | Type design: Gerard Unger _Gulliver

Terwijl je leest (While You Read), 1997
17.5 x 24.5 cm
In this book, Unger deals with the
readability of letter forms.

Design | Type design: Gerard Unger _Paradox

Pages from <u>Terwijl je leest</u>, 1997
17.5 x 24.5 cm
It is intended that the reader should
learn more about fonts and typography
in the book, and also enjoy the process
of reading.

Design | Type design: Gerard Unger _Paradox

Frank Heine, U.O.R.G.

Location_Stuttgart, Germany

Established_1992

Founder | Type designer_Frank Heine

Distributors_Emigre, [T-26], FontHaus
FontShop International (FSI)

Since 1992 Frank Heine has released fonts
through different foundries. The fonts span a
wide range of styles: curly headliners, crisp
text faces, reinterpreted historical faces,
as well as spontaneous, rough experiments.
Though they share no obvious similarities, all
the fonts have a love of detail and an emphasis
on quality. Each font has hundreds of manually
edited kerning pairs for each weight, numer-
ous ligatures and alternative characters,
all of which offer the user a rich source of
individual and expressive typography.

Apart from the creation of new fonts, U.O.R.G.'s
work includes graphic design projects such as
corporate identities, logos, brochures, posters
and designs for museums and exhibitions.

01

02

03

04

05

06

<u>Intro: Navigator</u> detail from
sequence on the first three pages.

Isle
of
tranquility

07

08

09

01 – 10:
<u>France</u> booklet, 1998
36 pages
14.5 x 21 cm
An illustrated diary of a three-
week trip to the south of France,
featuring typefaces that are still
under construction. Due to the
unfinished state of the fonts,
the pages reflect spontaneous
rough designs – more like small
posters than an intimate booklet.

Design | Type design: Frank Heine _Coolage Bold
 _Desolation
 _Vespasian

family
album

10

01

The future

02

03

POSTSCRIPT ERROR: timeout OFFENDING COMMAND: timec

04

05

06

07

3.

08

THE PREJUDICES
AGAINST THIS CO/
LOR ARE STILL SUF/
FICIENTLY STRONG
TO REQUIRE A DIS/
CUSSION OF THE
PROPERTIES OF
BLACK AND A VIG/
OROUS DEFENSE OF
ITS MANY VIRTUES.
BLANKET DENUN/
CIATION OF A CO/
LOR COMPLETELY
IGNORES THE RE/
LATIVE NATURE
OF ANY COLOR OR
FORM.

09

3

10

11

THE PREJUDICES
AGAINST

12

13

14

15

16

UNS OBLIEGET / nur das Gegen
so kurtʒ das es nicht zu messen /
so wir mit den Sinnen begreiffen k
theilbare Theile hat / jedoch aus d
ob er wohl nicht zu theilen / denn
die Ewigkeit bestehet. Welches mi
und Linien vorgestellet worden / c
die Ewigkeit. Wer sich ʒu erinnerr
der gegenwärtigen Zeit ʒu verder

Page 06: detail of Amplifier,
by Arthur Henkel/
Albrecht Schöne (editors),
Emblemata, Stuttgart, 1996.

17

18

19

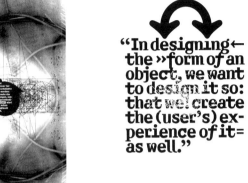

Detail from page 06
Text by Arthur Henkel/
Albrecht Schöne(editors),
Emblemata, Stuttgart, 1996.

Type design: Frank Heine _Amplifier

20

21

22

01 – 28:
Future is close booklet, 1997
36 pages
14.5 x 21 cm
The booklet is an interpretation
of quotations about typography,
design, space and time. The design
concept is based upon repetitions,
with text and formal links going
forwards and backwards between
the pages. The booklet's typography
is showing both, the text size
qualities of Amplifier Light and
the expressive headline capabil-
ities of Amplifier Bold. Within
the texts the use of ligatures,
alternative letters and small
caps demonstrate Amplifier's
typographic details. Amplifier
is a family of more than one
thousand different characters.

Quotations from:
03 Colin Davis, Chicago, 1996
09 Paul Rand, A Designer's Art,
New Haven, 1985
22 John Rheinfrank/Katherine
Welker, LookingCloser,
New York, 1994

23

24

25

26

27

28

Design | Type design: Frank Heine _Amplifier Family
_Opsmarckt

01 – 11:
<u>Interim compilation</u>
booklet, 1996
36 pages
14.5 x 21 cm
The booklet presents an 'interim
balance' of all typeface releases
between 1992 and 1996. Each font
is shown with a complete synopsis
and a full-page design sample.

02 Remedy
03 Remedy, design published
in <u>Emigre</u> #24 (Neomania)
04 Chelsea
05 Chelsea, self-promotion
06 Determination
07 Determination, <u>FUSE</u> poster
08 Indecision
09 Indecision, design for [T-26],
10 Detail of Amplifier,
text by Dan X.O'Neil,
11 Detail of Whole Little
Universe

Design | Type design: Frank Heine

01

02

03

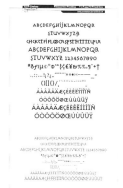

04

05

06

11

07

08

09

→
12 – 15:
Documentation for [T-26],
1995 –97, US letter
keyboard maps, notes & tips.
Pages used in [T-26] catalogues
and as accompanying material for
purchased disks to present all
necessary information
to make best use of the fonts.

12 Opsmarckt, cover sheet
13 Opsmarckt Basic
14 Amplifier
15 Feltrinelli

Design | Type design: Frank Heine

_Amplifier
_Feltrinelli
_Indecision
_Intolerance
_Kracklite
_Opsmarckt
_Whole Little Universe

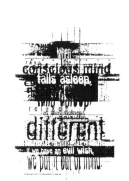

These words may not be able to stop—
even!in:the(face)of—the
underl*ying ter/ror they
›see in»their...own;
{punc?tuation.}

10

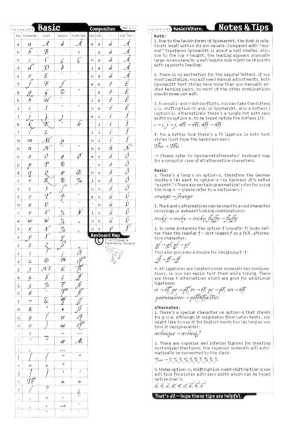

Notes & Tips

Both:

1. Due to the lavish forms of Opsmarckt, the font is relatively small within its em-square. Compared with "normal" typefaces Opsmarckt is about a half smaller. Also, due to the low x-height, the leading appears unusually large. As an example: a well legible size might be 18 points with 14 points leading.

2. There is no aesthetics for the capital letters. If you must capitalize, you will need manual adjustments. Both Opsmarckt text styles have more than 900 manually edited kerning pairs; so most of the other combinations should come out well.

3. To avoid i- and j-dot conflicts, you can take the dotless i (ı, shift/option-b), and in Opsmarckt, also a dotless j (option-j). Alternatively there's a single dot with zero width on option-b, to be typed before the dotless i/j:

4. For a better look there's a Th Ligature in both text styles (just type the backslash key):

→ Please refer to OpsmarcktAlternates' keyboard map for a synoptic view of all alternative characters.

Basic:

1. There's a long-s on option-s, therefore the German doubler-s (ß) went to option-z—in Germany it's called "eszett." (There are certain grammatical rules for using the long-s → please refer to a dictionary.)

2. The k and y alternatives can be used to avoid character crossings or awkward looking combinations:

3. In some instances the option-f (usually: f) looks better than the regular f—just regard f as a full, alternative character.
This also provides a choice for designing f-f:

4. All ligatures are located under numerals key combinations, so you can easily test them while typing. There are three t-alternatives which are good for additional ligatures:

Alternates:

1. There's a special character on option-q that stands for q-u-e. Although it originates from Latin texts, you might like to use it for English words too (as long as you find it decipherable):

2. There are superior and inferior figures for creating customized fractions; the superior numerals will automatically be connected to the slash:

3. Under option-o, shift/option-o and shift/option-q you will find flourishes with zero width which can be typed before char's:

That's all—hope these tips are helpful.

Notes & Tips

3. ◆◆ means: the Extensions contain superior characters that can be used for abbreviations in some languages, or for typical English ordinals:

Additionally the underline position is harmonized with these superior characters:

There are five punctuation marks for the superior char's:
$60.12 st,nd 80-AVE (a) (3)
(shift-, shift-, opt--, ())

4. Combinations: the Extensions contain some characters for useful combinations:

(opt-' shift/opt-' ')

(opt-, opt-. ')

Print:
(opt-l opt-m)

☐ Tick here, and there ☒
(x shift-x)

(opt-u/e f g opt-u/V)

(opt-e/e opt-i/e opt-i/E opt-i/e opt-u/e)

(opt-e/E opt-i/e opt-u/E opt-i/e shift/opt/p)

(opt-v opt-w opt-z)

(opt-v opt-w shift/opt-v, In Light Extensions)

(opt-v opt-w shift/opt-v, In Bold Extensions)

And a (simply) kerned combination:

1. ℓℓ means: some combinations with "l" look better when using the alternative "l" (on opt-l), for example: Floating (Floating).

2. 2323 means: there are six different sets of numerals in Amplifier, namely:
- Old style: 1234567890
- Lining: 1234567890
- Small caps: 1234567890
- Tabular*: 1234567890
- Superior**: 1234567890
- Inferior**: 1234567890

* Tabular numerals (in Extensions) are the same as Lining, but with equal widths which make them stand in even columns when set under each other (often needed in tables, annual reports, etc.).

** Superior and inferior numerals are also located in the Extensions—they can be used for creating customized fractions, e.g. 17/85 126/1024.

Additionally you can find (often used) "fixed" fractions under one character, e.g. 1/4 5/8.

These fixed fractions are drawn a bit larger to make them clearer at small sizes: 5/8 against 5/8.

Full overview of characters

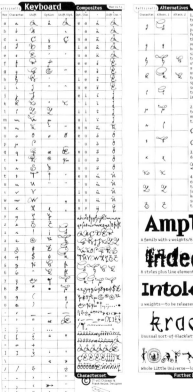

Notes & Tips

1. Due to the lavish forms of Feltrinelli, the font is relatively small within its em-square. Compared with "normal" typefaces Feltrinelli is about a half to a third smaller (depending whether you measure the x- or the cap-height). That means: 30 points size of Feltrinelli is equivalent to 10–14 points size of many other fonts. Also, due to the low x-height, the leading appears unusually large (although the alternative characters need this space). In order to get compact settings you will need to set Feltrinelli e.g. with 24/16 points, instead of 24/29.

2. The use of alternative characters (as listed left) will offer many attractive typographic options:

3. The capital alternatives are designed for use with vowels:

4. There is no aesthetics for the capital letters. If you must capitalize, you will need manual adjustments. Feltrinelli has 999 kerning pairs (manually edited), so most of the other combinations should come out well.

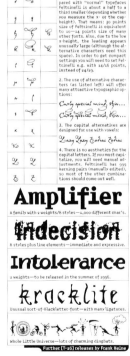

Amplifier
A family with 2 weights/8 styles—1,000 different char's.

Indecision
8 styles plus line elements—immediate and expressive.

Intolerance
2 weights—to be released in the summer of 1996.

kracklite
Unusual sort-of-Blackletter-font—with many ligatures.

Whole Little Universe—lots of charming dingbats.

Further [T-26] releases by Frank Heine.

ABCDEFGHIJKLMNOPQRSTUVWXYZabcdefghijklmnopqrstuvwxyz
ABCDEFGHIJKLMNOPQRSTUVWXYZabcdefghijklmnopqrstuvwx
ABCDEFGHIJKLMNOPQRSTUVWXYZabcdefghijklmnopqrstuvwxyz
1234567890

ABCDE

Typefaces belonging to
the font Trilogy DTC Hermes,
Imperial and Joker.
All the fonts have the same width.

Type design: Volker Schnebel, 1997 _DTC Joker Light, Regular, Bold
_DTC Hermes Light, Bold

(URW)++

Location_Hamburg, Germany

Established_1995

Founders_Svend Bang, Hans-Jochen Lau, Peter Rosenfeld
Dr Jürgen Willrodt

Type designers_Bigelow & Holmes, Frank Blokland, Albert Jan Pool
Volker Schnebel, Gerard Unger, Jovica Veljović
Hermann Zapf and many more

Distributors_URW America, (URW)++ France, (URW)++ España
(URW)++ Australia, AIT, FontShop International
(FSI)

The whole world of type!

(URW)++ is still a young enterprise that intends to establish
itself further in the graphic design industry by continually
developing and marketing innovative font and software prod-
ucts. In addition to the PostScript and TrueType font program,
which consists of more than 3500 typefaces, (URW)++ offers ser-
vices such as digitization of fonts and logos based on artwork,
special character layouts and formats, multimedia fonts, pro-
duction of personal scripts and corporate type design. (URW)++
also offers a collection of 4500 popular logos and symbols and
supplies fonts from numerous other foundries, for instance
Adobe, Agfa, Emigre, FontBureau, Linotype-Hell and Monotype.

The company's software products include Signus, a lettering
system for signmakers; Linus, a program for the automatic
digitization (auto-tracing) of logos, signets, pictograms and
line art; and Ikarus, a system for the professional design
and production of digital fonts. The company will develop and
license new versions of Ikarus to meet the requirements of
Asian markets, as well as the production demands of high-
quality screen representation.

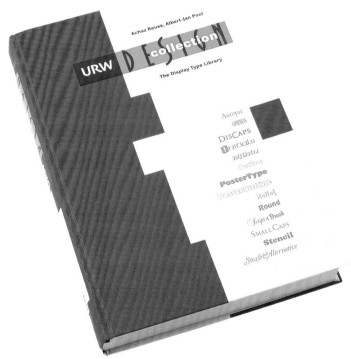

URW Design collection and
CD-ROM, 1994
catalogue: 21 x 29.7 cm
681 pages

Design: Sigrid Büter

Pages from URW Design
collection, 1994
21 x 29.7 cm

Design: Sigrid Büter
Type design: Joseph Churchward _Churchward Brush Regular Italic
Georg Trump _City Stencil D medium

ALLES
MÜLLER?
SCHÖN
WÄR'S!

ALLES
MÜLLER?
SCHÖN
IST ES!

City Stencil D medium

ABCDEFGHIJ
KLMNOPQSTV
URWXYZ
abcdefghijklm
nopqrstuvwxyz
1234567890

ÄÄÀÁÂÃÇËÈÉÊ
ÏÌÍÎÑÖÒÓÔÕ
ÜÙÚÛŸÆŒØ
äàáâãçëèéêïìíîñöòóôõ
üùúûÿæœøß

.,:;... --—''„"" / ‹›«» !?
£$¢% & [*†§¶]] (®©™)

Stencil

Pages from URW Design
collection, 1994
21 x 29.7 cm

Design: Sigrid Büter
Type design: Aldo Novarese _Stop Round D

Alan Birch _Rubber Stamp Solid T

ROUND MACHT'S RUND

ABCDEFGHIJKLMNOPQRSTUVWXYZ
1234567890 £$¢% & ---–.,:;...'',,"" / ‹›«» !? [*†§¶] (®©™)
ÅÄÀÁÂÃÇËÈÉÊÏÌÍÎÑÖÒÓÔÕÜÙÚÛŸÆŒØ
DIE ERFAHRUNG VON URW AUF DEM GEBIET DER SCHRIFTZEICHEN-
HERSTELLUNG INNERHALB DES IKARUS SYSTEMS UMFASST JETZT MEHR
ALS 20 JAHRE. MIT DEN MANNIGFALTIGEN MÖGLICHKEITEN DER MODI-
FIKATION UND DES INTERPOLIERENS WURDEN NEUE WEGE FÜR DIE
ENTWICKLUNG VON GANZEN SCHRIFTFAMILIEN AUSGEARBEITET. URW

RUBBER STAMP SOLID T

ABCDEF
GHIJKLM
NOPQSTV
URWXYZ
123456789
ÅÄÀÁÂÃÇËÈÉÊ
ÏÌÍÎÑÖÒÓÔÕ
ÜÙÚÛŸÆŒØ
.,:;... ---–"',,"" / ‹›«›
£$¢% & [*†§¶]

Antique

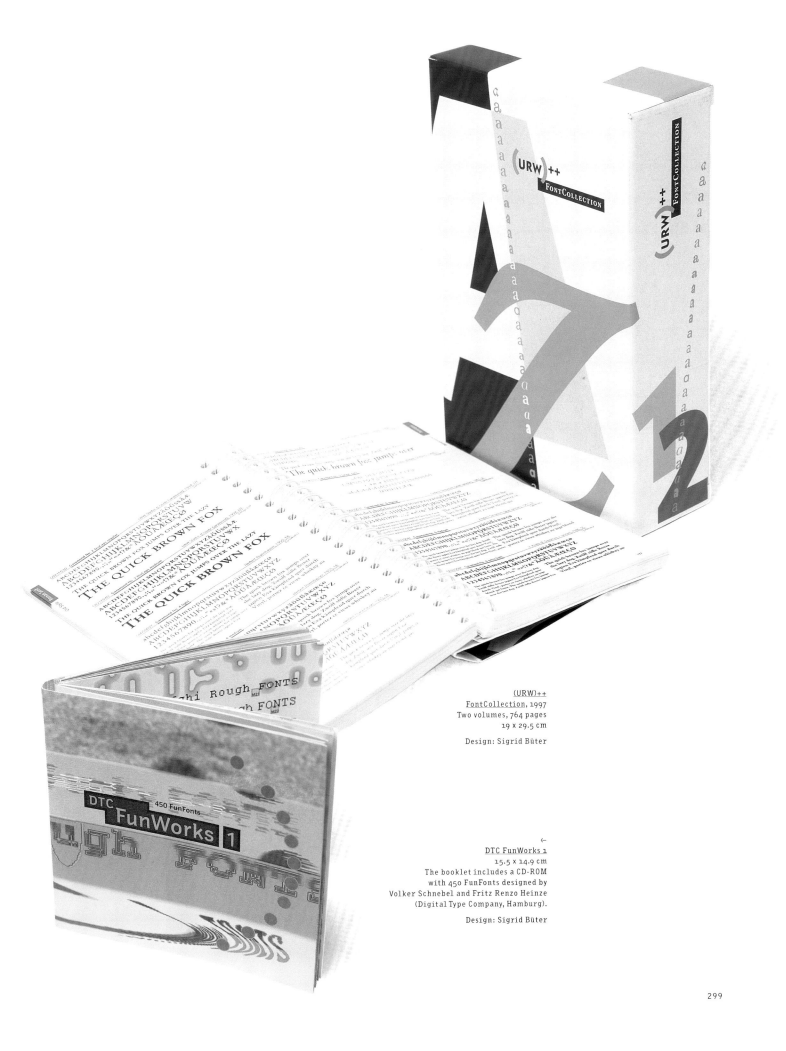

(URW)++
FontCollection, 1997
Two volumes, 764 pages
19 x 29.5 cm

Design: Sigrid Büter

←
DTC FunWorks 1
15.5 x 14.9 cm
The booklet includes a CD-ROM
with 450 FunFonts designed by
Volker Schnebel and Fritz Renzo Heinze
(Digital Type Company, Hamburg).

Design: Sigrid Büter

Virus

Location_London, UK

Established_1997

Founder | Type designer_Jonathan Barnbrook

Distributors_Virus, Fontworks

love first, money last

The philosophy of Virus is to produce experimental typography without consideration for commercial gain. It is not governed in any way by the desire to make money. The printed work Virus produces is a vehicle to make people think about the cultural and political place of a graphic designer, to draw them out of the vacuum that they work in most of the time.

Virus was founded by Jonathan Barnbrook, a font designer, graphic designer and advertising director. He releases his typefaces through his own foundry and is known for the fonts Exocet and Ma(n)son, released by Emigre. He recently finished designing the major monograph on Damien Hirst entitled <u>I Want to Spend the Rest of My Life Everywhere with Everyone, One to One, Always, Forever, Now</u>.

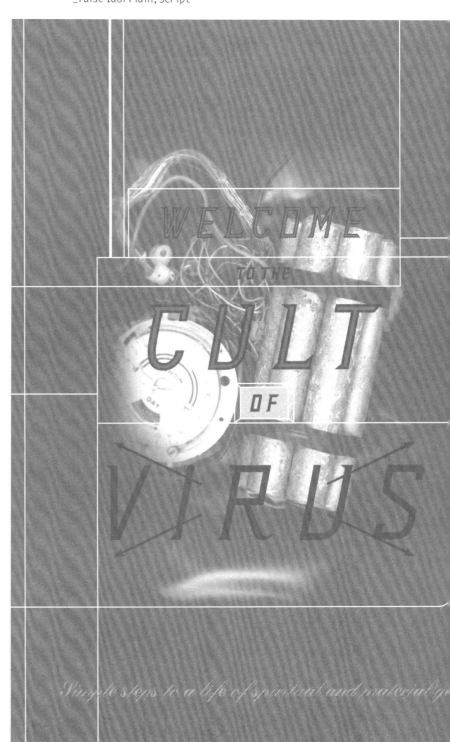

Pages from the catalogue, 1997
21 x 29.7 cm

Design | Type design: Jonathan Barnbrook _NixonScript
_Patriot
_False Idol Plain, Script
_Drone

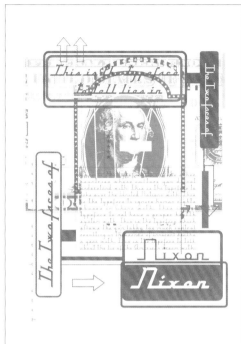

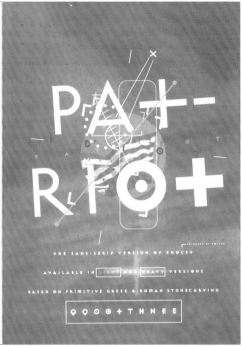

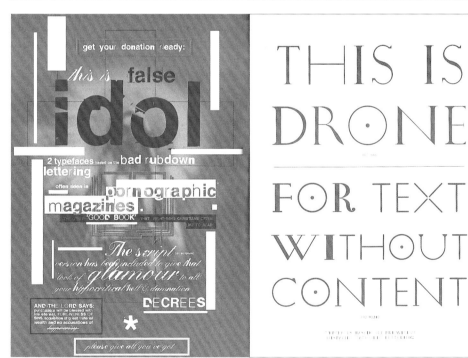

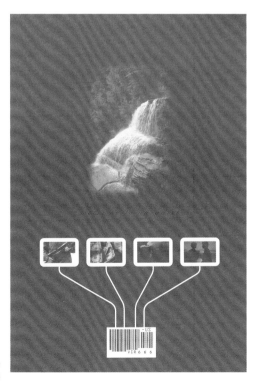

Back of the catalogue, 1997
21 x 29.7 cm

Design | Type design: Jonathan Barnbrook _False Idol Script

CONC

YOU

TH

NOW YOU

CONTACT

AS ALL

AGA

Website, 1998
www.virus.net

Design: Jonathan Barnbrook/axcess media
Type design: Jonathan Barnbrook _Draylon
_Patriot
_Delux

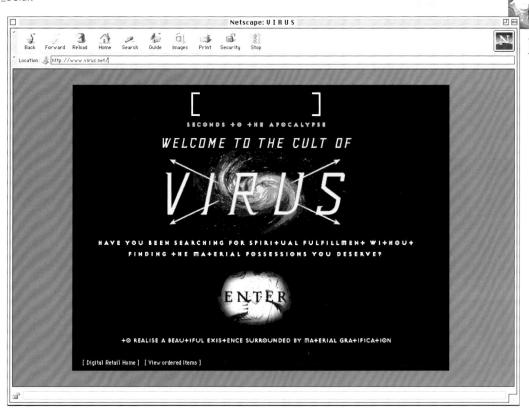

PL

YO

302

ULATIONS

TRULY MADE
T CHOICE

DO NOT ATTEMPT TO
ERS OF YOUR FAMILY
ARE IN CONSPIRACY
ULT OF VIRUS

CHOOSE
DESTINY

prozac

SIMPLIFY ALL MEANING
SIMPLIFY ALL MEANING

Click the graphic to place on order

prozac is a way of simplifying your life. prozac take things back to basics. prozac is a foolish experiment. it is typography from the vatican prozac affects the meaning of what you say. prozac takes the alphabet down to six basic shapes. prozac forms were designed by scientists in sterile environments without ethics. prozac is available without prescription in lite and max versions.

NYLON
PROTOTYPE
prozac
PA+RIO+

CHOOSE
YOUR
DESTINY

DRONE
False idol
NixonScript
Bastard
DELUX

ORDERING

[Digital Retail Home] [View ordered items]

Specimens presented on the website, 1998.

Design | Type design: Jonathan Barnbrook _Prozac
_False Idol
_Nylon/Draylon
_NixonScript
_Drone
_Patriot

False Idol

ABCDEFG
abcdefghij
ABCDEFG
abcdefghijklm

Confess your sins to the False idol
Confess your sins to the False idol

Click the graphic to place on order

false idol is an illusory object of worship, a failed attempt at glamourise your life. bad rubdown lettering taken from 1970s pornographic magazines [which i haven't seen] that try to mimic an atmosphere of elegance and sophistication but achieve only a seediness.

NYLON + DRAYLON

ABCDEF
GHIJKLM
ABCDEF
GHIJKLM

TYPE FOR MANIC DEPRESSIVES
TYPE FOR MANIC DEPRESSIVES

Click the graphic to place on order

nylon is taken from letterforms in paintings from the 13-16th century, they seemed to have this manic range of shapes which had very little to do with the classic ideal. draylon is much more restrained based on 17-18th century letterforms. both have been drawn to reflect they were produced on a computer and designed so that you can mix or plunder letterforms from different centuries in the same word.

NixonScript

ABCDEFGHIJK
abcdefghijklmn
ABCDEFGHIJK
abcdefghijklmn

Tell lies with NixonScript
Tell lies with NixonScript

Click the graphic to place on order

nixonscript is very loosely based on a piece of lettering seen on an old 1960s camera bought in a junk shop. it is typography from the vatican [piety] that meets 'the price is right' [self-celebration]. nixonscript is for telling lies with.

DRONE

ABCDEFG
HIJKLM
ABCDEFG
HIJKLM

FOR TEXT WITHOUT CONTENT
FOR TEXT WITHOUT CONTENT

Click the graphic to place on order

drone is something you just don't want to hear. drone is a primitive serif font based on lettering seen in hispanic catholic churches, drone is a religious dogma spoken at you for hours on end, drone is the sound of impending disaster. drone is a technology that is programmed to kill all life. drone is available in cut number 666 or 90210.

PA+RIO+

ABCDEF
GHIJKL
ABCDE
FGHIJK

SHOOT 'EM DOWN WI+H PATRIOT
SHOOT 'EM DOWN WI+H PATRIOT

Click the graphic to place on order

patriot is a stupid unthinking being that shouts the same message, patriot is the sans version of 'exocet', a font released through emigre. [patriot missiles shoot down other missiles, so there must be some logic there] patriot letterforms are based on primitive greek stonecarving.

__Addresses

2Rebels
4623 Harvard
Montreal, Quebec, H4A 2X3
Canada
T +1/5 14/4 81 09 84
F +1/5 14/4 86 86 57
E info@2rebels.com
W http://www.login.net/2rebels

Adobe Systems
345 Park Avenue
San Jose, CA 95110-2704, USA
T +1/408/536 6000
F +1/408/537 6000
W http://www.adobe.com/type/

Agfa / Creative Alliance
90 Industrial Way
Wilmington
MA 01887, USA
T +1/978/658 5600
F +1/978/657 8568
W http://www.agfahome.com

Apply Design Group
Thomas Sokolowski
Krugstraße 16
30435 Hannover, Germany
T +49/511/4 85 02 90
F +49/511/4 85 02 99
W http://www.apply.de

Bitstream
Athenaeum House
215 First Street
Cambridge, MA 02142, USA
T +1/617/520 8627
F +1/617/868 0784
W http://www.bitstream.com

brass_fonts
Friesenwall 24
50672 Cologne, Germany
T +49/221/2 57 77 33
F +49/221/2 57 77 03
W http://www.brass-fonts.de

Command (Z)
Ian Swift (Swifty)
Unit 66, Pall Mall Deposit
124-128 Barlby Rd
London, W10 6BL, UK
T +44/181/968 1931
F +44/181/968 1932
W http://www.swifty.co.uk

Creative Alliance /
Monotype Typography
Unit 2, Perrywood Business Park
Salfords, Redhill, Surrey
RH1 5DZ, UK
T +44/1737/765 959
F +44/1737/769 243
E enquire@monotypeuk.com
W http://www.monotype.com

Device
Rian Hughes
6 Salem Road
London, W2 4BU, UK
T +44/171/221 9580
F +44/171/221 9589
W http://www.devicefonts.co.uk.

Dutch Design
Albert-Jan Pool
Phoenixhof
Ruhrstraße 11
22761 Hamburg, Germany
T +49/40/85 37 43 00
F +49/40/8 51 53 08
E farbtontm@aol.com

Dutch Type Library
Kruisstraat 33
5211 DT 's-Hertogenbosch, The Netherlands
T +31/73/6 14 95 36
F +31/73/6 13 98 23
E dtl@euronet.nl

Elliott Peter Earls
82 East Elmstreet
Greenwich, CT 06830, USA
T +1/203/861 7075
F +1/203/861 7079
E elliott@www.theapolloprogram.com
W http://www.theapolloprogram.com

Elsner+Flake
Friedensalle 44
22765 Hamburg, Germany
T +49/40/39 88 39 88
F +49/40/39 88 39 99
W http://www.ef-fonts.de
W http://www.ef-fonts.com

Emigre
Zuzana Licko
4475 D Street
Sacramento, CA 95819, USA
T +1/916/451 4344
F +1/916/451 4351
W http://www.emigre.com

Face2Face
xplicit ffm
Ludwigstraße 31
60327 Frankfurt a.M., Germany
T +49/69/97 57 27-0
F +49/69/97 57 27-27
W http://www.xplicit.de/xxface2face.html

Face2Face
Moniteurs
Nollendorfstraße 11/12
10777 Berlin, Germany
T +49/30/2 15 00 88
F +49/30/2 15 00 89
W http://www.moniteurs.de

Faith
Paul Sych
1179a King St. West. # 202
Toronto, M6K 3C5, Canada
T +1/416/539 9977
F +1/416/539 9255
E faith@faith.ca

Font Bureau
326 A Street, Suite 6C
Boston, MA 02210, USA
T +1/617/423 8770
F +1/617/423 8771
W http://www.fontbureau.com

fontBoy
Aufuldish & Warinner
183 the Alameda
San Anselmo, CA 94960, USA
T +1/415/721 7921
F +1/415/721 7965
E bob@fontboy.com
W http://www.fontBoy.com

FontFabrik
Apostel-Paulus-Straße 32
10823 Berlin, Germany
T +49/30/78 70 30 97
F +49/30/78 70 58 78
W http://www.FontFabrik.com

Fontolgy
Fabrizio Schiavi
Via Vignola, 31
29100 Piacenza, Italy
T +39/0523/75 89 34
F +39/0523/75 89 34
W http://www.agonet.it/fabrizioschiavi/tve.htm

Fontolgy
Alessio Leonardi
Böckhstraße 21
10967 Berlin, Germany
T +49/30/69 80 93-3
F +49/30/69 80 93-55
W http://www.leowol.de/alessio/types.html

FontShop International (FSI)
Bergmannstraße 102
10961 Berlin, Germany
T +49/30/69 58 95
F +49/306 92 88 65
W http://www.fontShop.de

The Foundry
Studio 12
10-11 Archer Street
London, W1V 7HG, UK
T +44/171/734 6925
F +44/171/734 2607
E dqfs@thefoundrystudio.co.uk

GarageFonts
P.O. Box 3101
Del Mar, CA 92014, USA
T +1/619/755 4761
F +1/619/755 4761
E info@garagefonts.com
W http://www.garagefonts.com

garcia fonts & co.
P.O. Box 167
08107 Martorelles
Barcelona, Spain
T +43/93/5 79 09 59
F +43/93/5 79 09 59
E typerware@seker.es
W http://www.typerware.com/garciafonts

House Industries
P.O. Box 30000
Wilmington, DE 19805-7000, USA
T +1/302/888 1218
F +1/302/888 1605
W http://www.houseind.com

ITC (International Typeface Corporation)
229 East 45th Street
New York, NY 10017, USA
T +1/212/949 8072
F +1/212/949 8485
W http://www.itcfonts.com

kametype
Joachim Müller-Lancé
1635 Mason Street # 3
San Francisco, CA 94133, USA
T +1/415/931 3160
F +1/415/931 3160
E kame@wenet.net

Alessio Leonardi
Leonardi.Wollein
Böckhstraße 21
10967 Berlin, Germany
T +49/30/69 80 93-3
F +49/30/69 80 93-55
W http://www.leowol.de/alessio/types.html

LetterPerfect Fonts
Garrett Boge
526 First Ave. S. #227
Seattle, WA 98104, USA
T +1/206/467 7275
F +1/206/467 7275
W http://www.letterspace.com/
LETTERPERFECT_FONTS

LettError
Erik van Blokland
Molenstraat 67
2513 BJ The Hague, The Netherlands
T +31/70/3 60 50 25
F +31/70/3 10 66 85
E erik@letterror.com
W http://www.letterror.com

LettError
Just van Rossum
Koediefstraat 17
2511 CG The Hague, The Netherlands
T +31/70/3 62 51 47
F +31/70/3 46 29 76
E just@letterror.com
W http://www.letterror.com

lineto
Cornel Windlin
Pfingstweidstraße 6
8005 Zürich, Switzerland
T +41/1/2 71 90 66
F +41/1/2 71 90 65
E cornel@lineto.com
W http://www.lineto.com

lineto
Stephan Müller (Pronto)
Lützowufer 12
10785 Berlin, Germany
T +49/30/26 48 02 82
F +49/30/26 48 02 82
E pronto@lineto.com
W http://www.lineto.com

Linotype Library
Du-Pont-Straße 1
61352 Bad Homburg, Germany
T +49/61/72 48 44 24
F +49/61/72 48 44 29
E Linotype@internet.de
W http://www.LinotypeLibrary.com

LUST
Pastorswarande 56
2513 TZ, The Hague, The Netherlands
T +31/70/3 63 57 76
F +31/70/3 46 98 92
W http://www.lust.nl

Optimo
24 Côtes de Montbenon 24
1003 Lausanne, Switzerland
T +41/21/3 11 51 45
F +41/21/3 11 52 03
E service@optimo.ch
W http://www.optimo.ch

Dennis Ortiz-Lopez
267 west 70th street / #2-C
New York, NY 10023, USA
T +1/212/877 6918
F +1/212/769 3783
E sini4me2@soho.ios.com
W http://soho.ios.com/~sini4me2

ParaType
47 Nakhimovsky Ave, 19th floor
Moscow, 117418, Russia
T +7/95/3 32 40 01
F +7/95/1 29 09 11
E fonts@paratype.com
W http://www.paratype.com

Porchez Typofonderie
38 bis avenue Augustin-Dumont
92240, Malakoff, France
T +33/1/46 54 26 92
F +33/1/46 54 26 92
E jfporchez@hol.fr
W http://www.porcheztypo.com

Fabrizio Schiavi
Via Vignola, 31
29100 Piacenza, Italy
T +39/0523/75 89 34
F +39/0523/75 89 34
W http://www.agonet.it/fabrizioschiavi/tve.htm

Stone Type Foundry
626 Middlefield Road
Palo Alto, CA 94301, USA
T +1/650/324 1807
 +1/800/557 8663
F +1/650/324 1783
E stonefndry@aol.com

Judith Sutcliffe
The Electric Typographer
P.O. Box 224
Audubon, IA 50025, USA
T +1/712/563 3799
F +1/712/563 3799
E electtype@aol.com

[T-26]
Carlos Segura
1110 North Milwaukee Avenue, 1st Floor
Chicago, IL 60622-4017, USA
T +1/773/862 1201
F +1/773/862 1214
E T26font@aol.com
W http://www.T26font.com

Thirstype
117 South Cook #333
Barrington, IL 60010, USA
T +1/847/842 0222
F +1/847/842 0220
E Thirstype@aol.com
W http://www.3st.com

Type-Ø-Tones
Sant Agustí, 3-5, 3d
08012 Barcelona, Spain
T +34/93/2 37 68 56
F +34/93/4 16 15 88
E info@type-o-tones.com
W http://www.type-o-tones.com

Typerware
Anselm Clavé, 7
08106 Santa Maria de Martorelles
Barcelona, Spain
T +34/93/5 79 09 59
F +34/93/5 79 09 59
E typerware@seker.es
W http://www.typerware.com

Typerware
Bertrellans, 4 baixos
08002 Barcelona, Spain
T +34/93/3 02 40 27
F +34/93/3 02 40 27
E typerware@seker.es
W http://www.typerware.com

Typomatic
Ian Swift (Swifty)
Unit 66, Pall Mall Deposit
124-128 Barlby Rd
London, W10 6BL, UK
T +44/181/968 1931
F +44/181/968 1932
W http://www.swifty.co.uk

Gerard Unger
Parklaan 29A
1405 GN Bussum, The Netherlands
T +31/35/6 93 66 21
F +31/35/6 93 91 21

U.O.R.G.
Frank Heine
Seidenstraße 65
70174 Stuttgart, Germany
T +49/7 11/2 23 89 37
F +49/7 11/2 23 89 38
E frank@uorg.com

(URW)++
Design & Development
Poppenbütteler Bogen 29A
22399 Hamburg, Germany
T +49/40/60 60 50
F +49/40/60 60 51 11
W http://www.urwpp.de

Virus
Jonathan arnbrook
10 Archer Street
London, W1V 7HG, UK
T +44/171/287 3848
F +44/171/287 3601
W http://www.virus.net

_Type designers

__Fonts